ART OF EMPIRE

ART OF EMPIRE

Painting and Architecture
of the Byzantine Periphery

A Comparative Study of Four Provinces

Annabel Jane Wharton

THE PENNSYLVANIA STATE UNIVERSITY PRESS
University Park and London

Library of Congress Cataloging-in-Publication Data

Wharton, Annabel Jane.
Art of empire.

Includes index.
1. Art, Byzantine. 2. Byzantine Empire—Provinces—
Civilization. 3. Byzantine antiquities. I. Title.
N6250.E5 1987 709'.02 86–43039
ISBN 0-271-00495-9

For my beloved daughters,
Nicole Alexandra and Andrea Jerry

Contents

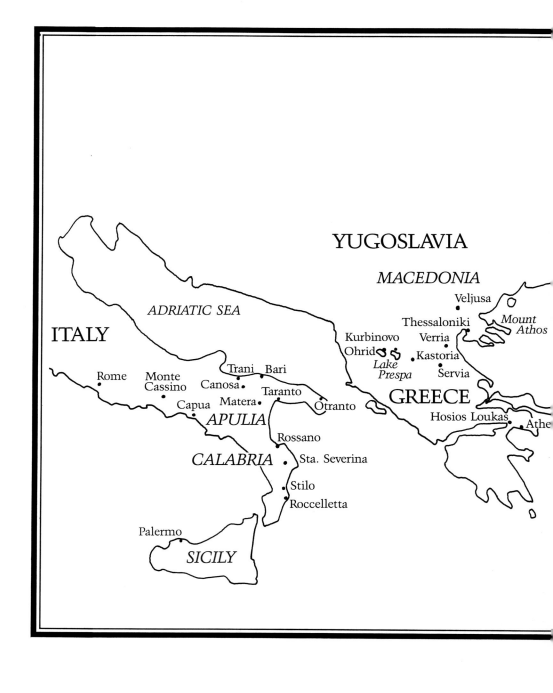

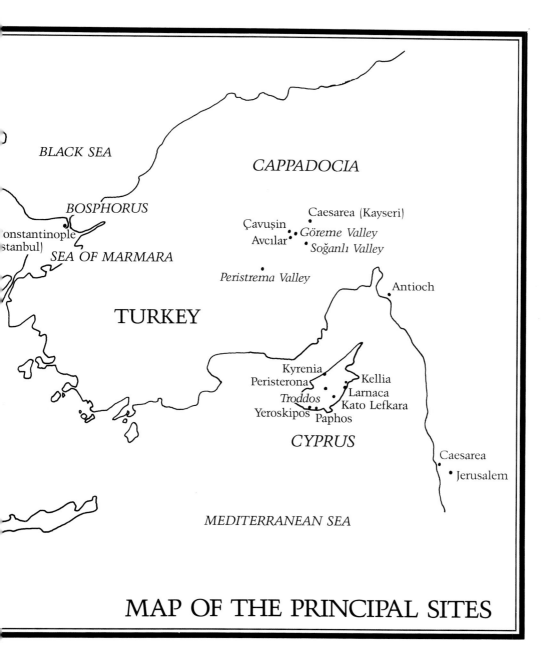

BLACK SEA

CAPPADOCIA

BOSPHORUS

Caesarea (Kayseri)

Çavuşin
Avcılar • • *Göreme Valley*
• *Soğanlı Valley*

onstantinople
stanbul)

SEA OF MARMARA

Peristrema Valley

Antioch

TURKEY

Kyrenia
Peristerona
Kellia
Troddos
Larnaca
Kato Lefkara
Yeroskipos Paphos

CYPRUS

Caesarea
• Jerusalem

MEDITERRANEAN SEA

MAP OF THE PRINCIPAL SITES

Acknowledgments

*T*his volume encapsulates my research of the last twelve years; it has generated a number of pilot articles and contributed to Byzantine Culture in the Eleventh and Twelfth Centuries, *a book which I co-authored with Aleksander Kazhdan. I am particularly grateful to Professor Kazhdan, who greatly enhanced my appreciation of both Byzantium and scholarly collegiality. I am also indebted to Robin Cormack, my adviser at the Courtauld Institute, who has provided me both guidance and a model of the art-historical craft. Several others have offered very helpful criticisms and insights on the whole or parts of the manuscript, including Ch. Bouras, Annemarie Carr, Elizabeth Clark, Anthony Cutler, Vera von Falkenhausen, Jaroslav Folda, Judith Herrin, Cynthia Herrup, Dale Kinney, Valentino Pace, and Athanasios Papageorghiou.*

The extensive traveling and field research required by this project was generously supported by the Central Research Fund of London University, the Field Research Fund of the University of Birmingham, the Research and Development Committee of Oberlin College, the Research Council of Duke University, and Dumbarton Oaks, Center for Byzantine Studies. A Dumbarton Oaks Fellowship (1978/79) allowed me to complete much of the background work for the project. A Fellowship from the American Council of Learned Societies (1981/82) enabled me to finish both the research and the first draft of the book. Duke University provided a supplementary Mellon Faculty Fellowship over the same period. I am most grateful to these institutions and the individuals involved in them not only

for the time that their funding provided for my work but also for the expression of confidence that these awards represent.

Numerous individuals have made contributions to the project as it progressed. Charlotte Burke and Claudia Vess of the Photographic Archive at Dumbarton Oaks helped me greatly with photographic documentation. The manuscript greatly benefited from the personal attention of Chris Kentera, director of The Pennsylvania State University Press, as well as from the Press's anonymous readers.

My greatest debt is to my family. To my mother, Janey Wharton, who has lent me support at every critical juncture. To my parents-in-law, Norman and Claire Lee Epstein, who continue to sustain us. And to my children, Nicole Alexandra and Andrea Jerry, who inevitably remind me how close life is to art. This book is dedicated to them.

List of Illustrations

CHAPTER 3: CYPRUS

CHAPTER 4: MACEDONIA

CHAPTER 5: SOUTH ITALY

1 Approach

Most surviving Byzantine monuments are situated not in the Empire's an-
cient capital, Constantinople, but in its provinces. All too often art histo-
rians have simplistically labeled high-quality works in the provinces
"metropolitan" and those of lesser aesthetic interest "provincial." In this study I
hope to show how a context in the hinterlands of the Empire affected the making
of all provincial buildings—great and small. Local traditions and distinct patterns
of patronage made their marks on even the most cosmopolitan structures. At the
same time, I argue that the relative receptivity of the provinces to metropolitan ar-
tistic conventions indicates the ideological power of those conventions. Monu-
mental works constructed in the provinces consistently served to reinforce
Constantinopolitan hegemony. The reciprocity of these actions in the art of the
Empire calls into question the facile equation of "provincial" with poor quality,
derivativeness, and artistic insignificance.

 This chapter provides both a historical and a methodological setting for a dis-
cussion of the art of specific provinces. The sections on "Empire," "Art," and "The
Capital" are rough historical sketches. Without an awareness of the centralized
character of the Byzantine state, Constantinople's cultural hegemony and the lim-
its of its influence cannot be fully appreciated. Without a sympathy for the power
of medieval images and holy sites, it is impossible to begin to understand the so-
cial functioning of art in Byzantium. The final section outlines the limitations of
the project and acknowledges the assumptions about art and its historical develop-
ment engendering my analysis. Although the perspectives adopted here are not

idiosyncratic, they may be controversial. It seems, in consequence, best to present them at the outset. The chapter ends with a fuller restatement of the objectives of the study.

EMPIRE

Between the ninth and twelfth centuries the Byzantine state was a model bureaucratic empire.[1] Its political system encompassed a wide geographical territory. At its greatest post-Iconoclastic magnitude, it included a land mass not much smaller than western Europe, extending from South Italy and Sicily in the west to Antioch and Armenia in the east, from the Danube and the Crimea in the north to Crete and Cyprus in the south. More important, this vast territory was highly centralized. Constantinople, the capital, was the core of the Empire economically, politically, and ideologically; the provinces were the periphery.[2] The fundamental economic mechanism of centralization was taxation. Though the means of revenue collection are not fully understood, the tax system of Byzantium was apparently based on taxes paid in coin by the provincial free-peasantry.[3] There were certainly landowners whose duties to the state were levied in kind, but essentially taxation assured the flow of gold to the state treasury. Salaries paid to the military and to provincial officials may have stimulated recirculation, but the difficulties encountered by peasants in obtaining coin for tax payments indicate that while agriculture was the source of the Empire's wealth, gold was concentrated in Constantinople. The state also exercised control over goods and services. Crafts were evidently regulated externally by the government rather than internally by guilds.[4] State monopolies also existed, especially in the areas of foreign trade and the production of luxury items. The collection of taxes and control of trade necessitated a large state bureaucracy, in which the senatorial elite played a major role. An elaborate ecclesiastical administrative organization which paralleled that of the secular state resided in the patriarchate, located between the Great Church, St. Sophia, and the Augusteion. The topographical proximity of the various institutions of the Byzantine state reflects their intimate interrelationship: The senate and the patriarchate both lay in the shadow of the Great Palace of the Byzantine emperors.[5]

The emperor embodied both the power and the ideal of a centralized Empire.[6] Byzantium did not have a feudal nobility with extensive hereditary rights; the emperor controlled offices and land. In consequence, there was much more social mobility in the East than in the West during the Middle Ages. The hierarchy of Byzantium was characterized by its unmediated vertical links. The elites of the Empire and even parts of the peasantry were not separated from their ruler by intermediate overlords. Because of the emperor's extreme importance in the society, his position was ideologically sensitive. While the image of the emperor in Byzantium was idealized, it was by no means static. For instance, the conception of the emperor as a great warrior, so important during the period of Iconoclast rule and again in the late eleventh and twelfth centuries under the Comnenians, was certainly not emphasized during the reigns of Leo the Wise (886–911) and Con-

stantine VII Porphyrogenitus (912–59). However, one aspect of the image was immutable: *pietas*. The emperor had to be orthodox. The Iconoclast emperor, Constantine V, was deemed by a later generation to be unorthodox; his tomb was broken open and his remains abused and scattered.[7] Conversely, orthodox emperors and their possessions frequently received the epithet "holy." The necessity of the emperor's closeness to God has a historical explanation. The Roman emperor was traditionally *pontifex maximus*, supreme priest, but the significance of an emperor's religious views increased with the Christianization of the Empire. Like other great historical empires, Byzantium embraced a belief in its catholic mission.[8] This mission was to realize universal order, an order which was not principally military and administrative as it had been in the Roman Empire, but rather spiritual and, reassuringly, predestined. The Empire was ultimately to rule God's kingdom on earth. This religious faith, generated by the long traditions of the imperium, in turn contributed to the stability of the state.

The concept of a universal Christian Empire focused not only on the person of the emperor but also on his capital. Constantinople's epithets reflect the ideological burden borne by the city. It was occasionally referred to by intellectuals with classical pretensions as "Byzantium," the city's original Hellenistic name and source of the modern convention "Byzantine," a term never applied to the Empire in the Middle Ages. The ancient imperial traditions of the Empire were more clearly indicated by the city's title, "New Rome." The Empire was, after all, still called "Roman" by its inhabitants and its neighbors. Constantinople's central position in the political and cultural sphere was alluded to in the common epithet, "Queen of Cities." Finally, the capital's religious significance was reflected in reference to it as "New Jerusalem."[9]

Just as the image of the emperor was imbued with religiosity, so the image of the city was spiritually heightened. Two traditions that evolved from late antiquity to the Middle Ages mirror the conceptual necessity of providing Constantinople with the requisite religious importance. First is the invention of the city's apostolic foundation by St. Andrew, the first-called and brother of St. Peter, founder of the church of Rome.[10] Second is the development of the cult of the Virgin as the city's special protectress.[11] In the life of St. Andrew the Fool, the holy idiot speaks these prophetic words:

> Concerning our city [Constantinople] you should know that until the end of time it shall not fear any enemy. No one shall capture it—far from it. For it has been entrusted to the Mother of God and no one shall snatch it away from her hands. Many nations shall smite its walls, but they shall break their horns and depart in shame, while we gain much wealth from them.[12]

Thus Constantinople, as the center of the Empire, was divinely protected. Its economic and political position provided the basis of the development of its ideological importance; this conceptual framework in turn facilitated the continued exploitation of rural provincial territories by the urban center.

Despite the hypertrophic development of the imperial core, there were many limits on Constantinopolitan control. The personal weaknesses of the ruler or his administrators often restricted the exercise of power. Moreover, while the degree of

political stability differed depending on the dynasty and the emperor, autocratic rule and social mobility also bred insecurities. Because of the arbitrary nature of the ruler's will, flattery and charm might lead to more rapid promotion than wisdom and hard work. The inconstancy of favoritism inevitably nurtured isolation and distrust among members of both the military and bureaucratic elites. The individual's inward turning was perhaps one of the factors contributing to the multiplication of private chapels, oratories, and small monastic foundations in the Middle Byzantine period. Especially in the eleventh and twelfth centuries, personal piety seems to have increasingly affected church programs. There were also external factors which restricted the imposition of centralized power. The Empire was large and means of communication were relatively cumbersome. News of the advance of the enemy in Asia Minor could be conveyed within hours to the capital by means of watch fires, and a fugitive might be located by imperial agents in a matter of months, but delays in the receipt of orders from Constantinople periodically caused the loss of battles. The ethnic diversity of the Empire must also have contributed to problems of control. While hellenized Armenians, Slavs, Turks, and Latins, usually members of the aristocracy, might well be co-opted by the state so long as they became Orthodox, their less acculturated brethren might retain their ethnic identity and even their pretensions to independence.[13]

Considering these centrifugal forces, it is small wonder that rebellion occurred in the more remote provinces of the Empire. The rebellions led by Meles in South Italy (1009/10) and by Isaac Comnenus in Cyprus (1184–91) ultimately led to the loss of those provinces to the Empire. This was rejection of centralized control at its most volatile. The extent to which nonviolent dissent at lower social levels existed is more difficult to ascertain. The uncanonical habits of provincial monks, as recorded in hagiographic sources, suggest that compliance with central authority was, in at least some instances, a matter of convenience. South Italian monks, for example, seem remarkably independent. In canon four of the Council of Chalcedon of 451, it was specified that the bishop's permission was required before founding a monastery.[14] This proscription was repeated in the first canon of the Council of Constantinople of 861.[15] Before Elias Spelaeotes founded a cenobium (monastic community) at Melicucca in 905, he received a blessing from his austere colleagues Cosmas and Vitalis, as well as visionary inspiration from God. He received nothing at all from the local bishop.[16] Vitalis founded the community of Sts. Adrian and Natalia sometime around 980 simply by organizing the ascetics attracted by the fame of his religiosity. Again no mention is made of a local bishop.[17] In the more detailed account of the founding of Grottaferrata in 1004, the absence of any reference to a bishop is even more noticeable. The only person outside the community whose approval was sought was the owner of the proposed site.[18] The limited control of the secular church over rural ascetics not only reflects the continued independence of the holy man in Byzantium but also the possible weakness of central authority. The power of Constantinople was impressive but by no means complete.

ART

The capacity of medieval images to intervene in human affairs distinguishes them from modern paintings. Byzantine sources are replete with instances in which images answered prayers—protecting cities, healing the sick, providing solace for the suffering. Efforts have been made to trace the development and historical impact of potent icons, but the means by which these images attained their power has not been (and perhaps never could be) fully explained.[19] Nevertheless, some basis for the power of images in Byzantium may be sought in the qualified orality of the culture. The Empire was an oral society that nonetheless particularly privileged those truths that were part of a religious *literary* tradition.[20] The truth of the central mystery of Christianity, Christ's comingling of divine omnipotence with mortal humanity, may even be more comprehensible in pictures than it is in words. For example, in his well-known description of the apse decoration of St. Sophia of 867, Photius, patriarch of Constantinople, argued: "The Virgin is holding the Creator in her arms as an infant. Who is there who would not marvel, more from the sight of it than from the report?...The comprehension that comes about through sight is shown in very fact to be far superior to the learning that penetrates through the ears."[21]

The isolated image of Christ, the Virgin, or a saint was the most common vehicle of miraculous action and the most popular object of personal veneration, as reflected, for example, in the distribution of graffiti in Cappadocian rock-cut churches. But both the portraits of holy figures and sacred scenes were empowered through narration, often oral narration, as is dramatically illustrated by the life of St. John Teriste, an Italo-Greek monk of the eleventh century. John, born after his Christian mother had been carried off from Calabria to slavery in Moslem Sicily, miraculously escaped and returned to his native village, Stilo. After being tested by the bishop and baptized, he spent much time walking in the church:

> Looking at the icons in the church at Stilo, John asked, "Who is depicted in this? And who in this other?" And so on with the rest. Coming to the icon of St. John the Baptist he asked, "And who is this man wearing the skin of a camel?" They told him, "This is St. John the Baptist who is copied by you, for you are named John as is this saint. Because of this you ought to imitate his life." Questioned about these things, they related to him the life of this saint, telling him that this saint lived in the desert and underwent many hardships in his life. Hearing this [John] was filled with the love of God, and finding the bishop, he asked his permission to go to some desert place in order to save his soul.[22]

If, as it has been argued,[23] oral culture fosters commonality, monumental decoration of a public nature must have borne a particular burden of communication in medieval society. This would explain such incidents as the conversion of the illiterate St. John Teriste to the monastic life, and the frequent references from the time of Gregory the Great through the Middle Ages in both Byzantium and the West to pictures as the books of the uneducated.[24]

Working miracles and inspiring asceticism were not the only functions performed by images in Byzantium. How images functioned depended on their audi-

ence, as is indicated by both Byzantine and non-Byzantine literary sources. The varied reactions of foreigners to Byzantine monumental art reveal its multivalence. Russians, ultimate inheritors of the spiritual traditions of Byzantium, show a consistent concern with Constantinopolitan monuments as the splendid repositories of relics.[25] The glories of Byzantium's ecclesiastical monuments are even credited with the conversion of the Russians to Orthodoxy by an author of the *Primary Chronicle* (written between 1040 and 1118). In a well-known passage he described the experiences of Russian envoys sent out to judge the benefits of the different dominant religions:

> Then we went on to Greece [Byzantium], and the Greeks led us to the edifices where they worship their God. And we knew not whether we were in heaven or on earth. For on earth there is no such splendor or such beauty, and we are at a loss how to describe it. We know only that God dwells there among men, and their service is fairer than the ceremonies of other nations. For we cannot forget that beauty.[26]

Moslem writers tended to be objective or quantitative in their appreciation of Constantinople. They seem to have been more likely to note the spectacular city walls than the glories of churches or even palaces. Ishaq al-Husain (tenth century) wrote:

> The city of Constantinople is situated in the sixth region, 49 degrees longitude and 45 degrees latitude. It is a great and important city which has no parallel. It has three gates and three sides, of which two are turned to the sea and the other towards the continent in the direction of Rome....It is surrounded by very strong walls....It has great churches and mosques for the moslems.[27]

Latins were much more venal. Villehardouin's *Conquest of Constantinople* was concerned primarily with military and political events and those who participated in them, but his short descriptions of Constantinople certainly reflect the Crusader's primary concern:

> Many of our men...went to visit Constantinople, to gaze at its many splendid palaces and tall churches, and view all the marvelous wealth of a city richer than any other since the beginning of time.[28]

In all, the emphasis placed on Byzantine buildings and their decoration in the writings of outsiders indicates not only that art contributed significantly to the external prestige of Constantinople but also that monuments functioned in different ways for different ethnic audiences.

Within Byzantine literature, too, art seems to have fulfilled various functions in addition to supernatural intervention. Descriptions in chronicles, letters, even in homilies, most often served as vehicles for praising a patron, as an integral part of the record of his or her accomplishments.[29] Art as a factor in establishing an individual's social status is even more clearly articulated in literary diatribes denouncing patrons for the profligacy of their extravagant undertakings.[30] Inventories and the like, in which works crafted from precious substances are sometimes listed in

order of their evaluation, show their owners' appreciation of their material worth.[31] Then as now, art could be a commodity. In a variety of literary genres, from monastic charters and theological tracts to personal correspondence, there occur sophisticated analogies between life and art, as well as expressions of appreciation for the beautifully crafted.[32] The creative process involved in the production of art as well as the final product might elicit an aesthetic response.

The centrality of art in medieval society and the complexity of its social functioning in Byzantium are most dramatically demonstrated by the violence and passion of the Iconoclastic Controversy. This struggle, which raged intermittently between 726 and 843, prefaced the period with which this study is concerned. It was a bitter and brutal conflict between the emperors, who were opposed to religious images, and those who advocated the maintenance of the established tradition of icon veneration, notably monks and women.[33] Indeed, the association of monks with icons was so close that it has been convincingly argued that Iconoclasm represented an attack on the spiraling status of the holy ascetic, who threatened the ascendance of the imperial ideal.[34] Whatever the underlying causes of the debate, the fact remains that it focused on images. With the resolution of the Iconoclastic Controversy in favor of iconodules (lovers of images), images not only took on an increasingly refined role in the programming of sacred space, as will be discussed in chapter 2, but also the other social functions they served were further enhanced.

THE CAPITAL

The centralization of the Empire and the social significance of art help explain the hegemony of Constantinople in artistic production. The wealth necessary for artistic production accumulated in Constantinople and the principal patrons of the arts—the imperial family and the elite—resided in the city. Not only the presence of wealth and patronage but also the relative stability of those two elements was essential to artistic production. Especially in those arts in which a high degree of technical knowledge and/or a sizable work force were required, such as large-scale bronze casting, high-quality multicolor cloth dyeing, stained-glass and mosaic making, gold and enamel working, the necessary skills could be maintained only with continuous material support.[35] Constant patronage and constant artistic production were also the prerequisites of an "artistic tradition." Constantinople was the only center in the Empire, or for that matter in all of medieval Europe, capable of sustaining traditions in several technologically sophisticated media throughout the period under discussion.

Because of the capital's control of artistic production, Constantinople attracted patronage from beyond Byzantium's borders. Great bronze doors fabricated in Constantinople were shipped not only to churches in the provinces but also as far away as Rome and Russia.[36] There is also considerable documentation for mosaicists and their materials being exported. At the end of the tenth century Byzantine mosaicists seem to have been sent from Constantinople to Spain, along with

140 marble columns, for the Madinat al-Zahra of Abd-ar-Rahman III.[37] The early Arab rulers in the Levant at least occasionally depended on Constantinople for mosaic decoration. Ibn Rusteh (d. 903) wrote:

> It is said that Walid ibn Abd al-Malik sent the following letter to the emperor of Byzantium: "We wish to restore the mosque of our great Prophet; to help us, send us workers and mosaic materials." The emperor sent loads of mosaic and more than twenty workers, though some say only ten workers. He is said to have sent with them the following message: "I am sending you ten workers who are worth a hundred."[38]

In his description of the reconstruction of the monastery at Monte Cassino, Leo of Ostia states that Desiderius "sent envoys to Constantinople to hire artists who were experts in the art of laying mosaics and pavements. The [mosaicists] were to decorate the apse, the arch and the vestibule of the main basilica."[39] Byzantine masters from Constantinople worked in the later eleventh century in the Veneto and in Kiev. In Russia and Italy, there is documentary evidence relating to imported mosaic materials and Greek masters with local apprentices.[40] The Constantinopolitan origins of the masters of the Sicilian mosaics have been cogently argued on the basis of style.[41] Theophanes continuatus reports that the Bulgarian Czar Boris was converted to Christianity by a Last Judgment depicted by an artist named Methodius, hired to decorate his palace.[42] While the story is apocryphal, it suggests that in the late ninth century the notion of Byzantine artists as purveyors abroad of Byzantine culture was by no means alien. After their deaths the saintly founders of the Cave Monastery of Kiev appeared to artists in Constantinople to persuade them to make the journey to Russia to decorate their new church.[43] The apparition may have been miraculous, but that it occurred in the Byzantine capital was not. Workers in the luxury monumental arts may have been sought from Constantinople because they were not so readily available elsewhere. Further, metropolitan art was suffused with the great imperial and (for Christian patrons) spiritual status of Constantinople. This, along with aesthetic considerations, must have contributed to the desirability of importing artists from the capital.

This brief introduction to the popularity of Constantinopolitan art outside the Empire provides some indication of the mobility of Byzantine artisans. This mobility was certainly not limited to travel for foreign commissions. The patrons of provincial foundations also sought Constantinopolitan artists for the decoration of their monuments. Even in architecture there appears to have been a desire on the part of at least some founders of major monuments to imbue their works with status through association with the metropolitan center. Recent monographs on two important structures from this period, the church at Dereağzi in southwest Turkey and the Nea Moni on Chios, suggest that masons, construction techniques, and/or building materials were imported to the sites from the capital or its environs.[44] Churches in Macedonia and Cyprus provide further evidence that metropolitan masters were employed in the periphery.[45] Although an artist's association with the cultural nexus, then and now, may have affected such decisions, the unavailability of comparably sophisticated professionals locally must also have played an important part in the decision to employ artisans from the metropolis.

This is not to say that all masters resided in the capital. Not only literary sources[46] but also surviving monuments indicate that capable artists lived and worked in the provinces. Evidence does not, however, support the postulation of regional "schools" of painting that consistently competed with the capital in determining the direction of artistic development in Byzantium.[47] The cultural dominance of the capital explains the impressive formal homogeneity of Byzantine art. Convincing comparisons can be drawn between contemporary frescoes in churches as far removed from one another as Ohrid and Soğanlı Dere, Kurbinovo, and Lagoudera.[48] This homogeneity is all the more formidable because it was not static; dramatic shifts occurred in the course of the four centuries under discussion. These changes were not simply a matter of style. They were holistic, affecting the conception of sacred space: its form and program as well as its figure style.

Despite examples of buildings in the provinces produced by workers from the metropolitan core, regional architectural traditions flourished during the Middle Byzantine period. The vast majority of the monuments treated in this study were products of local masons, reflective of long-standing regional building traditions sustained by continuous demand for construction. Though provincial traditions might be most clearly expressed in architecture, with a little scrutiny regional peculiarities are also legible in church programs. Metropolitan form is inevitably modified by the interests of the local audience. Thus, despite the cultural dominance of the capital, the social and political evidences of provincial independence find resonance in artistic developments in the periphery.

LIMITS, PREMISES, AND OBJECTS

In order to attain the necessary balance between depth of analysis and range of possible implications, discussion in this book is limited in terms of media, chronology, and territory. Analysis concentrates on monumental art (fresco and mosaic) and architecture, avoiding the problem of questionable provenance inherent in the more portable "minor" arts. Architecture and monumental painting, involving as they do very different craft traditions, allow two distinct perspectives on provincial art. The historical picture provided by the consideration of either medium alone would be distorted; together they present a more balanced view of medieval patterns of production.

This study is restricted to ecclesiastical monuments, some of which, in contrast to the poor fragments of secular structures that survive, retain their original decoration. The survival only of religious structures with their monumental decoration is not, however, as crippling for an understanding of Byzantium as it would be for the study of our own culture. In the theocentric society of Byzantium, religious foundations were a primary focus of both individual and communal pride and pretension.[49] Consequently, these monuments attracted a broad range of patronage and exercised artists and craftsmen of all skill levels. Just as significantly, of all genres of building in Byzantium, churches were accessible to the broadest audiences.

This study is confined to works of the Middle Byzantine period, from the end of Iconoclasm in the ninth century to the Latin conquest of Constantinople in 1204. It was during these centuries that Byzantium realized its most cohesive and centralized form. Because of the restraints of space, only four provinces—Cappadocia, Cyprus, Macedonia, and South Italy—are treated. Each of these provinces has a distinct physical and historical setting; consequently, each reflects a somewhat different artistic relationship to Constantinople. At the same time, all four provinces reacted to the artistic impetus of the capital. Together these provinces provide enough complementary evidence to allow general conclusions to be drawn about the nature of art in the periphery of Byzantium. The discussion is also limited to monuments that provide a significant insight into the problems central to the study; this is not an inclusive survey of the works of each province. Except in cases where no reliable secondary literature exists, dating arguments have also been avoided for the economy of space.

There are three interrelated premises underlying this consideration of artistic production in the Byzantine Empire. First, art is not devolutionary. As Alois Riegl suggested at the turn of the century, there is in the development of art no regression or pause, but only continuous progress.[50] He, of course, was comparing artistic developments of distinct cultures. But the notion that change need not be characterized in qualitative terms is relevant to the analysis of art within a single, broader culture.[51] The often unstated or even unconscious assumption that a creation degenerates as it is distanced from its archetype has long been recognized and criticized in fields related to art history, for example, in folklore studies.[52] This is not to deny that there are distinct levels of craft found in the art of the Empire, but rather to suggest that a lack of formal complexity (in the delineation of form, in the palette, in programmatic elements) does not imply either a simplicity of conception or of response. It certainly does not imply a limited historical significance.

A second premise on which this study is based is that artworks are the products not only of the masters who produced them and those who subsidized them but also of the audience (including the patron) for whom they were intended. The modification of literary form in response to its intended audience, as well as the reader's creation of meaning in a literary text, has been much considered by literary scholars.[53] Stylistics have also been treated by historians of Byzantine literature.[54] If it is possible that in Byzantine painting, as in its literature, the development and refinement of modes of expression were molded by the expectations of the intended audience, the nature of that audience must at least be considered.

The audience of a specific monument is not, however, easy to determine. Though all ecclesiastical, the buildings treated in this volume had different, if not distinct, clienteles. The principal divide was between secular and monastic foundations. The cathedral (*megalē ekklēsia*) would probably have had the broadest audience. Services would be attended by clergy, monks, and laity, men and women of all social levels and occupations. To this audience were addressed theological and political statements in the form of sermons and homilies, usually presented by bishops in their own churches.[55] It would therefore not be surprising to find a broadly didactic program in such a setting. Other secular churches were the parish church (*katholikē ekklēsia*), maintained by the bishop for public worship, and the

private chapel which was owned and operated by a private person. These are diffi-
cult to distinguish by function. Even the prerogatives of the parish church—
baptism and the celebration of church festivals—seem to have been eroded during
the Middle Byzantine period.[56]

The nature of the audience and the character of the patron are also important in
understanding monastic foundations. As in the sphere of the secular church, there
were private monasteries in Byzantium. The *ktetors* (founders or owners) of these
monasteries might receive income from their foundations and, upon their demise,
bequeath them to family members.[57] *Ktetors* often wrote the rules of these ceno-
bitic establishments and controlled the appointments of the principals of the
community. Surviving *typika* (monastic charters) written by *ktetors* indicate that
in at least some cases these secular founders also determined the decoration of
their churches.[58] Other monasteries developed organically around holy ascetics
who attracted an increasing number of disciples. In these instances the ascetic
himself often formulated the *typikon* of the monastery. An amusing instance of
the importance of the founder's authorship of a monastery's rule is provided by the
life of St. Lazarus, the monk who established a monastery on Mount Galesios.
Much to the brethren's horror, St. Lazarus died before he had ratified the draft of
the *typikon*. Miraculously, however, during the funeral services he awoke long
enough to sign the document.[59] It seems likely, too, that in such circumstances
the monks would have a determining role in the decoration of their church, even
when it was paid for by lay donors. Knowing the social function of a building is
useful in analyzing its art; when a monument's function cannot be established,
art at least occasionally permits some speculation about the nature of the specific
audience for whom it was produced, though in this case the pitfalls of circular ar-
gumentation are difficult to avoid.

The final assumption underlying this study is that all art has an ideological di-
mension that affects both the selection of subject matter and the way in which it
is presented.[60] In a largely oral culture like that of Byzantium, the importance of
the figurative arts as a means of reinforcing the worldview of those in power is po-
tentially even greater than in literate societies. Whether a dominant ideology was
consciously created by the ruling elite in an effort to manipulate the subordinate
population is another question; more likely the process was serendipitous and re-
ciprocal.[61] Indeed, material evidence in provincial art and architecture suggests
that the unempowered assumed and reinforced the value structures of the elite. If,
as argued here, the audience did have an impact on the art produced for them, it
does not follow that that audience was the passive recipient of elite propaganda.

I hope that some of the implications of this study of provincial art in Byzantium
will be applicable beyond the borders of the Empire. But the idiosyncracies of the
Byzantine state in some ways limit the relevance of generalizations drawn from
Byzantium to other bureaucratic states. For example, the artistic relationship be-
tween the capital and its provinces was essentially different in the Roman Empire,
Byzantium's imperial predecessor. While Constantinople was unquestionably the
dominant, if not the only, art center in Byzantium, the Roman Empire was a con-
glomerate of urban sites, a number of which rivaled Rome as centers of craft pro-
duction. The syncretic art of the early empire under Augustus was molded by

Attic craftsmen. The regionalism of the late empire, politically exemplified by the proliferation of imperial capitals, is artistically demonstrated in the development of identifiable regional schools, for example, in floor mosaics.[62] Nevertheless, in Rome, as in Byzantium, scholars have suggested that art affirmed the ideology of the elite.[63]

I believe this study indicates that the term "provincial," so often used by art historians in only a derogatory sense to specify the low quality of an art object, should be employed with greater care. To this end the following definition is tentatively suggested. A provincial work must be either located in the provinces or have a provable and direct association with the provinces. The work must be seen to respond (whether in its iconography, program, or style in the case of the figural arts, or in its plan or superstructure in the case of architecture) to identifiable local circumstances or traditions, whether they be social and political, geographic and geological, or artistic. A work must also exhibit a reaction directly or indirectly, positively or negatively, to metropolitan impetus. Such impetus might have a variety of vehicles ranging from a patron or artisan to imported exemplars. After all, if no metropolitan influence is discernable, "regionalism" would be a more accurate description of peripheral independence than "provincialism." "Provincialism" is not a derogatory term, but rather a creative process.

2 Cappadocia

SETTING AND AUDIENCE

Cappadocia, the heartland of the central Anatolian plateau in modern Turkey,[1] is rich in evidence of medieval religiosity, evidence preserved by the unusual geology of the province.[2] Volcanic cones to the east covered the red beds and gypsum of the plateau with almost flat sheets of lava and layers of volcanic ash. This ash consolidated into tuff strata, often as much as one hundred feet thick. Wind and water have modeled this soft stone into an exotic lunarlike landscape (fig. 2.1). Entire beds of light tan tuff have been carved away, leaving only tall pinnacles, with their oddly balanced protective caps of harder lava. Rorschach-like cliffs and outcrops stand isolated above the plateau, and small rivulets cut smooth, undulating rock valleys through it. The supernatural aspect of the terrain provided a proper stage for ascetic practice; its distorted organic forms seem to monumentalize the monks' struggle with physical and spiritual temptations.

The easily carved tuff invites the excavation of sacred and domestic spaces from the living rock. Rock-cut villages both above ground, carved from the flanks of tuff cliffs, or below ground, hollowed out of the deep tuff strata, are known from antiquity.[3] In contrast to the construction of masonry buildings, cave excavation required a minimum of professional help. Bathystrokos, abbot of a monastery in Soğanlı Valley, after "greatly toiling" in the rock-cut complex of Karabaş Kilise, was laid to rest there, suggesting that monks might help in the excavation of their own chapels.[4] Texts of the lives of other provincial saints—for example, those of

St. Neophytus of Paphos in Cyprus and St. Elias Spelaeotes of Calabria, discussed below—provide further documentation of monks excavating their own cells and chapels. Besides requiring relatively little skilled labor, caves had appropriate ascetic associations with Old Testament prophets, John the Baptist, and holy monks. In the twelfth century, Nicetas Choniates summarized the Byzantine sensibility: "It is fitting that monks should set up their habitation in out-of-the-way places and desolate areas, in hollow caves and on mountain tops."[5] In the early tenth century, one Cappadocian hermit, having carved his retreat high in a pinnacle at Zilve, went so far as to identify himself with the great column-sitting holy man, St. Symeon the Stylite. The new Symeon adopted the old one's name and decorated his chapel with an elaborate narrative of his famous predecessor's life.[6]

The relative ease of creating cave dwellings, as well as the drama of the setting, apparently contributed to Cappadocia's popularity as a place of monastic residence. The tuff regions of the province were all the more appealing because life there was not as austere as it appeared. The small valleys are well watered, readily supporting the production of vegetables, fruits, and grains. Judging from the number of surviving rock-cut wine presses, the wine was as good and plentiful in Cappadocia in the Middle Ages as it is today.

Political circumstances, as well as the geographical setting, conditioned monastic life and artistic production in the region. In contrast to other Byzantine provinces, where artistic developments occasionally contradict political and social ones, the historical framework in Cappadocia appears to mold the evolution of the province's art. From the seventh to the ninth centuries, Cappadocia was very much a frontier province under constant pressure from the east. The Arabs seem to have concentrated on border raids and borderland annexation after the frustration of their siege of Constantinople in 717–18.[7] In response, the Byzantines evidently adopted a policy of militarizing the borderlands through the removal of the civilian population and the creation of a series of small fortified towns which the Moslems could not easily capture. Urban life, as it had been known in Cappadocia in late antiquity, ended.[8] There are no churches with dated inscriptions surviving from this strife-ridden period.

Cappadocia's military conditions began to improve in the second half of the ninth century. Armenia became an independent state and effective buffer zone between Byzantium and the Arabs. In 863 the Byzantine general, Petronas, met and annihilated Omar, the emir of Melitene, and his large army. In 873 Basil I made significant advances in the area of the Euphrates, marking the beginning of Byzantine expansion to the east. Around 900 Nicephorus Phocas the Elder won an important victory over the Arabs at Adana. Cappadocia was no longer on the front line; the military frontier had moved beyond the Taurus Mountains. With the redirection of military emphasis toward the northern Euphrates, the northern and central land routes across Cappadocia increased in importance. The roads from Coloneia and Nyssa joined and passed through the tuff regions of the province.[9] The first significant group of decorated churches of the Middle Byzantine period can, in all likelihood, be ascribed to this era.

The creation of the Cappadocian bishoprics of Sebassos and St. Procopius as

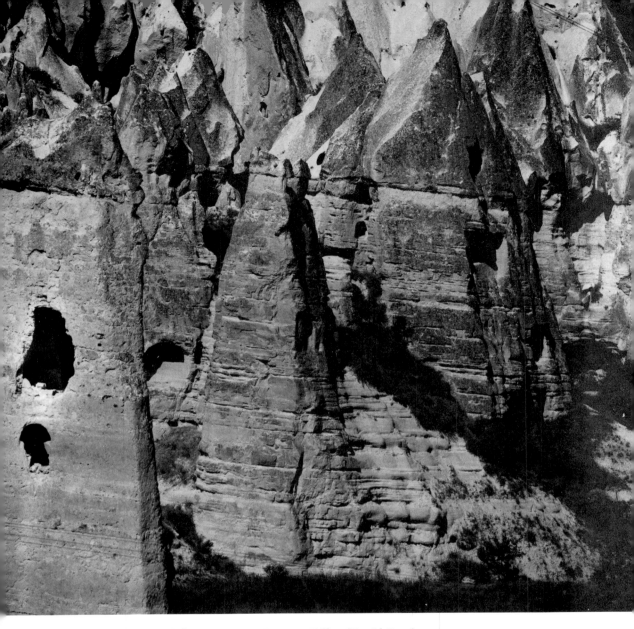

FIG. 2.1. Volcanic rock formations in Göreme Valley (David Page)

part of the reorganization of the church initiated by the *taxis* of Leo VI and patriarch Nicholas (901–7) may also reflect the political stability of the province. These sees, however, had disappeared from the ecclesiastical lists by 940, suggesting that this new security did not lead to a revival of urban life and institutions. The province's rural nature is documented in both Arab and Byzantine sources. In the tenth century Ibn Hawqual wrote, apparently of Cappadocia: "Rich cities are few in their [the Byzantines'] kingdom and country, despite its situation, size and the length of their rule. This is because most of it consists of mountains, castles,

fortresses, cave dwellings and villages dug out of the rock or buried under the earth."[10] As late as the twelfth century, Nicetas Choniates suggests that those parts of Asia Minor still under Byzantine control were still essentially rural.[11]

The relative prosperity of Cappadocia from the beginning of the tenth century through the first three quarters of the eleventh is reflected not in the resurgence of cities, but rather in the growth of the provincial military aristocracy and the multiplication of monastic establishments. The archetype of this new military elite is the epic hero Digenis Acritas.[12] Half Arab but fiercely Christian, Digenis Acritas is the warrior counterpart of the holy man, whose counsel and allegiance is sought even by the emperor. This mighty noble and generous hero lives a life of considerable luxury and complete independence. His story, which may have originated in Cappadocia, embodies the ambitions of the emergent military aristocracy of the province.

Some evidence concerning the relations between this new elite, the local population, and the monks is provided by dedicatory inscriptions which survive in the cave churches of the region.[13] These inscriptions suggest that support for monasticism came from a broad spectrum of the provincial community. At least a few of the aristocratic families holding estates in Cappadocia (notably the Scepides and Phocas clans) are associated with the decoration of Cappadocian churches.[14] Titles recorded in inscriptions indicate that some patrons were involved in the military organization of the province (kleisourarch and taxiarch), some with the provincial government (domestikos of the theme, stratēgos, tourmachos), and others held imperial rank (magistros, protospatharios, protospatharios of the golden dining room, and spatharokandidat).[15] Here were figures of the Byzantine establishment; they included members of the elite, who depended for their power on direct links with the emperor in Constantinople. These titles are indicative not only of the status of some of the donors involved in Cappadocian artistic production, but also, broadly speaking, of date. All the major titles found in dedicatory inscriptions in the cave churches of the province are common only before the late eleventh century, at which time the terminology of Byzantine titles changed in response to the values of the newly ascendent Comnenian dynasty, scions of the military class. Most artistic production in Cappadocia took place in the tenth century and first three quarters of the eleventh century.

The elites of Byzantine society were not the only contributors to artistic production in Cappadocia. Epigraphic evidence indicates that support also came from lower social echelons, as will be discussed in regard to particular monuments. But it is graffiti rather than painted inscriptions which allow some insight into the nature of the broader audience of these Cappadocian wall paintings. For the most part, graffiti are limited to formulaic prayers including the graffitist's name: "Lord protect your servant, [name]," or "Prayer of the servant of God, [name]." Although the formula of an invocation may not be particularly significant, the inclusion of nonformulaic information allows occasional glimpses of the pious at their devotions. Priests and monks, many of whom were in orders, represent a majority of those graffitists whose occupations are indicated. In fact, many of the monks who include their vocation were also in orders. Since monk-priests were much less common in Byzantium than in the West, this may imply that officiants left their

mark on the church that they served. If it can be assumed that only those who could write produced graffiti, it is tempting to go further and suggest that only the priestly monks, in distinction to the average members of the community, were literate.

Cappadocian graffiti also create the impression that literate laity as well as monks worshipped in the rock-cut churches of the province. A few graffiti were left by women, indicating that they were present in the community. The rarity of women's graffiti perhaps suggests that there was a lower rate of literacy among women; many more women were mentioned in painted inscriptions executed by the artist rather than by the subject herself. Illiteracy is not, however, the only explanation for the relative rarity of women's graffiti. Access to monastic churches might have been more restricted for women than for men; certainly in the *typika* of many monasteries, women were forbidden to enter the *katholikon*. It might even be suggested that, then as now, women had greater reservations than men about expressing themselves in this manner. Graffiti provide some evidence that the cave churches of Cappadocia were visited by travelers. One graffitist identified himself as a "foreigner"; other invocations mention Kotiaion, perhaps the city near Dorylaion, and the unidentified place name of Petreno.[16] It is impossible, of course, to know whether these individuals were passing through the region on their way elsewhere or if they came as pilgrims specifically to the monastic settlements of the province. The few dated graffiti, which range from the first half of the eleventh through the middle of the twelfth century, indicate that at least some chapels continued to be used after the Byzantine loss of Cappadocia to the Seljuks in 1071. In this respect, graffiti contrast with dated donors' inscriptions, none of which occurs during the last quarter of the eleventh or in the twelfth centuries.

The central plateau of Asia Minor fell to the Turks after Alp Arslan (Brave Lion) annihilated the army of Romanus IV and captured the emperor at the fateful battle of Manzikert in 1071. The transition of power from the Christian, Greek-speaking Byzantines to the Moslem Turks was apparently a bloody ordeal.[17] In contrast to, for example, the Norman conquest of South Italy or the Bulgarian occupation of Macedonia after the conversion of the Slavs, the conquerors had no religious sympathy for the Christian population. The Moslem distrust was doubtlessly aggravated by the close ties between the Greek Orthodox church and the Byzantine Empire. Further, there was no tacit legitimation of the universalism of "Roman" imperial rule of the sort evinced by both the Normans and the Bulgars. The bitterness of subjugation was not tempered for the inhabitants of Anatolia by any shared ideological framework.

Despite the limited documentation that has survived, it seems that the Seljuk occupation of Cappadocia caused a fundamental disruption of the life of the inhabitants. Caesarea was still in ruins when the Crusaders journeyed through Cappadocia at the end of the eleventh century.[18] Ecclesiastical and secular estates were confiscated. Bishops, having fled to Constantinople in the wake of the occupation, were unable to return to their dioceses. Many churches were converted to mosques and others were sacked. Some sense of the Christian reaction emerges from William of Tyre's twelfth-century description of the destruction of the churches of Antioch:

The sacrilegious race of Turks had desecrated the venerable places...and put the churches to profane uses. Some of the sacred edifices had been used as stables for horses and other beasts of burden, and in other pursuits unbefitting the sanctuary.... The pictures of the revered saints had been erased from the very walls—symbols which supplied the place of books and reading to the humble worshippers of God and aroused devotion in the minds of the simple people, so praiseworthy for their devout piety. On these the Turks had spent their rage as if on living persons; they had gouged out eyes, mutilated noses and daubed the pictures with mud.[19]

The Christian population was impoverished and Christian art lost its patronage. It is hardly surprising that the rock-cut churches of Cappadocia offer little evidence of artistic production from the last quarter of the eleventh through the twelfth century.

THE NINTH CENTURY

The art-historical value of the cave churches of Cappadocia is greatly enhanced by several factors. They survive in relatively large numbers, allowing the rhythms both of stylistic development and also of artistic impetus to be charted. Their numerousness reduces the risk that gaps in the series are simple historical accidents. The monuments are located within a geographically circumscribed area, and their decorations are consistent in scale and medium. Thus comparisons are not confused by differences in context or materials. The patterns of artistic change traceable in Cappadocia appear to be remarkably parallel to those occurring elsewhere in the Empire from the post-Iconoclastic period through much of the eleventh century. However, these changes take place within a stable framework of peculiarly local architectural and programmatic traditions, some sense of which is provided by the earliest group of painted churches ascribable to the Middle Byzantine period.

The Chapel of Nicetas the Stylite near Ortahisar is typical of this series (fig. 2.2).[20] Cut into the west side of one of a small group of cones, the church has a longitudinally barrel-vaulted narthex and small nave (2.25 by 2.75 meters). The nave is terminated by a commodious apse, horseshoe in plan. The horseshoe form is common in both the plan and elevation of Cappadocian monuments. Horseshoe-plan sanctuaries have the functional advantage of creating adequate liturgical space without an additional bay. The liturgical furnishings of the Chapel of Nicetas have been destroyed, although, extrapolating from surviving cave churches of a similar form, originally it probably had a freestanding, rock-cut altar, one or more seats in the bema, and low parapet slabs separating the sanctuary from the nave. The space allows for a congregation of no more than five or six. The simple, functional spatial arrangement of this chapel is endemic in the rock-cut milieu of Cap-

Opposite: FIG. 2.2. Near Ortahisar, Nicetas the Stylite. General view to the east

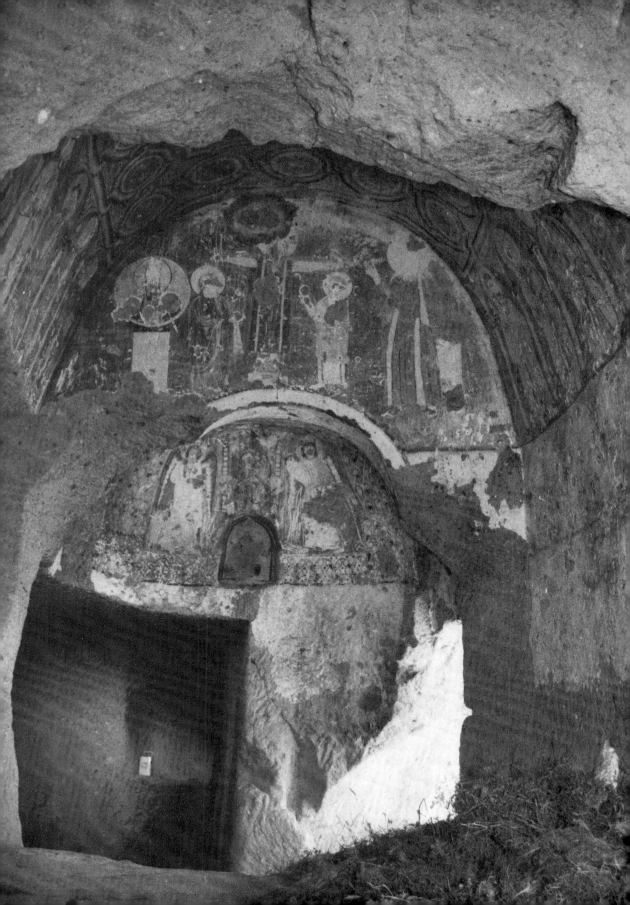

padocia; there is no reason to look elsewhere for architectural models.

The same can be said of the chapel's decoration. The church is adorned with figures and enframing geometric and vegetal ornament painted on a fine white plaster in a limited number of earth colors, of which bright ochre is the most dominant. The unmodeled images, delineated internally and externally by an unvariated black line, elaborate the interior surfaces of the chapel without compromising their flatness. As in the case of the architecture, a search for external models for these paintings is unnecessary. Although an art historian cannot afford to deny the validity of using style as a means of dating and association, the cogency of such efforts depends on many factors, one of which is the degree of an image's formal complexity. The less complex the technique and the fewer the number of visual stratagems in a painting, the more problematic are comparisons made with works outside its immediate vicinity. The vivacity of the frescoes of the Chapel of Nicetas depends on their simplicity. Relating them to works far removed territorially and/or chronologically is methodologically suspect: Similarities may imply only a shared level of craft, not specific links.

The program of the Chapel of Nicetas is as direct and explicit in its address as the style of the paintings in which it was realized. The main fields of the barrel vaults of the nave and narthex, as well as the apex of the conch of the apse, are devoted to jeweled crosses enframed by ornament. The cross is too often associated exclusively with Iconoclasts; it was in fact the valued protection of the pious from Early Christian times onward. The model monk and archiconodule Theodore of the Studius Monastery in Constantinople preached:

> Cross, of all objects the object most venerated; Cross, most steadfast refuge of Christians. . . . Height and breadth of the cross, most comprehensive measure of the vast heaven; strength and power of the cross, ruin of the might of every enemy; figure and form of the cross, of all forms the most honorable to look upon.[21]

Like innumerable monks before and after him, St. Gregory the Decapolite banished demons from his cave hermitage through the sign of the cross.[22] The glorification of the cross, the most potent of all apotropaic devices, fits the defensive political and spiritual circumstances of early Middle Byzantine monasticism in Cappadocia. The apostles, disseminators of the truth of the cross, are depicted below it in arches on the haunches of the vault. Four witnesses to Christ's power, as embodied in the cross (the holy healers, Cosmas and Damian, Panteleimon, and a female saint), occupy the west tympanum. The source of the power of the cross is illustrated on axis with the nave cross: Christ's sacrifice on the cross for our salvation is depicted paradigmatically on the triumphal arch; his incarnation is represented by the Virgin and Child enthroned in the conch of the apse.

The monk for whom the chapel was decorated, probably also the author of its salutary message, is represented to the left of the image of the Crucifixion by his surrogate, St. Symeon the Stylite. His invocation reads:

> For the prayer, deliverance, and forgiveness of sins of Nicetas the Stylite, the ascetic by whose piety (the sanctuary was adorned).[23]

A second invocation indicates that Nicetas received support for his enterprise from a secular patron:

> Eustathius, the most glorious *kleisourarch* of Zeugos (and) Klados?, offered, by divine inspiration, this service for the glory of the holy hierarchy. Protect him. Amen.[24]

This inscription is associated not with a portrait of the patron, but rather with the image of St. John the Baptist to the right of the Crucifixion.[25] Thus two great monastic archetypes flank the Crucifixion as ahistorical participants and intercessors, demonstrating the monastic tenor of the program. This suggests that Nicetas, not his secular patron, controlled the scheme of decoration.

A *kleisourarch* was commander of a military district.[26] Sources are not specific about the date at which a *kleisoura* was established in central Anatolia, although it is generally agreed that its institution can be ascribed to the reign of Theophilus (829–42). Charsianon, which incorporated large parts of eastern Cappadocia in the ninth century, was a *kleisoura* until 863, although the western part of the province was made into a *theme* (a territorial unit governed by a *strategos* whose power was civil and military) sometime before 830. Although the date of the Chapel of Nicetas is debated,[27] the appearance of the term *kleisourarch*, taken in conjunction with the emphasis on figural decoration, suggests that the church received its painted decoration after the Iconoclastic Controversy and before the disappearance of the *kleisoura*, that is, in the middle decades of the ninth century. Eustathius was not Nicetas's only admirer; the number of medieval invocations scratched next to saints depicted in the monument suggests that Nicetas's retreat was a shrine of some significance. These graffiti also indicate that the monument's directly rendered votive images very successfully attracted the veneration of the pious.

Associated with the Chapel of Nicetas the Stylite either through figure style or ornament are a number of other monuments, including St. Basil near Sinassos, St. Stephen outside Cemil, and Chapel I in Balkan Deresi.[28] In the decorations of these monuments the cross is glorified, John the Baptist is prominent, and figural representation is votive in nature. These frescoes indicate that the urge to decorate monastic chapels in Cappadocia antedated the significant influx of any specifically metropolitan artistic ideas and offer mute testimony to the strength and local independence of the monastic movement in the province. They provide a regional backdrop against which the more elaborate church decorations of the early tenth century can be fully appreciated.

THE TENTH CENTURY

Central to an understanding of Byzantine painting in tenth-century Cappadocia is Tokalı Kilise (Buckle Church) in Göreme Valley.[29] The foundation was made up of three churches. The first sanctuary carved on the site was a minute, aisled basilica

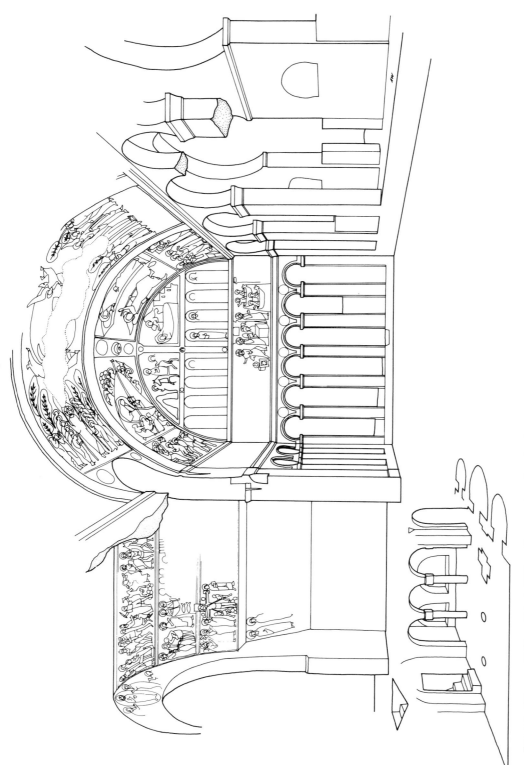

Fig. 2.3. Göreme Valley, Tokalı Kilise. Perspective sketch of the Lower Church (basilica in the lower left-hand corner), Old Church (single-nave, longitudinally barrel-vaulted structure directly above the Lower Church), and New Church (transverse barrel-vaulted hall in the center and right half)

with three apses opening off a transept. This church was apparently outgrown by an expanding monastic community. A larger chapel, the so-called Old Church, was excavated into the side of the cliff directly above the earlier Lower Church, which then served as its crypt. This second monument had a simple rectangular plan, a large sanctuary apse, and a *prothesis* niche for the rite of preparing the host. Both its narthex and nave were longitudinally barrel-vaulted, like the Chapel of Nicetas, but much more capacious. The New Church, the third and final extension of the complex, was carved through the east end of the Old Church; it had a great transverse barrel-vaulted nave with a *parekklesion* (side chapel) and triple-apsed sanctuary (fig. 2.3).

Surviving fresco fragments similar in palette and style to the painting of the Chapel of Nicetas suggest that the Old Church was carved and first decorated in the second half of the ninth century. In the early tenth century, the Old Church received a new program which dramatically differs from the votive emphasis of the province's ninth-century painting. Ornament virtually disappears; that which remains, like the *trompe l'oeil* corbels below the vault overhang, serves a subsidiary rather than primary decorative function. Single figures appear on the wall of the nave, but the principal space, the nave vault, is given over to an elaborate Christological narrative arranged in three registers on either side of a series of prophet's portraits in rondels in the apex (fig. 2.4). Each level broadly corresponds to one of the major divisions of Christ's life: Incarnation, Ministry, and Passion. The sophistication of the composition is reflected in the clarity of its cyclical order and in the way in which the artist moves the viewer's eye within the narrative. Narrative seams are eliminated. Figures of two scenes often overlap or turn either to react to the previous scene or to anticipate the next action. In the scene of the Nativity, for example, Joseph looks back to the Journey to Bethlehem at the left, and at the right an angel swings across the corner toward the shepherds on the west wall. Action is organized to be read laterally: The ox and ass look toward Christ in the manger, the Virgin looks toward Christ in the bath; the angel looks toward the shepherds.

The style in which the figures are rendered complements the narrative intention of the program. The characters are puppetlike, with heads and hands enlarged to make significant movements legible; they fill the registers which they occupy from top to bottom. The range of color is wider and the techniques of layering pigments more complex than in the Chapel of Nicetas. Comb highlights and ornamented costumes lend visual interest to the images without introducing volume to the figures. This vital figure style has close parallels elsewhere in the Empire, from Kastoria in Macedonia to Kellia in Cyprus. Iconographic features found in Cappadocia for the first time in these frescoes have been traced to metropolitan sources.[30] It seems likely, then, that this narrative form originated outside the province.

No donor's inscriptions survive in the Old Church. However, in a funerary chapel painted by the same artist, Ayvalı Kilise in Güllü Dere, there are a number of dedications. The Church of St. John and the monastery of the Virgin, of which it was presumably a part, were apparently founded and decorated with the help of an individual (John?) whose titles, if he had any, are lost.[31] Painted invocations

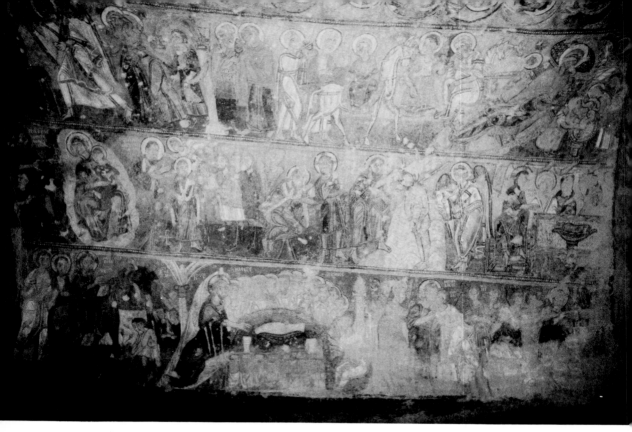

FIG. 2.4. Göreme Valley, Tokalı Kilise, Old Church. South side of the barrel vault

have also been left by others. Next to an orant saint is the supplication: "For the remission of the sins of the servant of God, Demna." Next to the military martyr St. Theodore: "Lord protect your servant Theodore." And accompanying the image of the venerable monk St. Macarius: "In the memory of the servant of God, Makar [Macarius], monk of the [monastery] of . . ."[32] These invocations suggest that the monastery had broader support than that of a single lay patron. This double-nave complex, with a deep arcosolium carved in its north wall, was elaborately painted. The eschatological and ascetic emphasis of the decoration, which includes not only a dense Christological narrative but also a Last Judgment, the Maiestas Domini, and prominently placed holy monks, further intimates that the program was determined by its funerary function and its monastic audience. This suggests that the monks' control of the program, already evidenced in the Chapel of Nicetas the Stylite, may have continued into the early tenth century. However, the introduction of nonlocal notions of painted decoration indicates perhaps that lay patronage played an increasingly important role in the artistic production of the province.

The distinctly narrative mode of painting found in the Old Church appears in a slightly different form in another early tenth-century church, Kılıçlar Kilise, in Göreme Valley (fig. 2.5).[33] The figures which animate the narrative are more organically conceived than their counterparts in the Old Church; though similarly proportioned with oversized heads, body parts, and drapery, they are less geometri-

cally handled. The palette with which they are rendered is also distinct, with bright blue, pink, and yellow pastels in addition to earth tones. Kılıçlar Kilise's fresco decoration has been convincingly ascribed to around the year 900 on the basis of its close stylistic relation to the miniatures in the Commentary on the Book of Job in the Biblioteca Marciana in Venice (gr. 538), which is dated by subscription to 905.[34] Further, the relatively close stylistic associations between the Job illuminations and miniatures in manuscripts, such as the Cosmas Indicopleustes in the Vatican (gr. 699), and the possibly contemporary manuscript of the Gospels now in Princeton, Garrett 6, suggest the paintings' nonlocal sources.[35]

Kılıçlar Kilise's plan, as well as its decoration, bespeaks external impetus. This cave church convincingly mimes the so-called cross-in-square plan, which was newly popular in Constantinople in the early tenth century. Like Emperor Romanus I Lecapenus's early tenth-century church in the capital, the Myrelaion Monastery, known also by its Turkish name, Bodrum Camii, Kılıçlar has barrel-vaulted cross arms and a central dome supported by four arches which spring from four columns (figs. 2.6–2.8). In Kılıçlar the corner bays are covered with cupolas (real in the east and painted in the west), another architectural convention known in Constantinople.[36] This centralized space is preceded by a domed narthex and terminated to the east with three apses: the sanctuary flanked by the *prothesis*

FIG. 2.5. Göreme Valley, Kılıçlar Kilise. Barrel vault of the north arm: Adoration of the Magi. Partially visible is the Flight into Egypt on the opposite side of the vault and the Dream of Joseph in the lunette

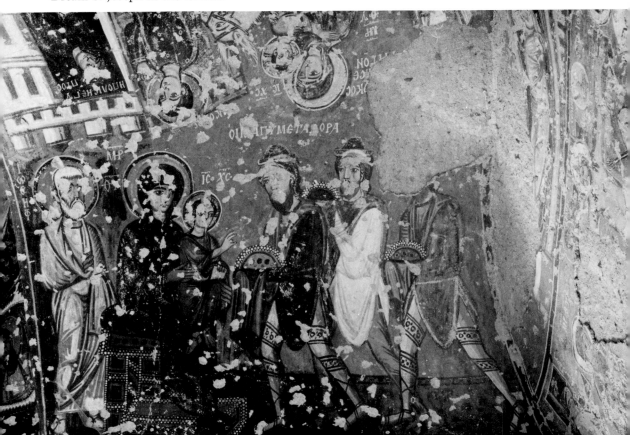

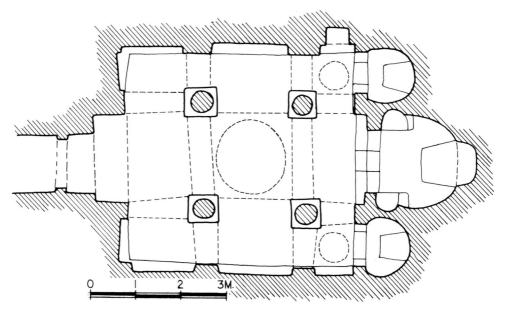

FIG. 2.6. Göreme Valley, Kılıçlar Kilise. Reconstructed plan of the church in its original state

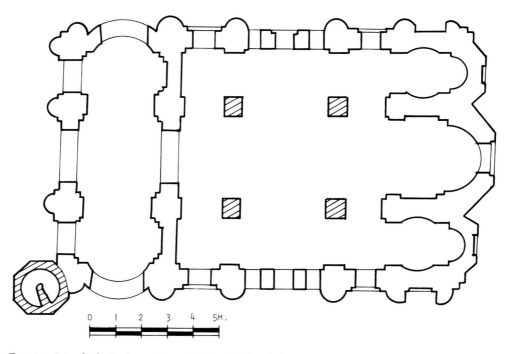

FIG. 2.7. Istanbul, Bodrum Camii. Sketch plan (after C. L. Striker)

apse, in which the Eucharist was prepared, and by the *diakonikon*, where liturgical objects were stored. Like the church's decoration, the architecture of Kılıçlar Kilise represents the provincial adoption of a metropolitan type.

The extent of this appropriation is apparent in the programmatic features of the church. Like the Old Church, Kılıçlar Kilise is decorated with an elaborate narrative program arranged in a broadly sequential order.[37] However, in response to the fragmented architectural spaces of the church, certain scenes, such as the Maiestas Domini in the apse, the complex Crucifixion, which (in contrast to other

FIG. 2.8. Istanbul, Bodrum Camii. General view of the exterior from the south, taken in 1938 (Dumbarton Oaks, Center for Byzantine Studies, Washington, D.C.)

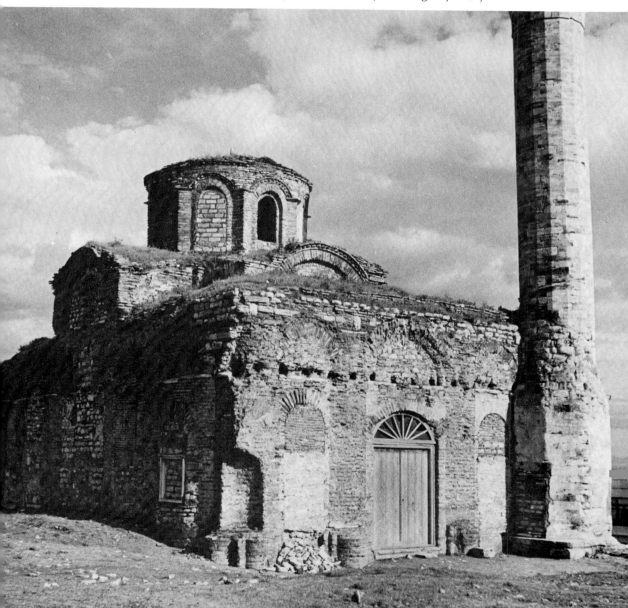

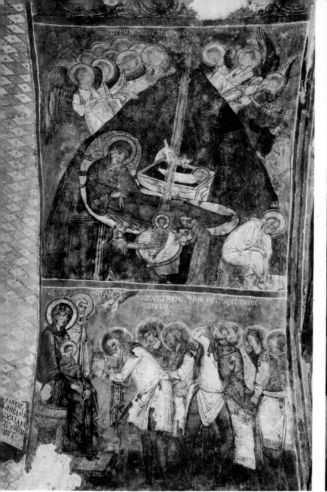

FIG. 2.9. Göreme Valley, Tokalı Kilise, New Church. West side of the north bay of the barrel vault: the Nativity, Magi Beholding the Star, and Adoration of the Magi

FIG. 2.10. Göreme Valley, Tokalı Kilise, New Church. East side of the central bay: the Ascension

scenes in the transept arms) extends its entire register, the Ascension in the central dome (appropriately preceded by the Blessing of the Apostles in the west barrel vault), and the Pentecost, above the east entrance bay, have been isolated from the narrative and given particular prominence by careful placement within their architectural settings. The full-length depictions of the Virgin and John the Baptist (?) which originally flanked the entrance to the apse at Kılıçlar are among the earliest examples of monumental sanctuary *proskynetaria* (icons of veneration) to survive.

The evidence provided by Kılıçlar Kilise suggests that the popularization of the centralized church plan at the core of the Empire in the first half of the tenth century was complemented by modifications in the narrative program. The direction and meaning of this programmatic shift are clarified in the decoration of the New Church of Tokalı Kilise, which dates to the mid-tenth century (figs. 2.9 and 2.10). Fragmentary cornice inscriptions in this great church commemorate the donations of the otherwise unidentified layman, Constantine, and his son Leo to the

Monastery of the *Asōmatōn* (Archangels).[38] Despite the lack of surviving titles, the materials used in the painting attest to the wealth of the New Church's patrons. Gold and silver foil is applied to the halos of the Virgin and Christ, and semiprecious lapis lazuli appears extensively in the intense blue ground—early instances of these materials being used in a monumental context. The classicizing rendering of the painted figures further suggests that these patrons had Constantinopolitan ties. The closest stylistic parallels to the paintings of the New Church are offered by the illuminations of the Leo Bible, convincingly ascribed to the capital and dated after 940.[39] Images in the New Church, such as Peter Ordaining the First Deacons, share with the miniatures a similarly corporeal conception of the figure—small heads with freely realized features set on voluminous bodies (fig. 2.11). Black calligraphic brush strokes articulate the irregularities of the drapery folds, as well as the variated contours of the figures. The artist in both instances depicts sentient human beings. The Tokalı master has modified this style to suit a monumental setting and monastic audience: The fresco lacks the classical illu-

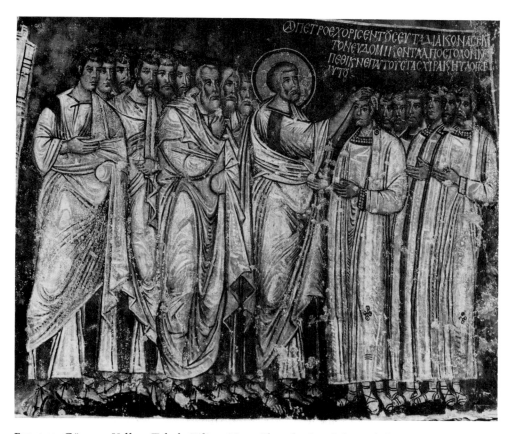

FIG. 2.11. Göreme Valley, Tokalı Kilise, New Church. South bay of the barrel vault, east side: Peter Ordaining the First Deacons

sionistic devices which create the vista in the miniature and which must have visually titillated the sophisticated patron for whom it was executed. Nevertheless, in both the illumination and the wall painting, figures carve out their own space in the immediate foreground of the picture plane. In contrast to the frescoes of the Old Church, the figures of the New Church are provided a limited depth in which to move convincingly. In all, while the paintings of Tokalı differ in function from those of the manuscripts of the so-called Macedonian Renaissance, they display a shared sensibility.

The program of the New Church is one of the most elaborate to survive in Byzantium from the Middle Ages. Its Christological cycle includes both monumental icons and dense narrative.[40] As in Kılıçlar, certain scenes in the New Church are given special prominence—the Annunciation, Nativity, Transfiguration, Crucifixion, Ascension/Blessing, Pentecost, and Koimesis (Death of the Virgin). But in the New Church these images of events central to the Orthodox liturgical calendar are not only enlarged and isolated by frames, but they have also been internally restructured. A comparison of the scenes of the Nativity from the Old Church and New Church demonstrates what might be termed the "iconization" of composition in the later monument (figs. 2.4 and 2.9). In the depiction of the Nativity in the Old Church, the artist contrives to move the eye inexorably from left to right. In the New Church the eye is entrapped by the image; details on the periphery return the viewer's attention to the dominant central axis created by the star and the Child in the bath. The image is no longer read as an illustration of truths embedded in a text; rather, it is contemplated as the embodiment of those truths. The formal differences between these two images reflect a dramatic change in the way they function within their programs, representing a fundamental shift from didactic narration to festival icon.

Prominently positioned in a niche between the sanctuary and the prothesis apse is a fresco icon of the Virgin Eleousa (Virgin of Tenderness) (fig. 2.10). It could be argued that this cult image was imported along with the other new programmatic ideas found in the New Church from the Virgin-protected capital of the Empire.[41] Certainly the unusual thickness of the candle-wax deposits which until recently obscured this image documents the congregation's veneration for the icon by indicating the large number of lamps once lit before it. The number of times the icon was copied in other churches in the vicinity reinforces the sense of the image's high local status. But the inscription accompanying one of these replicas, naming it the "Queen of the Asōmatōn," suggests that the icon lost whatever metropolitan connotations it might originally have had in favor of its local association with the Monastery of the Archangels. Meaning and form are transformed in the process of provincial assimilation.

The New Church itself shows a regional bias in certain programmatic emphases: the prominent depiction of scenes from the life of St. Basil, the great Early Christian bishop of the provincial capital of Cappadocia, Caesarea; the separate representation of each of the Forty Martyrs of Sebaste in Asia Minor; and the monumental icon of St. Hieron guarding the entrance to the nave. There is also a definite military accent to the scheme of decoration. Portraitlike images of each of the forty soldiers frozen and martyred at Sebaste dominate the hagiographic reper-

tory of the nave. Another great military martyr, George, is St. Hieron's pendant guardian of access to the church. Hieron, a local martyr, is not represented in his *Acts* as a soldier, but he is dressed in full military regalia in Tokalı Kilise. On the sole parapet slab separating the nave from the sanctuary corridor which retains its fresco decoration, the Roman general St. Eustathius is burned alive with his family in a brazen bull in one panel and the military hero St. Theodore occupies the second. The military bias of the program perhaps reflects the patronage of the local military aristocracy. This newly emerging elite, whose desire for independence and chivalric values are so boldly enunciated in the epic romance of Digenis Acritas, were, like the bureaucratic elite of the capital, dependent on the emperor's favor. However, the provincial basis of their power provided space for the active resentment of imperial authority. The scenes of St. Basil confronting the Arian Emperor Valens may represent a subtle anti-imperial statement.[42]

The architecture of the New Church, like aspects of its decoration, suggests that the patrons of the New Church were not entirely dependent on metropolitan inspiration. The novelty and complexity of the plan as well as its architectural refinements—beveled piers, molded cornices, pseudorelieving arches, vault bosses, blind arcades, and elaborate liturgical furnishings—indicate that the New Church was not an experimental invention of local masons. But it is unlikely that this type was imported from Constantinople, as no transverse nave church has been discovered there. Close analogies are, however, found in northern Mesopotamia. For example, Mar Yakub in Salah displays many of the same features found in the New Church: a transverse nave covered by a barrel vault divided by transverse arches into three bays, each of which is decorated by a boss; blind arches modulating the walls; and to the east a tripartite sanctuary with a monumental arch marking the entrance to the main apse.[43] Thus it appears that when new architectural forms were sought, it was not necessarily inevitable that Constantinopolitan types were adopted. Metropolitan hegemony was by no means complete.

In fact, many tenth-century Cappadocian monuments are very much local products, indicative of the continued independence of local artisans. This is clearest in architecture. The single-nave church, either barrel-vaulted or flat-roofed (often adorned with a sculptured cross), with a commodious horseshoe-plan apse continues to be the most popular type. Even imported architectural forms, like the cross-in-square and the transverse nave, once introduced, seem to have been readily absorbed into the local architectural tradition. The New Church had architectural progeny in its vicinity almost immediately. The closest copy of Tokalı Kilise is an unpublished monument, here titled Chapel 7A, only a few hundred yards removed from its model. Its transverse barrel-vaulted nave with three eastern apses and lower, barrel-vaulted west arm and *parekklesion* incorporate both the Old Church and New Church (fig. 2.12). Chapel 7A is much smaller than its archetype and lacks an eastern corridor, but, like the New Church, its walls are elaborated with blind arcades and its vaults with bosses. Less exact copies of the New Church are numerous. The dominant feature of the New Church, its great transverse barrel-vaulted nave, is repeated most impressively in a church next to Sarıca Kilise, near Ürgüp. Chapels 6, 16, 28, and 2A in Göreme Valley also appropriate the formula.[44] The number of copies made of Tokalı Kilise appears to reflect not only

FIG. 2.12. Göreme Valley, Chapel 7A. Sketch plan of the church modeled on the Tokalı Kilise complex

on the monument's high local status but also on the rapidity with which "foreign" types could be assimilated.

Imported ideas in fresco decoration, as well as imported architectural types, were adopted by local craftsmen. An unpublished monument, Chapel 2B in Göreme, is typical of locally carved and decorated chapels. The nave of Chapel 2B is a simple rectangle, with a flat roof sculpturally elaborated with a very large cross to the east and three separately enframed crosses to the west (fig. 2.13). Its spacious single-sanctuary apse has fallen away. The lower of the two registers of painting on the wall is devoted to standing saints. An elaborate figural cycle occupying the upper register and the quadrants between the arms of the ceiling cross includes scenes from the Childhood of the Virgin and a Last Judgment, as well as a Christological sequence. This complex cycle, which seems to be a variation of the scheme found in the Old Church, demonstrates a similar preoccupation with narrative.[45] Individual images are also closely related to those in Tokalı Kilise's west arm. The Nativity appears to be dependent on a rendering similar to that in the Old Church but modified to emphasize the separateness of the episodes. Thus Joseph no longer faces the previous scene of the Journey to Bethlehem but awkwardly turns toward the reclining Virgin (fig. 2.14). The stylistic characteristics of this narrative mode are also modified in Chapel 2B. The geometric highlights which in the Old Church are schematized to conform to body parts have become in Chapel 2B decorative borders of white triangles, as in the drapery over Joseph's thigh. This is not the only monument produced by this artist. The frescoes of El Nazar, Chapel 1 in Göreme Valley, are identical to those of Chapel 2B in their iconography, palette, and style, even to such details as the lively green underdrawings

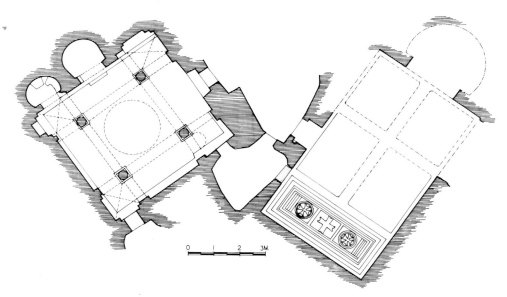

FIG. 2.13. Göreme Valley, Chapels 2B and 2C. Sketch plan

used by the artist to lay out his composition.[46] In fact, a large number of complex programs executed with considerable skill can be ascribed to local artists working in a mode related to that in either the Old Church or in Kılıçlar Kilise.[47] Cappadocian artists imitate artistic ideas newly imported from the heartlands of the Empire, but they transform them into a local idiom identifiable by its bias for isolated and flattened figures.

Similar tendencies are found in regional production affected by the frescoes of the New Church. Among the churches thus inspired is the Great Pigeon House at Çavuşin.[48] The church, with its single barrel-vaulted nave terminated by a large apse, looks conventionally Cappadocian despite the complexity of its east end (it has *diakonikon* and *prothesis* apses and transeptlike blind arches). This indigenous form is adorned with paintings dependent on Tokalı Kilise. The calligraphic hatching of highlights and shadows used by the master of the New Church to model his figures is transformed by the painter of the Pigeon House into a decorative and flattening interplay of unmodulated line. The artist at Çavuşin apparently did not see linear modeling as a means of creating the illusion of three dimensions, but rather as another variety of pattern. The cool, varied palette of the New Church is replaced with a limited repertory of brilliant ochres, green, black, and white. The program of the Pigeon House reflects the artist's dependence on Tokalı Kilise even more explicitly than his painting style. The west end of the barrel vault is divided into narrative registers arranged like those of the Old Church. The east end of the vault is devoted to the combined scene of the Blessing of the Apostles and the Ascension (though through misunderstanding or a lack of care, there are two additional apostles), analogous to the central bay of the barrel vault of the

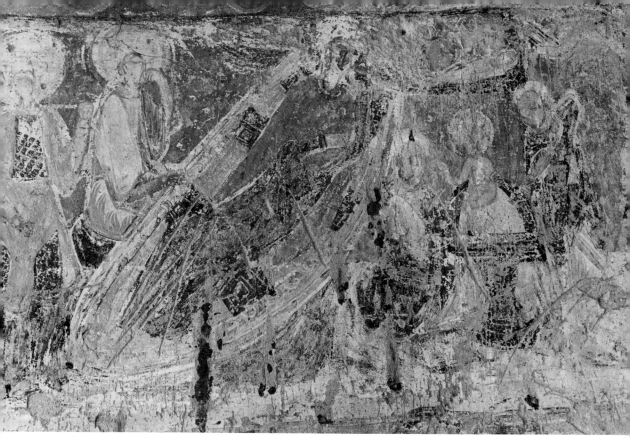

FIG. 2.14. Göreme Valley, Chapel 2B. South wall: the Nativity

New Church (fig. 2.15; see also fig. 2.10). The medieval programmer of the Great Pigeon House viewed his model as a whole and not as a series of discrete phases.

The military bias of the decoration of the Great Pigeon House is even more pronounced than that of its archetype in Göreme: The militant Archangel Michael, with Joshua bowed before him, is depicted immediately above the prothesis niche, in which are represented the warrior-emperor Nicephorus Phocas and his family; on the wall of the nave, soldier saints depicted as knights are led by the *magistros* Melias toward the transept niche, in which appears a second colossal image of Michael, at whose feet are badly damaged portraits of the church's patrons. The number and prominence of elite portraits that appear in the church suggest that the donors were associated with the highest echelons of Byzantine society. The work of local artists was apparently privileged by highly placed patrons.

Monuments such as Chapel 2B and the Great Pigeon House not only reflect a considerable dependence on foundations which had direct or indirect links with the capital, but they also provide insight into how metropolitan forms were interpreted by artists in the provinces. Although external influence may affect the iconography and style of painted decoration, local artists show some resistance to imported artistic conventions, such as hierarchical programming (see below) and the use of space-creating devices. They avoid the modeling of figures or the introduction of perspectival elements within the picture plane. The flattening and sim-

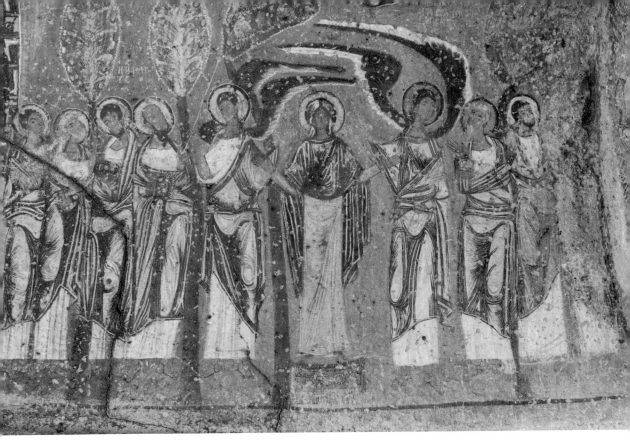

FIG. 2.15. Çavuşin, Great Pigeon House. North side of the barrel vault, east end: the Ascension (detail)

plification of form characteristic of the Cappadocian artists' reactions to metropolitan models complements an abiding interest in the isolated figure. Their images are highly legible. Finally, the many chapels apparently executed by local artists indicate a density of provincial artistic productivity for which documentation in other parts of the Empire has been lost.

Further evidence of the nature of local expression is found in the iconographic features of church programming. Even in those monuments which have the strongest affiliation with metropolitan art, certain features appear autochthonos. For example, the most common theme found in the sanctuary in tenth-century Cappadocian churches is the Maiestas Domini. A particularly elaborate version survives in the Holy Apostles at Sinassos, a church closely related to the Old Church of Tokalı Kilise (fig. 2.16).[49] In a starry aureole with an irised frame, Christ sits on a jeweled lyreback throne, blessing with his right hand and holding in his left a closed book. Around the throne are the symbols of the evangelists, originally identified with liturgical inscriptions: *kelegonta* ("calling," the man), *kekragota* ("roaring," the lion), *adonta* ("screaming," the eagle), and *boonta* ("bellowing," the bull). Below Christ is a crystal sea with adoring angels on either side; above him is the hand of God and medallions of the sun and moon; to his left and right are *hexapteryga* (six-winged figures) and pairs of flaming wheels. Flanking the image are the prophets Isaiah and Ezekiel; on the wall below is a series of standing

FIG. 2.16. Near Sinassos, Church of the Holy Apostles. General view of the east end, showing the Liturgical Maiestas in the apse conch

saints, including John the Baptist, St. Euphemia, St. Nicholas, St. Anastasia, and, originally, probably the Virgin on the cord of the apse.

The earlier scholarly supposition that the Cappadocian Maiestas was artistically anachronistic has been reassessed: There are metropolitan examples of the theme from the late ninth and tenth centuries.[50] It is not the prototype of the image but its persistent popularity which now needs investigation. Some insight into the relevance of the image to the monks of the province is provided by the theme's textual sources. There are, of course, Old and New Testament visions.[51] The synthetic Cappadocian vision must have been inspired also by liturgical texts. The Prayer of the Trisagion at the beginning of the Mass of the Catechumens in the liturgy of St. John Chrysostom shows the closeness of liturgical parallels:

> Holy of holies, our God, the one holiness and in holiness unceasing, holy from the beginning, who possesses unsurpassed glory; holy God who through the Word created all; holy God whom the four-headed beast praises in an unceasing voice; holy God who is adored and praised by multitudes of holy angels and archangels trembling in awe; holy God, watching and inclining your ear toward the many-eyed Cherubim with the unceasing voices and unclosing eyes; holy God who is carried by six-winged seraphim and who accepts the beating of their wings and their victorious song of songs, the Holy, Holy, Holy Lord of Hosts.[52]

Or again in the anaphora after the thanksgiving in the liturgy of St. Basil, the Lord of Heaven is graphically depicted:

> The angels, archangels, thrones of powers, dominions, ministers of the mighty, the many-eyed cherubim praise you. The seraphim are placed near to you in assembly, six wings by one and six wings by the other; by two covered are their faces, and by two their feet and by two they fly, crying the one to the other with unceasing lips; with the unsilenceable word of God... *bellowing, roaring, screaming, calling* the triumphant hymn... Holy, [holy, holy, Lord of Hosts, the heaven and earth are filled with your Glory].[53]

The Old and New Testament sources combine admonitions to the sinful with a promise of salvation to the righteous. Thus the benefits or rewards of monastic self-discipline, as well as the dire consequences of failure, are implicit in the image. The inclusion of prophets and saints as witnesses of the superhuman gives proof of the divine appearance, as well as providing figures with whom the monks could identify. Further, the liturgical basis of the image, specifically alluded to in the inscriptions of the evangelist symbols, embodies the heart of the monastic vocation: the unceasing glorification of God. In all, the theme is particularly appropriate for an ascetic setting. Its popularity in Cappadocia reflects not simply provincial conservatism but the maintenance of the values of ascetic provincial monasticism. In the same way, the erosion of this theme's prominence may well reflect changing values in the cenobitic communities of the province. Although the scene maintains its position of prominence in the sanctuary conch of the Great Pigeon House, the eschatological impact of the Prophetic Vision is modified already in the New Church. The image is relocated from the sanctuary to the *prothesis* apse (whence the portraits of holy ascetics are also exiled), and simplified—only the enthroned Christ flanked by archangels and accompanied by a *hexapterygon* and *tetramorph* remains. By the middle of the eleventh century the scene had disappeared altogether, in favor of the more hierarchical image of the Deesis.

THE ELEVENTH CENTURY

By the early eleventh century the so-called Middle Byzantine feast program emerged as a popular formula for church decoration.[54] It is a subtle, infinitely variable ornamentation of sacred space. At the apex of the decoration, in the dome of the central bay, is Christ Pantokrator (All Sovereign). The Virgin, often with the Child, appears in the conch of the apse, emblematic of the Incarnation. In the vaults of the church are narrative icons representing those events in the life of Christ celebrated during the liturgical year in the Orthodox Church; on the walls a *mēnologion* (calendar) of single saints.[55] The image of the Pantokrator is a theophany of monarchical power; the earthly emperor provides an archetype for divine rule. The analogy between the Pantokrator and the Emperor is made most elo-

quently by emperors of the Macedonian dynasty from Constantine Porphyrogenitus onward, who use the image of the Pantokrator on the obverse of their coins.[56] Below Christ, in the drum of the dome and in the supporting vaults, appear angels, prophets, and/or evangelists mediating between the Ruler and the pious petitioner in a manner analogous to the ranked entourage at the imperial court. Indeed, well-known allusions to the organization of church decoration as an image of social order are made in literature. In a description of the palace church of the Virgin of the Pharos presented as a homily at its inauguration in 880, Patriarch Photius writes:

> On the very ceiling is painted in colored mosaic cubes a man-like figure bearing the traits of Christ. Thou mightest say He is overseeing the earth, and devising its orderly arrangement and government....In the concave segments next to the summit of the hemisphere a throng of angels is pictured escorting our common Lord.[57]

A similar use of the language of court hierarchy appears in the sermon preached by Emperor Leo VI (886–912) in the Church in the Monastery of Kauleas in Constantinople:

> In the midst of it [the church] is represented an image of Him to whom the craftsman has dedicated the church. You might think you were beholding not a work of art, but the Overseer and Governor of the universe Himself.[58]

In his description of his father-in-law's, Stylianus Zaoutzas's, foundation, Leo alludes to courtly regimen even more explicitly. Below the Pantokrator in the dome appeared his minions, ordered according to their rank:

> His servitors whose being is higher than that of matter [angels]....Next to these [the artist] has placed another category of servitors who are agreeable to God; these, although beings of a material composition [prophets and saints], have nevertheless surpassed the bounds of matter and attained to the immaterial life.... Here you may see kings and priests—so that the universal King receives universal homage.[59]

The hierarchical program is perfectly complemented by the spatial hierarchy of a centralized church with its principal dome controlling the subordinate volumes generated by the plan. The decorative scheme functions not only as a visual liturgical metronome but also as a clearly articulated statement of world order, a monumental metaphor for the political structure of the Empire. Although this scheme is perhaps best known from the great mosaic decorations of Hosios Loukas and Daphni in Greece and the Nea Moni on Chios, versions are found in the Middle Byzantine period from Kiev to Sicily. Because of the flexibility of the constituent parts of its cosmos, this program was particularly responsive to the requirements of particular patrons and local audiences. But the popularity of this scheme over a wide geographical area and an extended period of time must also reflect the power of its visualization of the hierarchical nature both of Byzantine religion and of Byzantine society.

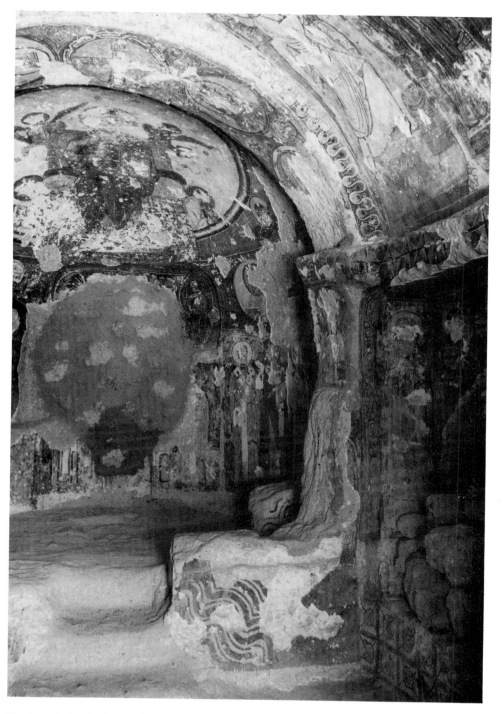

FIG. 2.17. Soğanlı Valley, St. Barbara. Decoration of the sanctuary conch: Maiestas Domini with Adam and Eve: To the right of the low sanctuary screen is the *proskynesis* image of St. Barbara next to a Deesis at the east end of the south wall

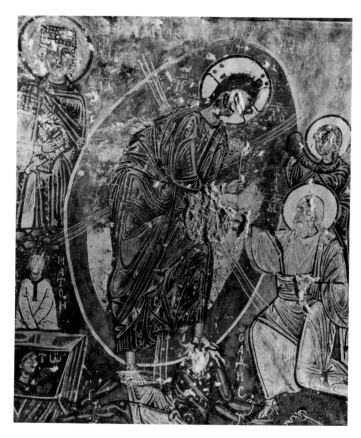

FIG. 2.18. Soğanlı
Valley, St. Barbara.
North side of the
barrel vault, east end:
the Anastasis

The early evolution of this program seems to be mirrored in the decoration of the New Church; its impact is recognizable in the early eleventh century; its dominance is exemplified in several Cappadocian churches of the middle of that century. Nevertheless, some tension always seems to exist between the metropolitan, hierarchical scheme of images and local votive and adopted narrative traditions that had been established in the region by the tenth century. The paired monuments from the early and middle years of the eleventh century discussed in this section should provide some indication both of the accessibility of current artistic trends in Cappadocia and of the creativity of local response to metropolitan importations.

St. Barbara in Soğanlı Valley is dated to 1006 or 1021 by an inscription which reads:

> This church of St. Barbara was decorated in the reign of Constantine and Basil in the year 6 . . . and indiction 4, in the month of May on the fifth day, with the aid of Basil the *domestikos* on the doors[?]. Those reading this pray for him.[60]

Unfortunately this last Basil has not been identified, although the title he bears suggests that he is an imperial court official of some significance. Basil's foundation is a single-nave church with a large sanctuary apse, articulated with a heavy cornice and a central relieving arch springing from simple responds. The church is entered through a minute domed cruciform narthex. Thus, although somewhat more elaborate in its carving than many single-nave cave churches, this chapel is typically Cappadocian in its plan. In contrast to the popular metropolitan centralized types, space in this church is not hierarchically ordered.

As in its architecture, the program of the church is not formally hierarchical. The most prestigious part of the chapel, the sanctuary apse, is adorned with a modified version of the Maiestas Domini rather than a Pantokrator (fig. 2.17). Christ is enthroned in a starry aureole surrounded by beasts of the Apocalypse, with a *hexapterygon* and a *tetramorph* directly below him on the wall. This familiar theme appears in an untraditional setting: In the corners of the conch Adam and Eve bow in *proskynesis* (a position of obeisance) to Christ; the evangelists in roundels appear on the wall of the apse above a register of church fathers; and to the right of the sanctuary an image of the patron saint of the church, St. Barbara, accompanies the Deesis (lit. prayer; Christ flanked by the Virgin and John the Baptist turning to him in supplication). Such modified versions of the Maiestas Domini, juxtaposed or interposed with the theme of the Deesis, are common in early eleventh-century Cappadocia.[61] Like the image in St. Barbara, these modified visions often include the characteristically Cappadocian names of the beasts.

In the nave, the central relieving arch, ornamented with enframed icons of the Seven Sleepers of Ephesus, divides the narrative which decorates the sides of the barrel vault. On the south there are two scenes in each quadrant—the Annunciation and the Visitation, followed by the Trial by Bitter Water and Joseph Confronting the Virgin. On the north, each quadrant is devoted to a single monumental image: the Nativity and the Anastasis, the festival icons of the two major feasts of the Orthodox liturgical year, Christmas and Easter (fig. 2.18). The sequence to the south, particularly the scenes from the Apocrypha, perpetuates the tenth-century narrative which was widely adopted in Cappadocian programs. The icons of the north apparently represent a response to the newly popular feast cycle.

Although the program shows a tension between new and more traditional forms, the rendering of the frescoes distinctly departs from the province's tenth-century conventions. Like the miniatures of eleventh-century metropolitan manuscripts, framing elements and interstices are filled with ebullient ornament: rinceaux, ribbon work, flowered scrolls, and diapering.[62] Realized in bright ochres and contrasted with blues, greens, and purples, the narrative images are also treated decoratively. The coloristic handling of the attenuated figures complements their action: Within the generous framed spaces of the north half of the barrel vault particularly, the participants in the Nativity and the Anastasis relate to one another with brittle vitality.

As in the case of the early tenth-century painting of Kılıçlar Kilise and the Old Church of Tokalı Kilise, this early eleventh-century mode appears to have generated local variants, one of which is represented by the frescoes of an unpublished church near Avcılar. This chapel, now a cistern, is a typical single-nave, barrel-

vaulted structure with large eastern and small western blind arches carved in its lateral walls (fig. 2.19). The paintings of this church exaggerate certain aspects of the rendering of St. Barbara (fig. 2.20). The figures are even more elongated and more brittle in their movements. The Avcılar master realized his images with great vivacity in bright ochres, splintered white highlights, and strong black outline—a similar sense of contrast as that evinced by the St. Barbara painter. But the pigment is laid on in broad, undifferentiated strokes. The effect is a bold, flat style. As in St. Barbara, the artist exhibits a certain *horror vacui:* Busts of saints and roundels of prophets are embellished with elaborate decorative surrounds; spandrels and other parts of the architecture not included in the picture space are filled with ornament. The patterns used are closely related to those in St. Barbara.[63]

The nave program exhibits the same ambiguous relation to the feast cycle as that found in St. Barbara. Narrative images are limited in number, although those that are depicted appear as continuous narrative, without the disruption of vertical frames. The south side of the barrel vault is decorated with scenes from the Incarnation: the Annunciation, Journey to Bethlehem, and the Nativity; the north side of the barrel vault is devoted to the Passion: the Last Supper, the Betrayal by Judas, and the Crucifixion. However, the conch of the sanctuary apse is adorned with a monumental Deesis. This shift from the Maiestas Domini to the Deesis is so widespread in Cappadocia in the eleventh century that it is difficult not to see it as significant.

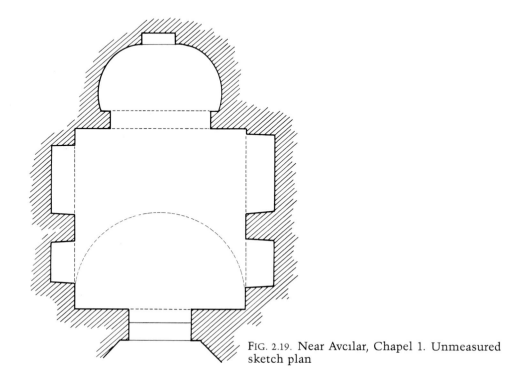

FIG. 2.19. Near Avcılar, Chapel 1. Unmeasured sketch plan

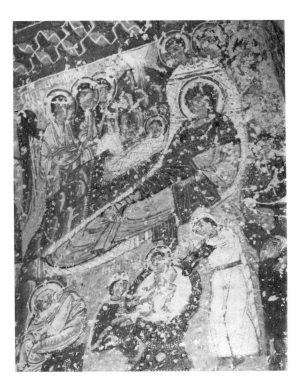

FIG. 2.20. Near Avcılar, Chapel 1. West end, south side of the barrel vault: the Nativity

The layers of meaning embodied in the Deesis are analogous to those of the Maiestas Domini: epiphanic, liturgical, and eschatological.[64] Christ appears enthroned with the revealed word in his hand. As in the Maiestas Domini, human witnesses of this revelation are included in the image: The Virgin and Baptist represent, respectively, the material nature of Christ and the prophetic essence of his kingship. Also like the Maiestas Domini, the Deesis is eschatological. Implicit in the image is not only a promise of redemption for the pious but also the threat of damnation of those who are not righteous. The emergence of the Deesis as the focus of representations of the Last Judgment in the tenth century must have made this image something of a pictograph of the meanings of that scene.[65] Although the scene shares certain themes with the Maiestas Domini, the Deesis is a much more powerful visual statement about intercession, relief obtained through the good offices of an intermediary between the petitioner and the empowered. The faithful in the nave are physically included in the pyramidal structure of the image: the divine ruler at the apex, the advocate, the pious beholder. Liturgical formulas, such as that found in the liturgy of St. John Chrysostom, are thereby explicitly represented:

> We offer to you this verbal service on behalf of those who died in faith, [our] fathers, patriarchs, prophets, apostles, deacons, evangelists, martyrs, confessors, as-

cetics, and all the righteous who died in faith. . . . [Hear] the intercession of our
Lady the all holy, undefiled glorious Mother of God and forever Virgin Mary, of the
holy John the Precursor and Baptist and of the holy [name] whose memory we
honor and all of your saints who will shelter us with prayers, O God.[66]

But implicit in the potent simplicity of the icon is the expression of political as
well as spiritual reality. Access to worldly authority was similarly mediated. The
Deesis embodies imperial ideology as well as theological dogma. Thus the new
popularity of the Deesis in Cappadocia seems to reflect the provincial assimila-
tion of the worldview of the center.

Although there are no clues in the chapel at Avcılar as to who promoted this
new image, some sense of the level of patronage may be provided by Chapel 33 in
Göreme Valley, which was decorated by the same artist.[67] In both chapels, not only
is the conch of the sanctuary apse occupied by the Deesis, but the selection of
saints has a distinctly military bias.[68] In the chapel at Göreme, small donors' por-
traits of a man and his wife in proskynesis at the feet of a standing Virgin and
Child are depicted on the west wall opposite the sanctuary. Neither has a title.
Nothing suggests that they are imperially connected magnates; rather, they appear
to be members of the provincial well-to-do. The programs of both Chapel 33 and
the chapel at Avcılar suggest that metropolitan assumptions of social layering and
the martial ideals of the military aristocracy were being absorbed by the lesser pro-
vincial elites in the early eleventh century.

The shift in artistic control from the monk to the lay patron which appears to
affect such monuments as Chapel 33 is even more apparent in monuments of the
second and third quarters of the eleventh century. The military aristocracy contin-
ued to patronize Cappadocian foundations. Karabaş Kilise in Soğanlı Valley, a
single-nave, barrel-vaulted cave church, was the katholikon (principal church) of a
monastery from at least the early tenth century.[69] In 1060/61 it was redecorated;
its new frescoes find their closest formal analogy in the sophisticated paintings of
St. Sophia in Ohrid.[70] The Annunciation, Nativity, Presentation of Christ in the
Temple, Transfiguration, Crucifixion, Women at the Tomb, and Anastasis appear
as monumental icons on the barrel vault, triumphal arch, and west tympanum of
the church. The conch of the sanctuary apse is devoted to an impressive rendering
of the Communion of the Apostles, with Christ depicted twice behind the altar,
offering wine to the left and bread to the right (fig. 2.21). This liturgized version of
the Last Supper is unusual in Cappadocia, but by the eleventh century it had be-
come common elsewhere in the Empire.

The currency of this phase of Karabaş Kilise's decoration may be attributed to a
distinguished family of patrons, the Scepides. The dedicatory inscription reads:

> This church was decorated with the aid of Michael Scepides the protospatharios
> and Katherine the nun and Nyphon the monk in the reign of Constantine Doukas
> in the year 6569 [1060/61] indiction 14. Those reading this pray for them to the
> Lord. Amen.[71]

Moreover, a number of personages, at least some of whom were presumably mem-
bers of the family, are represented in full-length portraits in the nave: a protospa-

tharios, whose first name has not survived; two richly dressed laywomen, Irene and Maria; Katherine, the nun; an elaborately robed male with a turban; and several monks, including the Nyphon mentioned in the dedication. *Protospatharios* is a relatively high-ranking imperial title;[72] its appearance in the context of a sophisticated program of church decoration suggests that the family had direct links with Constantinople.

The local well-to-do, as well as the metropolitan-connected elite, promoted themselves by patronizing art forms associated with the capital. Donors' portraits are very prominent in Karanlık Kilise (Dark Church) and Çarıklı Kilise (Sandal Church), two members of the mid-eleventh-century Column Church group in Göreme Valley.[73] As in the case of Chapel 33 and Karabaş Kilise, these portraits suggest the importance of nonmonastic patronage. Not one of the five recognizable donors represented in Karanlık Kilise is a monk.[74] In the narthex, over the entrance into the church, at the feet of Christ in the Blessing of the Apostles, are two figures in *proskynesis:* one Ge⟨i⟩ou and John the *entalmatikos,* apparently a minor official in the patriarchical bureaucracy. More surprising is the appearance of two further donors, the priest Nicephorus and the layman Basil(?), in the sanctuary of the chapel, participating in the Deesis. The context of these patrons' por-

FIG. 2.21. Soğanlı Valley, Karabaş Kilise. Conch of the sanctuary: Communion of the Apostles painted over a Maiestas Domini

traits is particularly appropriate for the inscription which accompanies all the donors in the Column Churches: "Prayer [deesis] of the servant of God..." On the west wall of Çarıklı, full-length portraits of the donors, Theognostus, Leo, and Michael, turn in prayer to the Ancient of Days, who displays a large cross, inscribed "The Precious Cross." The north and south walls of this same bay are adorned with the great military martyrs St. George, St. Theodore, and the mounted St. Procopius. Thus the donors associate themselves with the cross, whose veneration in Cappadocia is long-standing, and with knightly saints. The cross and St. Theodore attracted the attention of many pious visitors to the church, as the long series of graffiti invoking the aid of the cross and the martyr testifies. Although their brocaded garments and, in the case of Theognostus, a turban, are indicative of a certain social status, neither titles nor occupations are included in the inscriptions which accompany the portraits.[75] The obscurity or lack of titles, as well as the cooperative nature of the undertakings, indicates that the donors were not counted among the highest social echelons of the Empire but were members of the provincial establishment.

The shift in dominant patronage from monk to lay donor may be associated with an increased appropriation of metropolitan forms. Indeed, the architecture and even more clearly the decoration of the Column Churches suggest that local well-to-do patrons mimed elite metropolitan donors. Karanlık Kilise, Çarıklı Kilise, and Elmalı Kilise, the third member of the group, all imitated the cross-in-square type, a relatively conservative plan in the architecturally experimental mid-eleventh century.[76] The three churches are carved with varying degrees of care. Çarıklı Kilise, apparently left in an unfinished state, lacks the two western corner bays; its articulation is sinuously unarchitectonic. In contrast to the regular pilaster strips or half-columns of Elmalı and Karanlık, in Çarıklı the narrow responds wobble and dissolve. Despite its small scale and architectural irregularity, Çarıklı Kilise was a popular pilgrimage shrine in the Middle Ages, as indicated by the many graffiti which survive in it. The imprint of two feet in the floor of the chapel immediately below the image of the Ascension in the vault, like similar impressions in the Church of the Ascension in Jerusalem, appears to have been the object of popular veneration. The leveled rectangular area in the floor around the impressions seems to indicate that they were the focal point of special attention.[77] Karanlık Kilise, in contrast, is not only the largest of the churches but also the most regularly cut and architecturally complex—with carefully executed cornices, capitals, and half-round pilasters (fig. 2.22). Karanlık Kilise also appears to respond to contemporary liturgical requirements. Like most built churches (and in contrast to Cappadocian rock-cut ones), the sanctuary apse communicates with the prothesis apse. In addition, the narthex is large and elaborately carved to meet the increasing demands being made on it. As recorded in eleventh- and twelfth-century typika (monastic charters), confession, the Blessing of the Waters, and the offices for certain hours were performed in the narthex.[78] The narthex was also increasingly used as the site for the burial of donors. Karanlık Kilise's narthex, which is much larger than traditional nartheces in Cappadocia, has a monumental arcosolium with graves carved in its south wall, suggesting that from its inception the patrons and the monastery had long-term reciprocal commitments. The

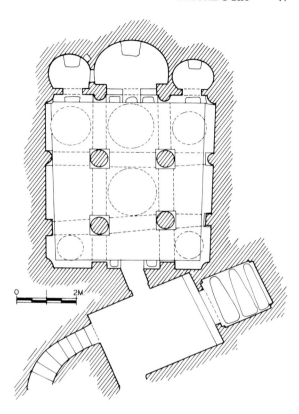

FIG. 2.22. Göreme Valley, Karanlık
Kilise. Sketch plan

monastic complexes associated with these chapels are much more elaborate than those of the tenth century. Carefully carved refectories, complete with rock-cut tables and benches, testify to the institutionalized asceticism practiced in these foundations.

More clearly than their architecture, the Column Churches' painted decoration demonstrates Cappadocian proximity to Constantinopolitan artistic developments. Formal similarities in the paintings of all three churches suggest that they were executed by a single master: Stylistic differences that appear among the works are attributable to change in scale (the compositions in Karanlık are larger than those in its sister chapels) or in the time spent in execution (Elmalı and Çarıklı appear to have been more hurriedly executed than Karanlık). Lapses in the artist's attention should not qualify an assessment of his competence. The Column Church master had an exceptional sense of coloristic effect. The contrasts between the bright pastels and warm ochres of the figures and the neutral, recessive grounds (dark blue in Karanlık and gray in Çarıklı and Elmalı), further heightened by the black line which is used throughout to delineate and decorate, can be fully appreciated now that the frescoes have been cleaned.[79] These images have the appearance of bright cutouts laid on a flat plane. The Christ in the apse of

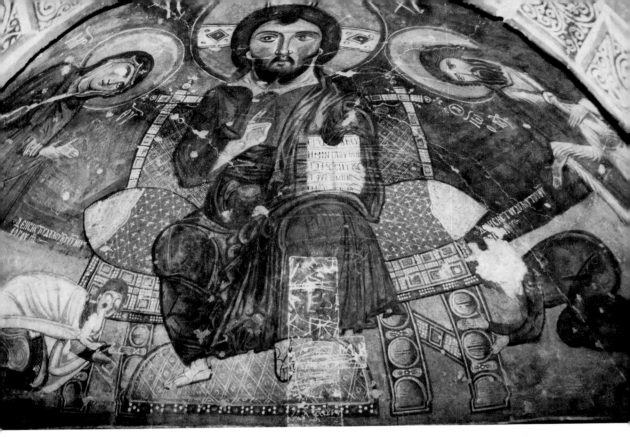

FIG. 2.23. Göreme Valley, Karanlık Kilise. Conch of the central apse: Deesis with donors

Karanlık Kilise indicates the level of decorative intensity that this artist might obtain (fig. 2.23). His competent use of difficult pigments, like the cinnabar with which he highlighted the cheeks of his figures in all three churches, is indicative of his professional status. As Thierry has pointed out, this master's work is comparable to that found in contemporary metropolitan monuments; her most convincing parallel is the Menologion of Basil II (Vat. gr. 1613).[80]

Further, the programs of the Column Churches are, by Cappadocian standards, exceptionally conventional. The central dome contains the bust of the Pantokrator, surrounded by archangels, evangelists, and prophets. Archangels and military saints are prominent in the hierarchical scheme; holy ascetics are conspicuously absent. The Mandylion, the *acheiropoietos* (an image not made by human hands) of the face of Christ impressed by him on a cloth and sent to King Abgar, is represented in the *diakonikon* of Karanlık Kilise. This icon, which was closely associated with imperial piety, was credited with exceptional apotropaic powers which might be used in aid of both the community and the individual.[81] In 1036/37 Michael IV processed the image from the palace through the city in an attempt to end a drought of six months' duration.[82] When in 1034 Constantine Dalassenus was recalled to Constantinople by his enemy Emperor Michael IV, he demanded that his safety be assured with oaths taken on Abgar's relic before he would leave his estates in Asia Minor.[83] The early appearance of the Mandylion with its imperial associations in Cappadocia in Karanlık Kilise is indicative of the Column

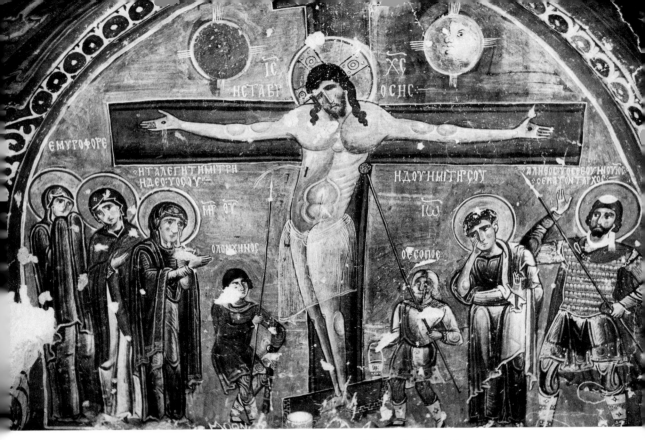

FIG. 2.24. Göreme Valley, Karanlık Kilise. South-central bay: the Crucifixion

Churches' responsiveness to metropolitan forms of piety. As in metropolitan monuments, images of the great festivals of the church year, centering on the Incarnation and Passion, decorate the vaults and upper walls of the structures. Also following convention, each of these feast scenes occupies an architecturally defined surface, enclosed within a simple red border. In Karanlık these borders are as regular as the structure permits; in Elmalı and Çarıklı, because of the smaller scale of the monuments, scenes were fitted into more irregularly framed spaces.

But the programs of the Column Churches also respond to local artistic traditions. In the apse is the Deesis, not a Virgin. The choice of feast scenes in the Column Churches also seems affected by their context: A repertory of twelve great church festivals, perhaps dependent on a modelbook, is shared by the members of the group. Additional scenes (e.g., the Way to Golgotha in Elmalı Kilise, Simon Carrying the Cross in Çarıklı Kilise, and the combined Blessing of the Apostles and Ascension in Karanlık Kilise) are derived from earlier local monuments.[84] The Virgin Eleousa represented on the south wall and in the *prothesis* apse of Çarıklı Kilise is modeled on the Eleousa icon of the New Church.[85] Also demonstrative of the strength of local artistic practice is the continued impetus of tenth-century narrative. The principal feast scenes are augmented by secondary ones: The Nativity is complemented not only by the traditional Flight to Egypt but also by the Journey to Bethlehem; the Crucifixion similarly is accompanied by the Way to Golgotha or Simon Carrying the Cross.

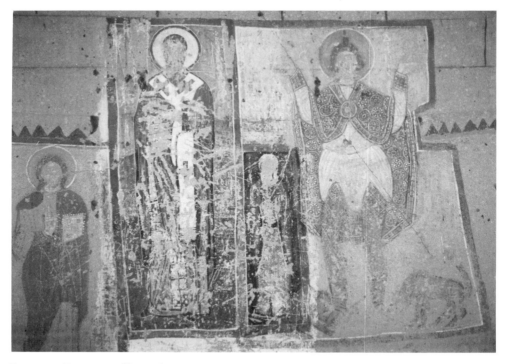

FIG. 2.25. Göreme Valley, Chapel of Daniel. South wall: panels of St. Basil and donor, Daniel in the Lions' Den, and Christ

The Crucifixion itself reflects its Cappadocian context (fig. 2.24). This scene remains a central image of the Passion in the province; its position is not inevitably usurped here by the Anastasis (Christ's Triumph over Hades).[86] In the Crucifixion in all three churches, there is also an iconographic detail which is idiosyncratically Cappadocian. Two small figures appear on either side of the foot of the cross, one on Christ's right with the spear which has pierced the Lord's side and one on his left with a sponge on a stick. These figures bear names referring to their respective instruments: Longinus (from *logchē*, meaning spear-head) and Esopos (from *hyssopos*, an aromatic plant mentioned as the shaft to which the sponge with vinegar was attached in John 19.29). Longinus is named in apocryphal texts of the Crucifixion, and his appearance and identification in Byzantine images are not uncommon. However, Esopos as a proper name does not appear in any text with which I am familiar, or in any images outside the province that I have found. Such a name does, however, occur in Cappadocian images of the Crucifixion from the early tenth century, for example, in the Old Church of Tokalı Kilise. The sponge-bearer not only has an unusual label in the province, he also has a specific appearance. Where the figure is still legible, he is usually depicted as an old man, with a short white beard and white hair. Outside Cappadocia he is typically represented as a young, often rather evil-looking character. Esopos apparently had a par-

ticular local persona. Naming figures according to their attributes generally seems to have been a local habit. In the scene of the Marriage at Cana in the Old Church of Tokalı Kilise, the figure filling an urn with water is titled Antlion, from the Greek for "draw out" (*anteleo*), Christ's command to the servant (John 2.8). Similarly, as discussed above, in the appearances of the Maiestas from the early tenth to the early eleventh century, the beasts of the Apocalypse take their names from the liturgical noises they make. The appearance of Cappadocian pictorial peculiarities, as well as the residual influence of local work, provides some evidence of continued provincial independence, despite the apparent assimilation of metropolitan values by the local lay patronage.

As in the early tenth century, the appearance of two current stylistic modes of painting in Cappadocia in the mid-eleventh century—one in Karabaş Kilise and the other in the Column Churches—is indicative of the province's close ties with the metropolitan core. Again as in the tenth and earlier eleventh century, these newly introduced artistic ideas were adopted and modified by local artists. In the region of Göreme Valley, image makers were particularly affected by the paintings of the Column Churches. A series of chapels in Göreme Valley, commonly called the Yılanlı Group, after one of its members, Yılanlı Kilise (Snake Church), are stylistically and programmatically dependent on the three sister foundations.[87] On the basis of dated graffiti, at least some of the members of this group can be ascribed with some assurance to the second half of the eleventh century; others may be even later. With exceptions, such as Chapel 17 and Chapel 25, these monuments are crudely carved. The Chapel of Daniel in Göreme is typical.[88] Its irregular rectangular nave is terminated by a single apse. Its floor is given over to graves, including those of four children. Most members of this extensive group have very few images; narrative scenes are rare. As in the Column Churches, a Deesis commonly appears in the apse, but the walls are decorated only with a few isolated icons, often including the Mandylion.

The level of craft represented in these icons is not high. The palette is restricted to dull earth tones, black, and white. The inorganic figures are heavily rendered with repetitive brush strokes. Figures are usually painted on thin plaster or directly on the rock wall of the church; they are depicted on gray grounds and enframed with simple red ochre borders. The images in the Chapel of Daniel in Göreme are again characteristic of the group (fig. 2.25). Originally painted on the south wall of the church was a single icon of St. Basil, accompanied by the deceased female donor in a subsidiary panel. An inscription reads: "The servant of God Eudocia has fallen asleep [died]." This image was rendered on a space directly opposite the entrance to the chapel, the structure's only source of natural light. To position his panel to take full advantage of all available illumination, the painter cut away a segment of the simple cornice at the springing of the barrel vault. Subsequently added images, including Christ, the Virgin, and Daniel between lions (which was painted partially over Eudocia, at the instigation of its donor, Basil ["Lord protect your servant Basil of Dabi(?)"]), also clustered around this lighted area. Two icons of the mounted military martyr Procopius accompanied by inscriptions again naming donors (or in the case of Michael, perhaps the painter) appear on the west and north walls of the chapel.

As the decoration of the Chapel of Daniel suggests, the frescoes of these chapels, in contrast to monuments like Tokalı Kilise or the Column Churches, consisted of ex-voto panels dedicated by individual donors; they were apparently produced for nonelite patrons with a minimum of expenditure, to judge by the cheap pigments and simple surface preparation. These images seem to represent a dissociation with the capital and a revival of the visual vocabulary of the ninth century: the holy individual, isolated and frontal, as the object of personal devotion. However, the pious inscriptions on these ex-votos, as well as the selection of the subjects (notably St. Basil and the military martyrs) and the uneven distribution of graffiti in favor of holy knights, suggest that the local peasantry rather than the resident hermit was responsible for the few artistic decisions that were being made in Cappadocia in the third quarter of the eleventh century. The relative prominence of donors' portraits in these churches is also reflective of the increasing emphasis given to patrons and their images, a pattern which emerged in the province in the early eleventh century. In the ninth and early tenth centuries, invocations are added to the images of patron saints, but the donor rarely appears. The remarkable emphasis given donors' portraits in the Column Churches and Karabaş Kilise, and continued in a less pretentious mode in the Yılanlı Group, reflects on the shift in spirituality in the province. It seems that the nature of monasticism in Cappadocia changed in the course of the later tenth and eleventh century; the vitality of asceticism in the province appears to have declined. It is unclear how this process was affected by the impoverishment of the Christian population in the wake of the Seljuk invasion. In terms of the artistic production of the province, however, it seems that once isolated from the rest of the Empire by the Turkish conquest of central Anatolia, Orthodox Christians in Cappadocia had neither the material resources nor the links to the imperial core that would allow them to continue to adapt metropolitan artistic ideas to local circumstances.[89]

3 Cyprus

SETTING AND AUDIENCE

Although the island of Cyprus was only a day and a night's voyage from Tyre on the Levantine coast, it was ten days' sailing from Constantinople in the most propitious of circumstances.[1] The island's relative remoteness from the Empire's bureaucratic center, as well as its physical isolation by the sea, fostered a degree of spiritual and political independence which conditioned the artistic production of the population.

The autonomy of the Cypriot church was established early. Through the miraculous intervention of St. Barnabas, the patron saint of Cyprus, the islanders won their long-standing struggle with the patriarchate of Antioch. According to tradition, Emperor Zeno (474–91) affirmed the autocephalos status of the Church of Cyprus and awarded the island's primate such unique imperial trappings of independence as the right to sign in red ink, wear a purple cloak at religious festivals, and bear a scepter instead of a normal pastoral staff.[2] The Cypriot church was subject only to imperial authority.[3] Secular administrative independence of Antioch was achieved somewhat later, during the reforms of Justinian in 535. Independence from the Empire itself was externally imposed by the Arabs. Cyprus was invaded in the 640s, but in contrast to other regions overrun in the Arab conquests of the seventh century—Palestine, Egypt, North Africa, or even Crete—Cyprus was never Islamicized. From 688/689 until the tenth century the Cypriots lived under a treaty with the Arabs whereby they would maintain military neutrality

and pay a tribute to the Caliphate equal to that paid to the Byzantines.[4] The occasional Arab invasions of the island during this interim are excused by Arab historians as punitive ventures necessitated by the Cypriots' lapses in neutrality. Al-Laith in the tenth century wrote, "The Cypriots are constantly charged by us with infidelity to Moslems and loyalty to Allah's enemies, the Greeks."[5] Even Greek accounts of Arab excesses suggest that Cyprus enjoyed a special status in the Mediterranean. Theophanes gives the impression that Cyprus was a place of asylum:

> In the same year [812–13] many Christian monks from Palestine and all over Syria arrived in Cyprus having fled the unending evil of the Arabs. . . . The renowned monasteries of Sts. Chariton and Sabas in the desert along with other churches and monasteries were destroyed. Some [monks] became martyrs while others went to Cyprus and from it to Byzantium. The Emperor Michael [I Rangabe] and the holy patriarch Nicephorus welcomed them and Michael provided aid in every way. He gave the men coming into the city [Constantinople] a well known monastery and he sent a talent of gold to the monks and laity still in Cyprus.[6]

The question remains: What was the nature of Cypriot neutrality? The three-hundred-year period between the first Arab invasion of Cyprus in the late 640s and the official Byzantine reconquest of mid-tenth-century Cyprus has been presented as a "dark age," and the island characterized as a "no-man's land" between Christians and Moslems.[7] It seems at least equally possible that, despite disruptions and occasional depredations, life in Cyprus went on in a productive, if not sumptuous, manner. It has even been cogently argued that "in Cyprus as in the cities of Dalmatia and elsewhere, the old civic structures of Late Antiquity survived, in which effective local power lay in the hands of city notables and the bishops."[8] Indeed, from the life of St. Demetrianus, written in the early tenth century, it appears that the ecclesiastical structures of the island were enduring and resilient; they may even have been strengthened in the absence of imperial authorities.[9] This hypothetical reconstruction of the social setting in Cyprus before the mid-tenth century receives support from the monumental remains of the era. These works are for the most part communal foundations, located in towns rather than in the countryside. The buildings are local in character, indicative of the island's relative isolation; the few remaining fragments of their original fresco decoration, however, betray the Cypriots' cultural allegiance to Byzantium. Nicephorus Phocas's "conquest" of Cyprus in 965 may then represent not so much the reestablishment of the Byzantine presence on the island, but rather the termination of all former obligations to the Saracens. The casual treatment of this occupation in Byzantine sources would be explained if Nicephorus Phocas's "victory" represented simply the political realization of already well-established Byzantine loyalties.

From the imperial "reconquest" of Cyprus in the tenth century until the late twelfth century, Byzantium's dominance was challenged only by occasional rebels and usurpers, such as the disloyal governor Theophilus Eroticus (1042/43), Rhapsomates (1092), and Isaac Comnenus (1184–91), who all profited from the island's remoteness.[10] The official incorporation of the island into the Empire may be re-

flected in changing patterns of patronage: Funding appears to expand from urban, congregational structures to monastic or private foundations often located in the countryside. The building of monasteries and oratories in the mountains appears to increase proportionally with the Empire's military presence. During the reign of Alexius I (1081–1118), Byzantine strategic interest in Cyprus was particularly acute. In the face of the Seljuk threat in Asia Minor, in reaction to internal turmoil represented by the revolt of Rhapsomates in 1092, and as a protective measure against the ambitions of the Latin Crusaders, the Byzantines made efforts to secure the island. A series of castles—at Kyrenia, Buffavento, Kantara, and St. Hilarion—were built in the northern range of mountains.[11] Not only governors but also high ecclesiastics were sent to Cyprus from Constantinople.[12] The emperor and his functionaries became conspicuous sources of artistic patronage. Local dignitaries evidently attempted to mime the achievements of the metropolitan elite; as in Cappadocia, artistic production reflects their assimilation of the dominant ideology.

Monastic organization, as well as monastic structures, appears to have become more formalized. The *typikon* of the Machaeras monastery, founded with the financial support of Emperor Manuel I Comnenus (1143–80), exhibits a specificity characteristic of monastic communities established by Byzantine magnates in Constantinople. For example, it legislates the placement and number of candles to be lit in celebration of different feasts as well as the topography of liturgical practice. As in the Constantinopolitan *typika* mentioned in chapter 2, the Machaeras *typikon* dictates that certain daily services are to be sung in the narthex.[13] The adoption of such metropolitan ritual formulas has monumental implications. One of the peculiarities of Cypriot church planning is that nartheces apparently were not incorporated into ecclesiastical structures before about the middle of the twelfth century.[14] From that time onward, however, nartheces not only were included in the construction of new churches but also were commonly added to old ones. It would seem that even ritual practices were affected by centralization under the Comnenians.

In the twelfth century there were also increasingly numerous contacts of a commercial and spiritual character with the Holy Land. The principal vehicle of this communication was pilgrimage. Travelogues from the seventh through the tenth centuries, for example, those of St. Willibald and St. Elias the Younger, give the impression that the pilgrim was an isolated alien, the object of curiosity or suspicion.[15] In the wake of the First Crusade, pilgrims to the Holy Land multiplied.[16] Cyprus was an important stop en route to Palestine. An anonymous pilgrim, probably of the twelfth century, wrote: "The shortest way to the [Holy] Land is from Famagusta [on the east side of Cyprus]."[17] Christians in the Levant were also spiritually linked to the island as the nearest substantial enclave of co-religionists. For example, when in the face of the Crusading armies the Saracens planned to raze the Church of the Holy Sepulchre, the Christians of Jerusalem ransomed the site with the generous aid of the Cypriots: "The entire possessions of the Christians living in Jerusalem were not sufficient to pay the sum [that was demanded]. It became necessary, therefore, for the venerable patriarch to make a voyage to Cyprus in order to obtain the means of satisfying this exorbitant demand."[18]

The general spiritual links between the Christian communities of Cyprus and the Levant were formalized in particular circumstances.[19] The monastery of St. Catherine on Sinai may also have acquired its *metochia* (landholdings) on the island in the late eleventh or early twelfth century.[20] There is also a Latin presence on the island: In 1148 Emperor Manuel Comnenus extended to the Venetians the same commercial privileges in Cyprus that were enjoyed in the rest of the Empire.[21] This development corresponds chronologically with the introduction of the pointed arch in Cyprus. This device was foreign to the island. Although it occurs in Constantinople, it was not aesthetically exploited in the architecture of the capital. The pointed arch was, however, common by the mid-twelfth century in Crusader construction in the Levant.[22]

There is little information about the relative wealth of Cyprus in the eleventh and twelfth centuries. According to the bitter complaints of Nicholas Muzalon, archbishop of Cyprus from about 1107 to 1110, the people of the island must eat as the Baptist did; they go naked during the day; their only shelter is provided by caves.[23] This denunciation was, however, written in an attempt to exonerate himself of the charge of deserting his bishopric after he had negligently returned from Cyprus to Constantinople. Moreover, Muzalon specifically attributes the island's impoverishment to its brutal taxation by the Empire. Accounts of the island by pilgrims,[24] Crusaders,[25] and Arab historians[26] indicate, in contrast, that Cyprus was quite wealthy. The account of an anonymous pilgrim of the twelfth century is typical:

> And in that island there are one hundred and thirty cities and good castles, excellent sweet wine, handsome, strong and brave men, and a great and exceedingly rich kingdom.[27]

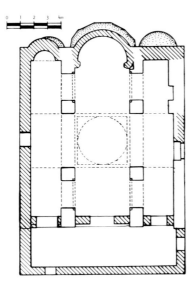

FIG. 3.1. Kellia, St. Anthony. Sketch plan. Reconstructed areas are hatched

It does not appear, then, that Cyprus was a hopelessly poverty-stricken province through the Middle Byzantine period. It seems to have survived the periodic raids of the Arabs and the depredations of Byzantine usurpers with a relatively healthy agrarian economy and population. This economic and social stability provides the basis for identifying the strong local architectural tradition found in Cyprus. Although certain features of church planning, and more particularly church decoration, demonstrate the artistic dimension of Cyprus' political and cultural ties with Constantinople and Palestine, autochthonous construction technique and sensibility ensure the peculiar character of Cypriot architecture.

At the end of the twelfth century, the island was cruelly incorporated into the Crusader territories.[28] Richard Coeur de Lion's conquest of the island after his defeat of the rebel Isaac Comnenus, the brutalities of the Templar occupation, and the demographic and administrative upheavals of Guy de Lusignan and his brother Aimery brought about such radical social changes in Cyprus that the traditional patterns of artistic patronage and practice were disrupted. In contrast to the period of Arab-Byzantine neutrality, the era of Crusader rule is marked by artistic discontinuity.

THE EARLY TENTH CENTURY

Cyprus is made up of two mountain ranges, the massive Troodos in the southwest and the Kyrenia forming a northern spine. Between these two ranges is a fertile saucer plain. The Troodos is also flanked by a girdle of foothills and coastlands. The Middle Byzantine monuments of the lowlands of Cyprus are distinct from those in the mountains in scale, plan, style, chronology, and social context. The churches of the lowlands, which by and large seem earlier than those of the mountains, are medium-sized structures ranging from about 16 to 32 meters in length with a dominant longitudinal axis. They are vaulted buildings, usually with one or more domes. Though fabrics differ in the size and quality of ashlar used in their construction, limestone was the dominant building material because of its availability. Tertiary limestones and marls characterize the coastal areas, as well as the plain between the two mountain ranges. The lowland churches tend to be urban foundations; whatever their original function, monastic or parochial, most are associated with towns. Patronage apparently focused on foundations within the community. An analysis of a few of the lowland structures establishes the character of both the architecture and patronage of the group.

The church plan perhaps most common among lowland churches of Cyprus is the pier basilica with a single dominant dome. Although reflective of the general popularity of centralized domed structures in the Middle Byzantine period, these monuments are thoroughly local in character. This group includes the Panagia Kanakaria at Lythrankomi,[29] three monuments on the Karpas Peninsula (the Asomatos and the Panagia at Aphendrika and the Panagia at Sykha),[30] and the Panagia Angeloktistos at Kiti.[31] The church now dedicated to St. Anthony, located in Kellia, a small town on the east coast of Cyprus north of Larnaca, is typical of this se-

FIG. 3.2. Kellia, St. Anthony. General view of the interior, looking east

ries in its architecture; moreover, the remarkable survival of fragments of its early fresco program gives it a unique place in a study of the development of Byzantine painting in Cyprus (figs. 3.1–3.3).[32]

Like many other members of the group to which it belongs, St. Anthony incorporates several building phases. Thus the monument represents a degree of continuity in the urban setting of which it is a part. The earliest part of the present superstructure is the core of the building, including the four oblong freestanding piers, the eastern and western responds, and parts of the south wall, all of which are constructed of irregularly coursed ashlar. Much of the present vaulting of the monument is post-Byzantine, but from the remains of the earliest medieval phase, the church appears to have had a central dome supported by four piers and buttressed to the east and west by longitudinal barrel vaults and to the north and south by shorter transverse barrel vaults. Although in its plan and vaulting system the church bears some resemblance to the metropolitan cross-in-square type, it is given a basilican sensibility by the longitudinal barrel vaults which cover the corner bays and the single-order moldings of the east-west arches. These simple moldings are one of the few linear features of the structure, which has a marked

organic, unarticulated character. Despite the greater centrality of St. Anthony's plan, the building's rough-cut ashlar masonry, the broad handling of its structural members, and the heavy proportions of its interior spaces closely associate it with the other members of the series of lowland churches. One unique feature of the architecture of the church at Kellia is its figurative sculpture: The protomes which appear at the bottom angle of the pendentives below the central dome seem to have been part of the original structure.[33]

The earliest surviving phase of this church retains fragments of its medieval fresco decoration, uncovered recently during the removal of later internal buttressing. The oldest fresco layer is located on the east and west pier-faces of the south arch of the central bay. To the east is a Crucifixion (see figs. 3.2 and 3.3). Christ is central, and except for his slightly tilted head, he is rigidly frontal. The Virgin raises both her hands to Christ; St. John holds the Gospels in his left hand and raises his right toward the cross. Verses from John 19:26–27 appear below the horizontal arms of the cross. The sun and moon are depicted in the upper corners of the composition. Although the fresco was badly damaged in the process of preparing the surface for a later plaster layer, it is possible to decipher the style of the paintings. The figures, flattened against the surface of the picture plane, fill the entire framed space. Christ's hoselike arms and oval torso show no signs of torsion; modeling on all three figures is minimal and drapery is rendered with a series of pleatlike striations. The palette is limited to earth colors. Similar frescoes are found in Komo tou Yialou on the Karpos Peninsula in a chapel dedicated to Hagia

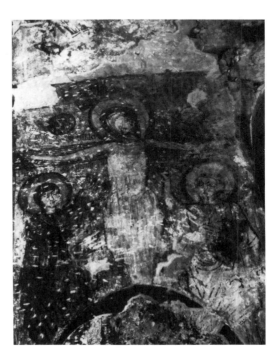

FIG. 3.3. Kellia, St. Anthony. Crucifixion on the west face of the southeast pier

Solomoni and in the rock-cut church of Agia Mavra at Khrysokava, Kyrenia.[34] Outside Cyprus, the closest stylistic and iconographic parallels are found in the derivative members of the early tenth-century Ayvalı-Tokalı group in Cappadocia, such as the church of El Nazar.[35] The Crucifixion from the earliest-surviving ninth-century layer of fresco from the now-inundated church of Episkopi, Eurytania, in Greece, also shows many of the same features.[36]

In El Nazar, the Crucifixion is part of an elaborate narrative cycle; in St. Anthony the scene is an enframed, isolated icon, prominently positioned immediately to the right of the sanctuary. Like the representation of the Crucifixion in the Chapel of Nicetas, this is an image of sacrifice associated typologically and physically with the eucharistic ritual as it occurred in the apse. The number of medieval graffiti scratched on the Crucifixion suggests that it was an effective devotional icon. The stylistically related panel of two standing saints which was painted opposite the Crucifixion on the southeast pier shares its votive character. Better preserved are a series of ex-voto images of the enthroned Virgin and Child on the southwest pier. The Virgin and Child on the lowest exposed plaster layer on the north face of the pier seems to belong to the same period as the Sacrifice of Abraham, which appears on the southwest respond. Another panel of the Virgin and Child was rendered on the west side of the same pier, on a plaster layer which overlaps the first image. This squatly proportioned Virgin on a lyre-back throne is constructed of neat geometric segments and given precise, simplified features. The style of this fresco is similar to that found in the early twelfth-century church of the Panagia Phorbiotissa at Asinou in the Troodos.[37] The earliest-surviving phases of fresco decoration of this monument thus seem to be of a votive character. Mounted military martyrs proliferate, especially on the north piers at some later time, perhaps the twelfth century. Apparently at a later date the church was also decorated with a feast cycle: A fragment representing Peter cutting off Malchus's ear from the scene of the Betrayal of Christ by Judas survives in the lower corner of the south barrel vault. Unfortunately only a few words of a long dedicatory inscription written on a slab of reused marble sunk into the east wall of the nave are decipherable. Nevertheless, evidence provided by the fresco decoration at Kellia indicates that the church had been rebuilt by the early tenth century. Its ex-voto decoration also suggests that individual members of the community supported the church's piecemeal decoration perhaps into the eleventh century. Apparently only rather late in its medieval life did the church receive a conventional Middle Byzantine program of the sort discussed in chapter 2.

The decoration of St. Anthony at Kellia seems to indicate that during the late ninth or early tenth century in the lowland towns of Cyprus there was a communal interest in the local church. Perhaps a parallel can be drawn with the medieval reconstructions of the Panagia Kanakaria at Lythrankomi. On the southwest nave pier in that structure is an inscription ascribed by Cyril Mango to the ninth or tenth century which states that John, a sinful deacon(?), with the collaboration of Theodore(?), archbishop [of Cyprus?], Solomon of Jerusalem [archbishop c. 860–65?], and Eustathius, repaired(?) the church.[38] This enumeration of names suggests a collaborative project. The lack of secular titles seems to intimate an absence of imperial authority, while the appearance of high-ranking clergy (and the lack of

FIG. 3.4. Yeroskipos, St. Parasceve. North aisle from the west.

reference to monks) may allude to the status of the urban community which the church was to serve.

The architecture of the Panagia Kanakaria, which has been thoroughly analyzed by A. H. S. Megaw, has much in common with St. Anthony. Most obviously it shares its complexity, born of numerous reconstructions and attesting to the longevity of the ecclesiastical associations of a particular lowland site. The Panagia also has many of the same formal features as found at Kellia: limestone ashlar construction, heavy proportions, and in all of its phases a longitudinal bias. Its initial reconstruction as pier basilica has been dated by Megaw to about 700, largely on the basis of favorable historical circumstances.[39] It took the form of a single-domed basilica in its second medieval building phase. It is unclear as to what phase of reconstruction the inscription mentioned above refers, although judging from the personages involved, it seems unlikely to have been a minor one.

Building activity on Cyprus in the early tenth century is also attested by a second series of lowland churches, including St. Lazarus at Larnaca, St. Barnabas at Salamis, Sts. Barnabas and Hilarion at Peristerona, and St. Parasceve at Yeroskipos. The most prominent shared feature of this group is the multidomed nave.[40] Its least pretentious member is a church now dedicated to St. Parasceve located on the south coast of Cyprus in the small town of Yeroskipos (figs. 3.4–3.6). St. Parasceve is a small basilica with a main vessel of three bays, each covered by a low dome, and barrel-vaulted side aisles centrally interrupted by domical vaults. The nave bays are delimited by heavy piers, from which spring the transverse and longitudinal arches which support the domes. The nave arcades are infilled with walls punctured only by small roundheaded openings, giving the low aisles a cavelike

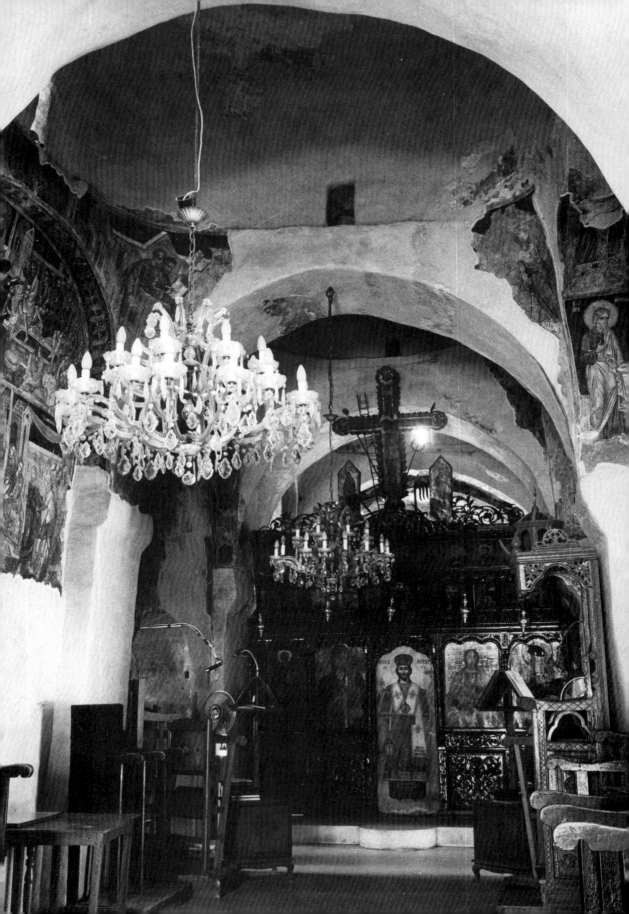

sensibility. Reused capitals or simple masonry lumps mark the springing of the arches. The interior of the church is plastered; cornices appear to grow out of the walls below them, only vaguely defining the constituent volumes of the interior space. The exterior of the building reveals the reason for the absence of linear articulation: The fabric is rough-cut limestone set in thick mortar beds. The quatrafoil martyrium or tomb in the southeast corner of the structure is original; the narthex and bell tower are later additions.

Its scale and location suggest that St. Parasceve functioned as a congregational church; its rendering indicates that the community it served was limited in its means. Nevertheless, the building did receive a fresco decoration, several phases of which survive in a fragmentary form. On the northeast tympanum of the nave, a post-Byzantine layer of plaster has been removed to reveal the remains of the scene of the Koimesis (Death of the Virgin). Formal parallels with work in Bethlehem suggest a twelfth-century ascription.[41] In the eastern dome covering the sanctuary bay, an earlier phase of painting has also been uncovered (fig. 3.6). The fresco divides the dome into three registers. The lowest register is almost entirely destroyed; the middle register is filled with a large, broadly executed rinceau; the crown of the dome, separated from the lower sections by a simple rope interlace, is ornamented with a great gemmed cross, the center of which has fallen away. This aniconic decoration is realized in a limited palette of blues and reddish-browns, muted now through fading. The work was executed on its own plaster layer and consequently cannot be dismissed as a temporary, apotropaic decoration. Cappadocian parallels—for example, the cross in the conch of the apse of the Chapel of Nicetas the Stylite in Cappadocia—share with Yeroskipos their rinceau borders, geometrically patterned grounds, and internal elaboration of the cross. Further, the conception of the fresco, with the cross occupying the most prominent height of the interior space, is the same.[42] It is, in consequence, tempting to ascribe the painting in Yeroskipos to the same period as the principal series in Cappadocia, that is, to the late ninth or early tenth century. This attribution provides a *terminus ante quem* for the construction of the church.

The obvious irregularities of St. Parasceve's layout, the deformations of its elevation, the unworked nature of its fabric, and its broad, personable proportions all express the local nature of the building. Nevertheless, the complexity of its five-domed scheme makes it unlikely that the plan was this master mason's own invention. His dependence on a preexisting model is all the more probable as he would not have had far to look for inspiration. Closest in form to St. Parasceve is the church of Sts. Barnabas and Hilarion in the town of Peristerona, located in the lowland trough between the Troodos and the Kyrenia ranges (figs. 3.7 and 3.8). The church is apparently dedicated to two obscure anchorites rather than to the homonymous patron saint of Cyprus, the apostle Barnabas and the great ascetic Hilarion.[43] Although larger than the church at Yeroskipos, Sts. Barnabas and Hilarion is a moderate-size basilica with three bays covered with domical vaults.

Opposite: FIG. 3.5. Yeroskipos, St. Parasceve. View of the nave from the west

FIG. 3.6. Yeroskipos, St. Parasceve. East dome of the nave, enframed jeweled cross (Robin Cormack)

Like St. Parasceve, it has barrel-vaulted aisles which are interrupted at the midpoint by domed bays. The springing of the transverse arches of the nave is again queerly marked (though more regularly than at Yeroskipos) by small reused marble capitals intrusively embedded at the corners of the piers. It also resembles St. Parasceve in its massiveness and heavy proportions. In all, the programmatic similarities between these two churches suggest that they were produced in response to similar requirements at about the same time.

There are, nevertheless, significant differences between the two structures. Both the exterior volumes and the interior spaces of Sts. Barnabas and Hilarion (despite the introduction of pointed-arch reinforcements in the nave) have a geometric clarity that is absent in Yeroskipos. The exposed exterior displays much better quality ashlar masonry. Internally, the main arches are all ordered; cornices at the bases of the drums are more crisply treated, although still no distinction is made between the drum and the corona of the cupola; the aisles are more fully integrated into the nave, allowing a rational flow of light. The church at Peristerona also has peculiar architectural details which are not found at Yeroskipos. For example, the westernmost cupola of the nave is oddly elaborated with four flat, riblike elements springing unarchitectonically from above the four windows opened into its haunch. These details, particularly the decorative treatment of a structural feature such as dome ribs, seem to betray the church's dependence on a more complex structure. Like the church at Yeroskipos, this is a local church apparently built to serve the local community. But even more clearly than St. Parasceve, Sts. Barnabas and Hilarion seems to be derived from a more complex archetype.

Closely related to Sts. Barnabas and Hilarion are the churches of St. Lazarus at Larnaca and its sister church, St. Barnabas, near Salamis (fig. 3.9).[44] Despite differences in scale and complexity, the plans of the churches at Larnaca and Salamis have much in common with that at Peristerona: No nartheces, tripartite sanctuaries, and naves provided a ponderous rhythm by broad, domical bays. They too are constructed of good-quality limestone ashlar, but, like Sts. Barnabas and Hilarion,

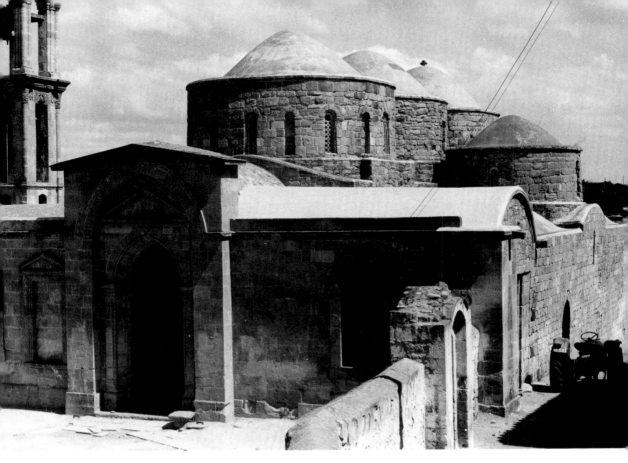

FIG. 3.7. Peristerona, Sts. Barnabas and Hilarion. General view of the exterior from the southwest

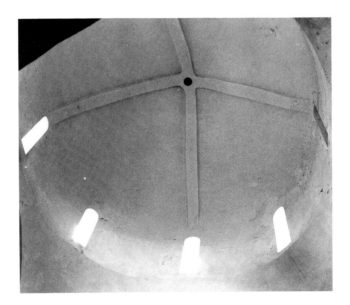

FIG. 3.8. Peristerona, Sts. Barnabas and Hilarion. View of the western dome of the nave

show relatively little concern for spatial articulation. These monuments also share certain idiosyncratic details. Spolia capitals again are set incongruously into massive piers to mark the springing of arches. More instructively, the eight flat ribs of the western dome of St. Barnabas, which rise as ribs should between the windows of the drum, seem to have provided the misunderstood model for the "ribs" at Peristerona. Perhaps St. Lazarus's long-lost domes were also ribbed. This, in addition to their greater size and elaboration, suggests that the churches of Larnaca and Salamis were constructed earlier than those at Peristerona and Yeroskipos, and that they served as models for the later buildings.

Unfortunately neither St. Lazarus nor St. Barnabas is securely dated. A. H. S. Megaw posits that the partially reconstructed St. Barnabas is dependent on the more complete church at Larnaca.[45] Further, he tentatively accepts an argument for a date of around 900 for St. Lazarus, according to which the impressive triple-domed church was constructed with funds provided by Emperor Leo VI in recompense for receiving from Larnaca the relics of Lazarus. However tentative this variety of historical argument in favor of a late ninth- or early tenth-century ascription for St. Lazarus must remain, such a dating receives support from the fresco decoration of the church at Yeroskipos.

Metropolitan associations put forward by Megaw would help explain not only the date of St. Lazarus but also its form, which in its superstructure and nave plan seems to have borne a resemblance to the now-lost Church of the Holy Apostles in Constantinople. In St. Lazarus each dome of the nave is supported on its own set of four piers. This support system is similar to that used by the architects of San Marco in Venice and in part also by the builders of St. John of Ephesus—two monuments which are generally acknowledged as having been modeled on Justinian's great five-domed cruciform church. Without the evidence of textual sources, speculation on what meaning the form of any church might have had for its audience remains hypothetical. However, reference to the apostolic foundation of the capital, which served as a memorial to the disciples of Christ, would have been appropriate at Larnaca, where the church was not only dedicated to the memory of the city's first bishop, the friend of Christ, but, judging from the ancient tombs under the sanctuary, may also have marked the traditional site of his tomb. Moreover, some medieval copies of the Holy Apostles, such as the Cathedral of Canosa in Apulia or San Marco in Venice, suggest that its significance continued to be understood even on the periphery of the Empire.[46] Perhaps, then, the patrons of Peristerona and Yeroskipos were also aware of the traditional associations of the church type they had appropriated. Lateral domes, so prominent in the cruciform metropolitan prototype, are missing at Larnaca and Salamis but appear at Yeroskipos and Peristerona, though in a basilican context. The martyrium/tomb at Yeroskipos may have also derived its location and centralized form from the mausoleum attached to the east side of the original Holy Apostles by Emperor Constantius for the entombment of his father.[47] It thus seems at least possible that the builders even of relatively unpretentious foundations might make meaningful allusions to distant metropolitan monuments such as the Holy Apostles.

St. Anthony at Kellia, St. Parasceve at Yeroskipos, and the monuments related to them indicate that there was considerable artistic production in Cyprus during

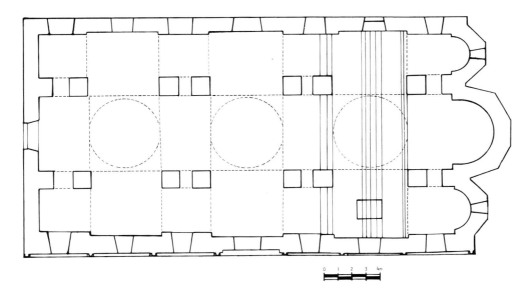

FIG. 3.9. Larnaca, St. Lazarus. Sketch plan

the late ninth and tenth centuries, before the official Byzantine reconquest of the island. Most of these churches occur in urban settings and are large enough to have served sizable congregations. The architecture of this period has a distinctively regional character. Building materials and techniques are local; there is no evidence, for example, of imported marble. Roughly worked limestone is used throughout, often in brick-shaped form for the vaults and infill and more carefully cut blocks for quoins.[48] The lack of articulation suggests that a minimum of stone-cutting was done on the site. Cypriot builders show a characteristically Byzantine lack of concern with the regularity of their structures.[49] If the considerable deformation of the superstructure and the irregularities of the plans are any indication, the masons worked rapidly. The plans, though diverse and often incremental, suggest a well-established local bias in favor of a longitudinal axis. This strong local character of Cypriot architecture before the Byzantine "reconquest" is indicative of a certain insular autonomy. Although the multidomed plan shows the architects' awareness of metropolitan forms, they selected their model from the past, not from the present. Enough has been written about revivals in Byzantium to assure us that differences between the past and the present were appreciated. The appearance of apostles' buildings in the provinces indicates that this distinction was not the sole prerogative of the intellectual elite of the capital. The earliest surviving Middle Byzantine frescoes have programmatic and stylistic analogies elsewhere in Byzantium, suggesting that the urban coastal communities in which these churches occur were not entirely disengaged from Constantinople. That is, the architecture of the island indicates a certain independence, while the painted decoration suggests that such independence was not simply the result of isolation.

THE LATE TENTH TO THE EARLY TWELFTH CENTURY

A shift in functional focus seems to occur among Cypriot patrons of ecclesiastical foundations after Nicephorus Phocas's "reconquest" of 965. In contrast to the urban character of the earlier churches, most new foundations of the eleventh and twelfth centuries were monastic chapels or oratories located not only in the lowlands but also in the Troodos and Kyrenia ranges. From surviving dedicatory inscriptions, most of these churches seem to have been initially supported by a single individual or family for its own eternal benefits. This represents the substitution of private foundations for communal buildings.

The change in the function and setting of Cypriot churches corresponds to a change in form. These chapels are small in scale. The size of the undertaking seems to have been determined by the wealth of an individual patron. The Kyrenia range retains its overlaid strata of sedimentary limestone, but in the higher Troodos range weathering has exposed its igneous core. Consequently, in the Troodos, because of the difficulty involved in working the available hard granites and schists, building stone was rarely squared but simply laid in thick mortar beds. The constituent volumes of the building thus are even less clearly articulated than in the lowland churches. The development of the distinct types of plans in the mountain churches, which will be discussed below, is also related both to the scale of the churches and their building materials. Despite these significant changes in form and function, a number of characteristics reflect the continuity of the local building tradition on the island. Proportions remain heavy. The longitudinal bias evidenced in the early Middle Byzantine structures of the lowlands is found again in the mountain churches, even within the constraints of "centralized" types.

The Cypriot character of much of the island's construction after its reintegration with the Empire is typified by the church of St. Nicholas of the Roof, a monument generally ascribed to the late tenth or early eleventh century on the basis of its fresco decoration.[50] St. Nicholas is set high in the Troodos mountains well above the village of Kakopetria. Its size and location reflect its monastic function. The form of the structure has much in common with the cross-in-square type so familiar in Middle Byzantine architecture: a central domed bay, barrel-vaulted cross arms, and low corner bays (figs. 3.10 and 3.11). Sometime after its construction, the church was covered by a massive timber pitched roof for protection against the heavy winter snows. It is from this feature that the church received its epithet. St. Nicholas is distinguished by a number of other nonmetropolitan features. The dome is conical in section rather than spherical; instead of four central columns, the church has heavy, oblong piers; longitudinal barrel vaults, rather than groin vaults or cupolas, cover the corner bays; the delicate delineation of architectural forms with ordered blind arches and cornices, which characterizes a Constantinopolitan church like Bodrum Camii (fig. 2.7), is totally absent in St. Nicholas. Further, the Cypriot monument lacks additional sanctuary bays and, originally, it had no narthex. As in the lowland churches, neither the west end nor

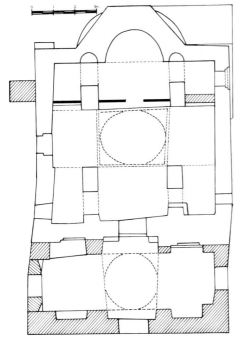

FIG. 3.10. Kakopetria, St. Nicholas of the Roof. Sketch plan. Later additions are hatched

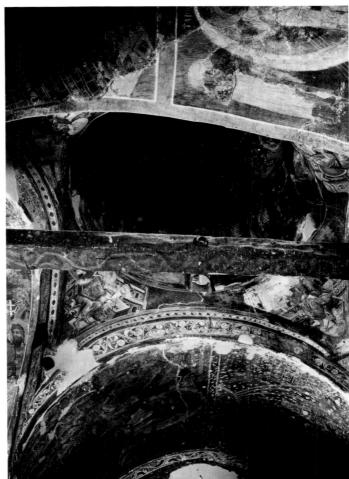

FIG. 3.11. Kakopetria, St. Nicholas of the Roof. General view into the central dome

the east end of the church was complex in plan: The central apse is flanked only by niches, not by proper apses. More basically, the plan and elevation of the church are highly irregular and the fabric is extremely rough. The heavy murality of St. Nicholas, emphasized by its small punctured windows, contrasts dramatically with the open, skeletal conception of a Constantinopolitan church like the Bodrum Camii. Although the plan of St. Nicholas suggests direct or indirect influence from outside Cyprus, its regional features are striking: Its longitudinal bias despite its centralized form, its organic irregularity, and its broad proportions bespeak the rootedness of the local building tradition.[51]

If the structure of St. Nicholas embodies regional particularity, the fresco decoration of the church expresses the idiom of the Empire. The first phase of frescoes in the church indicates that the artist was acquainted with metropolitan developments of the late tenth or early eleventh century (fig. 3.12). The extensive olive-green modeling of the figures' flesh, in addition to their stocky proportions, gives them a certain physicality, which, however, is contradicted by the painter's inorganic handling of transitions between body parts and by the pooled highlights which lay on the surface of the painting. The closest analogies with this work are offered by early eleventh-century frescoes in Cappadocia in Direkli Kilise (dated by inscription to 979–1012) and the Triconch of Tağar.[52] All these monumental works have features in common with metropolitan manuscript illumination of the period, for example, the scenes from the life of David from the early eleventh-

FIG. 3.12. Kakopetria, St. Nicholas of the Roof. East barrel vault: detail of an angel from the Ascension

century psalter in Venice (Marc. gr. 17).⁵³ The extensive remains of this first phase indicate that St. Nicholas was adorned with the familiar Middle Byzantine program: An orant Virgin and flanking angels in military garb occupy the conch of the apse; a few of the original complement of single saints adorn the lower reaches of the walls of the church; and in the east and west barrel vaults are, respectively, the Ascension and Pentecost and the Raising of Lazarus and Entry into Jerusalem. The unified decoration of the *katholikon* in a single phase suggests that the monastery was founded by either a single patron or several donors coordinating their contributions. This arrangement contrasts dramatically with the earliest phases of decoration in St. Anthony at Kellia—a series of ex-votos, painted and repainted, most probably for individual patrons in their village church.

In the late eleventh or early twelfth century a superb *proskynesis* panel (image of veneration) representing St. Nicholas was painted on the walled-in west arch of the southeast bay, directly to the right of the entrance to the sanctuary (fig. 3.13). The style of this work allows it to be ascribed to a master who worked elsewhere in Cyprus in the late eleventh or early twelfth century.⁵⁴ Also in the twelfth century, a narthex was appended to the church. The interruption of the blind niches on the west wall of the nave by the pier responds of the narthex vaults shows that the narthex is a later addition. It was decorated with an extensive Last Judgment (fragments survive in the vault of the north bay) and a carefully executed panel of the Virgin and Child (to the left of the entrance into the church). At the same time, a number of images were also added in the nave, including a panel of the Forty Martyrs of Sebaste. These vigorous images were rendered in a mode abstracted from that represented by the St. Nicholas panel. The appearance of these later images at Kakopetria indicates that the monastery flourished through the eleventh and twelfth centuries. The shaping of the program of the church to ascetic concerns—the prominence of monastic saints and the appearance of a monumental Last Judgment, as well as the donor's portrait—suggests that it was determined by the monks themselves rather than a lay patron. Like the much more dramatic statement of monastic interests in the decoration of the Hermitage of St. Neophytus at the end of the twelfth century, it may indicate a certain independence of central, secular authority and of the laity whose interests were so closely bound up in it.

St. Nicholas of the Roof is one of the few monuments with painted decoration surviving from the period between the Byzantine reconquest and the assumption of imperial power by Alexius I Comnenus (1081–1118), a member of the military aristocracy and founder of the Comnenian dynasty. That dynasty's military interest in Cyprus seems to correspond with the proliferation of religious establishments in the mountains of the island. According to a tradition recorded in the fifteenth century after a fire destroyed the original account, the famous Kykko monastery, located high in the Troodos, was founded by Manuel Boutoumites, the Byzantine general who successfully quelled Rhapsomates' rebellion in 1092. After maltreating the hermit Esaias, Manuel was afflicted with an illness. Despite having been abused, the holy man cured Manuel of his malady in return for a promise to secure for Esaias from Constantinople the icon of the Virgin Eleousa painted by St. Luke. After returning to the capital, Manuel was finally able to make good his

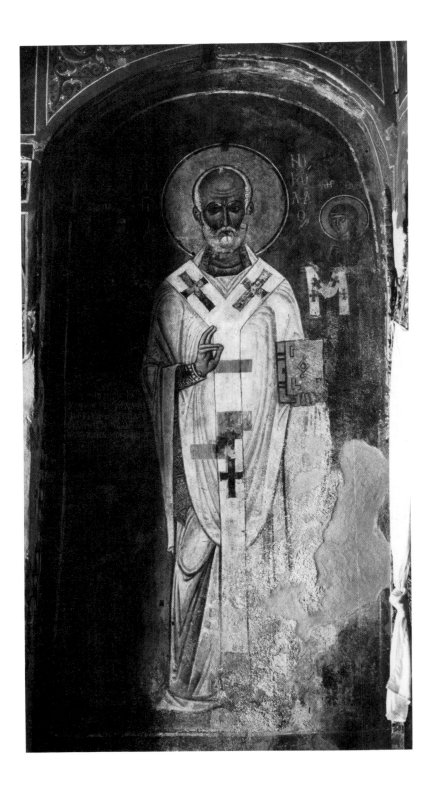

promise when the emperor's daughter and then the emperor himself fell sick from the same illness that had nearly caused his own death. When the emperor agreed to Manuel's petition to have the famous image sent to Cyprus, he and his daughter were immediately healed. Manuel and the emperor attempted to placate Esaias with icons they had painted for him in Constantinople, but only the authentic relic would do. Both also made other contributions toward the founding of Kykko.[55] Although all that remains of the original monastery is the miraculous Virgin painted by St. Luke, now entirely masked by silver gilt and gold embroidered tapestry, the metropolitan patronage which Kykko supposedly received implies close bonds between the provincial ascetics of the island and their Constantinopolitan devotees.

There can be little doubt that there was increased metropolitan interest in Cyprus in the early twelfth century. After the suppression of Rhapsomates' rebellion, Alexius I took steps to strengthen the island's defenses by having a series of fortresses built in the Kyrenia range. The plans and even in some cases the building materials of the churches built in these fortresses appear to have been imported to the island. In the fortress of St. Hilarion, built near the port of Kyrenia where Rhapsomates once gathered his troops to attack the Byzantines, are the ruins of a sizable domed-octagon church.[56] The nave of this church is oblong in plan, converted at vault level into an irregular octagon by squinches and covered with a large dome. To the east is a triple-apsed sanctuary; a skewed rectangular narthex was added to the west at a later date. Although no less irregular in plan than many Cypriot churches, the interior space of this structure is much more carefully articulated than most structures on the island: Engaged columnar piers supported the squinches; arches were ordered; windows, like the double-light in the sanctuary, were large. This refinement was made possible through the use in the superstructure of considerable amounts of brick, a material whose linear and decorative properties were fully exploited in Byzantium. Many of the architectural features of the church are foreign to Cypriot building tradition. Its plan, despite its elongation and unevenness, is uncompromisingly centralized. Its open, domed nucleus is related generically to that of the Nea Moni on Chios, built in the middle of the eleventh century by Constantinopolitan architects and funded by the Emperor Constantine Monomachus (1042–55), a ruler criticized by Psellus for the architectural extravagances of another centralized domed building, St. George of Manganas.[57] The building material—brick laid in thick mortar beds—is equally uncommon on the island. The fabric gives an impression similar to the popular recessed brick technique, which is associated broadly, though not exclusively, with metropolitan construction of the eleventh and twelfth centuries.[58] This technique, in which alternative layers of brick are set back from the wall surface and concealed by pointing, occurs, for example, in Chios, in the cistern of the Nea Moni, as well as in churches modeled on the *katholikon*, such as the Panagia Krina.[59] In its plan and in details of its execution, the church in the fortress of St. Hilarion

Opposite:
FIG. 3.13. Kakopetria, St. Nicholas of the Roof. To the right of the entrance to the sanctuary is a *proskynesis* image of St. Nicholas with a donor

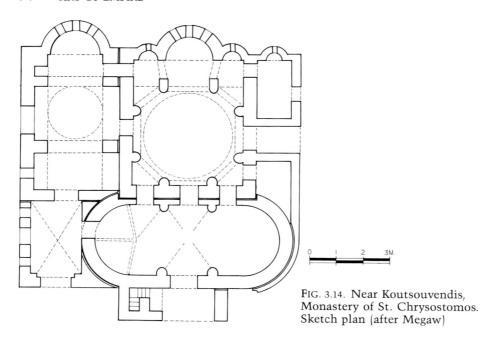

FIG. 3.14. Near Koutsouvendis,
Monastery of St. Chrysostomos.
Sketch plan (after Megaw)

represents an intrusion on the architectural tradition of the island. Its nonlocal
character and military context suggest that its construction was part of the impe-
rial consolidation of the area.

The fortress church of St. Hilarion is not the only monument which bears wit-
ness to the extension of central power at the end of the eleventh century. From
what was recorded before its destruction, the *katholikon* of the monastery of St.
Chrysostomos near Koutsouvendis, also in the Kyrenia range, was similar in its
form to the church at St. Hilarion (fig. 3.14).[60] The dome of the surviving single-
aisled *parekklesion* of the Holy Trinity, which abutted the south wall of the
katholikon and appears to have been contemporary with it, is constructed in cloi-
sonné brickwork. This technique, in which brick is laid in decorative patterns
within thick mortar beds, is foreign to Cyprus but common in Greece, Macedo-
nia, and Constantinople.[61] The Nea Moni, whose visible fabric is cloisonné, is at-
tributed on the basis of a textual tradition to masons sent from Constantinople.[62]
Like the church in the fortress of St. Hilarion, the monastery of St. Chrysostomos
is closely connected with Comnenian rule. An inscription that survives in the
parekklesion on the southeast pier, next to the sanctuary, identifies the donor of
the church as Eumathius Philokales,[63] who was *dux* of Cyprus between 1092 and
1103 and again from about 1110 to before 1118.[64] The *typikon* of this foundation in-
dicates that the monastery was established by a certain abbot George in December
1090. This suggests that the construction and decoration of the church took place
in the first period of Eumathius's governorship. The work attests to the fact that
representatives of the state made spiritual investments in the regions to which
they were assigned.

These structures seem to have had an attraction for local builders, perhaps because of their metropolitan associations: The centralized plan represented by the churches of St. Hilarion and Koutsouvendis appeared in regional variations. Best known of these versions are the *katholikon* of the monastery of the Apsinthiotissa and the *katholikon* of the monastery of Christ Antiphonites, both in Kyrenia range.[65] The Apsinthiotissa had a central dome supported on six piers rather than eight engaged columns. The church of Christ Antiphonites retains the support system of eight columnar piers, but the octagon is distorted into an ovoidal shape. Both monuments, which are constructed with traditional Cypriot masonry techniques, indicate how readily a foreign building type might be locally assimilated.

Architecture was not the only artistic importation of the late eleventh century. As might be expected, metropolitan ideas in monumental painting seem to have been introduced on the island concurrently with a new church type at the monastery of St. Chrysostomos. The figural decoration of the *parekklesion* survives only in a fragmentary form. Remains of an Anastasis, a Crucifixion, and a Koimesis show an eschatological bias appropriate for a funerary or commemorative chapel. According to Mango and Hawkins, the quality of these fresco fragments is extremely high—elegantly proportioned figures realized in bright pastels subtly modulated by white washes and set off by a dark blue ground (fig. 3.15).[66] The appearance in Cyprus of this style of painting in a church which is foreign in its building type and materials and which has a patron associated with the capital suggests that the master working at Koutsouvendis may also have been imported

FIG. 3.15. Near Koutsouvendis, Monastery of St. Chrysostomos. *Parekklesion* of the Holy Trinity: detail of the prophet Ezekiel (Dumbarton Oaks, Center for Byzantine Studies, Washington, D.C.)

to the island. Such a hypothesis can perhaps be further refined through reference to work outside Cyprus. The St. Chrysostomos frescoes seem to be distinct stylistically from works of the late eleventh or early twelfth century, such as those of the Assunta at Torcello, the Church of the Archangel Michael at Kiev, and the *katholikon* at Daphni, which have been linked to Constantinopolitan practice.[67] They more closely resemble decorative programs, arguably of metropolitan origin, of the middle of the eleventh century: St. Sophia in Kiev, the Nea Moni in Chios, and St. Sophia in Ohrid.[68] It might even be conjectured that the St. Chrysostomos master was trained in the mid-eleventh century and only in his later maturity came to work on Cyprus.

The painting in the *parekklesion* of St. Chrysostomos is similar to the *proskynesis* image in St. Nicholas of the Roof, suggesting that a master, once in a province, might remain there, finding employment from other patrons. The Chrysostomos master seems to have had an even wider effect on Cypriot painting through the agency of an artist, perhaps his apprentice, associated with him at Chrysostomos. A simplified version of the Chrysostomos style occurs in the same monastery. In the ossuary just below the monastery there is the image of the Lamentation Over the Dead Christ as well as single figures of saints.[69] The palette of these frescoes is more limited and the style of the figures is more schematized than that in the *parekklesion*, but the paintings retain an impressive monumentality.

The same painting style that occurs in the mortuary chapel of St. Chrysostomos is found, more fully preserved, in another mountain church, the Panagia Phorbiotissa at Asinou, located above the village of Niketari in the Troodos foothills.[70] This church is extremely rich epigraphically. The portrait of the donor, Nicephorus, *magistros*, with his church in his hands, accompanied by a woman (probably a family member) who died in 1099, was repainted in the fifteenth century. Another inscription again names Nicephorus as donor and provides a dedication date of 1105/6 for the church. Nicephorus is mentioned once more in a prayer inscribed in the apse.[71] Here is a man who wished to be remembered. Nicephorus's title, *magistros*, had been thoroughly debased by the end of the eleventh century; it virtually disappeared in the twelfth.[72] From a note in a *synaxarion* (calendar of feasts) which belonged to the monastery (Paris gr. 1590), it appears that Nicephorus later became a monk in the monastery, adopting the name Nicholas, before he died in 1115.[73]

Nicephorus seems to have been a local figure with considerable social pretension. He had the means to found a monastery, but it was a small one. The church is an architecturally unassuming single-nave structure of three bays, each of which is barrel-vaulted. There is no reason to believe that it ever had a domed eastern bay, as is sometimes postulated. Its fabric is mortared rubble, fieldstone laid in friable mortar, originally concealed with a stucco facing (incised to resemble large ashlar blocks) and decorated with red zigzags. The miming of ashlar in the mountains of the Troodos perhaps indicates that well-cut limestone masonry was the material of greatest local status. The prestigiousness of certain building materials is also evidenced in other provinces by patrons imitating them in cheaper substances.[74] The local character of the Panagia—recognizable in its longitudinal bias,

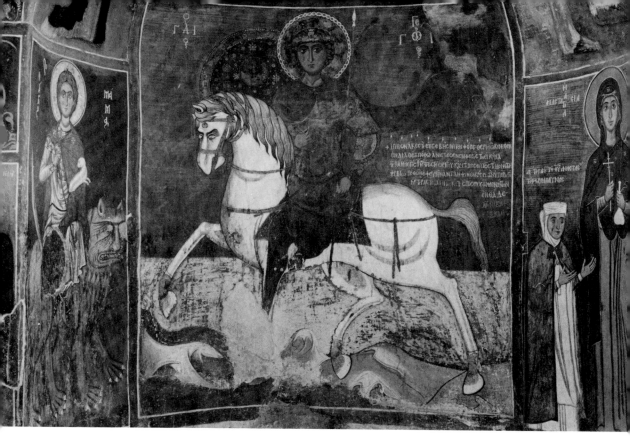

Fig. 3.16. Asinou, Panagia Phorbiotissa. South apse of the narthex: St. George

its heavy masonry, and its broad proportions—is confirmed by the popularity of similar plans on the island. The three-bayed, single-nave church, with or without a dome over the central bay, is one of the most common types in twelfth-century Cyprus. It is found, for instance, at Perachorio, Pelendri, Lagoudera, Kato Lefkara, Kaliana (in its original form), and Monagri, as well as in the *parekklesion* of St. Chrysostomos.

Like the nartheces of so many other churches in Cyprus, that of the Panagia Phorbiotissa was added later in the twelfth century. The plaster layer on which the ashlar pattern of the facade was incised extends under the narthex wall abutting the nave. This not only establishes the fact that the decorative facing layer was part of the original structure but also that the narthex was a later addition. The narthex is architecturally more complex than the nave of the church. It has lateral conches and a domed central bay. It is also built from relatively well-dressed limestone (the masonry of the main south facade is more carefully cut and coursed than that of the north or west faces). A *terminus ante quem* for the construction of the narthex is provided by the late twelfth-century fresco of the mounted St. George, which blocks its south entrance (fig. 3.16). This spectacular statement of knightly virtue was the ex-voto of the horse-tamer Nicephorus.[75] The construction of the narthex and the quality of some of the frescoes adorning it attest to the relatively stable afterlife of the *magistros* Nicephorus's foundation.

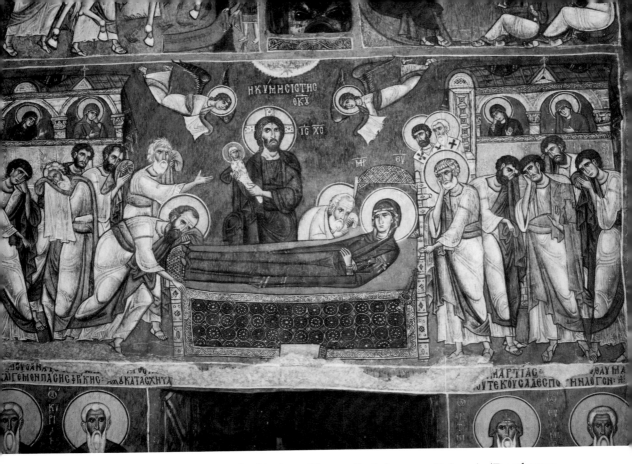

FIG. 3.17. Asinou, Panagia Phorbiotissa. West wall of the nave: Koimesis (Dumbarton Oaks, Center for Byzantine Studies, Washington, D.C.)

If the initial phase of construction of the Panagia Phorbiotissa does not adequately convey the patron's pretensions, the frescoes do. This minute church retains much of its original program: the Communion of the Apostles and the bishops below them on the wall of the apse; the Virgin and Archangel of the Annunciation on either side of the triumphal arch, with Mary the Egyptian and Zosimos below; and the feast scenes in the west end of the nave, including the Raising of Lazarus, Entry into Jerusalem, Last Supper, Washing of the Feet, Ascension, Pentecost, and Koimesis (fig. 3.17). It is tempting to reconstruct the program of Asinou with scenes from the Infancy cycle in the west bay (where there are now fourteenth-century frescoes) and the Pantokrator either there or in the conch of the sanctuary apse. The relatively little emphasis given to monastic holy men, like Nicephorus's repetitious appearance in inscriptions, suggests that the lay patron rather than a *hegoumenos* (abbot) selected the images to be depicted in the church.

The images in the church at Asinou are rendered with grave simplicity in the style similar to that found in the ossuary at St. Chrysostomos. The principal characters have a certain monumental presence at the front of the picture plane. Subsidiary figures are smaller and kept to a minimum number. There is a restrained

emotional expressiveness in these figures. For example, the gestures of the apostles in the Koimesis are evocative of intense emotion, but except for tragic, linear tear lines, the figures are only decorously dramatic in their expressions of grief (see fig. 3.17). The ground is a subdued blue, with an equally low-saturation green for the baseline; these recessive colors provide a striking contrast for the bright pastels of the figures and their few landscape and architectural props. An intense red is also used extensively for drapery and decorative features. There is a sense of the compositions being larger than the small and sometimes irregular architectural spaces they adorn.

The Mavriotissa monastery in Macedonia provides perhaps the closest visual analogy to Asinou.[76] The master of the Mavriotissa employs a heavier, less flexible outline and more abstracted drapery patterns than does the painter at Asinou, but the Macedonian monument does share certain iconographic features with that in Cyprus. The scene of the Koimesis in both monuments represents at an early date the holy women as bust-length figures in arcaded buildings behind the bier of the Virgin. In both images the artist makes an attempt to depict explicitly the deep emotions of the figures in the scene. Typical too of the frescoes both in Macedonia and Cyprus is a modal duality in the treatment of the figures: The physiognomies of the isolated saints on the lower walls are treated in considerably greater detail than those of the figures in the narrative panels. It would seem that the Asinou frescoes bear the same relationship to the work in the *parekklesion* at Koutsouvendis, as do the frescoes in the Mavriotissa monastery in Kastoria to the painting in the cathedral at Ohrid. Both seem to represent the impressive provincial development of a metropolitan-inspired style.[77] It appears that the *magistros* Nicephorus provided his foundation with funds enough for its construction and comprehensive decoration. The multiplication of votive images from the end of the twelfth century on suggests that the monastery was later sustained through multiple small benefactions. This is perhaps indicative of changed economic circumstances on the island.

Apparently Nicephorus was not the only Cypriote who wished to engage an artist working in a style associated with monuments founded by high-ranking imperial emissaries. The Asinou master's work is found in many other churches on the island, including the Panagia Theotokos at Trikomo, Sts. Joachim and Anna at Kaliana, and the Panagia Amasgou at Monagri.[78] A number of icons in the collection of St. Catherine on Sinai are also related to the Asinou frescoes.[79] These panel paintings also attest to material and spiritual links between Cyprus and the Holy Land formed after the success of the First Crusade.

THE LATER TWELFTH CENTURY

Despite the appearance of certain forms of political independence, metropolitan artistic production continued to affect provincial practice through the late twelfth century. The usurpation of power on the island by Isaac Comnenus, grand nephew

of the Emperor Manuel, between 1184 and 1191 does not appear to have under-
mined the cultural authority of the imperial core. This is evident in the coins
minted by the despot in Cyprus, which are difficult to distinguish from those of
the Emperor Isaac II Angelus (1185–95; 1203–4).[80] It is also indicated by the suc-
cessful solicitations for grants and exemptions made by the *hegoumenos* of the
Machaeras monastery from Emperor Isaac II in Constantinople.[81] Cypriot church
decoration in the later twelfth century also attests to an awareness of shifts in
metropolitan notions of decoration. Indeed, formal changes in late twelfth-
century Cypriot frescoes are analogous to developments that can be seen not only
elsewhere in Byzantium but also beyond its political borders, from Sicily to Rus-
sia. Trends in painting style in the second half of the twelfth century were clearly
outlined and expressively characterized by Demus, Weitzmann, and Kitzinger de-
cades ago.[82] Certain questions remain: How were artistic ideas disseminated? And
what are the historical implications of their assimilation in the provinces?

The type of patron generated by the highly centralized bureaucratic Byzantine
state must have played an important role in this phenomenon: patronage for Cyp-
riot foundations continued to come on occasion from the highest social levels.
Emperor Manuel I Comnenus (1143–80), whose interests in the arts are well
known,[83] apparently invested spiritually in the island. According to the *typikon* of
1210 of the Machaeras monastery, the emperor generously answered the petition
of the monks Ignatius and Procopius with a land grant and annual endowment for

FIG. 3.18. Kato Lefkara, Church of the Archangel.
Sketch plan. Later additions are hatched

FIG. 3.19. Kato Lefkara, Church of the Archangel. Drum of the dome: detail of the Prophet

the establishment of the monastery, a foundation second only to Kykko in importance on Cyprus.[84] Although nothing remains of the medieval foundation, it is tempting to suggest that this direct link with Constantinople stimulated the importation of artists from the capital.

Three monuments—the Church of the Archangel at Kato Lefkara, the Panagia tou Arakos at Lagoudera, and the Encleistra of St. Neophytus—exemplify late Comnenian developments on Cyprus. The unpublished church at Kato Lefkara, a mountain town known for its manufacture of fine lace, is typical of Cypriot church architecture of the period.[85] It is a simple single-nave space with a central dome raised on a high drum; the east and west bays are barrel-vaulted (fig. 3.18). The east bay of the church is its sanctuary, with a single central apse flanked by niches cut into the thickness of the wall. The fabric is fieldstone, though parts of the structure, such as the quoins of the arches, were executed in roughly dressed stone. There is virtually no exterior articulation; on the interior the base of the drum and the springing of the sanctuary conch are marked by simple cornices, and the main arches have a single order. As in the case of the church at Asinou, the simplicity of the sanctuary arrangements, the dominant longitudinal axis of the structure, and the construction techniques all emphasize the local nature of the architecture of this church. There is here, however, a deviation from traditional Cypriot architectural practice: Arches in the church are pointed (as they are also at Lagoudera). Pointed arches appear widely in Cyprus only in the second half of the twelfth century, a development that apparently corresponds with the formalization of trading relations with the Levant.

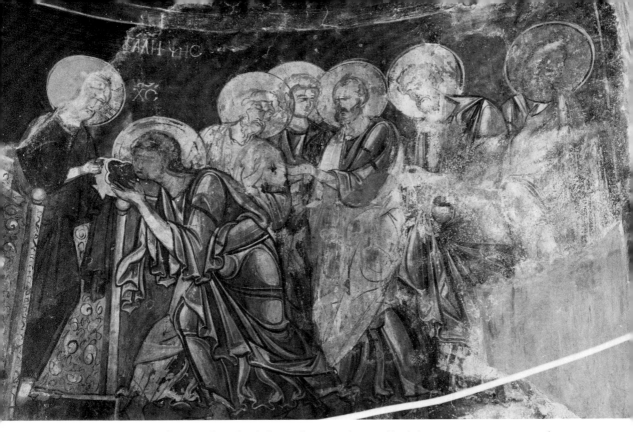

FIG. 3.20. Perachorio, Church of the Holy Apostles. Wall of the sanctuary apse, south side: Communion of the Apostles

If the architecture of Kato Lefkara embodies strong local traditions modified only slightly by practice on the mainland, its frescoes show a striking familiarity with current metropolitan theological notions, as indicated by the appearance on the apse wall of the holy bishops officiating before Christ-Amnos.[86] This dogmatic image is not only a visual statement concerning the literalness of Christ's sacrifice in the Eucharist, but it is also an expression of the centralized control of theological discussion. Although this iconography is known elsewhere in the Empire in the twelfth century, the image at Kato Lefkara is the theme's only monumental occurrence on Cyprus in the twelfth century of which I am aware. The rest of the fresco decoration of the church, as it can be reconstructed from the few remaining fragments, also conforms to the pervasive hierarchical program. Although the central roundel of the dome is now destroyed, the processing angels of the next register and the prophets holding scrolls in the drum suggest that it contained the bust of the Pantokrator (fig. 3.19). In the apse was a standing Virgin; below the conch in an oddly narrow register appears the Communion of the Apostles. Christological images (Nativity, Presentation of Christ at the Temple, Baptism, and Raising of Lazarus) were depicted in small panels in the south lunette. Instead of exploiting a structurally defined space exclusively for a single monumental image, the artist divided the wall surface into a number of quadratic units. This multiplication of the number of Christological scenes is broadly typical of a late trend in Byzantine wall painting.

The paintings in Kato Lefkara are related to the well-published frescoes of the church of the Holy Apostles at Perachorio. The Perachorio decoration has been convincingly ascribed to the 1160s or 1170s on the basis of formal analogies with works elsewhere in the Empire.[87] Both exhibit a change in the treatment of the picture plane. The narrow stage dominated by the figures placed upon it, characteristic of monumental images of the eleventh and early twelfth century, is superseded by a deeper field. Figures no longer have the same authority within the space they occupy, but they enjoy a greater freedom of movement. In the Perachorio Communion of the Apostles, for example, there is a sense of foreground and middle ground in which the apostles convivially circulate (fig. 3.20). But for all their similarities, the frescoes at Kato Lefkara are more brittle than those at Perachorio. A comparison of the lower body of one of the surviving prophets from the drum of Kato Lefkara with the foremost apostle in the Communion at Perachorio shows how drapery folds are ornamentally multiplied and more angular. The elegance of line at Kato Lefkara perhaps compensates for a loss of the figural robustness found at Perachorio. This linear elaboration is one of the principal Morellian characteristics of late twelfth-century painting. Its appearance at Kato Lefkara in conjunction with equally current programmatic features suggests that the patron of this small church was in a position to have it decorated according to the latest fashion. Above the south entrance to the church is a refined representation of the Mandylion, the cloth on which Christ's portrait was miraculously preserved.[88] The image is enframed by a red border, on the lower side of which is the fragmentary remains of a dedicatory inscription. All that remains of the date is the month of October; all that remains of what was presumably the identification of the donor is part of his title, *sakellarios*.[89] The title *sakellarios* could be one of considerable eminence, as it was given to officials in the patriarchate and at court. The imperial office seems to have been eclipsed between 1145 and 1186, and it disappears completely after the fall of Constantinople to the Latins in 1204.[90] But a *sakellarios* might also be attached to a provincial see. Whether or not the patron was counted among Constantinopolitan elite, his church was fashionably decorated.

The same accessibility to metropolitan artistic concepts is displayed in the church of the Panagia tou Arakos.[91] This monastic foundation, located above the village of Lagoudera, like the church at Kato Lefkara, is a single-aisled structure with a dome over the main bay. Also like the monument at Kato Lefkara, masons have employed slightly pointed arches; here too the narthex is a later addition to the nave. The church is built of local stone, with brick used in the arches; it was later covered with a massive roof, which masks its typically Cypriot profile, to protect it from the winter snows. Judging from its architectural form, it seems likely that the Panagia tou Arakos was built in the third quarter of the twelfth century. The original founder of the structure is unidentified. This patron provided the church only with a partial decoration; in the conch of the sanctuary apse is an enthroned Virgin and Child flanked by angels, with two registers of frontal bishops on the wall below (fig. 3.21). The artist used an unusually luminescent green for his underpainting, which is visible where the overpainting has bubbled and flaked. The same vibrant bright green was also used as the underpainting in an isolated image of an enthroned figure flanked by angels which originally appeared

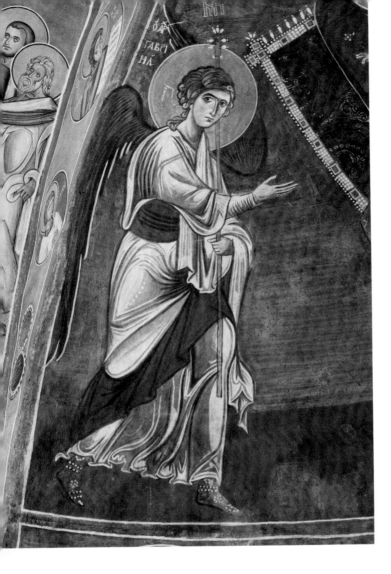

FIG. 3.21. Lagoudera, Panagia tou Arakos. North side of the sanctuary conch: Gabriel

on the nave wall to the south of the bema. The patron of the initial decoration appears to have dedicated his limited means to iconic images. This first painting phase is given a *terminus ante quem* by the frescoes, dated by inscription to 1192, which were subsequently painted over the enthroned figure at the east end of the nave.

The patron of the second phase of painting at Lagoudera identified himself twice in the church. A dedicatory inscription on the south wall, again with the Mandylion, gives the date of this decoration:

> The most venerable church of the most Holy Mother of God of Arakos was painted through the benefaction and great ardor of lord Leo tou Authentos in the month of December, indiction 11 of the year 6701 [1192].[92]

On the north wall, accompanying a standing Virgin and Child, is a further inscription in which Leo again takes credit for the decoration of the church. The inscrip-

tion takes the form of a verse addressed to the Virgin:

> He who has formed your image in perishable colors, all pure Mother of God, Leo, the poor and worthless suppliant, surnamed tou Authentos from his father, along with his wife and fellow servant, . . . request faithfully and with countless tears that they may find a happy ending to the remainder of their life, with their fellow servants and children thy suppliants and that they may find an end among the saved, for you alone O Virgin has glory. . . .

The principal donor, Leo, is a pious layman apparently of only local standing. The lack of titles in his long address to the Virgin suggests that he did not have any. Nevertheless, the fresco ensemble he subsidized remains one of the most impressive to survive from twelfth-century Byzantium. In contrast to the church at Kato Lefkara, the scenes are allocated architecturally defined spaces, assuring them a certain monumentality. A magnificent Pantokrator in the dome, surrounded by busts of archangels and standing prophets, holds dominion in the inte-

FIG. 3.22. Lagoudera, Panagia tou Arakos. View into the central vault with the Pantokrator in the cupola (Dumbarton Oaks, Center for Byzantine Studies, Washington, D.C.)

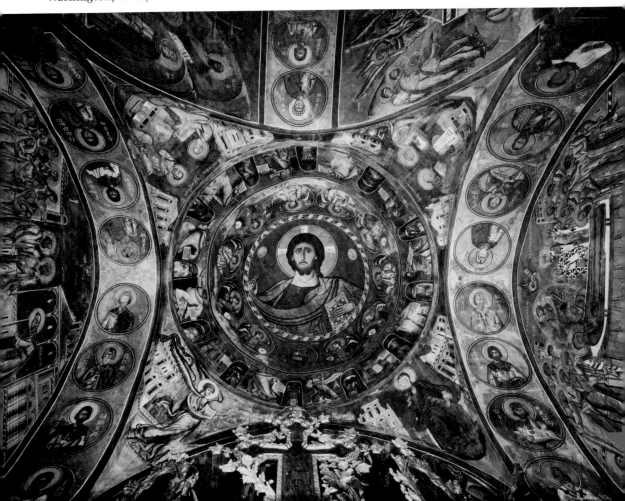

rior (fig. 3.22). Below is a Christological cycle which reflects, in its Mariological bias (Presentation of the Virgin at the Temple, Annunciation, Nativity, Presentation of Christ at the Temple, and Koimesis), the same devotion to the Virgin that is expressed by the donor in the nave inscriptions (fig. 3.23). The Baptism, Anastasis, and Ascension are represented, but the Passion is notably underemphasized. To the left of the apse, the Virgin Paraklēsis addresses a prayer to her Son, on the opposite pier. A pair of portable icons representing the Panagia Arakiotissa and Christ, painted by the same hand as the frescoes, also emphasizes the intercessory role of the Theotokos in this church.[93] Like the Sinai icons associated with the Asinou master, this pair of panels, now in the archbishop's palace in Nicosia, indicates that an artist did not necessarily live by monumental commissions alone. Military saints appear only in medallions in the arches; the apotropaic Mandylion, which is depicted at the apex of the triumphal arch, as well as on the south wall, is very prominent. Cypriot tradition is reflected in the positioning of Barna-

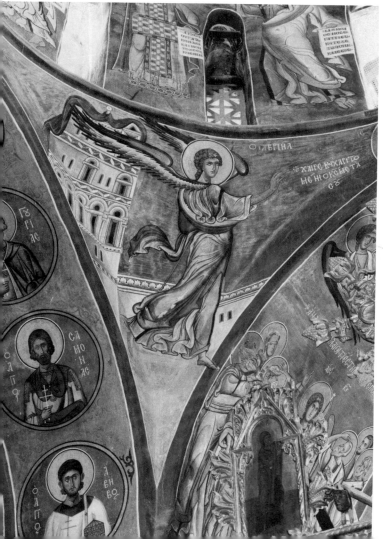

FIG. 3.23. Lagoudera, Panagia tou Arakos. Northeast pendentive: angel of the Annunciation

bas and probably Epiphanius, the island's patron saints, between the windows in the apse, as in Asinou and Perachorio. These features, in addition to the emphasis on blessed ascetics, reinforce the impression given by the inscription that Leo was a local figure, who did not entrust his spiritual or material well-being to the military establishment. Perhaps this represents a natural reaction to the conquest of the island by the Crusaders the previous year.

Whatever realignment of spiritual priorities might have taken place among the local well-to-do in the wake of the Latin occupation of the island, the style of the frescoes at Lagoudera suggests that artistic production on the island was still within the cultural sphere of Constantinople. The style of these frescoes is most clearly expressed in the elongated, uninhibited figures which inhabit the narrative scenes. Their drapery, like their self-conscious posing, is complex, with decorative, repetitive S-curves rendered in a calligraphic play of outline and highlight. Color is bright, strong, and ornamental. The linear elegance of the paintings of the second phase of painting at Lagoudera associates it intimately with the final phase of Comnenian art.[94] The appearance of this sophisticated painting style in a small church in Cyprus patronized apparently by a man of only local importance requires some explanation. David Winfield, who worked for a number of years on the cleaning and restoration of the frescoes and who is preparing the final publication of the monument, interpreted a now-fragmentary inscription on the scene of the Baptism as the signature of the artist: "Remember, O Lord, Thy slave, Theodore, the erring monk and painter of this church."[95] Winfield argues that the artist at Lagoudera was the painter Theodore Apseudes, who had labored nearly a decade earlier in the Encleistra of St. Neophytus, located in the foothills of the Troodos above Paphos. Although the reading of this inscription is problematic, the stylistic connections between the frescoes of the nave of Lagoudera and those of the Encleistra are close enough to warrant the hypothesis that they were painted by the same master.[96]

The original Encleistra of St. Neophytus remains largely intact: The saint's cell and tomb, the oratory (later bema), and naos of the church all survive.[97] The Encleistra was decorated in two main phases, both of which seem to have been executed during Neophytus's lifetime. The paintings of the first phase, found largely in the cell and in the bema, are dated by inscription to 1183 and signed by Theodore Apseudes. The images include the Anastasis, two Crucifixions, Ascension, Annunciation, a Deesis, standing bishops in the apse, monks on the west wall, and military saints in roundels. The images of St. Stephen the Younger and the enthroned Christ (originally part of a second Deesis?) in the naos flanking the entrance into the bema seem also to be a part of this phase. In 1196 the nave was further excavated and then decorated by a second artist. The vaults were adorned with an elaborate Passion cycle, and holy monks were depicted on the walls.

Theodore's frescoes, especially those in the saint's cell, have a delicacy reminiscent of miniature painting. The attenuated figures are lyrically unsubstantial. Characteristic of the painter's style are unnaturally elaborate details, such as the intestinelike treatment of Christ's fluttering drapery in the scene of the Anastasis (fig. 3.24). These mannerisms become increasingly rigid in the more repetitive images of the holy monks in the sanctuary. The frescoes in the nave of Lagoudera

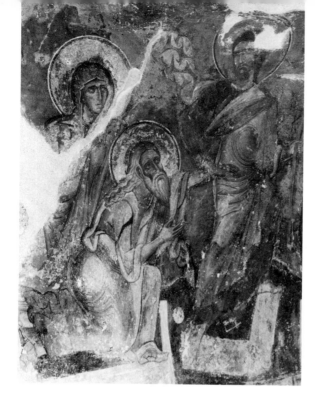

FIG. 3.24. Near Paphos, Encleistra of St. Neophytus. Niche above the saint's tomb in his cell: the Anastasis

appear to represent a further schematization of the artist's personal style. It seems at least possible that Theodore came to Cyprus, worked at the Encleistra, and later, as a monk, completed the decoration of the Virgin Arakou at Lagoudera.

The *typikon* of the Encleistra provides the historical context of the monument's decoration.[98] Neophytus, evidently born of peasant stock, became a monk at St. Chrysostomos instead of marrying, taught himself how to read and write, and then went on a pilgrimage to the Holy Land. After returning to Cyprus, Neophytus decided to seek his spiritual betterment as a hermit on Mount Latmos. While awaiting passage at Paphos, he was robbed of his fare. Penniless, he retreated into the hills behind the city and established a hermitage in a cave. His saintliness later came to the attention of Basil Cinnamus, bishop of Paphos, perhaps a scion of the same famous family as the historian John Cinnamus. It was Basil who provided funds for the extension and decoration of the rock-cut Encleistra some twenty-eight years after its establishment. While protesting land donations, Neophytus accepted financial aid for the ornamentation of the monastery.[99] Such a situation is not untypical of monastic practice in Byzantium.[100] Basil might well have been in a position to import to Cyprus an artist from the capital and thus determine the style and quality of the frescoes of the Encleistra.

The spiritual as well as the historical setting of the Encleistra can be reconstructed with the help of its *typikon*, which provides a rare insight into the psychology of a medieval patron and conventions of spirituality in the twelfth century.[101] The desire for individual salvation through ascetic practice which it embodies stands in stark contrast with the concern with salvation through good works characteristic of documents written by wealthy lay patrons. Both modes of spirituality are equally self-interested. Neophytus's idiosyncratic self-absorption,

so well characterized by Cyril Mango, as well as his ascetic concerns, is startlingly mirrored in the arrangement and decoration of his cave complex. The *typikon* shows clearly how seriously Neophytus took religious accoutrements: He wrote lovingly of his books, relics, and icons. The same personal concern is reflected in the subject matter of the fresco ornament of his foundation. Neophytus's visit to Jerusalem in search of a relic of the True Cross may be alluded to in the unusual iconography of the Annunciation over the door between the cell and the bema, in which Christ Emmanuel appears between the figures of the Virgin and Gabriel. According to pilgrims' descriptions, this same arrangement occurred on the sanctuary arch of the Church of the Holy Sepulchre.[102] The program of the Encleistra is also monastic in its specific content and in its underlying eschatological nature. The monastic bias of the cycle is demonstrated by the prominence accorded to monastic saints. The walls of the nave are lined with holy monks, most of whom bear scrolls with inscriptions relevant to the life of an ascetic; they invade even the bema. The number and conspicuous placement of monks in the paintings of the Encleistra distinguish its program from that commonly found in Middle Byzantine churches, in which bishops and military martyrs have a position at least equal to that of the monks.

Neophytus's eschatological preoccupations are enunciated in the invocation of his *typikon:* "Fear of God and the memory of Death are the greatest of all good things." This concern is physically expressed in the double functioning of the cell as mausoleum—Neophytus's tomb is opposite his bed. The program, with its almost exclusive emphasis on the Passion and post-Passion narrative, also shows an eschatological bias. Moreover, a number of the scenes treating death and resurrection are depicted more than once: The Crucifixion appears three times in the program; the Anastasis and Ascension are also repeated. The Deesis, the eschatological nature of which was discussed in chapter 2, appears prominently in the cell; it may also have been painted to the right of the opening into the sanctuary.

Most indicative of Neophytus's personal supervision of the decoration of the church is found in the repetition and conspicuousness of the founder's own image. Neophytus appears at the feet of Christ in the Deesis in his own cell and again in the sanctuary, being raised to heaven by angels, an image which in its hubris borders on heresy (fig. 3.25). Adam being lifted out of his sarcophagus by Christ in the scene of the Anastasis, an image which appears directly above Neophytus's rock-hewn tomb, also looks suspiciously like the saint. Its analogical function thus becomes explicit. Neophytus's portrait may also have been painted as part of the second main phase of decoration to the right of the entrance into the church. Even during his lifetime the saint associated himself with the godhead, appearing physically in the aureole of the ascending Christ in the "dome" of the nave by means of a shaft which led to the saint's retreat above the church.[103] In all, the painting scheme of the Encleistra is unusually reflective of the personal interests of its holy founder. It may therefore be concluded that Neophytus was the author of the Encleistra's painted program, just as he was the author of the foundation's *typikon.* The holy man in this case, and not the wealthy donor, determined the message of the church's ornament. Its idiosyncracies offer a dramatic example of how the familiar elements of the Middle Byzantine program might be manipu-

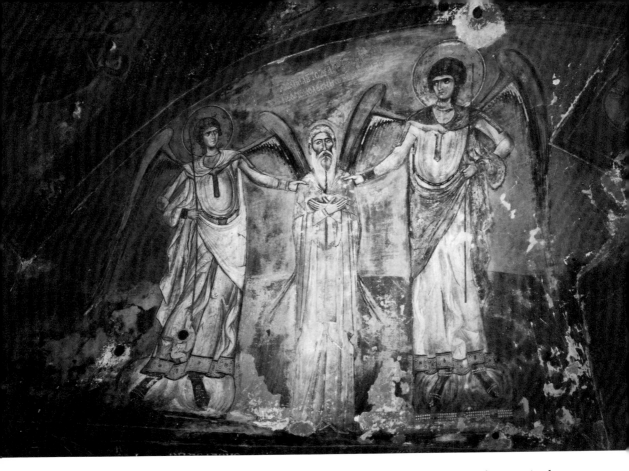

FIG. 3.25. Near Paphos, Encleistra of St. Neophytus. Sanctuary: St. Neophytus raised to heaven by angels

lated to create a highly individualistic scheme within the parameters of commonly accepted universals. This deviation from standard practice is inherently a criticism of the ideology from which that practice arose. Neophytus's church decoration, like his *typikon*, represents a reaction against formal hierarchies of power.

Late twelfth-century painting that survives in Cyprus is intimately related to contemporary monumental work elsewhere within Byzantium's cultural sphere. The Crusader conquest of the island in 1191, however, marks a dramatic end to the Cypriots' participation in the visual commonality of the Empire. Monumental painting by credible artists is still executed in Cyprus, as exemplified by frescoes of the second main phases of decoration at Neophytus (1196) and Monagri (early thirteenth century), the Church of St. Herakleidios of the monastery of St. John Lampadistis at Kalopanayiotis (first half of the thirteenth century), and the Panagia at Moutoullas (1280).[104] But these works are regional in character; they are informed by earlier Cypriot paintings, not by contemporary Byzantine ones. Cyprus was no longer a Byzantine province, and its wall painting is no longer indicative of Byzantine provincial artistic production.

4 Macedonia

SETTING AND AUDIENCE

The ancient region of Macedonia straddles the modern border between Yugoslavia and Greece, a factor that has significantly affected the historiography of its art.[1] Comprised of the watersheds of two great rivers, the Haliacmon and the Vardar, Macedonia is divided into three principal geological regions.[2] The easternmost zone, including the western fringes of the Thracian mountains, is geologically characterized by crystalline and granite rocks. In the center is the plain of the Vardar trough, with its diluvial and alluvial deposits, rich in clay and sand. On the western rim of the trough is a travertine terrace, upon which Verria is set, overlooking the plain stretching eastward toward Thessaloniki and the Themaic Gulf. To the west is the high, wide Pelagonian massif, extending from Sar Planina to the Pierian Mountains. This area, which has close geological affinities to Greece, has large limestone formations occurring in the lake-land areas of Ohrid, Kastoria, and Prespa. The geological differences of the main parts of the province not only affected the characteristic textures of the medieval churches built within them, but they also molded the political geography of the region. The coastlands and plains were dominated by the Byzantines; the northern highlands were held or threatened by the Bulgars or Slavs throughout the period under discussion.

The Balkans were subjected to massive Slav migration probably beginning in the late sixth century. While the nature of the conquest is unclear and the consequences of settlement are much debated, it seems that by the eighth century the

Balkans were thoroughly Slavicized.³ Rehellenization in the northern areas of the Empire was never complete, in part because Slavic or Slavicized states retained a threatening independence on Byzantium's northern frontier.⁴ In consequence, there was a cultural bifurcation in Macedonia of a sort which did not exist in Cyprus or Cappadocia. Within the sphere of the monumental arts, Byzantium's hegemony was not seriously challenged during the Middle Byzantine period; nevertheless, this ethnic division had repercussions for artistic production, as reflected in the existence of two major focuses of activity: Thessaloniki and Ohrid.

Thessaloniki was strategically located between east and west. In late antiquity it had been the seat of the prefect of Illyricum and under Emperor Galerius an imperial residence. Throughout the Middle Byzantine period it was the Empire's second city and an important trade center. A sense of the cosmopolitan constitution of the great fair held in honor of the city's patron saint, St. Demetrius, is provided by *Timarion*, a twelfth-century satire:

> The Demetria are a festival, just as the Panathenaia were in Athens. . . . Not only does the native and indigenous throng pour in but also men of every conceivable race and country. Greeks from wherever they happen to live, the entire motley crew of Mysians who are our neighbors as far as the Danube and Scythia, Campanians, Italians in general, Iberians, Lusitanians, and Transalpine Celts. In short, the shores of the ocean send pilgrims and sightseers to the martyr, so famous is he in Europe. I myself, being just a Cappadocian tourist from abroad, never having been to the fair before but only having heard about it, wanted to see everything there was to see.⁵

Thessaloniki was also an important stop on the major Roman military east-west connecting road, the Via Egnatia, which ran from Dyrrachium (Durazzo) on the Adriatic through central Albania, down to Thessaloniki, then along the coast to Constantinople. This same road looped around Lake Ohrid to the north, passing through the city of Ohrid. Ohrid became an important cultural center under the Bulgars in the ninth century as the site of the crucial educational and religious missions of St. Clement and St. Naum. Not only were Greek texts translated there but also, according to medieval sources, several thousand Slav priests were ordained in the city.⁶ Exaggerated as such numbers might have been by the chroniclers, they illustrate the cultural importance of Ohrid under the Bulgars. Ohrid also served as a patriarchate and royal residence under Bulgarian rule. Even after the Byzantines destroyed the Bulgarian empire, Ohrid, converted from a patriarchate to an autocephalous archbishopric, continued to be the most important religious center in northern Macedonia.

Thus, despite changing political configurations, there were two major urban centers in Macedonia throughout the period under consideration. These centers were not, however, the only sites of church construction. The region as a whole is rich in medieval monuments. The question remains as to whether the patrons of these monuments sought craft skills locally in provincial cities or in Constantinople. Although tentative links between Thessaloniki or Ohrid and less urban Macedonian sites might occasionally be drawn, the surviving monuments suggest that

neither city had the critical mass of patronage necessary to establish for any significant length of time an artistic tradition completely independent of the capital.

THE NINTH AND TENTH CENTURIES

The Slavic occupation of the Balkan peninsula was challenged seriously in the eighth century. The southern parts of Macedonia were secured and Byzantium went on the offensive. Constantine V mounted several campaigns against the Bulgars in the third quarter of the eighth century; at the end of the century Constantine VI also had some success in improving the position of the Empire in the Balkans. The *theme* of Thessaloniki was apparently created between 829 and 842 in an effort to secure the region militarily.[7] Macedonia continued to be vulnerable, however. At its greatest extension under Czar Symeon (893–927), the first Bulgarian empire extended almost to the Aegean. The Byzantines retained control only of Verria, Thessaloniki, Serres, Philippi, and the coastlands connecting them.[8]

A building program seems to have been part of the process of Byzantine recovery and consolidation in the Balkans. In conjunction with verses from church dedication prayers, invocations in the form of monograms appear in mosaic in the apse of the church of St. Sophia in Thessaloniki. These call on God to protect the Emperor Constantine, his mother, the Empress Eirene, and the bishop Theophilus.[9] The inscriptions suggest that the church was constructed during Constantine VI and Eirene's joint reign (780–97). It has been argued that the church was raised as a monumental *tropaion* set up to celebrate the Byzantines' successful campaigns against the Slavs.[10] It is also hypothesized that the church symbolized a closer union between the see of Thessaloniki and the patriarchate of Constantinople.[11] Until the middle of the eighth century, the archbishop of Thessaloniki had been the apostolic vicar of the Roman pope for the province. When Rome would not endorse the policies of the Iconoclasts, Illyricum was transferred to the jurisdiction of Constantinople. Both purposes may have been served by the great church that was built. Whatever specific ecclesiastical intentions were embodied in St. Sophia in Thessaloniki, such a building also confirmed the imperial presence in the province.

The mosaic monograms are the most explicit indication of the monument's link with the imperium. Association with the imperial city is also suggested by the church's dedication to St. Sophia, the Holy Wisdom, the same distinctive dedication as the Great Church of the capital. In the eleventh century, that epithet is also applied to the church in Thessaloniki.[12] Apparently St. Sophia in Thessaloniki had much the same function as its counterpart in the capital, being the liturgical and administrative seat of the archiepiscopate of the empire's second most important city.[13] It was, in any case, built on previously consecrated ground, the site of an enormous five-aisled basilica, 122 meters in length, of the late fifth or early sixth century.[14]

The form of the new church may also have been regarded by contemporaries as a version of its Constantinopolitan prototype (fig. 4.1). It is extremely large for an

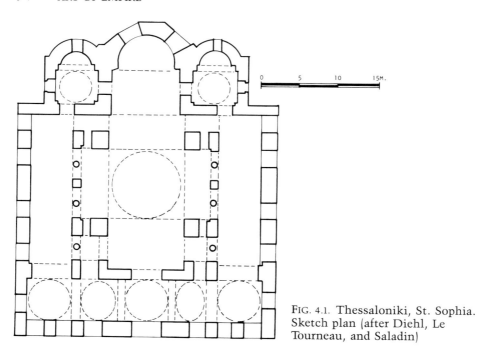

FIG. 4.1. Thessaloniki, St. Sophia. Sketch plan (after Diehl, Le Tourneau, and Saladin)

early medieval building. Instead of following the longitudinal, basilican plan of its predecessor on the site, St. Sophia has a complex, centralized form, generically related to the plan of the Great Church in the capital: a domed nucleus enfolded in auxiliary spaces both at ground and gallery level. In contrast to the flowing sinuosity of St. Sophia in Constantinople, the space in the Thessalonikan church is rectilinearly defined by the cruciform core; supplementary spaces, like its deep sanctuary flanked by domed, apsidal chambers, are treated as separate entities. No attempt is made to obscure the heaviness of the masonry mass of the piers, whose bulk is emphasized by their protrusion into the nave. Gone are the columnar screen walls of Justinian's St. Sophia. The distinct sensibility of St. Sophia in Thessaloniki has parallels in other provinces: the Church of the Koimesis in Nicaea, the cathedral at Vize, and the church of St. Nicholas in Myra.[15] This group seems to exemplify the post-Justinianic architectural vernacular of congregational building.[16] As no earlier monuments of this form are known in Macedonia, St. Sophia represents a significant architectural intrusion in the province. Considering the church's inscriptions, its origins are most likely Constantinopolitan.

The building techniques employed in St. Sophia also suggest that the church was not built by local artisans. Its fabric is neatly banded, with five courses of well-cut ashlar masonry alternating with five courses of brick. Mortar beds are about the same thickness as the brick.[17] Similar wall construction is found in the post-740 reconstruction of St. Eirene, part of the complex of the Great Church in Constantinople.[18] Large-scale construction had probably not been undertaken in

Macedonia for over a century. In the long period of military and political disloca-
tion on the Balkan peninsula, the architectural technology necessary for raising a
major structure might well have been lost. Practical necessity and political or
symbolic considerations perhaps prompted the imperial patrons of St. Sophia to
send master masons as well as plans for the church from Constantinople to Thes-
saloniki.

The image of the Virgin and Child now enthroned in the apse of St. Sophia only
in the eleventh century replaced the mosaic cross which earlier adorned the
conch. The original cross can be reconstructed from sutures in the gold ground
that were visible before the mosaic's modern restoration. It was a very large out-
lined figure with teardrop serifs, similar in form to that commissioned by the arch-
Iconoclast, Constantine V, for the apse in St. Eirene in Constantinople.[19] The
apparent contradiction of the empress who orchestrated the restitution of icons at
the Iconodule Council of 787 (bishop Theophilus was one of the signatories) com-
missioning such an image disappears in light of the cross's traditional association
with imperial triumph.[20] As is shown also by the fresco decoration of Cappadocian
cave chapels of the ninth century, the representation of the cross was not regarded
by Iconodules as an antitype to holy figures. Artistic inertia may explain the sur-
vival of the cross in the sanctuary apse of St. Sophia in Thessaloniki until the elev-
enth century; but it was perhaps the imperial associations of the cross which
assured its continued existence so long as the church had imperial patrons.

The church of St. Sophia in Thessaloniki received a further mosaic decoration
in the late ninth or early tenth century.[21] The great central dome of the church was
adorned with an Ascension of spectacular geometric clarity (fig. 4.2). At the apex,
Christ, enthroned on a rainbow within an aureole of light, is carried heavenward
by angels. Below, the dome is divided radially by trees, its segments occupied by
the twelve apostles and an orans Virgin flanked by angels. The bold abstraction of
the composition complements the dramatic simplicity of the figure style, which
is characterized by strong color contrasts, easily read gestures, and the geometry of
its drapery highlights. The schematic nature of both the style and the composi-
tion makes this image eminently legible, even from the nave far below. As has
been noted, the Ascension, as a well-witnessed epiphany, was given particular em-
phasis in church decoration after Iconoclasm. A second Ascension, painted in a
closely related style, is found in the apse of the Rotunda of St. George in Thessa-
loniki.[22] In figure style and the prominent placement of the Ascension, these
works have parallels in early tenth-century painting in Cappadocia. Such identity
is best explained by the employment in both provinces of artists associated, di-
rectly or indirectly, with Constantinople, where close analogies are found in the
late ninth-century decoration of the Great Church itself.[23]

The Bulgarians, like the Byzantines, expressed their political policies monu-
mentally. After Czar Boris's (852–89) conversion to Christianity in 864, Bulgar-
Byzantine relations are mirrored in the changing character of Bulgarian church
building in Macedonia. Boris purportedly founded seven major churches before his
abdication, one of which was the cathedral of Ohrid. Whether the present church
at Ohrid incorporates substantial parts of the ninth-century construction is de-
bated.[24] Sections of banded ashlar and brick suggest that at least parts of the sanc-

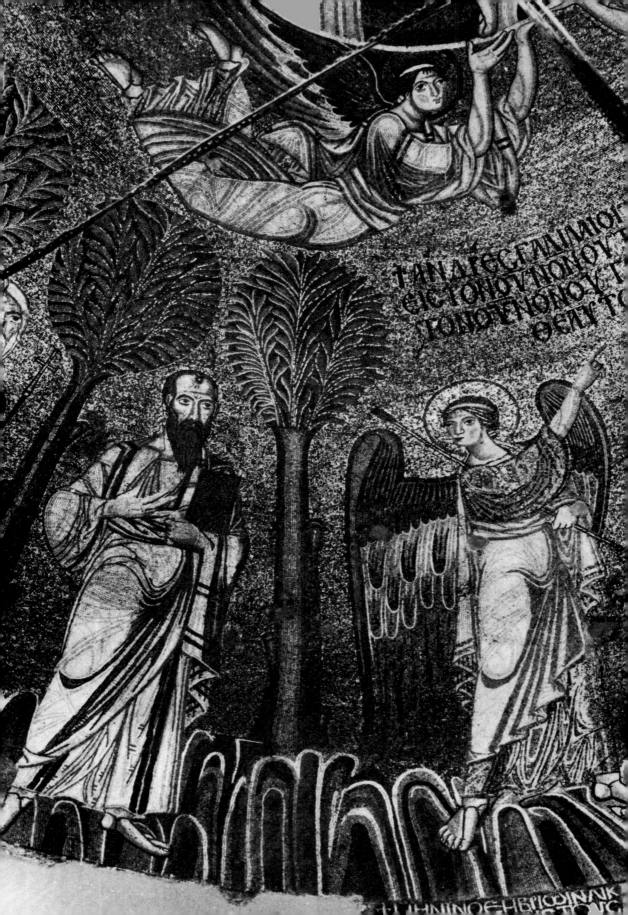

tuary date from the foundation of the church (fig. 4.3). Such fabric is unusual in Bulgaria. Most monuments ascribed to the ninth or tenth century are rendered in mortared rubble or roughly coursed local stone. The similarity of this masonry to that of St. Sophia in Thessaloniki or St. Eirene in Constantinople may indicate that Boris employed masons from Byzantium. References to painters working in Bulgaria indicate that artisans did cross the northern frontier.[25] As Christianization of the Bulgars was in the interest of the Byzantines, they may have facilitated Boris's building program. Although related to contemporary Byzantine architectural practice by its fabric, the plan of the cathedral of Ohrid does not seem to have been informed by the centralized building type current in the Empire in the eighth and ninth centuries. Theophylact of Ohrid (d. 1108) in his *Life of St. Clement* praised the centralized churches founded by Clement (d. 916) as being more beautiful than Boris's cathedral.[26] Theophylact's apposition between Clement's centralized structures and Boris's cathedral suggests that the royal foundation was a longitudinal basilica. Such a plan, even if rendered by Byzantine masons, might express the Early Christian nostalgia that has been identified in the first Bulgarian churches.[27] It might equally represent the most functional means of housing a large congregation.

Bulgarian independence is even more marked in the church of St. Achilleus, built on an island in Lake Prespa.[28] St. Achilleus is a large basilica, approximately 45 meters in length (fig. 4.4). Its high nave was separated from its galleried aisles by a pier arcade. The church was entered at the west through a broad narthex; it was terminated to the east by a large semicircular apse pierced by three windows. This sanctuary was flanked by two cruciform, apsed chambers. Except for the domes covering the flanking chambers of the bema, the church was wooden-roofed. The masonry is purely local mortared rubble with some brick. The basilica at Prespa appears to have been built at the end of the tenth century. John Skylitzes, writing at the end of the eleventh century, records the transference of the relics of St. Achilleus from Larissa to Prespa in 985–87; a supplement to his text indicates that Czar Samuel (980–1014) transferred his court to Prespa and built a great church there in Achilleus's name.[29] Epigraphic evidence in the apse of St. Achilleus—inscriptions in small arches around the synthronon apparently naming the suffragans of Prespa—further supports a dating at the end of the tenth century. The inclusion of Vidin, which after 1002 was no longer a suffragan of Prespa, suggests a *terminus ante quem* for the church's construction.[30]

In the 980s Czar Samuel enjoyed considerable success in his attempt to reassert Bulgarian power in the Balkans at the expense of the Byzantines. His construction of a large, new basilica dedicated to one of the most venerated saints in Bulgaria might even be seen as an expression of optimism which had military parallels in his conquest of Larissa and recapture of Preslav and Pliska. In any case, the absence of many current Byzantine architectural features in both the plan of the church and in its construction techniques bespeaks not only a relatively highly

Opposite:
FIG. 4.2. Thessaloniki, St. Sophia. Central dome: the Ascension (detail) (David Wright)

developed local building tradition but also a certain defiance of Byzantine cultural hegemony. Thus, while St. Sophia in Thessaloniki seems to represent a direct artistic importation from Constantinople and Boris's cathedral at Ohrid embodies an acceptance of metropolitan Byzantine forms, St. Achilleus appears to assert Bulgarian independence. Such an interpretation perhaps is too politicized. However, if political aspirations had any monumental vehicle in the Middle Ages, it is most likely to have been the great congregational church, whether in the capital or in the provinces.

Three small churches, the Koubelidiki, Hagios Stephanos, and the Taxiarchs, in the town of Kastoria in northern Greece provide a perspective on artistic and architectural developments outside the major cities of Macedonia.[31] Despite the fact that during much of the ninth and tenth centuries Kastoria was located in a contested frontier territory between the Bulgarians and Byzantines, there seems to have been the necessary surplus wealth in the city to found churches. The number and small scale of these late ninth- or early tenth-century foundations suggest that the patrons represented the local well-to-do. The original function of the three chapels is unclear. No dedicatory inscriptions remain from the first phase of their decoration, though later epigraphic evidence suggests that these churches were family foundations, serving as private oratories or small monastic establishments.[32]

FIG. 4.3. Ohrid, St. Sophia. General view of the exterior from the east

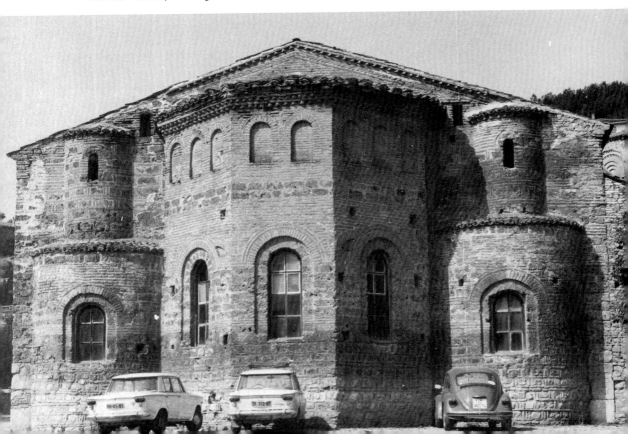

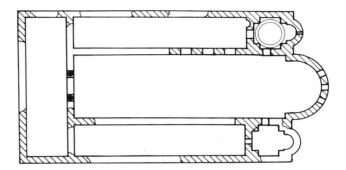

FIG. 4.4. Lake Prespa, St. Achilleus. Sketch plan. Hatched sections represent surviving fabric (after N. K. Moutsopoulos)

The Koubelidiki is a domed triconch with a longitudinal narthex; H. Stephanos and the Taxiarchs are barrel-vaulted basilicas with triple-niched sanctuaries and lateral nartheces (fig. 4.5). Simple blind niches break up the wall surface, internally in H. Stephanos and externally in the Taxiarchs. The nave is separated from the aisles by a single pier supporting double arches in H. Stephanos and by a triple arcade supported by paired columns in the Taxiarchs. Despite variations in their plans, these chapels share an expressive character. The internal proportions of the

FIG. 4.5. Kastoria, Koubelidiki. View from the south

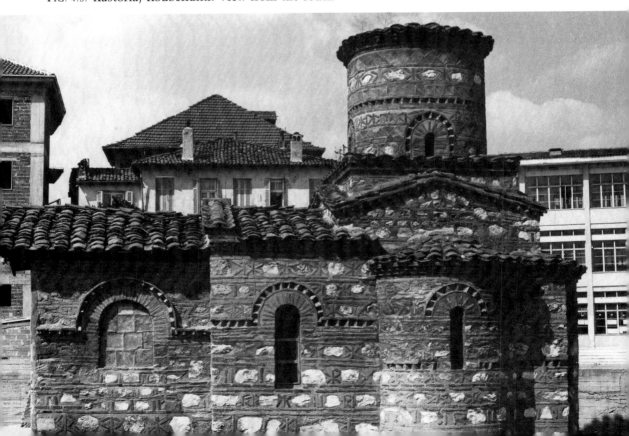

churches are extremely steep; this manipulation of spatial ratios, along with the dimness of the interiors, contributes to a disconcerting illusion of loftiness peculiar to these minute monuments.[33] Externally, too, the churches of Kastoria show a close family resemblance. The constituent parts of the plan are delineated as separate volumes. For example, in the Koubelidiki and the Taxiarchs, the sawtooth string courses which run at different levels on different parts of the structure serve to isolate rather than unify building segments. More particular to these churches is their fabric. Although their vaults are wholly brick, the walls are mortared rubble with a facing of coursed brick and small, roughly cut blocks of local stone. Mixed-media construction is commonplace in the Eastern Empire from the late Roman period, continuing in the provinces and in Constantinople itself throughout the Byzantine and post-Byzantine eras, but it is only fully exploited for its decorative effects beginning in the Middle Byzantine period.[34] Characteristic of the period is a concern with the exteriors. In the metropolis this concern is evinced by an increased modeling of brick surfaces through columnar pilasters and ordered niches. In Macedonia it is reflected in the ornamental elaboration of the flat surface through the so-called cloisonné brick technique. The morphology of this decoration in Kastoria consists of regular horizontal brick courses of irregularly cut local stone separated vertically by bricks laid in decorative patterns. The most popular motif is the kappa, which is used forward and backward, singly and paired. But numerous other figures, some symbolic, most purely decorative, are also found. The cloisonné effect of warm stone and red brick in a thick matrix of light tan mortar is texturally enriched by unglazed tile laid in contiguous squares or diamond bands and by sawtooth string courses. These linear, horizontal elaborations are surrogate moldings, marking cornices and breaking up the vertical planes of the building. The distinctive character of the shared features of these structures suggests that they are local products. In the late ninth and early tenth centuries, Kastoria apparently was rich enough to support a mason's workshop.

Although the architecture of Kastoria shows a remarkable degree of local consistency and autonomy, the fresco decoration of H. Stephanos and the Taxiarchs has much in common with late ninth- and early tenth-century painting elsewhere in the Empire (fig. 4.6). Compositions are dominated by figures of squat proportions, full-register scale, and rigid arrangement within a two-dimensional ground. The figures themselves are dependent on the broad, dark outlining of constituent parts, both of physical features and drapery. Triangular patches of highlight give the figures ornamental interest while denying their substance. In the Last Judgment in H. Stephanos, surface pigment has flaked off, revealing freely rendered preparation sketches not unlike those found in Chapel 2B and El Nazar in Cappadocia. Treatment of both the figures and composition in these churches represents a coordinated denial of illusionistic space. Whether the artist working in Kastoria came from Thessaloniki or from further afield, the character of these paintings indicates that patrons in the city had access to artists with some metropolitan connections.

Because of the loss of much of the original decoration of the Taxiarchs and H. Stephanos, it is difficult to reconstruct their programs.[35] A badly preserved image of the Virgin flanked by an archangel and a figure holding a scroll on the pier be-

FIG. 4.6. Kastoria, Hagios Stephanos. South wall of narthex: apostles and angels from the Last Judgment (Robin Cormack)

fore the sanctuary closure may represent a donor's portrait. The most ambitious scene is the Last Judgment painted in the narthex of H. Stephanos. From the fragments in the narthex and on the walls of the nave, the program might very tentatively be characterized as eschatological. The appearance of isolated images of holy figures on the lower walls nevertheless suggests an intimacy between the audience and the divine of the sort found in the church at Kellia in Cyprus.[36] Liturgical arrangements in the chapels confirm this sense of intimacy. In the Taxiarchs, there is no evidence of a screen separating the sanctuary from the nave; in H. Stephanos, two low parapet slabs apparently performed this function. As is evident from the rock-cut liturgical furnishings of Cappadocian cave churches of the early tenth century, priestly mysteries were not yet universally concealed from the laity.[37] Personal as these three chapels might be, their architecture and decoration provide evidence of Kastoria's relative wealth during these militarily tense centuries. The frescoes indeed suggest that even at a level of patronage lower than that represented by Boris's cathedral at Ohrid, frontiers were not necessarily barriers to artistic exchange.

The diversity of church plans in Kastoria suggests that founders might express spatial preferences. Monastic structures of the ninth and tenth centuries in Macedonia indicate further that holy ascetics certainly had scope for architectural idiosyncracy. A monk's effect on his built habitat is traceable in the history of the small church of St. Andrew, which was built in 870/871 in Peristerai, near Thessa-

loniki (fig. 4.7).[38] This monument has a complex plan. The nucleus of the nave is square, but its space is fragmented by four columns which have been set in from the corners of the central bay in order to reduce its diameter for the construction of a dome without centering. Opening off each side of the central square is a domed triconch bay, the eastern one being flanked by barrel-vaulted pastophories (diaconicon and prothesis). In its five-domed arrangement and in its dedication to St. Andrew, traditionally the apostolic founder of the see of Constantinople, the church makes typological allusions to Justinian's great Church of the Holy Apostles in Constantinople, a structure to which, it seems, provincial builders often looked in the Middle Byzantine period.[39] Despite the complexities of the plan, the scale of the church is very small and its architectural detailing minimal. It is constructed of mortared rubble with reused brick used in the upper parts of the superstructure. Small roundheaded apertures puncture the thick walls. Mortared rubble does not lend itself to the linear articulation of structure, and, particularly from the exterior, the church is organically massed. But internally, the domes, apsidoles, and arches are defined by simple moldings. The fabric helps establish the local character of the monument.

The architectural idiosyncrasy of St. Andrew finds an echo in the life of its founder, St. Euthymius the Younger. St. Euthymius, born in Ancyra in Galatia, lived the life of a monk on Mount Olympus and on Mount Athos before establishing himself at Peristerai. Euthymius built his *katholikon* with the help of two or three laborers in the face of opposition from demons who inhabited the site and wished to remain undisturbed by the saint's holy presence.[40] In the eclectic form of St. Andrew it is perhaps possible to see the personality of a strong-minded ascetic. The church represents not so much a regional building tradition as the will of a provincial saint.

St. Euthymius's church does not seem to have had an impact on architectural developments, even locally. In contrast, the Lavra of St. Athanasius the Athonite, another unusually shaped church produced under the aegis of another holy ascetic, was enormously influential. St. Athanasius, the well-connected and well-educated son of a Pontic family, attracted by his piety the devotion of Nicephorus Phocas.[41] To escape the favors of the future emperor, St. Athanasius fled to Mount Athos, disguising himself as an illiterate neophyte. When the saint first arrived at the Holy Mountain, ascetic life there was exclusively eremetic. Independent monks simply gathered for religious feasts at the Protaton, church of the *protos* (first monk), who was their nominal leader. Despite the opposition of the resident hermits, St. Athanasius established the first cenobitic community on Athos at the Lavra in 961 with the financial support of Nicephorus Phocas. First he built a retreat for his patron—which Nicephorus neglected to occupy in favor of the imperial throne—then an oratory honoring the Forerunner, and after 964 a church dedicated to the Koimesis of the Virgin. Construction continued on cells, a mill, kitchen, refectory, hostel, infirmary, and waterworks.[42] Among Athanasius's first disciples were the masons, who he miraculously freed from devilish torments. It is tempting to speculate that labor costs might be significantly lowered through the conversion of workers to the monastic life. Athanasius's active participation in the building works is proved by the injuries he suffered on the site: He was involved in

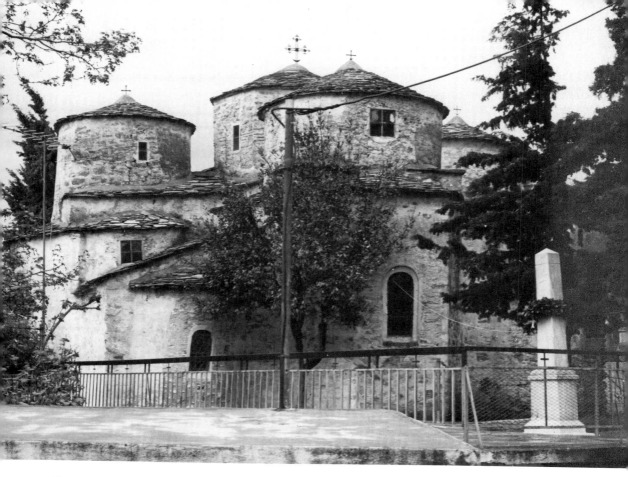

FIG. 4.7. Peristerai, St. Andrew. General view of the exterior from the east

an accident in the construction of his monastery's port and was mortally injured in the enlargement of its church in 1002.[43] The Lavra appears to be a monk's foundation, not an emperor's.

The church that was being enlarged in 1002 seems to have survived to the present.[44] This monument has a sizable central dome supported on short barrel vaults which spring from bulky piers (fig. 4.8). To the east is a tripartite sanctuary. The north and south arms telescope into generous conches. In the west there is a *liti* (deep narthex) flanked by small cross-in-square chapels. This plan had a great impact on the building tradition of Athos, though it is unclear whether the churches of two important monasteries of Iviron and Vatopedi were direct copies of the first *katholikon* of the Lavra or versions of the reconstructed monument. These cenobitic communities were founded in the last quarter of the tenth century, but it is possible that the principal churches of the monasteries were not constructed until after Athanasius's work on the enlargement of the Lavra was begun.[45]

The source of inspiration for this unusual form of Athonite church is still open to question. The fabric of the structure provides no help; the stuccoed surface masks the wall material, though there is some evidence that it was rendered in lo-

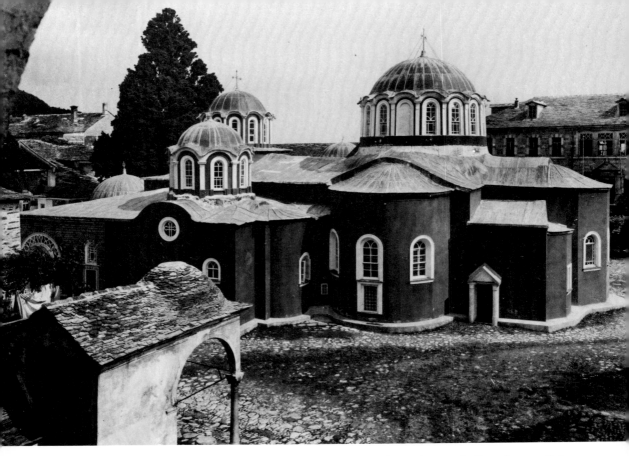

FIG. 4.8. Mount Athos, the Great Lavra. General view from the south (Dumbarton Oaks, Center for Byzantine Studies, Washington, D.C.)

cal mortared rubble, as was the Protaton.[46] It has been argued that the Lavra's triconch plan was derived from Caucasian structures.[47] However, Mylonas believes that the Lavra's lateral apses were secondary additions to a cross-in-square nucleus.[48] Moreover, the Athonite church's voluptuous complexity of multiple domes and conches and relatively low, broad profile bear only the remotest resemblance to the tall, disciplined geometry of Caucasian architecture of the tenth century. The proliferation of triconches in the tenth and early eleventh centuries discourages the identification of a particular prototype.[49] It seems more likely that St. Athanasius's structure, like the less pretentious church of St. Euthymius the Younger, was the product of the saint's own rich experience.

THE ELEVENTH CENTURY

Northern Macedonia was violently reincorporated into the Byzantine Empire by Basil II (975–1025), the "Bulgarslayer." According to the well-known story, Basil blinded fourteen thousand Bulgarian soldiers captured after the battle of Kleidion, leaving only one man out of every hundred with a single eye to lead his ninety-

nine comrades back to Czar Samuel. At the sight of this bloody procession, Samuel supposedly fell into a fit and died;[50] Samuel's widow surrendered the Bulgarian empire to the Byzantines at Ohrid in 1018. The church was an important vehicle in the acculturation of the province which followed Basil's conquest. Ohrid, patriarchate of the Bulgarian church, became an autocephalous archbishopric in the Orthodox ecclesiastical structure with a Greek prelate in power. The shift in status does not, however, appear to have affected Ohrid's authority. Counted among its suffragans were Kastoria, Skopje, the provincial capital of the region, and Strumica. The traditional position of Ohrid as a cultural center under the Bulgarians, as well as its new role as propagator of Orthodoxy in the Byzantine sphere, may have inspired Leo (1037–56), its first Byzantine bishop, to rebuild his cathedral. The entry in the bishop's list reads:

> Leo, first of the Romans [i.e., Byzantines], *chartophylax* [archivist] of the Great Church [St. Sophia in Constantinople], founder of the lower church in the name of the Holy Wisdom of God [St. Sophia].[51]

There seems then to be a direct connection between Ohrid and Constantinople. Not only was a prelate sent from the seat of the metropolitan patriarchate to the province, but the cathedral was rededicated in the name of its mother church in the capital. The analogy to circumstances in Thessaloniki two centuries earlier is striking.

Archbishop Leo appears to have significantly modified the existing cathedral, rebuilding it as a domed basilica. The dome of the church, which can be reconstructed on the basis of remains above the present fifteenth-century vault, was probably added by the archbishop.[52] The dome, a form emblematic of St. Sophia in Constantinople, would have strengthened the allusion to the church's dedicatory prototype. The Constantinopolitan connections of the church's patron and dedication may also explain masonry features which seem to be peculiar to the capital and sites dependent on it, like the brick crosses in the interstices of arches.[53] However, the cloisonné technique found in this phase of construction is, as has been noted, common in Macedonia (see fig. 4.3).

The refurbished church received an elaborate fresco decoration. The figures in these paintings, like Christ flanked by the apostles and angels in the representation of the *proskomide* (the prayer blessing the host after the Great Entrance) in the apse, convey by their concentrated expressions the seriousness of the eucharistic drama being enacted in the sanctuary. The flesh of the apostles is starkly modeled through contrasts between white highlights and deep umber shadows. Their himations are as expressively rendered as their faces: Dark passages are juxtaposed with brilliant pastels to delineate the staccato rhythms of the folds. The style in which the master of St. Sophia is working has no earlier regional analogies. Its closest parallels occur outside Macedonia at a somewhat later date. Similar in conception are the high-quality frescoes in Karabaş Kilise in Cappadocia of 1060/61. Stylistically related works arguably executed by metropolitan masters are also found in Cyprus and Russia.[54] These comparisons suggest that Leo arranged for metropolitan painters to decorate his rededicated cathedral.

The program of the fresco cycle of St. Sophia further links the church with the capital. On the basis of surviving fragments, including the Presentation of the Virgin in the Temple, the Nativity, and the Koimesis, it is possible to reconstruct a feast cycle in the nave of the church.[55] A distinct series of paintings of the same date, but noticeably more carefully rendered, is found in the unusually elongated sanctuary arm of the church. This most sacred part of the building holds its most significant images (figs. 4.9 and 4.10). Though closed to the laity by a marble sanctuary screen, there was no opaque separation between the nave and the bema.[56] Laity and clergy alike might observe the fresco decoration of the bema during the service. Attention is directed to the apse by a number of compositional strategies. The Ascension in the barrel vault of the east arm has an emphatic west-east axis. In contrast to the same scene at Çavuşin or Kakopetria, there is here no frontal Virgin with flanking angels to provide a contending transverse axis. The Virgin is, instead, unconventionally rendered off-center and in a three-quarter stance on the south side of the vault, with only one of her usual pair of escorting angels (a second angel appears on the north side of the vault). There is no diversion from the west-east directionalism established by the ascending Christ. Below the Ascension a ritual procession of bowing angels moving in the direction of the east end of the church reinforces the movement of the eye toward the apse. One might, then, expect there an image of some significance. The enthroned Virgin displays epiphanically the infant Christ, who wears liturgical insignia, perhaps to be identified as a deacon's *orarion*, a long strip of material worn over the shoulder. Many of the other central images are explicitly liturgical in content. The *proskomide* is enacted by Christ with the apostles below the Virgin on the cord of the apse. It is enacted again by St. Basil, its author, in an unusual image on the north wall. Typological allusions to the institution of the Eucharist drawn from the Old Testament (an Abraham cycle, the Three Hebrews in the Fire, and Jacob's Dream) are depicted on the opposite wall.[57] A Deesis, the liturgical content of which was discussed in chapter 2, occupies the apex of the triumphal arch. The peculiar features of the program may be explained as part of a visual exegesis on the superiority of the Greek liturgy, more particularly that of St. Basil, the most popular liturgy in Byzantium in the eleventh century.[58] Such a glorification of the Greek rite would be appropriate in Ohrid, an outpost of rehellenization. The Greek sense of superiority which underlaid this Byzantine attempt at acculturation was articulated by one of Leo's successors, Theophylact, bishop of Ohrid at the end of the eleventh century. This Constantinopolitan intellect denounced the barbarism of his Bulgarian setting in terms more virulent than those used in the twelfth century by Nicholas Muzalon to describe Cyprus.[59] The program of the decoration provides an explicit statement of the imperial agenda for the newly reintegrated province.

As in Ohrid, there is evidence in early eleventh-century Thessaloniki of close artistic links to Constantinople, though not of the same propagandistic character.

Opposite:
FIG. 4.9. Ohrid, St. Sophia. General view of the sanctuary from the west (Dusan Tasić)

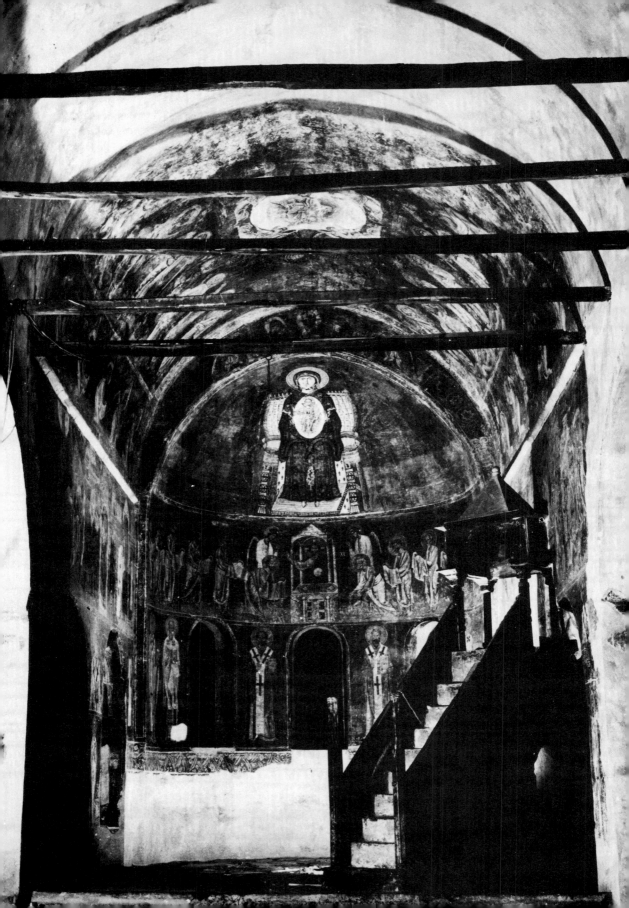

The inscription over the entrance into the Panagia tōn Chalkeōn in Thessaloniki reads:

> [This] previously unsanctified place was hallowed [by] the notable church of the Theotokos, [founded] by Christopher, most honored by the emperor, *protospatharios* and *katapan* of Longobardia [South Italy] and his wife Maria and his children Nicephorus, Anna and Katakales. In the month of September, indiction 12, [in the] year 1028.[60]

The inscription provides the date of the church and indicates that the patron, Christopher, was a high court dignitary and governor of the Byzantine holdings in South Italy.[61] The function of the church is not specified. The arcosolium in the north arm of the nave suggests that it was planned as a funerary monument for the founder. It has been hypothesized that the Panagia was the *katholikon* of a monastic establishment; the prominence of monastic saints in the decoration of the interior, for instance, in the southwest bay, provides some substantiation for this notion.

The Panagia is architecturally isolated in Macedonia (fig. 4.11). Its plan and superstructure, though without analogues in the province, have close parallels in

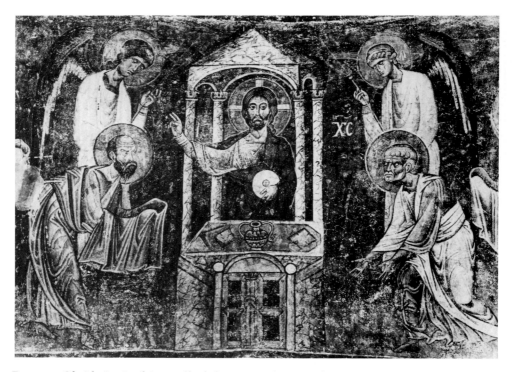

FIG. 4.10. Ohrid, St. Sophia. Wall of the apse: Christ with apostles in the *proskomide* (Dusan Tasić)

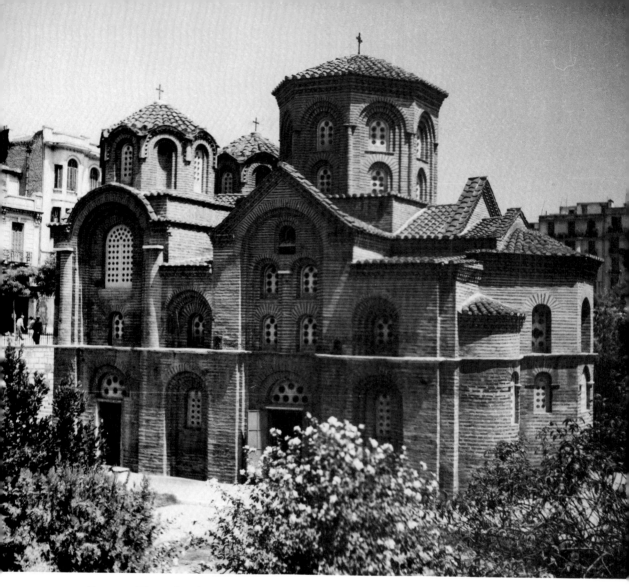

FIG. 4.11. Thessaloniki, Panagia tōn Chalkeōn. General view of the exterior from the south (Robin Cormack)

Constantinople.[62] Its cross-in-square form is similar to that of the Bodrum Camii: It too has sanctuary bays added to the core and a spacious narthex.[63] The use of half-column buttresses in the elaborate articulation of the facade, as well as its all-brick fabric, makes the link between the Panagia and Bodrum Camii even more compelling. The original pure brick construction of the upper church of the Bodrum Camii distinguishes it from the traditional Constantinopolitan structures of alternating bands of brick and squared stone. The use of brick without stone is even more surprising in Macedonia. The fabric of the Panagia is, moreover, an early example of recessed brickwork.[64] Reused tile rather than brick was employed in the concealed course, suggesting that this construction technique perhaps

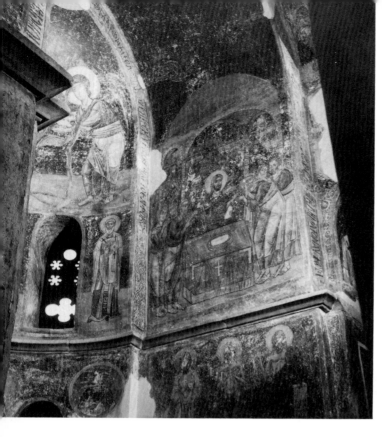

FIG. 4.12. Thessaloniki, Panagia tōn
Chalkeōn. South wall of the
sanctuary: Communion of the
Apostles (Foto Marburg)

originated not because of its decorative potential but from economic consider-
ations.

For all its metropolitan connections, the Panagia is a peculiarly non-
Constantinopolitan structure. It lacks the refinements (the niches of the *prothesis*
and *diakonikon*, the goring of the dome, and the sinuous handling of the interior
space) of the Constantinopolitan churches with which it is most convincingly
compared. The walls of the building are bulkier and the external delineation of
the structure is more complex and decorative, even if the reconstructed gables
were not part of the original church. Most notable, however, is the conservatism of
the monument. The churches most like it in the capital predate it by a century.

The fresco program which the Panagia received probably soon after its construc-
tion combines conservative and current features (fig. 4.12).[65] By the eleventh cen-
tury a Pantokrator usually occupied the summit of the central dome. In the
Panagia the Ascension, so popular a dome motif in the tenth century, is found in
that position, perhaps reflecting the local authority of the dome mosaic of St.
Sophia. In contrast, the appearance of the feast cycle of the nave indicates that its
painters were familiar with contemporary programmatic ideas. The style of the
frescoes similarly shows that the monument was by no means retardataire. The
somber figures, rendered either in isolation or in balanced narrative panels, may be
compared with works ranging from the Menologion of Basil II and the so-called
Phocas Lectionary in the *skevophylakion* (sacristy) of the Lavra on Athos, which
has been ascribed to a Constantinopolitan atelier of the early eleventh century.[66]
These parallels make it difficult to treat the fresco cycle of the Panagia as a purely

local product.[67] The currency of the decoration of the Panagia seems to confirm the architectural evidence that the patron desired to be respectably, if not conspicuously, metropolitan.

If St. Sophia in Ohrid and the Panagia in Thessaloniki represent the continued artistic hegemony of the capital, a series of congregational and monastic structures inside and outside the major urban centers in Macedonia indicates the vitality of local patronage and craft in the period of relative political stability between Basil II's demolition of the Bulgarian empire in the early eleventh century and the late eleventh-century threats from the Latin west, first the Norman incursions, then the dislocations of the First Crusade. Major public churches in Thessaloniki were at least partially redecorated. Votive images modeled on earlier panels in the same church were added in the martyrium of St. Demetrius. There are also fresco fragments of this period in the church, for instance, a well-painted monk on the east pier of the south aisle. In St. Sophia, an eleventh-century building phase has been identified; the church also received some fresco decoration as well as a mosaic program in the apse.[68]

In other Macedonian towns congregational buildings were constructed or reconstructed. In Servia, the bishop Michael had a three-aisled, wooden-roofed basilica about 22 meters in length constructed on the city's acropolis (fig. 4.13).[69] The plan of the church is simple: The aisles are separated from the nave by a wall punctured by four arches. To the west is a narthex opening to the nave through a triple-arcade springing from reused colonnettes and to the aisles by simple arched doorways. The original east end and its later reconstruction are lost. The rough fabric is mortared rubble with brick used in the arches and laid horizontally between rough-cut or uncut blocks of local stone. Both the exterior and the interior were originally plastered. The few pieces of sculptured marble functioning as impost blocks are simply ornamented with bosses and vine tendrils. The building bespeaks local masons. The two medieval phases of the church's fresco decoration have all but disappeared. Standing saints were represented on the lower wall; a Christological narrative appeared in the clerestory. Despite the relative security of Macedonia, the church's location, as well as its dedication to the warrior-martyr, protector of

FIG. 4.13. Servia, Metropolis. General view of the exterior from the south

cities, Demetrius, suggests that the local population and its shepherd, Bishop Michael, did not take their security for granted.

The construction or restoration of the very large (nearly thirty-nine meters in length) basilica, the Old Metropolis, at Verria may also be ascribed to the eleventh century (fig. 4.14).[70] Pairs of reused columns alternating with piers divided the large central vessel of the medieval structure from the aisles; a transept before the sanctuary is suggested by the introduction of large lateral arches. The fabric is mortared rubble with varied-size brick laid horizontally between roughly squared stone. The triple-light windows of the apse and clerestory seem to be later additions. Again a narrative sequence of Christological images appears in the clerestory level, including the Passion cycle from the Last Supper to the Anastasis, rendered in individually enframed scenes on the north wall. It is possible that these frescoes were executed as part of the refurbishing of the church, though their date is problematic because they were badly damaged by picking in preparation for a later phase of decoration. Nevertheless, the appearance of two sizable basilicas functioning as congregational churches in towns in Macedonia suggests improved local resources in the eleventh century. They also indicate that the traditional basilican form and the continuous narrative pictorial sequence retained their popularity in the Byzantine provinces.

The popularity of the basilican plan in Macedonia was not limited to large congregational buildings. The Anargyroi (Sts. Cosmas and Damian), a tiny pier basilica, was built in Kastoria probably in the early eleventh century.[71] The similarity of its cloisonné fabric to the earlier churches of the city provides evidence of the vital continuity of local masons' workshops. Only fragments of the monument's first phase of frescoes survive, including the portrait of a donor with Constantine, his patron saint, and Helena in the corner of the narthex. The accompanying inscription reads: "The servant of God, Constantine, has died. The month of November on the twenty-first."[72]

From those parts of the narthex where the paintings of the second phase, which may be ascribed to the late twelfth century,[73] have fallen from the wall, it appears

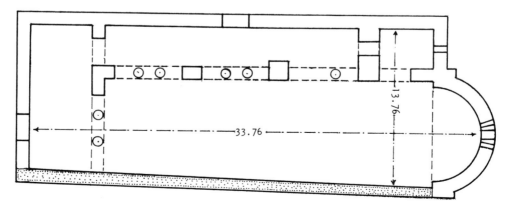

FIG. 4.14. Verria, Old Metropolis. Sketch plan (modified from A. Soteriou)

FIG. 4.15. Kastoria, Anargyroi. Narthex, arch intrados: St. Nicholas, lower plaster layer eleventh century (head); upper plaster layer twelfth century (body) (Robin Cormack)

that the later artists closely followed the original arrangement of the decoration. It is possible, then, that the Christological narrative now in the nave reproduced a cycle of the eleventh century. The early frescoes of the Anargyroi, though few in number, are better preserved than those in the churches of Servia and Verria. The figures of the Anargyroi are large in relation to their architectural settings; the figural forms have closed contours and broadly rendered features and drapery (fig. 4.15). It seems unlikely that a town of the size of Kastoria would have the means to support a workshop of professional painters. More likely, the artists working in the Anargyroi were itinerant. The generic similarity that the paintings of the Anargyroi bear to the frescoes in the crypt of Hosios Loukas and to the paintings of the Panagia tōn Chalkeōn in Thessaloniki suggests that they too date to the early eleventh century. Similarly rendered paintings are, however, found throughout the Empire at this time, making generalizations about regional workshops very problematic.[74] As in the late ninth and early tenth centuries, there is a remarkable homogeneity in the monumental art of the period.

Two late eleventh-century monuments, the Mavriotissa in Kastoria and the

FIG. 4.16. Kastoria, Mavriotissa. West wall: Koimesis (detail) (Robin Cormack)

FIG. 4.17. Kastoria, Mavriotissa. West wall: diagram of the program

Panagia at Veljusa, are emblematic of the extreme responses to Constantinopolitan form found in Macedonia in this period. The architecture of the Mavriotissa is Kastorian vernacular—a simple single-nave, wooden-roofed *katholikon* with a narthex rendered in cloisonné brickwork.[75] Its dramatic decoration may also be a regional product (figs. 4.16 and 4.17). Frescoes survive only in the narthex (the Last Judgment and a twelfth-century Baptism), on the east wall of the nave (the Ascension and Annunciation in the triumphal arch, a Virgin Enthroned with Child, seated evangelists and bishops in the apse have been much repainted), and on the west wall of the nave (the Pentecost, Washing of the Feet, Crucifixion, Betrayal by Judas, and Koimesis).[76] The rest of the church may never have been decorated. The intense expressiveness of the original paintings is realized through color contrasts, including the extensive use of black, and the dramatic exaggeration of features and gestures. The frescoes share stylistic features with later eleventh- or early twelfth-century cycles throughout the Empire, including Asinou in Cyprus, Myrtia monastery in southwest Greece, and Episcopi on the island Santorini.[77] But the unlikely monument with which it has most in common is Sant'Angelo in Formis near Capua, which can be dated between 1072 and 1087.[78] These painting cycles share certain stylistic details, such as the continuous eyebrow and rouged cheeks. More basically, the figures are equally understood as acting energetically along the surface of a two-dimensional plane. The similarity of two cycles is certainly not due to a direct link between them. More likely it stems from their parallel relationship to earlier local monuments. It has long and, I think, rightly been assumed that Sant'Angelo in Formis was dependent in its painted program, as well as its architecture, on Desiderius's great Benedictine monastery of Monte Cassino, a church decorated by Constantinopolitan artisans with the help of young apprentices recruited from the cloister.[79] The frescoes of Sant'Angelo may thus represent the work of local artists trained by metropolitan masters. As the artist of the Mavriotissa appears to exaggerate effectively the dramatic style found in St. Sophia in Ohrid, it may perhaps be tentatively suggested that he was a local person who worked with the master of the frescoes of the archdiocesan cathedral.

The Mavriotissa's frescoes reflect a regional sensibility not only in their apparent response to the metropolitan paintings of Ohrid but also in the unusual iconographic features of the program. First, the cycle, with its emphasis on the Passion and Last Judgment, is exaggeratedly eschatological. Further, the representations of the apocryphal episode of Jephonias the Jew's attempt to upset the bier of the Virgin in the image of the Koimesis and of Synagogue being ejected from the site of the Crucifixion make an oddly early appearance in the Mavriotissa. The prominent placement of these scenes on the central axis of the west wall, along with the Jews in the furnaces of Hell in the Last Judgment, suggests a certain anti-Semitism.[80] There was, in fact, an important Jewish rabbinical school in Kastoria in the late eleventh century, led by the Rabbi Tobiah ben Eliezer. This rabbi bitterly described the tragedy of the Jews of Mainz, where seven hundred men, women, and children were slain by Crusaders. He must also have been aware of the threat of similar dangers attendant on the Crusaders' passage through Macedonia on their way to the Holy Land. He is mentioned in a puzzling passage of a letter written by a Thessalonikan Jew in 1096:

At the present time we are looking forward to receiving letters from R. Tobiah and from the holy congregations. For we are amazed at the great miracle that has occurred in Thessaloniki, where the Christians have always hated the Jews most intensely. . . . For had the sign and great miracle not taken place, and had the king not heard of it, not one of the Jews would have escaped.[81]

The Crusaders' approach certainly elicited apocalyptic fears among the Byzantines. The frescoes of the Mavriotissa suggest further that the Latins' anti-Semitism infected the Christians of Kastoria in the aftermath of their halt outside the city on Christmas in 1096. In any case, nothing is heard in the twelfth century of the once-flourishing Jewish community of Kastoria.

If the Mavriotissa shows the power of local donors and artisans to produce an impressive statement of regional concerns, another monastic foundation in Macedonia, the Theotokos Eleousa at Veljusa, demonstrates the continued attraction of the metropolis for the patrons of monuments in the provinces.[82] The inscription which appears over the main door into the church reads:

This church of the most holy Theotokos Eleousa was raised from its foundations by Manuel the monk, being bishop of Tiberioupolis [Strumica], in the year 1080.[83]

Several imperial charters and the *typikon* of the monastery have also survived, providing considerable insight into the nature of monastic life in the small cenobitic community and into the character of the founder.[84] Manuel, needing a place of respite from his labors as bishop, founded the monastery in a desolate, "un-Christianized" location near Strumica. Manuel carefully specified that this was a private foundation, built with family, not ecclesiastical, funds. He wrote the monastery's charter and appointed its *hegoumenos*. A tomb was prepared for him in the church. Despite his spiritual office and his own early monastic experience in the famous monastery of St. Auxentius in Bithynia, Manuel fits the mold of a secular patron rather than that of a charismatic holy man. How he came to hold his bishopric in Macedonia is unknown; that he had ties with Constantinople is evident, however, from the rapidity with which he received imperial grants. As early as July 1085, Alexius I Comnenus granted the monastery general exemption from taxes and independence of civil and religious authorities. While the patronage pattern is that of the Byzantine aristocracy, Manuel gives the impression that his wealth is not unbounded. He wrote, for instance, that the transformation of the barren land of the site into a monastic property was carried out at great personal sacrifice. Further, Alexius I's second grant of 1106 seems to have been made to relieve the poverty of the monks. Thus the monastery was not only small (its membership was limited to ten monks) but also perhaps undersubsidized.

The social and economic circumstances of the patron had material repercussions in the monastic church that he founded. The Virgin Eleousa is a tetraconch with a cruciform narthex and a tiny centralized *parekklesion* (fig. 4.18). The exonarthex and the southern subsidiary burial space are twelfth-century additions. In scale and sensibility, if not in the detail of articulation, the church is not unlike the eleventh-century Panagia Kamariotissa on the island of Heybeliada, at Chalki, close to Constantinople.[85] The treatment of the fabric is also reminiscent of build-

FIG. 4.18. Near Strumica, Veljusa, Virgin Eleousa. General view of the exterior from the southeast

ing in the capital. The modeling of the wall, with triple-ordered blind arches and two-story niches, and the use of sawtooth cornices have parallels in metropolitan churches such as Gül Camii, from the end of the eleventh or beginning of the twelfth century, or Christ Pantepoptes (Eski Imaret Camii), which dates to sometime before 1087.[86] Despite these Constantinopolitan aspects of the church at Veljusa, certain features of the structure establish its Macedonian character. Its elongated proportions make the monument conspicuously top-heavy, similar in sensibility to the early monuments of Kastoria. The fabric of the church was also covered with stucco and painted with banded brick and stonework. A similar stucco layer is found a century later on St. George at Kurbinovo.[87] As at the church at Asinou in Cyprus, poor-quality masonry was disguised by plaster painted in imitation of a more finely worked facade. The building appears to have been constructed by a local mason who knew something of current trends in Constantinopolitan architecture.

The decoration of the church, which is apparently contemporary with its construction, displays the same ambiguous relationship to Constantinopolitan artistic impetus as is found in its architecture.[88] Frescoes survive in the nave, sanctuary, narthex, and parekklesion, but the best-preserved paintings are in the central dome, where the Virgin, Baptist, angels, and prophets surround the bust of the Pantokrator. The figures are somber, broad-hipped, and bulky. Instead of the bright pastels of Ohrid and the Mavriotissa, the palette is dominated by blues and dark ochres. The artist sought to give his figures volume by modeling rather than

layering their flesh and by treating their drapery more freely, less schematically. He seems to be attempting a seminaturalistic, not to say classicizing, style of the sort found in the mosaics of Daphni, which are usually ascribed to the late eleventh century. The Veljusa master does not, however, handle this style with great assurance.

The program of the paintings at Veljusa is as intrusive as their style. The scheme of the central dome has been considered archaic or transitional, combining the current theme of the Pantokrator and prophets with the Virgin and angels from the Ascension common in earlier domes. More likely, the Virgin, Baptist, and archangels represent the migration of the popular Deesis from the templon screen or triumphal arch into the dome under the pressure of the chapel's limited space. Other images are equally current. The Christ in a mandorla carried by angels in the conch of the *parekklesion* is identified by Djurić as an image of the synaxarium of the archangels.[89] If this observation is correct, then the image is one of the earliest monumental examples of a subject which becomes particularly popular in the fourteenth century.[90] More notable is the representation of the bishops in the apse, depicted as turning toward a central *hetoimasia*, the prepared throne with a book and dove. This liturgical theme developed its most explicit form with the infant Christ represented on the sacrificial altar only in the later twelfth century. The appearance of an early form of this theme in the late eleventh century at Veljusa suggests that the subject evolved over the course of a hundred years.[91] This kind of iconographic innovation suggests a familiarity with metropolitan theological, as well as programmatic, developments. The style of the frescoes and the program of the decoration, as well as the architecture of the church, confirm the documentary evidence of Manuel's connections with Constantinople. At the same time, Manuel's financial problems may help explain the limitations found in both the structure and its decoration.

THE TWELFTH CENTURY

Much of the considerable artistic activity in Macedonia during the second half of the twelfth century took place outside the two major centers of the province. Perhaps the most impressive work is found in St. Panteleimon at Nerezi, not far from Skopje. This church seems to have been built and decorated at the behest of a donor closely connected with the elites of the capital.[92] An inscription on the lintel over the entry into the nave reads:

> The church of the holy and renowned great-martyr Panteleimon was beautifully made with the aid of Lord Alexius Comnenus, son of the purple-born Theodora, in the month of September, indiction 13, 1164, Ionnikos the monk being *hegoumenos*.[93]

The patron of this *katholikon*, Alexius Comnenus, was a scion of the Angeloi and closely related to the ruling family. It might be assumed that such a well-

connected patron, possibly *dux* of Macedonia residing in the province's nearby capital of Skopje, could bring to his foundation an artist from the capital. Not only the donor's judgment that the church was beautifully made but also an assumption of metropolitan impetus is vindicated by the sophistication of the original painted decoration of the church.

Only the lower parts of the twelfth-century program survive at Nerezi. When the church was repainted in a post-Byzantine period, the original plaster, along with its layer of fresco, was scraped from the vaults to assure the adherence of the new plaster. At the same time the paintings on the walls of the church were simply plastered over and repainted. These original frescoes, uncovered in 1923, are well preserved; their deep, clear blues and greens and their brilliant pastels retain their resonance.[94] The individual figures show an expressive force at least comparable to the Ohrid frescoes. The eloquence of the figures complements the emotive themes selected to adorn the church. The Threnos, a moving depiction of the Virgin's lamentation over her dead son, is among the earliest examples of this subject found in monumental painting (fig. 4.19).[95] The emergence of this theme can perhaps be related to the new sensitivity to individual responses that develops in the second half of the twelfth century, identifiable in literature as well as art.[96]

The quiet passion of the Threnos in St. Panteleimon is derived not only from

FIG. 4.19. Nerezi, St. Panteleimon. North arm of the nave: Threnos (north wall), Deposition (west wall), and holy monks (only four of the five monks on the north wall are visible) (David Wright)

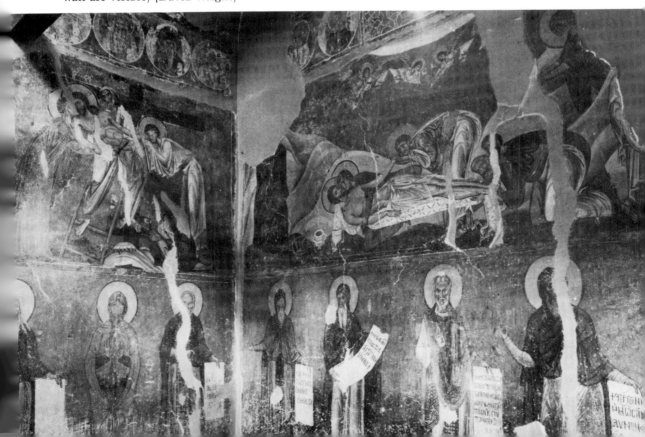

the dramatic rendering of the figures but also from the solemnity of the composition. The image, which appears in the zone below the windows on the north wall, is carefully symmetrical. John bending over Christ is the fulcrum of the composition, between the Virgin holding her son's head and two figures at his feet. This figural focus is further framed by the entrance to the tomb on the left and a standing figure on the right. The subtle bilateral symmetry of the scene is reinforced by the two facing angels and the window mullion above John. The broad rhythm of the composition, established by the five amply spaced emphases, is repeated by the five frontal holy monks below. The consciously reiterative placement of standing saints below the principal figures in the narrative scenes above is consistent throughout the program. Except in the crowded scenes from the life of the Virgin at the west end of the church, the Nerezi master created large, uncluttered compositions. There is no sense of *horror vacui*, no cramping of the figures' movements. As in the New Church of Tokalı Kilise, the decorative scheme seems to have been laid out with great care.

The church of Nerezi initially appears to be a poor vessel for a painted decoration of such a high level of craft (fig. 4.20). Its irregular plan, its squat symmetry, and its motley patchwork construction make it seem a cheap work, related by its building techniques and stubborn murality to other buildings in the region.[97] Nevertheless, in its open, broadly handled interior space, Nerezi reflects current developments in Constantinopolitan architecture. Churches like the late eleventh- or early twelfth-century phase of the Kariye Camii and Gül Camii, or the twelfth-century phase of the Kalenderhane Camii, seem to suggest a new concern for breadth realized in a large cruciform core covered by a central dome. It is the new spaciousness which allows the master of Nerezi to develop his compositional formulas with such great success. The dignified unfolding of such a richly narrative cycle like that found at St. Panteleimon would have been impossible in a cross-in-square church of similar size. In any case, the balance between architecture and fresco decoration, in addition to the stylistic and iconographic features of the program, suggests that the paintings and the building may be ascribed to the same period. Attempts to date the paintings later than 1164 have rightly been rejected.[98] St. Panteleimon at Nerezi stands as an impressive reminder of the contribution of the Comnenian dynasty to Byzantine art.

Patronage of a very different level is found in Kastoria. The church of St. Nicholas Kasnitzes was built probably in the third quarter of the century. The inscription over the west door reads:

> Having received many gifts, thrice-blessed, from the time that I came into this place of weeping; sinner, piteous (fellow), servant, base (person), even now (I) Nicephorus, by fortune *magistros*, surnamed Kasnitzes, with ardent zeal raise a church from the very foundations shining with holy embellishments and all sorts of varicolored images, for you, dispenser of all good (things).[99]

The inscription provides some sense of the donor's passion both for God as the source of good things and for beautiful paintings. His title, *magistros*, had been devalued since the later eleventh century and had all but disappeared by the second half of the twelfth. Consequently, Nicephorus may be identified as a *ktetor* (founder) of not necessarily more than local standing.[100]

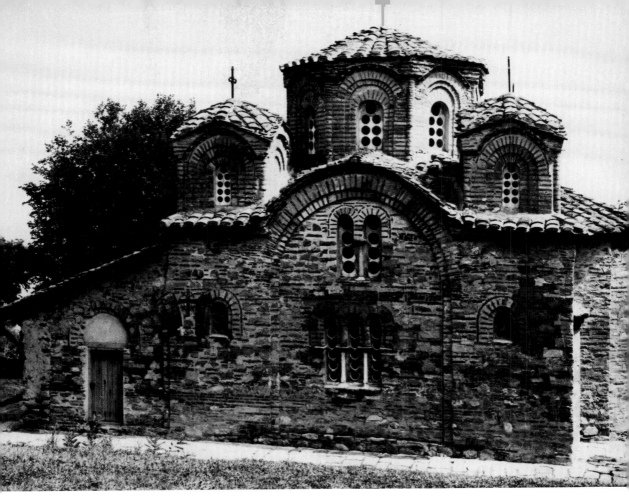

FIG. 4.20. Nerezi, St. Panteleimon. General view of the exterior from the south

Nicephorus's church, like that of Alexius Comnenus's, is comparatively more spacious than earlier churches in Kastoria, but the breadth of the interior is realized through an extremely simple plan. The church is a single-nave, wooden-roofed building with a narthex. Its facing of brick and small blocks of stone treated in the cloisonné manner indicates that it was built by local artisans. Certain shortcuts taken by the masons reflect their dependence on earlier structures in the city: The cut-tile bands ornamenting the drum of the Koubelidiki are imitated in St. Nicholas (and in the Anargyroi) with a cornice of tiles with diagonal finger patterns filled with mortar. The fabric generally is handled more slickly than the churches of the ninth and tenth centuries, with running patterns in the brickwork and more consistent sawtooth string courses. The continuity of the building form in Kastoria provides an excellent example of the vibrant local architectural traditions independent of Constantinopolitan influence which flourished in the provinces.

Nicephorus, who is depicted holding a model of the church in the narthex along with his wife, Anna, was rightly proud of the frescoes which adorned his foundation. The lower walls are filled with standing saints.[101] Because of the plan of the church, the images of *proskynesis* appear on the lateral walls to the west of the

FIG. 4.21. Kastoria, St. Nicholas Kasnitzes. West wall: Koimesis (N. K. Moutsopoulos)

original sanctuary screen: the Pantokrator to the north and St. Nicholas to the south. In contrast to Nerezi, where the Virgin and Panteleimon are enclosed in elaborately carved marble frames,[102] Nicholas appears under a blind arch and Christ in a painted trilobe niche. Expensive materials are mimed in relatively cheap ones. On the upper walls (as there is no vault) are quadratically enframed scenes from the life of Christ. At Nerezi, the master fully exploited the architecturally determined picture plane. The unarticulated surfaces of St. Nicholas lent themselves to an unarchitectonically conceived continuous narrative. For example, the Koimesis on the west wall is not centered over the entrance into the nave as at Asinou or in the Mavriotissa but was shifted to the left to accommodate the smaller image of the Transfiguration (fig. 4.21). The narrative strategy may also have induced the artist to reverse the normal position of the Virgin, thus reinforcing the eye's movement from left to right. To the east the orans Virgin appears in the apse; in the pediment above is the Deesis. The program emphasizes the dedicatory saint. His portrait is prominently displayed not only in the nave but also in the narthex, along with an early monumental cycle of scenes from his life.[103] A separate panel of the Baptism was added to the right of the entrance into the nave also in the later twelfth century. Fresco icons of the Baptism were introduced in

the same position at about the same time in other churches in Kastoria, including H. Stephanos, the Anargyroi, and the Mavriotissa, apparently in response to a changed liturgical usage of the space (fig. 4.22). The rite of the Blessing of the Waters may have been moved to the narthex at this time.[104]

The paintings in St. Nicholas Kasnitzes are related to those found in Nerezi—elongated figures with dramatically delineated features freeing themselves from the plane on which they act. The frescoes of Nicephorus's church also have features in common with the late twelfth-century paintings in the second phase of decoration of the Anargyroi in Kastoria and those in St. George in Kurbinovo, a village just over the present Yugoslav border (figs. 4.23 and 4.24). The same master appears to have worked in both these later churches.[105] An *ad quem* date for both cycles was provided by one of the artists working in Kurbinovo, who noted on the back of the altar: "We have begun to decorate the church on the 25th of April, indiction 9, in the year 1191."[106] Apart from this inscription, nothing is known about the history of St. George at Kurbinovo, though its remote location would suit it to a monastic function. The function of the Anargyroi is suggested by inscriptions: At least by the later twelfth century, this church seems to have served a monastic purpose. The donor of the redecoration is portrayed with his wife and son presenting a model of the church to the Virgin on the south wall of the north aisle.[107] An inscription identifies him as Theodore Lemniotes, the donor. Theodore seems to have retired to the church as a monk, taking as his new name one starting with the same letter as his old one, in traditional Byzantine fashion. The bearded figure beside the image of Christ in the south aisle is inscribed: "Theophilus, *monachos*, Lemniotes and *ktetor.*" A graffito on the image of the Anargyroi at the entrance to

FIG. 4.22. Kastoria, Mavriotissa. East wall of the narthex, to the right of the entrance into the church: Baptism (Robin Cormack)

the church also suggests that the church was associated with a monastery. It reads: "The servant of God Lazarus the monk has fallen asleep."[108] As in the case of Nicephorus Kasnitzes, there is no reason to assume that Theodore/Theophilus was a metropolitan magnate. The fragmentary inscription over the entrance to the church includes a reference to the church's frescoes ("... the most real of the miracles of which I paint the images ..."), but no mention is made of titles held by the founder.[109] The redecoration of the Anargyroi and the foundation of St. Nicholas were apparently undertaken by local notables. The same patronage pattern probably applied to Kurbinovo.

The complex basilican arrangement of the eleventh-century Anargyroi contrasts with the simple forms of both St. Nicholas Kasnitzes and St. George at Kurbinovo. Like St. Nicholas, the church at Kurbinovo is a single-nave, wooden-roofed structure, although without a narthex or a blind arch for an image of *proskynesis* on the wall. The structure is mortared rubble. However, the relatively high status of brick as a decorative medium is indicated in the ornamentation of the church's facade: It was originally plastered, then painted, to give it the appearance of cloisonné brickwork.[110] Thus, in a sense, St. George is related to Kastoria not only by its frescoes but also by its architecture.

FIG. 4.23. Kastoria, Anargyroi. Triumphal arch, north side: angel (Robin Cormack)

The program of the frescoes of the church follows a scheme not unlike that of St. Nicholas Kasnitzes: saints on the lowest register of the wall and feast scenes in the second register. The pediments are devoted to the Ascension to the east and the Pentecost to the west. At Kurbinovo, standing prophets were represented in a third register on the north and south walls below the roof. As in St. Nicholas, images of *proskynesis*, Christ, and the military martyr St. George are depicted under painted arches on the lateral walls, just before the original emplacement of the templon screen.

The style of the frescoes of the Kurbinovo master is remarkable. The drama in which the figures participate is expressed not only in the bulging features of their faces but also in their exaggerated actions. Even the swirling drapery of the figures has become threateningly energetic. Artistic concern with decorum, so pervasive in Byzantine art, has vanished. The linear complexities of late twelfth-century painting at Lagoudera, in the Annunciation icon at Sinai, and in a number of other monuments associated directly or indirectly with Constantinople convey a sense of ornamental vacuousness.[111] Though intimately associated with these same works in conception and execution, the same conventions are imbued at Kurbinovo and Kastoria with an emotional intensity which borders on the expression-

FIG. 4.24. Kurbinovo, St. George. East wall, triumphal arch: angel of the Annunciation (David Wright)

istic. Twelfth-century frescoes in this mode have not been found in Thessaloniki or Ohrid.[112] Thus in small churches outside the urban centers of Macedonia, constructed and decorated apparently for local *dynatoi* (powerful men) apparently without metropolitan connections of note, a unique and impressive artistic expression emerged. Peculiarly Macedonian as this aesthetic sensibility is, it disappeared with the fall of Constantinople. Apparently even local painting traditions might be dependent on the cultural center.

5 South Italy

SETTING AND AUDIENCE

The art of Cappadocia, Cyprus, and Macedonia can legitimately be treated in a conventional chronological sequence. In contrast, it is difficult to distinguish a developmental pattern in South Italy's artistic production. This apparent lack of stylistic "progression" need not be identified with artistic impoverishment due to a lack of patronage or to the ravages of time. It might better be explained by the particular social and physical circumstances of the province. South Italy is remote from Constantinople and relatively close to alternative artistic centers. Before the Norman conquest, Byzantine holdings in South Italy corresponded roughly to the modern territories of Apulia, Basilicata, and Calabria. The province lay at the extreme western periphery of the Empire, constantly pressured by Lombard princes, German emperors, and Norman adventurers from the north and by Arabs in Sicily and North Africa from the south. No neat physical barriers isolated the Empire's holdings from either the aggression or influence of its neighbors.[1] Ethnic and cultural overlapping, common enough in the Byzantine provinces, is particularly acute in South Italy. In the other regions under consideration, not only was the Orthodox religion a unifying force, but Byzantine culture dominated Slavic, Turkic, and Arab traditions in the artistic sphere during the Middle Byzantine period. By contrast, Byzantine culture was not hegemonic in South Italy. Although Greek was spoken in some parts of the peninsula, perhaps continuously from antiquity, it was by no means the dominant language.[2] Byzantine attempts to impose the

Greek liturgy in traditionally Latin sees failed, though bishoprics were rearranged in favor of the Orthodox with some success.[3] The artistic traditions of Rome and central Italy were strong and familiar. Almost all Italo-Greek saints, for example, made a pilgrimage to Rome at some point in their careers, whereas very few went to Constantinople.[4] The capital did not, in consequence, exert the same unifying force in South Italy as it did in other provinces.

The great differences in the geological structures of various regions within the province also contributed to its lack of artistic homogeneity. Apulia is geologically separate from the rest of the Italian peninsula—a tableland consisting of stratified limestone which has been gently folded.[5] In contrast, the core of Calabria consists of a series of impermeable, crystalline rock masses. In Apulia, where limestone was readily available, ashlar masonry was common as a facing material from antiquity through the Middle Ages. During the period of Byzantine rule, ashlar tended to be small in size and set alternately with brick bands, although good-quality ashlar also occurs. Ashlar apparently had considerable status as a building material, as is evident from an inscription now immured in the wall of S. Nicola in Bari:

> At the cost of great pain and with great wisdom, the very powerful Basil Mesardonites . . . has built the *astu* with consummate technique, remaking it anew with brick as strong as stone. . . . Moreover, possessed by sincere devotion, he has erected the holy church of the glorious Demetrius, constructed in stone, so that like a lighthouse it shown clearly in its all-powerful glory for those who lived here.[6]

This quotation suggests that patrons regarded brick as good, but ashlar as stronger and more beautiful.

In Calabria, available schists were not appropriate for ashlar construction. As limestone strata were rarer, so ashlar was used more sparingly, at pressure points and for decorative details. Brick played a greater part in facing the mortared-rubble core. Plaster was used as a final, relatively cheap resort for protecting the friable mortar of the fabric. Columns were employed less commonly in Calabria than in Apulia, indicating not only that building traditions were different but also that marble *spolia* were more difficult to obtain in the south. Geology contributed to the different architectural aesthetic of the two regions: Apulian monuments tend to be lighter, less massive, and more linearly articulated than Calabrian works.

Geography also modeled the economies of the two regions and thereby further affected building traditions. In Calabria, rough terrain made large-scale grain production impossible. Subsistence farming with the addition of a money crop such as mulberry and silkworm apparently provided the economic underpinnings of the region.[7] Natural harbors were rare and overland travel was extremely difficult. In consequence, the population was sparse and cities relatively small. Tiny hillside towns such as Rossano and Stilo lacked the wealth to construct massive basilicas. The economy of Apulia was essentially different from that of Calabria. The Apulian plain provided agricultural land for staple crops.[8] Further, its coastal cities—Bari, Trani, Brindisi, and Taranto—became important trading centers, generating wealth for merchant classes and landowners, and contributing to the devel-

opment of an urban economy.[9] The scale of these towns, as well as the relative
wealth of their populations, provided the patronage base for the construction of
large ecclesiastical monuments.

Civic pride may have further stimulated church construction as a reflection of a
city's importance. Although evidence is limited, the prominence given to com-
munes in the annals of the cities suggests a self-consciousness on the part of the
local elite rarely found elsewhere in Byzantium.[10] Archbishops tended to have
strong family or economic connections with their sees, and townspeople may
have occasionally had a voice in the election of bishops.[11] Even villagers might play
a role in the selection of the abbot of a monastery located in their midst.[12] The un-
characteristically large scale of some of the pre-Norman buildings in South Italy,
as well as typical controversies over the possession of venerable relics, may thus
reflect not only wealth but also a degree of urban self-consciousness uncommon
in the Byzantine provinces.[13] The third and fourth sections of this chapter discuss
the archaeological evidence of emergent urban life in South Italy during the Byz-
antine period and the impact of this Byzantine architectural tradition on post-
Byzantine Norman building practice.

Because of the many Italo-Greek saints' lives that have survived, monastic
habits in South Italy are much better documented than urban institutions.[14] The
vitae (lives) of these holy men, often written by their disciples, have a vivacity and
authenticity commonly lacking in the genre. They eloquently testify to the vari-
ety and fluidity of Orthodox monastic forms. A monk might live alone, with a sin-
gle companion or in a small group, as a hermit, in a lavra (like the monks on Athos
before St. Athanasius), or in a cenobitic establishment. Women's options were cir-
cumscribed: They lived in organized monastic communities.[15] In contrast, male
monks moved readily among the various monastic modes, though the *vitae* sug-
gest that the eremitic life, with its considerable independence, was most presti-
gious. This independence is reflected in the transience of South Italian monks,
who traveled extensively—to go on pilgrimage, to escape the notoriety of their
own holiness, or to flee Saracen raids.[16] The cenobitic communities of South Italy
grew up around model ascetics and were regulated more by imitation than by law.
The rule of St. Basil was mentioned on occasion, but this rule functioned as a
statement of principles rather than a legislative code. Like bishops, holy ascetics
tended to be local men, often from well-to-do families. Part of their appeal to their
fellows may have resided in the real sacrifice entailed by their rejection of the
world. Though the spiritual authority of the holy founder was never questioned,
his status was not materially expressed. Individual monks dressed, ate, lived, and
worshipped alike. The *hegoumenos* labored alongside his spiritual children. With
his disciple Stephen, Nilus returned annually from his hermitage to his monastery
to help with the harvest. Elias Spelaeotes sweated along with his brethren in the
completion of their God-made cave chapel.[17] Such an ascetic ideal of equality was
rarely realized in great propertied foundations established by metropolitan mag-
nates, though it was often enough expressed in their *typika*.

Provincial monks served important community functions. They were local
prophets and healers. Because of their proximity to God, their efficacious prayers
were sought by peasants for their harvests and by local governors for military pur-
poses. In decision making their judgments could be trusted because they had no

vested interests. Luke of Isola Capo (d. 1114), when asked to judge between two peasants in a dispute over crop damage done by an errant cow, caused the guilty party's hand to wither.[18] Elias the Younger (d. 903) was a prophet of the future even in his adolescence; he delivered Christians who had fallen into unbelievers' hands; he healed the mentally and physically ill; and he avenged himself on a government official who refused to recognize his holiness. Such activities attracted the attention even of the emperor.[19] Impressed by Vitalis's (d. 994?) counsel and miracles, the *dux* of Bari offered him gold and silver. Vitalis, however, accepted only liturgical vessels and holy images for his church.[20] The *strategos* Basil first proffered precious fittings for St. Nilus's oratory and then offered to replace his mud-brick chapel with a grander church. Nilus refused both gifts, knowing prophetically that Saracens would destroy the site.[21]

These last two episodes suggest that Italo-Greek monks might be the objects of artistic patronage. Ascetics also built churches on occasion. Luke constructed a basilica dedicated to St. Peter in a naturally fortified position at Armento. Bartholomew (d. 1055) built a church dedicated to the Theotokos, adorned it with images, and filled it with precious furnishings. Leo-Luke (d. 910) was buried with great pomp in another church of the Theotokos, erected on the site of his cell. Elias the Younger was entombed in the *katholikon* of his foundation at Salinas, which received gifts and revenues from the Byzantine emperor.[22] Saints' lives also indicate that figural images adorned monastic chapels. The catepan of Bari provided Vitalis's church with images, and John, monk in Leo-Luke's monastery on Mount Mula near Casano, was cured of elephantiasis by the application of oil from a lamp placed before the image of the Theotokos.[23] It has been argued that the extreme asceticism of monks of South Italy explains the relative dearth of artistic material surviving in the province. This chapter suggests that monks affected the artistic and architectural, as well as the spiritual, traditions of South Italy more positively.[24] The following section of this chapter attempts to define some of the features of the artistic habitat of the monk or pious layman.

SMALL FOUNDATIONS

In Italy, as elsewhere in Byzantium, it is difficult to distinguish small monastic foundations from private oratories. Monasteries were located both inside and outside cities and villages. In Taranto, for instance, six of the eight churches known to have existed inside the walls in 1080 belonged to monastic foundations.[25] Similarly, physical surroundings only occasionally aid in the identification of a church's function. While monastic subsidiary buildings indicate that the chapel was part of a cenobitic community at some time, the absence of a refectory, cells, storehouses, and the like does not prove that the church never had a monastic function. Secondary structures, like other medieval domestic buildings, were commonly built without substantial foundations in ephemeral materials such as mud brick and timber. Furthermore, the liturgical accoutrements of private chapels do not appear to be distinct from those of small monastic foundations. At

least occasionally it seems that a structure built as a private chapel might be converted to monastic use. Instances of monks occupying deserted oratories are common in the lives of Italo-Greek saints. After becoming monks, Christopher and Sabas retreated to a solitary place called Ctisma and restored a church dedicated to the archangel Michael. Other ascetics soon joined them in their new community.[26] Even more commonly, judging from legislation, a man might establish a church, then later become a monk in it—perhaps a form of retirement.[27] Without the aid of epigraphic or literary documentation, it is not always possible to determine the specific function of these small churches. As monastic chapels and oratories seem to have drawn their audiences from the same social group, a distinction may not even be critical to an understanding of the monument.

The rock-cut churches of the province best preserve the setting of privatized piety in South Italy.[28] The greatest number of cave chapels are located in southwest Apulia, around the towns of Matera, Massafra, and Ginosa, where the ridges and canyons which resulted from the erosion of stratified limestone provided suitable sites for the excavation of caves, not only for monks but also for the peasant population. Elsewhere in Apulia and in Calabria, cave builders were often forced to excavate below ground level into a limestone substratum or find an appropriate natural cave in the much harder volcanic rock masses. Consequently, cave churches outside southwest Apulia tend not only to be simpler and rougher but also more isolated. Even in the most favorable limestone areas the material was not as pliable as the soft tuff of Cappadocia. Nevertheless, being permanent, secure, and ready to occupy with minimal material commitment, cave churches were well suited to function both as private oratories and as chapels for the small, transient monastic communities of the peninsula. When practical difficulties or the desire for more elaborate facilities required some expertise, cave excavation did not necessitate a large skilled labor force so much as a single master to direct the excavation, as illustrated in the *vita* of Elias Spelaeotes:

> 42. When the brothers had increased in number, making for crowded conditions in the small grotto, the Lord God deigned to make manifest a sacred and famous cave to his servants in this manner. A great number of bats flew up through a small crevice from the hillside over-head, and in the morning flew into it. Our fathers, having seen this many times, concurred that there was a hollow in the hill below the opening. They took up torches because of the smallness of the entrance and the narrowness of the opening through which they could scarcely go. Within they beheld a great cavern, spacious in its height, breadth and length. The devout man rejoiced in this and glorified the Spirit because it was as a church prepared for them by God. However, his purpose was sorely vexed anew because the sun's rays were not admitted through the entrance passage for lighting the cave. But God, knowing the cause of his anxiety and heeding their prayers, unexpectedly sent to him a man experienced in all things, whose name was Cosmas. Going into the cave and coming outside, carefully examining the hill, and hiring as workers men who were experienced at cutting stone, he carved a spacious entry to the cave in the middle of the south wall. Thus the light of the sun shone on the things inside so that the bats flew out since they needed darkness for wickedness and the adjustment of their senses. In this way the place fit for demons became in a short time a cavern for the lovers of God.

43. Now Cosmas had settled there and labored on great works for the monastery, a salt pit for the use of the monastery and a small mill by which to grind wheat; in peace upon completing these things, he died. In the meantime, our holy father Elias by much hard work and perspiration fitted out the formless interior [of the cave] with his brothers, building the altar which was dedicated, designated as a holy sanctuary, and named after the well-loved and holy apostles, from which he had received help through prayers.[29]

Apparently a skilled worker was needed to plan and execute the alteration from natural cave to chapel, and hired stonecutters provided the labor. Although Cosmas came to work as a professional mason, he may have then joined the monastery, providing his expertise free, as one of the monks. Elias and his brothers managed the internal arrangements of the cave themselves. Thus cave churches not only required less wealth, they also invited communal participation.

Despite the intractability of the stone into which these churches were carved, many were shaped to conform with the liturgical requirements of the Orthodox rite. The nave took a variety of forms; there were hall churches and double churches, squat basilicas with longitudinal pier arcades of two or three bays,[30] and cross-in-square chapels. In most of the cross-in-square churches, including S. Leonardo in Massafra, S. Maria in Poggiardo, S. Domenica in Ginosa, and S. Salvatore in Giurdignano, the nine bays of the nave tend to be equal in size.[31] Elsewhere in the Empire, the central bay was dominant in breadth as well as height in churches of this plan. The crescendo of volumes which characterized the familiar Byzantine cross-in-square plan was lost in a cave chapel like S. Salvatore, where

0 1 2 3 M.

FIG. 5.1. Giurdignano, S. Salvatore. Sketch plan

FIG. 5.2. Matera, S. Barbara. General view of the interior to the east: rock-cut *templon* screen

space was cubically compartmentalized (fig. 5.1). S. Salvatore was typical of rock-cut churches also in its lack of a narthex or carved anteroom. Moreover, the height limitations and intractability of the limestone strata dictated simplified "vaulting" systems. In Giurdignano, stepped medallions with central crosses in relief over the eastern bays suggest cupolas. Although the impression of a nine-bay cave church is very different than that of a masonry monument, the conception of the space is essentially the same.

As in Cappadocia, the liturgical furnishings of these cave churches often escaped destruction because they were excavated out of the living rock; they provide otherwise lost documentation concerning the internal arrangements of small medieval chapels.[32] The plan of S. Salvatore exemplifies the relatively large amount of space devoted to the sanctuary in these cave churches. There was usually ample room for the officiant and deacons. Further, the sanctuary was often provided with a *prothesis* and *diakonikon*; where side apses were absent, subsidiary niches commonly were substituted. In Giurdignano the side apses as well as the central apse were provided with permanent rock-cut altars. These churches are most informative about sanctuary closures. Low screens of paired, rock-cut parapet slabs defining a narrow entrance into the sanctuary were common. As in S. Salvatore, these closures were carved between the eastern piers of the cross-in-square plan; the sanctuary thus usurped the eastern bays of the nave. In most churches, there are no postholes or other marks indicative of an additional curtain or iconostasis. In a

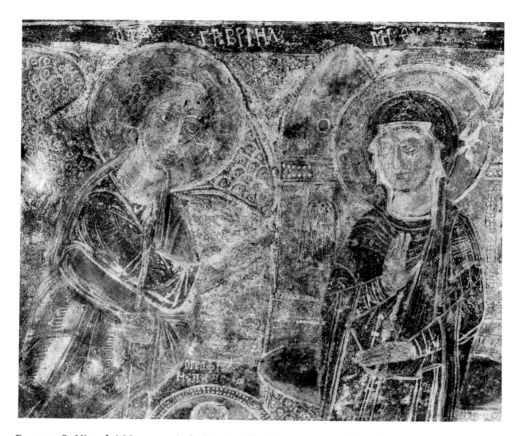

FIG. 5.3. S. Vito dei Normanni, S. Biagio. The Annunciation (detail)

few chapels there was a high screen, consisting of a thin wall of rock pierced by an arched door and roundheaded windows, as in St. Barbara at Matera (fig. 5.2).[33] Although these *templa* dramatically separate the nave and the sanctuary, there is again no evidence that their doors or windows were closed or veiled. In South Italy as in Cappadocia, it appears the laity was not yet divided from the priest and his offering by an opaque barrier.

As the liturgical furnishings of the rock-cut churches of the province reflect on what has been lost of medieval monuments above ground, so their fragmentary decoration provides some insight into the programmatic traditions of Byzantine South Italy. One of the most elaborately decorated cave churches to survive in the province, S. Biagio at S. Vito dei Normanni, is dated to the late twelfth century by inscription (fig. 5.3):

> The venerable church of the holy martyr Blasius, our father, was built and decorated in the time of the *hegoumenos* Benedict, through the benefaction of . . . by the hand of master Daniel and . . . in the year 1197, indiction 15.[34]

FIG. 5.4. Carpignano, SS. Maria e Cristina. General view of the south wall. Frescoes of 1020 on the left and of 959 on the right

Here, just as in Cappadocia, a monastery seems to have attracted a patron to subsidize the decoration of its chapel. The painted decoration of the irregularly rectangular cave includes a prophetic vision of the Ancient of Days, images from Christ's infancy and the Entry into Jerusalem, a scene from the patron saint's life, and standing saints. The stocky figures of Mary and Gabriel in the Annunciation fill the height of the register they occupy. The Romanesque device of an enframing blue ground controls their restrained gestures and restricts recession, while flat drapery highlights limit the projection of the figure on the viewer's side of the picture plane. The figural style and compositional features, which are reminiscent of late ninth- and early tenth-century painting in Byzantium, might suggest that Daniel depended on an earlier model. Nevertheless, the delightfully ahistorical inclusion of the prophet roundels within the narrative frame, as well as a number of the iconographic details in other scenes, indicates the artist's distance from any Byzantine prototype.

S. Biagio is exceptional in the richness of its narrative program. From what survives, it appears that nave decoration in South Italian rock-cut churches was usually limited to isolated panels dedicated by individual members of the congregation. For example, in the chapel of SS. Marina e Cristina at Carpignano, an enthroned Christ in a niche flanked by the figures of the Annunciation is accompanied by an inscription naming the donor and the artist (figs. 5.4 and 5.5):

> Remember, Lord, your servant Leo the presbyter and his wife Chrysolea and his son Paul. Amen. Written by the hand of Theophylact the painter in the month of May in the second indiction in the year 959.[35]

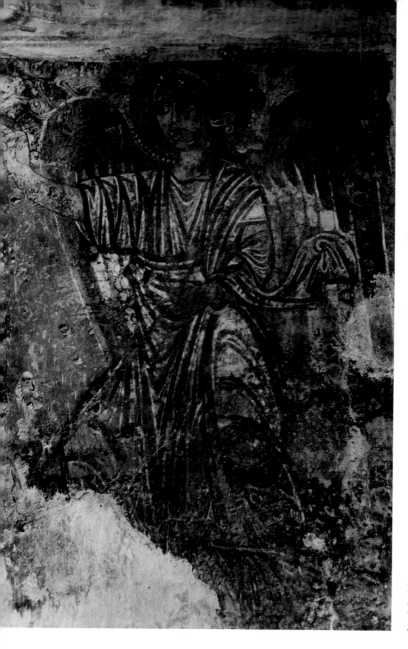

FIG. 5.5. Carpignano, SS. Maria e Cristina. South wall: angel of the Annunciation

The local priest and his family offered images to God in the hope of being remembered. As in the case of the paintings in S. Biagio, this fresco bears no relation to contemporary Constantinopolitan work. The proportions of the figures, their domination of the picture plane, even the geometric treatment of highlights and the extensive use of heavy outline again suggest that the artist worked from an earlier model. A later painting in the same cave indicates how strong the influence of such a model might be. In 1020 a second votive image representing an enthroned Christ flanked by an enthroned Virgin and Child and an archangel was painted in a second niche on the same wall as the first image. Its inscription reads:

Remember, Lord your servant Andrianus and his wife and children . . . rebuilding and painting these holy icons (?), in the month of March indiction 3 in the year 1020. Written by the hand of Eustathius the painter. Amen.

Not only was the dedicatory formula derivative, but the image was dependent in its style and iconography on the earlier painting: The impact of one local work upon another is apparent. Among the other panel paintings in the chapel is an image of S. Cristina opposite the main entrance to the chapel. This icon too is accompanied by an inscription. The first half movingly commemorates the death of a child beloved by his parents, requesting that the Virgin, along with Nicholas and Christine, place him in the lap of Abraham; the second half originally named the donor and identifies him as a *spatharios* and inhabitant of Carpignano.[36] André Jacob, who published the inscription, ascribes it to the eleventh century. A personage of more than local standing was apparently content to commission a local painter to execute a votive image in a local cave church. The paintings at Carpignano are unusual in that some of them are datable, but here as elsewhere the number of panels and the variety of local artists employed attest to communal participation in the decoration of neighborhood shrines.

The choice of saints for the panels in the Apulian cave churches also reflects the particular character of South Italian patronage. Both the localism and the diverse cultural linkages of the region affected these choices. South Italy's geographical proximity to Rome and the Latin West is as clearly articulated in the hagiography of cave paintings as it is in South Italian monks' lives. Among all the apostles, Peter is by far the most commonly represented. Saints with Roman connections like Silvester and Lawrence occur regularly. Benedict, patriarch of Western monasticism, also appears often. He seems to have been venerated by both Latin and Greek monks in South Italy. One of the most renowned of the South Italian Orthodox saints, Nilus, composed a canon in Benedict's honor while he was resident at Monte Cassino.[37] Some saints who appear in South Italian cave churches, like Basil, Panteleimon, the Anargyroi, and Demetrius, enjoyed their greatest popularity in the East; others were celebrated in both the East and the West, including Parasceve, Margaret, Theodore, and Stephen. The most venerated saint in South Italy, to judge from the number of times he was depicted in the cave chapels, was Nicholas, the great fourth-century bishop of Myra in Asia Minor.[38] Nicholas's cult was established in South Italy before the theft of his relics from Myra and their translation to Bari in 1087, but it is difficult to date any of his many images before the late eleventh or twelfth century (fig. 5.6).[39] As in Cappadocia, John the Baptist was also popular.[40] Not all cults were imported; some saints in these chapels were local. S. Cataldo, bishop of Taranto and patron of Palermo, is depicted in the caves, as were S. Cristina of Bolsena, whose relics were taken from Bolsena to S. Salvatore in Palermo in 1160, and Vito, patron saint of Paestum.[41]

The votive character of the nave programs of these cave churches is distinctively South Italian. However, their sanctuaries are often adorned with the Deesis, so familiar from Byzantine programs. For example, in the church of S. Nicola in Mottola, the piers and blind arches of the walls are decorated with icons of saints on superimposed plaster layers which have been variously dated between the eleventh and thirteenth centuries (see fig. 5.6).[42] Behind a low screen, on the back wall

FIG. 5.6. Mottola, S. Nicola. Southeast arch intrados: St. Nicholas in two phases

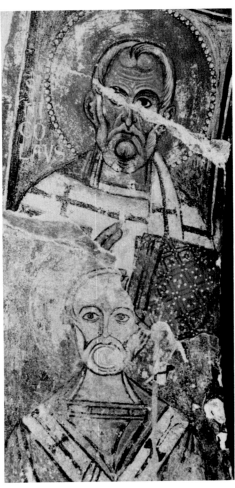

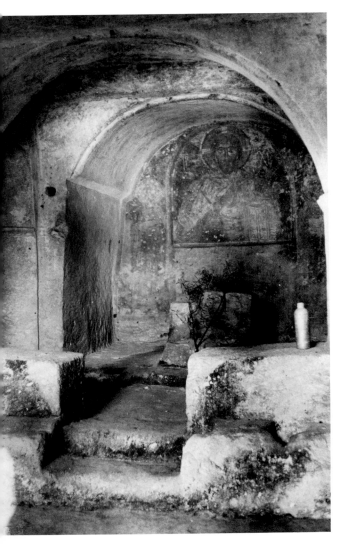

FIG. 5.7. Mottola, S. Nicola. General view of the interior to the east, showing the low sanctuary screen and the Deesis in the apse recess

of the sanctuary recess, is a Deesis (fig. 5.7). The appearance of the Deesis in the apses of both South Italian and Cappadocian cave churches need not imply a direct relation between the two provinces, but rather a similar reaction to comparable circumstances. In built churches the Deesis is associated with the sanctuary: It occasionally appears at the apex of the triumphal arch, as in St. Sophia in Ohrid; more often the theme was placed on the epistyle of the sanctuary screen.[43] Because this barrier has been destroyed or denuded in most churches, the importance of the image in the original decoration of the church is sometimes overlooked. The migration of the theme to the conch of the apse when there was no proper screen would seem a partial explanation for the Deesis' prominence in the fresco decoration of cave churches. But the theme's ubiquitousness in South Italy as well as in Cappadocia also suggests that its eschatological and liturgical implications lent it a particular appeal to monks. The Deesis in any case also appeared in the apse of the built church of S. Angelo near Monte Raparo, the only major eleventh-century Greek monastery in South Italy in which the sanctuary program survived until the present century.[44]

The small scale and particularized decoration of the cave churches of South Italy suggest that their patrons were local figures, not representatives of the great families of the Empire. This does not imply that the region was impoverished. On the contrary, the large numbers of competently rendered panels suggest that a broad stratum of the community participated in the adornment of local shrines. The difficulty in finding close stylistic analogies to these frescoes elsewhere in the Empire also indicates that regional painters received enough support to allow the establishment of local painting traditions.[45] These unpretentious chapels reinforce the impression given by Italo-Greek saints' lives of a certain independence of metropolitan hegemony.

The characteristic features of Italo-Byzantine form expressed in the rock-cut milieu find some analogy in surviving built churches. Best known of the Byzantine churches of the peninsula is the Cattolica at Stilo (figs. 5.8a and 5.9).[46] This tiny structure (c. 7 meters wide) is a cross-in-square church with sanctuary apses attached directly to the core and without a narthex. Domes raised on high drums springing from pendentives cover the central and corner bays. The vaults are supported internally by four *spolia* columns. The peculiar absence of spatial hierarchies in this church stems from the uniform size of each of its nine bays. The *prothesis* and *diakonikon* apses are equal in diameter to the sanctuary apse. Moreover, though the central dome is higher than the others, they all have the same diameter. As in nine-bay rock-cut chapels, the central cupola does not represent a crescendo of volumes as it does in most Byzantine churches. Internally, the equality of the bays exaggerates further the cellular quality of the cross-in-square plan; externally the Cattolica appears to be a delightfully odd collection of cylinders. A less uncommon feature among provincial cross-in-square churches is the Cattolica's lack of sanctuary bays to the east. Judging from the scars on the walls, a screen dividing the nave from the sanctuary was at one time set between the eastern columns of the church. As in St. Nicholas of the Roof, the three eastern bays of the nave were thus absorbed by the sanctuary. The amount of space allocated to monks or laity was even smaller than it now appears. The church also has no nar-

thex, though this might be explained by its precarious position on the side of a cliff. In many important features of its plan, the Cattolica resembles the most elaborately carved cave churches, suggesting that the latter expressed not only the peculiarities of their rock-cut medium but also architectural traditions established earlier in the province.

The simple plan of the Cattolica is complemented by its charmingly complex fabric. The body of the church is brick-faced mortared rubble. The brick is of a typical Italian variety, squat and oblong in shape, distinct from the tilelike brick used elsewhere in the Empire. But it is handled in a familiar Byzantine manner. The arches of the door and of the drum and apse windows, as well as the cornice line, are elaborated with sawtooth brick courses. Around the drums and originally over the apses, sawtooth string courses unify the structure horizontally. The drums of the domes are diapered with tile. Although the surface of the building is coloristically ornamental, the flat walls provide no indication of the support system of the building. The unarticulated wall and tall proportions of the Cattolica relate it to monuments like the Koubelidiki in Kastoria of the late ninth and early tenth century. Current scholarly opinion ascribing the church to around 900 thus seems correct.

No documentation concerning the Cattolica has come to light. It seems from the life of John Teriste, however, that a monastery existed in Stilo when the *vita* was written in the eleventh century. John's mother, carried into slavery by the Saracens while she was pregnant with the saint, describes the location of his patrimony in Stilo through reference to a monastic foundation.[47] Although the information provided by the text is too limited to identify this monastery with the Cattolica, the scale of the church and its location on the outskirts of the town suggest that it was a private or monastic foundation, rather than the ancient cathedral or episcopal church, as has been suggested.[48] Its name might even be derived from *katholikon*, the Greek term for the main church of a monastery.

Another cross-in-square church in Calabria, S. Marco in Rossano, is so similar in conception to the Cattolica that it is probably a contemporary construction (figs. 5.8b and 5.10).[49] Like the Cattolica, but without its topographical excuse, S. Marco did not originally have a narthex. The plan of the monument, as in Stilo, has nine equal-size bays and three shallow east apses. It is also roofed in the same manner, with barrel-vaulted crossarms and cupolas on steep drums resting on pendentives over the central and corner bays. The cluttered sense of the interior noted at Stilo is aggravated at Rossano by the substitution of masonry piers for columns. The internal articulation of the building is minimal; although S. Marco has pilaster wall responds for the arches (they occur in Stilo only on the east wall), it lacks cornices. The exterior is even more austere. At Rossano brick is used in the window and door arches and perhaps in the vaults, but the bulk of the fabric is mortared rubble covered with stucco. The flatness of the surface is unrelieved by brick and tile ornament, as in Stilo, although originally its plastered facade may have been painted to resemble brickwork or ashlar masonry. S. Marco, like the Cattolica, is located on the periphery of the town, some distance from the present cathedral. Again, it seems likely that the church originally served a monastic or private function.

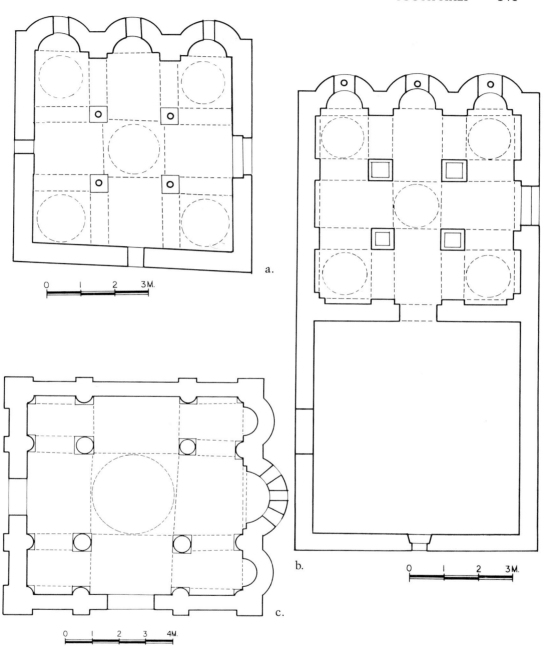

FIG. 5.8. Sketch plans of (a) Stilo, Cattolica; (b) Rossano, S. Marco; and (c) Otranto, S. Pietro

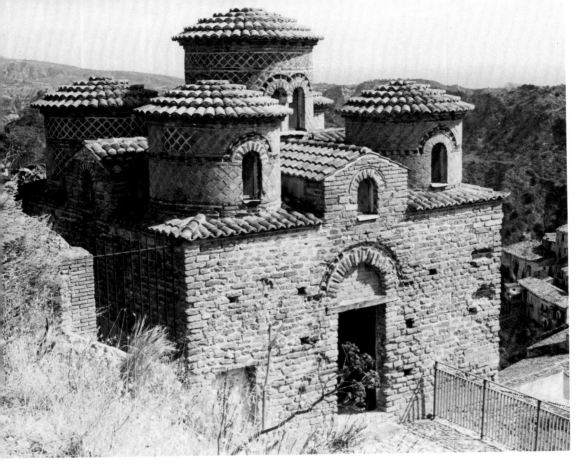

Opposite top: FIG. 5.9. Stilo, Cattolica. General view of the exterior from the south

Opposite bottom: FIG. 5.10. Rossano, S. Marco. General view of the exterior from the east

FIG. 5.11. Otranto, S. Pietro. Northeast corner bay

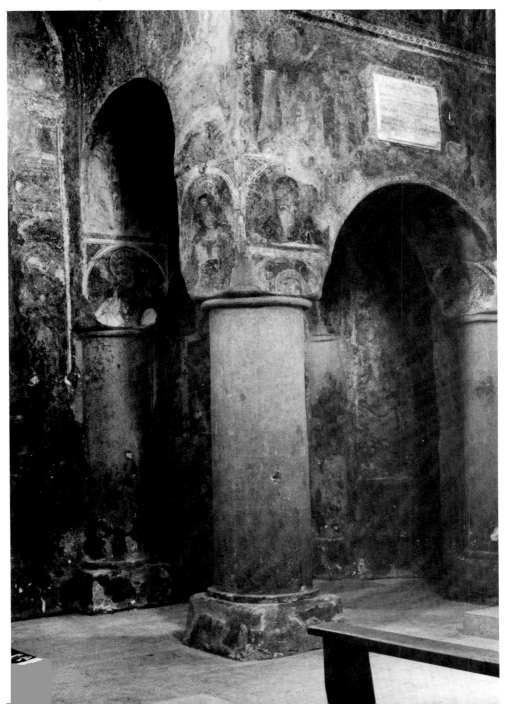

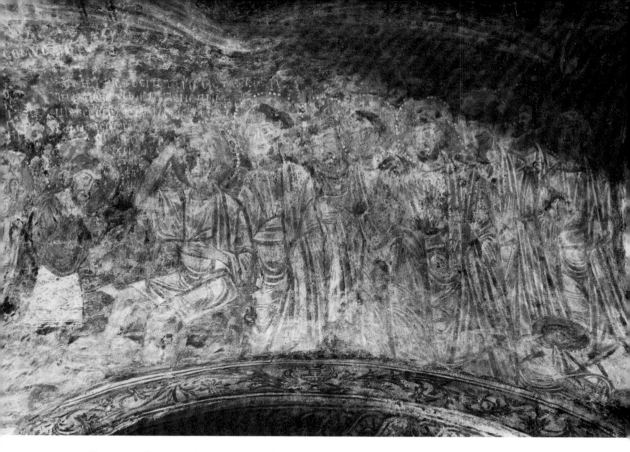

Fig. 5.12. Otranto, S. Pietro. Northeast bay, barrel vault: Washing of the Feet (detail)

The problem of location is more acute with the third member of this small group of cross-in-square churches, S. Pietro in Otranto (figs. 5.8c and 5.11).[50] According to local tradition, S. Pietro was the city's cathedral in Byzantine times. Supposedly, the church's venerability kept the Normans from destroying it when they built their cathedral (consecrated in 1088) directly to the west.[51] Such a scenario seems somewhat implausible. The Normans' consistent usurpation of consecrated ground for the construction of their new churches seems to have been part of their political program of conquest. In Otranto as elsewhere in South Italy, the Norman cathedral probably occupied the site of the Byzantine one. It also seems unlikely that a Byzantine archbishopric of the prominence of Otranto would be served by a cathedral with a capacity for fifty laity at the most.[52] There certainly were other large Byzantine cathedrals in South Italy, as will be discussed below.

Whatever its original function, S. Pietro is a carefully crafted building. Its plan is more conventional than those of S. Marco or the Cattolica: The domed central bay is not only higher but also broader than the barrel-vaulted secondary bays, and the central apse is more capacious than the pastophory apses. The volumes of the building are also more regularly delineated. The springing of the vault is marked by a slight instep; the central supports are columnar piers, and half-column responds articulate the interior walls; the central apse is framed by a recessed arch

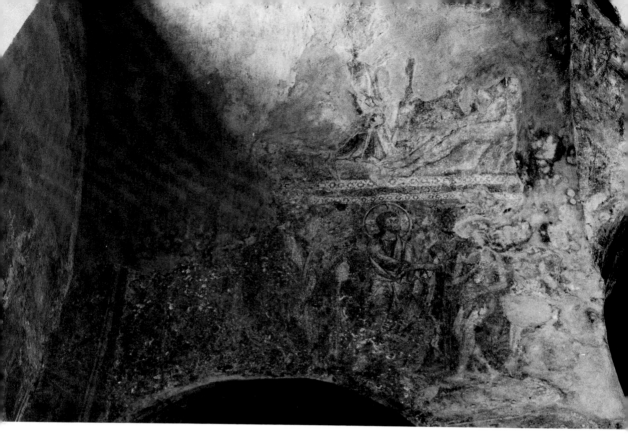

FIG. 5.13. Otranto, S. Pietro. North bay, barrel vault: Christ Confronting Adam and Eve

and illuminated by a triple-light window. Externally, too, the structure of the church is clearly defined: Blind arches coincide with the internal divisions of the building. The architectonic nature of this elaboration is complemented by the use of ashlar in the pilaster strips, arches, and corners of the church. Most of the rest of the building is mortared rubble covered with stucco. Although S. Pietro is in many ways a more sophisticated structure than either S. Marco or the Cattolica, it does share some of their basic features: It is relatively small, it lacks interposed sanctuary bays to the east so that its apses are added directly to the nine-bay nucleus of the church, and it does not have a narthex. Its essential similarity to the churches in Stilo and Rossano suggests that it too may be ascribed to the tenth century.

Recent excavations and an analysis of the surviving frescoes lend further support to the tenth-century ascription of S. Pietro.[53] The Washing of the Feet and the Last Supper, which survive in the northeast vault, may be dated on formal grounds to the time of the church's construction, although the evidence of style is particularly problematic in South Italy (fig. 5.12). These images may have originally been part of a larger Christological cycle, thus distinguishing the program of S. Pietro from the votive bias of most of the province's rock-cut churches. The familiar figural style of these paintings—squat, flat characters filling the enframed space, their draperies ornamented with geometric highlights—is characteristic of early

tenth-century painting in Byzantium. The segmental highlights separated by two or three brush strokes, the quiescent drapery, and even the lack of a border separating the two images suggest comparison with the paintings of Cappadocian artists working at that time. According to Guillou, the epigraphy of the inscriptions also supports an early tenth-century date.

Images from Genesis and Christological scenes surviving in the north and south cross arms of the church indicate that patrons felt the appeal of Byzantine modes of expression long after the Norman conquest of the region. These frescoes are rendered in a style similar to that which appears ubiquitously in the Empire in the late twelfth century: elongated, hyperactive figures robed in energetic drapery. But if these frescoes are stylistically related to late Comnenian works, their program has distinctly un-Byzantine features.[54] It is, for example, tempting to ascribe the prominence of the Genesis cycle to the influence of a Norman foundation like Monreale, itself an exemplar of late Comnenian style.[55] In any case, from the fragmentary remains at Otranto, it appears that the two cycles share a number of iconographic details (fig. 5.13). In both monuments, the scene of Christ confronting Adam and Eve after the Fall is similarly treated: Christ strides toward Adam, holding in one hand a scroll and raising the other in a gesture of speech. Adam stands to receive his rebuke with one hand across his breast and the other modestly holding foliage to cover himself. In Otranto the image is more animated than at Monreale; the rapid gestures of the figures are more expressively rendered. Both in the drapery and in the flesh, tonal contrasts are greater in the pigment than in the tesserae. Like the Kurbinovo painter, the Otranto artist may represent the local variation of a metropolitan style.

Both the narrative program of S. Pietro and the metropolitan links (whether they are direct or indirect) of two phases of its decoration distinguish the church from most surviving Italo-Greek monuments in South Italy. Even in other monuments of some architectural pretension, like the church of S. Maria della Croce in Casaranello near Gallipoli, an Early Christian baptistery reconstructed as a basilica in the Middle Ages, the program was hagiographic in character.[56] Distinctive South Italian features are found not only in the province's architectural tradition but also in the conception of church programming. Apparently ties with the capital existed and were periodically exploited, but local artisans trained in local traditions were not only more readily available, but their work was well regarded. Thus South Italian artistic evidence indicates an unusual degree of regional independence.

THE BYZANTINE ELEVENTH CENTURY

Apulia and Calabria had been fully reclaimed by the Empire by the late ninth century.[57] Until recently, however, the era of Byzantine control of South Italy has been treated as architecturally unproductive. Little was known of any large-scale urban building in the province. However, recently uncovered archaeological evidence now suggests that before the Norman conquest the Byzantines did undertake a

FIG. 5.14. Taranto, Cathedral.
North-aisle arcade, third
column: acanthus capital
with eagles (Tessa Garton)

program of significant urban construction. Material remains complement literary
indications of an eleventh century revival of urban life. Pina Belli D'Elia, in a ger-
minal exhibition and catalogue of 1975, presented archaeological and art-
historical documentation of the pre-Norman origins of a number of cathedrals.[58]
The earliest parts of Bovino and Vieste are dated to about 1000. Excavations sug-
gest that sections of the present cathedral of Bari may be ascribed to the original
structure begun by archbishop Bisantius (1028–35), confirming the statement by
Antonio Beatillo, an otherwise questionable seventeenth-century chronicler, as-
cribing to Bisantius the cathedral "which stands today and which was erected to
the level of the capitals of the columns in his lifetime."[59] The so-called Trulla, the
cylindrical building attached to the northern flank of Bari Cathedral, may incor-
porate parts of the baptistery referred to in a land-transaction document dated to
1032 found in the cathedral archive.[60] Taranto Cathedral apparently also retains
parts of the earlier Byzantine foundation on the site, which may be ascribed to a
period after the Saracen destruction of Taranto in 927, and probably also after the
elevation of Taranto to an archbishopric, which seems to have occurred before
978.[61]

These findings suggest that Apulian prelates were building sizable churches
during the period of Byzantine rule. Although it is difficult to reconstruct these
monuments fully on the basis of what remains, it seems that they were all basili-
cas. The simple basilican form and architectural sculpture recovered from Bovino
and Vieste have their closest stylistic parallels in Campanian buildings of the
tenth and eleventh century, and more particularly in Benevento, the archbishopric
to which these sees were subordinate.[62] In contrast, certain features of the cathe-
drals of Bari and Taranto, such as the modeling of the wall with blind arcading and
the style of some of the architectural sculpture, are Byzantinizing.[63] In Taranto, for
example, a number of capitals are carved with sawtooth acanthus, flattened,
geometricized, and populated with plastically treated figurative elements such as
animal heads, birds, or anthropomorphic images (fig. 5.14). Sculpture of this type

was known in the Empire since the late fifth century.[64] Close contemporary parallels to this work are found in Venice, another city within the Byzantine sphere of influence in the eleventh century.[65] The nave capitals in S. Marco have similarly adapted the precise, linear quality of Byzantine sculpture to the three-dimensional demands of the capital. It appears that in Bari, capital of the catepanate, and in Taranto, also a city of considerable political status, ecclesiastical patrons had Byzantine tastes.

How close the connections between South Italy and Constantinople might be is best demonstrated by the cathedral in Canosa. Canosa, the ancient city of Canusium, may have been founded by the Greeks as one of the many colonies of Magna Graeca. It is the oldest see in Apulia, being documented since 364, though traditionally the church traces its foundations to the time of the apostles. During the early Middle Ages, however, it lost its importance. By the end of the sixth century Canosa had been so devastated that Pope Gregory the Great lamented that neither baptism nor communion was offered there.[66] In the second quarter of the ninth century, the city may even have lost the relics of its patron saint, Sabinus, the venerated sixth-century archbishop of Canosa.[67] According to Beatillo, the translation of St. Sabinus's bones from Canosa to Bari was carried out by bishop Angelarius in secrecy, so that the poor people of Canosa would not be upset by their loss.[68] In fact, Canosa never seems to have admitted the relics' removal. Consequently, archbishop Elias of Bari, a man well known for the successful realization of his ambitions, miraculously rediscovered the relics of St. Sabinus in the cathedral of Bari during restoration work on the crypt in 1091.[69] The cathedral, earlier dedicated to the Virgin, was reconsecrated to St. Sabinus. The same Elias, as abbot of the most important Benedictine foundation in Bari, had previously secured the stolen relics of St. Nicholas of Myra for his monastery. Bari had been made an archiepiscopal see under Byzantine overlordship; consonant with imperial policy, the seat of political power, the capital of the catepanate, was also made the seat of spiritual power in the province.[70] This assumption of archiepiscopal authority by the church of Bari under the Byzantines was recognized by Rome only in 1025. At that time Pope John XIX conceded to the archbishop of Bari, Bisantius, the church of Canosa and its suffragans.[71] The see thereafter was commonly referred to as the archbishopric of Bari and Canosa. The continued inclusion of Canosa in the archbishop's title should not be seen as a simple sop to tradition. Evidently, Canosa continued to vie with Bari for precedence. This competition is reflected in the occasional exclusive use of Canosa in the archbishop's epithet.[72] It is also indicated by the ongoing controversy between Canosa and Bari as to which cathedral was in possession of St. Sabinus's remains.

Documents indicate that the cathedral of Canosa, originally dedicated to Sts. John and Paul, was probably built during the episcopate of Nicholas, archbishop of Bari and Canosa between 1035 and 1062.[73] This archbishop had been the imperial candidate for the see. Not only did he spend time in Constantinople, but he also acted at least on one occasion as an emissary for the emperor.[74] The fabric of the church, ashlar alternating with brick courses, and the sculptural style of the liturgical furnishings of the cathedral provide support for a dating in the second quarter of the eleventh century. The 1101 date usually given to the church was the occa-

sion only of Paschal II's rededication of the cathedral to St. Sabinus, perhaps to counter archbishop Elias's attempts to strengthen Bari's claim on the same saint.

The architecture of the church also mirrors the polemics between Bari and Canosa. The interior of the cathedral of Canosa retains its medieval sensibility despite its whitewashed walls and the anomalous postmedieval extension of its nave (figs. 5.15 and 5.16). It was planned as a domed transept basilica. The five primary bays of the church are covered with shallow cupolas. The nave is lit only by the windows in the lunettes above the aisles; even the crossing dome lacks a lighted drum. These broad domes are supported on arches springing from monolithic columns. Eight of these columns are *spolia—verde antico* shafts with white marble Corinthian capitals. The rest are medieval imitations of the earlier members, rendered in granite with marble capitals. The arches springing from these columns define the major bays of the nave. A secondary rhythm is established by the triple-arched pier arcade which divided each bay of the nave from the aisle.

Even more ostensibly than S. Lazarus in Larnaca or S. Andrew in Peristerai, the form of the church is modeled on the Holy Apostles in Constantinople, the monument which not only housed the relics of the apostles but also the earthly remains of many Byzantine emperors and their relations. The apostolic and imperial connotations of the five-domed cruciform shape of this great building were evidently so strong that they were implicit in copies as well as in the prototype. The builders of the early eleventh century cathedral of Sts. John and Paul in Canosa apparently wanted to emphasize the apostolic tradition of their church. Even after the Norman conquest of the region, the symbolic content of the church's shape was evidently still understood. It seems that the Norman prince Bohemund, frustrated in his ambition to seize the throne of Byzantium for himself, arranged to emulate

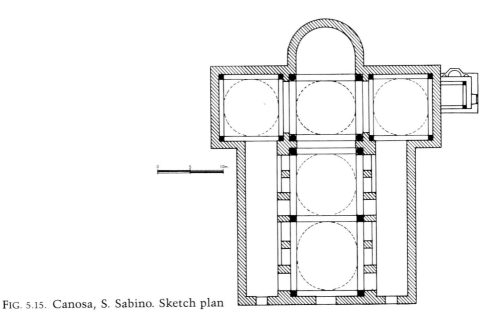

FIG. 5.15. Canosa, S. Sabino. Sketch plan

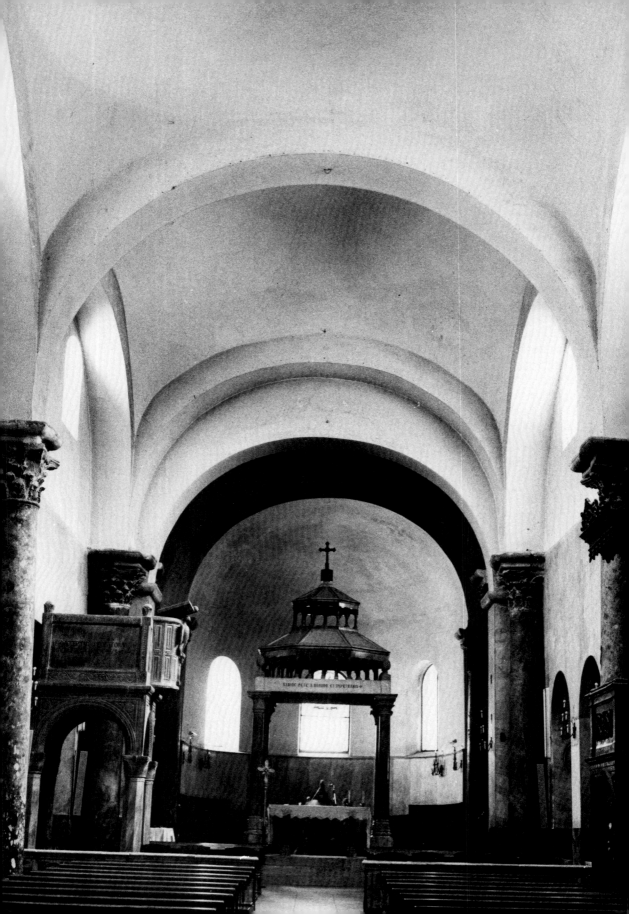

the emperors at least in death. He had himself entombed in a centralized structure added to the south transept of the cathedral of Canosa, in a position analogous to the Mausoleum of Justinian at the Holy Apostles.

S. Sabino in Canosa appears to be the only Apulian cathedral of the Byzantine period to remain largely intact, perhaps because the economic and political weight had shifted toward the port cities of the coast, and with it, ecclesiastical power. It was in Bari, Trani, Otranto, and Taranto that the Normans apparently wished to commemorate their conquest with great cathedral structures, burying the earlier buildings on the site.

The remains of the congregational churches of Calabria are even more fragmentary than those of Apulia. The archiepiscopal sees of Reggio Calabria and Cosenza have been racked by earthquakes; what has survived these tremors has not outlived later reconstructions. A few monuments remain in the countryside and in the less populous towns.[75] Preserved in Sta. Severina on the east coast of Calabria are two structures which exemplify the medieval ecclesiastical architecture of a Calabrian mountain town. Sta. Severina was raised to metropolitan status probably in 886; it had that status in any case by 901/902, according to the *diatyposis* of Leo VI.[76] Remains of a relatively large basilica (c. twenty-seven meters in length), identified as "il vescovato vecchio," are located a short distance from the present, thirteenth-century cathedral (fig. 5.17). This structure has been convincingly dated to 1036 by Guillou on the basis of two Greek inscriptions:

> This church was founded in the time of Ambrosius, the most venerable archbishop.

> Remember your servant Stauracius, the imperial *spatharokandidatos*, who has given his support to this holy church of God.[77]

Patronage for the foundation thus came from a highly placed source.

A number of the features of the building confirm its eleventh-century ascription and its ties to the eastern Empire. The nave and aisles were terminated at the east with communicating apses for the rite of *prothesis* and for the circulating processions which characterize the Orthodox service. Small roundheaded windows in the clerestory repeat the rhythm of the seven bays of the nave. Familiar Byzantine masonry, alternating bands of brick and ashlar, is used in the piers of the nave arcade; brick and ashlar are also employed in window arches. The remaining fabric is mortared rubble. The structure was originally wooden-roofed.

Another, better-preserved building of pre-Norman date also survives in Sta. Severina—the baptistery (fig. 5.18). Apparently constructed on the site of a burial monument, the plan is a Greek cross within a circle.[78] Internally, a narrow ambulatory is defined by eight *spolia* columns with crude capitals and impost slabs which extend to the outer wall of the building. The dome is gored; windows are aligned with the arms of the cross. Typological evidence for dating is ambiguous:

Opposite: FIG. 5.16. Canosa, S. Sabino. General view of the interior to the east

The baptistery has been ascribed to periods ranging from the fifth to the tenth century. The style of the building—the plastic treatment of the vaulting system, the lack of clear articulation of the wall, the gored cupola, the squat proportions of the structure, and the stepped, tiled dome exterior—typifies early Middle Byzantine architecture. Historical circumstances and an inscription suggest a more specific date. The Greek inscription, crudely carved on the sides of a capital in the baptistery, reads: "Archbishop John constructed [this place] in indiction 13."[79] Although this archbishop has not to date been identified by architectural historians working on the monument, it seems possible that he is the same archbishop John of Sta. Severina who in 1032 signed a synodical letter of the Patriarch Alexius the Studite.[80] If such an identification is accepted, the indiction allows the building to be dated tentatively to 1029/30. Such a date is historically convenient: it puts construction after the pacification of the region by Nicephorus Phocas and before the Norman occupation. Large baptismal halls reappear with the emergence of communes in northern Italy in the eleventh century; Byzantine South Italy apparently participated in this development.

Another Calabrian building which incorporates both Italic and Byzantine traditions is the great basilican ruin at Roccelletta near Squillace (figs. 5.19 and 5.20).[81] Roccelletta's massive scale, unique form, and unusual fabric give it a critical position in the evaluation of medieval Calabrian architecture. The church is a single-nave structure approximately sixty meters in length, with narrow transept arms extending beyond the walls of the nave. The three groin-vaulted, apsed bays of the sanctuary intercommunicate. Below the sanctuary and transept is a crypt, accessible, as is common in the east, from the exterior of the building. Too little of the

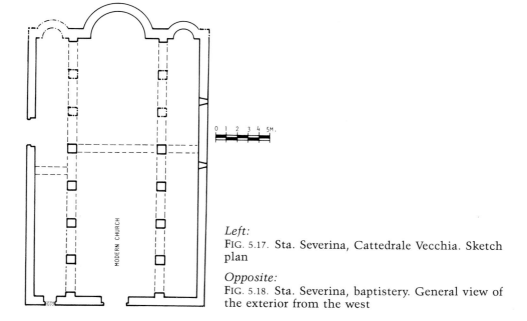

0 1 2 3 4 5M.

MODERN CHURCH

Left:
FIG. 5.17. Sta. Severina, Cattedrale Vecchia. Sketch plan

Opposite:
FIG. 5.18. Sta. Severina, baptistery. General view of the exterior from the west

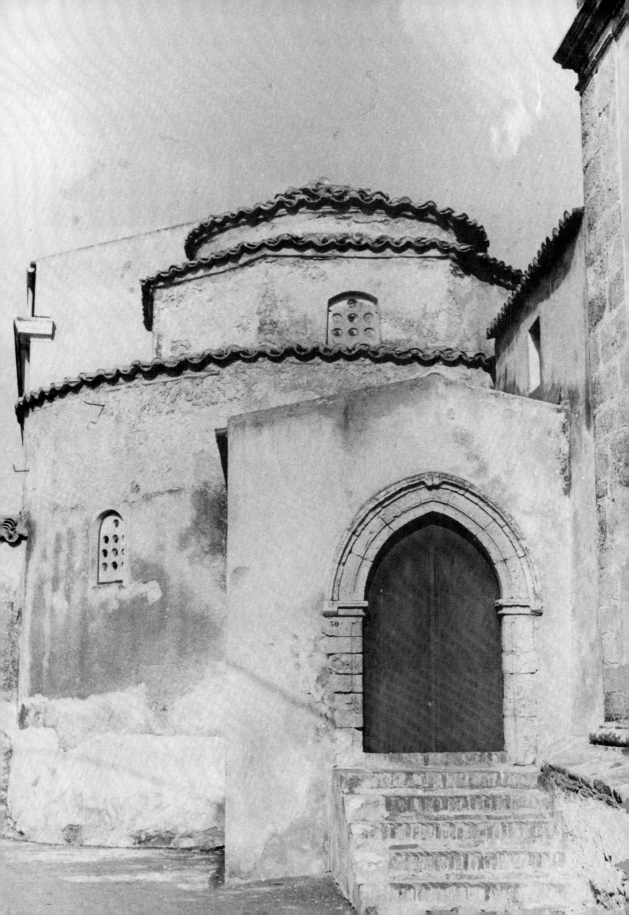

superstructure remains to specify exactly how the crossing and transept arms were covered, although the great fragments of masonry still lying on the floor of the transept indicate that these spaces were also vaulted. The long, aisleless nave was wooden-roofed.

Roccelletta is generally dated to the late eleventh or early twelfth century. On the basis of comparisons with French buildings, such as St.-Guilhem-le-Desert or Cluny II, Roccelletta is regarded as the product of French monastic influence working in the wake of the Norman conquest. But these comparisons are not convincing when considered in detail.[82] French monuments are heavier and darker, being vaulted throughout. Their spaces are cloisonnated by arches and arch responds—features notably absent at Roccelletta, even in the vaulted sanctuary. The medium of construction and the articulation of the wall are different. More important, in contrast to most northern churches, the subsidiary apses of Roccelletta are fully integrated into the sanctuary scheme. The three spaces also open on the same transverse section of the church, a line which might easily be closed by a *templon* screen or sanctuary barrier. Thus, the east end of the church appears to be arranged for the Orthodox liturgy, not for a Latin one. This particular organization of the sanctuary of the church distinguishes Roccelletta from a series of Norman basilicas built in South Italy. The plan of one of the earliest members of the group, the Holy Trinity at Mileto, founded in the 1060s by Roger I, looks superficially very much like Roccelletta. It too has a deep bema flanked by subsidiary apses, all opening onto a narrow transept with a domed crossing.[83] However, the Holy Trinity is arranged for the Latin rite: the side chapels, in which the mass is conducted independently of the high altar, do not communicate with the central apse. The same treatment of the sanctuary is characteristic of a series of Latin-rite churches built by the Normans.[84] If Roccelletta was liturgically arranged for the Orthodox rite, its large size makes it unlikely that it served an Italo-Greek monastic com-

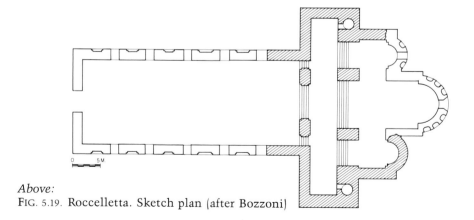

Above:
FIG. 5.19. Roccelletta. Sketch plan (after Bozzoni)

Opposite: FIG. 5.20. Roccelletta. Apse exterior from the southeast

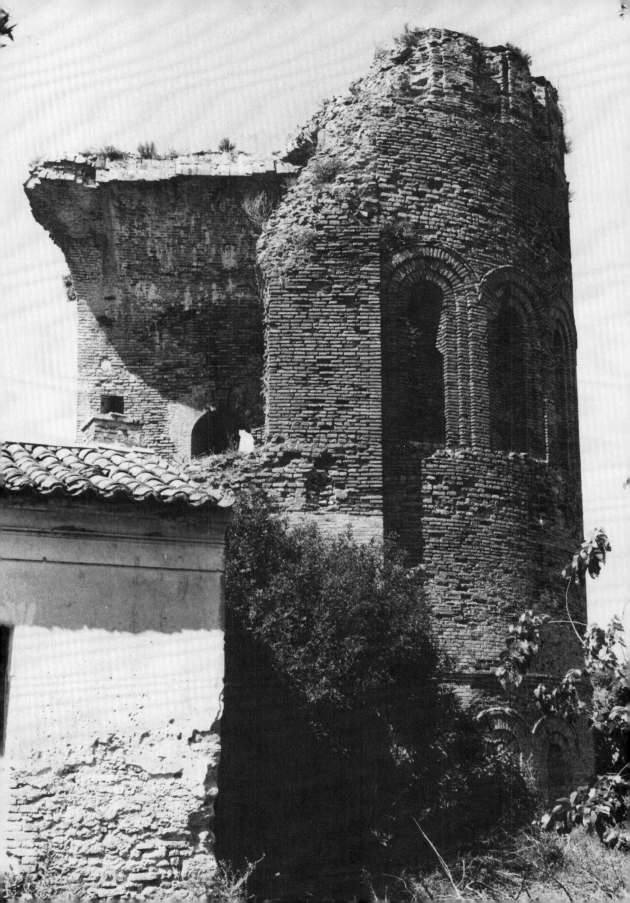

munity; more probably it had a congregational function. As the Latin rite replaced the Greek one in Squillace in 1096, it is tempting to ascribe Roccelletta's construction to sometime before this date.[85]

Roccelletta's construction, like its plan, shows both eastern and western features. The church is almost entirely brick-faced. As at Stilo, Italic, oblong brick is used; in contrast to Byzantine practice, the mortar joints are thin in relation to the thickness of the brick. Wall construction as well as facing is un-Byzantine. As in most medieval Italian brick buildings, brick is used as the protective covering of the mortared-rubble core of the wall.[86] Although brick is aesthetically dominant in Byzantine architecture, it works in a different way. Byzantine monuments are typically constructed of alternating bands of brick and stone; the brick, which often continues through the thickness of the wall, serves as a leveling agent. Generally, brick is used exclusively only in the construction of vaults. The distinct functions of brick in the two building traditions help explain the different form both of the brick and of the structure. Mortared rubble, being fundamentally inert, has an inherent bias for simplicity of form and mass, both characteristic of the basilica. Typical of Italian brick construction in the Middle Ages, especially in Rome, is its large-scale and geometric simplicity. Roccelletta certainly shares these features with the Roman monuments of the High Middle Ages.

Brick is not, however, generally used by the Normans in their construction of Latin-rite buildings in South Italy. The Norman cathedrals of Calabria and Sicily are typically mortared rubble with ashlar or stucco facing. The exterior treatment of the apses of Roccelletta is equally foreign to the building traditions of both the Normans and the medieval Romans. The east end of the church is articulated with three horizontal bands of arched niches, reflecting an interest in the modeling of the wall which is characteristic of Byzantine architecture both in Constantinople and in the provinces. The closest parallel in terms of scale, if not of detail, is provided by St. Sophia in Kiev, begun in 1037.[87] This church, although beyond the borders of the Empire, was probably built by Constantinopolitan masons. Its double- and triple-ordered blind arches, arranged in horizontal bands, are strikingly similar to the niches of Roccelletta. A more elaborate curvilinear treatment of the surface is found in the early eleventh-century Panagia tōn Chalkeōn in Thessaloniki. This rare example of an all-brick Byzantine building is perhaps only coincidentally constructed by the catepan of Italy. Whatever the date of Roccelletta, its form and fabric reflect on the cultural heterogeneity of South Italy.

Although few monuments survive from the period of the Byzantine occupation of South Italy, evidence indicates that large-scale building activity did take place. Congregational churches were constructed. It also seems likely that baptismal halls—which in the north Italian cities embodied civic pride in the fourth and fifth centuries and again in the eleventh century—were also built in the province. While Sta. Severina is the only fully preserved medieval baptistery in South Italy, parts of what seem to be a similar circular building are associated with the cathedral at Bari. The Baroque sacristy attached to the north arm of S. Sabino in Canosa was perhaps also built on the foundations of an early baptistery. These monuments provide significant documentation of the revitalization of urban life in South Italy in the course of the eleventh century.

BYZANTIUM AND THE NORMANS

From the late ninth through the early eleventh century, South Italy was an integral part of the Empire. Despite the enemy incursions which continued to violate the peace of the province, Byzantium's political control was not effectively challenged until the arrival of the Normans. Norman mercenaries, initially invited to participate in the complex internal affairs of the catepanate in 1017 by the rebel leader Meles, rapidly became the principal threat to imperial power. Bari, capital of the catepanate, fell to Robert Guiscard in 1071; the Norman conquest was all but over by the end of the third quarter of the eleventh century.[88]

The Norman conquest involved an enormous military upheaval, but it was not attended by a cessation of relations with the Byzantine heartland, as was, for instance, the Seljuk conquest of central Anatolia. The Byzantines did not acknowledge the loss of the province. In the 1070s there were negotiations between Robert Guiscard, first with Romanus IV Diogenes, then with Michael Doukas for a marriage contract between Robert's daughter and an imperial prince. Later, Bertha of Sulzbach, sister-in-law of Conrad III of Germany, was to bring as a dowry to her marriage with the Emperor Manuel I Comnenus the South Italian possessions of Apulia and Calabria.[89] Military intervention was also attempted. In the 1150s Manuel had some success in his bid to reconquer the peninsula. His troops took Bari and Trani before being decisively defeated at Brindisi by the army of William I of Sicily. Cinnamus's description of the affair gives the distinct impression that the Byzantines did not consider South Italy permanently lost to the Empire.[90] Cultural links were also maintained. The Normans were familiar with Byzantium. Norman mercenaries from these occupied provinces were an important element in Byzantine armies, and Norman lords, including prince Bohemund, spent time in Constantinople.[91] Artistic ties are documented. Desiderius, abbot of Montecassino (1058–87), hired craftsmen and ordered goldwork from Constantinople for the decoration of his new basilica. Byzantine bronze doors proliferated in the peninsula in the eleventh century. The Norman kings of Sicily apparently imported Constantinopolitan mosaicists to ornament their churches.[92]

Not only did military, diplomatic, and cultural relations persist, but the early generations of Norman conquerors continued to exploit imperial ideology. The first Norman counts of Taranto persisted in dating their documents by the reigns of Byzantine emperors; in Bari, Trani, and Conversano, documents might not be written in Greek, but they were often signed in Greek.[93] Both Guiscard and his son Bohemund aspired to the imperial throne; later, Roger II seemed to attempt to supersede the imperial court at his own in Palermo. This association with the Empire had its emblems. Bohemund adopted the nomenclature of the Byzantine state in his government of Apulia. His chief official retained the Byzantine title of catepan and the Norman judge was still known by the Greek title *critis*.[94] His seal took a Byzantine form, displaying on the obverse a Byzantinizing St. Peter holding a cross and on the reverse the familiar formula, in Greek, "Lord protect your servant Bohemund."[95] Even Bohemund's tomb at Canosa may have been modeled on the imperial mausoleum of the Holy Apostles, as discussed above.[96] There was, in other words, a receptiveness of Byzantine imperial forms which reflects not so

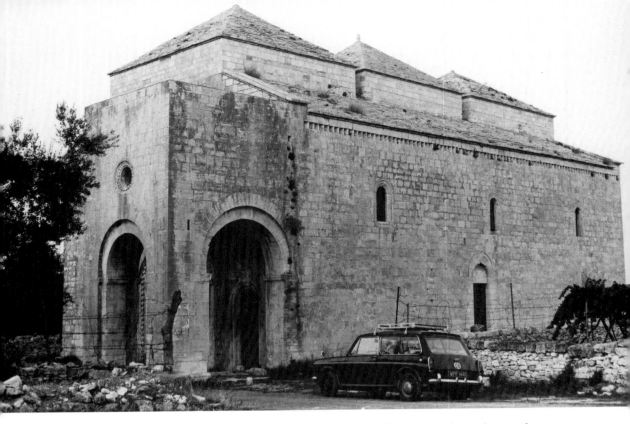

FIG. 5.21. Valenanzo, SS. Ognissanti. General view of the exterior from the southwest

much a cultural inferiority complex as an effort to co-opt the apparatus of the state in preparation for assuming autocratic control of the Empire. In this respect, the Normans of South Italy seem distinct from the Latins of the Fourth Crusade, who appear to have regarded Byzantium as another great fiefdom. Because of the acceptance of the Byzantine model of governance, and because of the relatively stable population of the peninsula, many basic social structures survived the Latin occupation.[97]

The architecture of South Italy from the early phase of the Norman occupation reflects the strength of local practice developed under the Byzantines. A few suggestions of the residual impact of Byzantine architecture must suffice to indicate the vitality of the earlier tradition. After the construction of S. Sabino in Canosa, there seems to have been a proliferation of churches of the multidomed type. The earliest of these is S. Maria di Calena, a small monastic foundation that was prominent in the mid-eleventh century, declined later in the same century, and was revived with the aid of Norman donations in the twelfth. It may be cogently argued that the two major phases of the present building belong to these two periods of activity.[98] All that survives of the first phase of construction of S. Maria di Calena are two bays of the nave, each domed with sail vaults of a type similar to those in S. Sabino at Canosa. Meeting the thrust of the cupolas above the aisles are quadrant vaults.[99] This same formula is widely adopted in a series of Norman monastic churches, including the Ognissanti at Valenzano, S. Benedetto at Conversano, S. Francesco at Trani, and culminating in the thirteenth-century cathedral of

Molfetta (fig. 5.21). The location of these monuments in close proximity to S. Sabino and their consistent utilization of a procession of domes suggest that these Norman and post-Norman buildings do not represent, as is often assumed, an importation from the north but rather an evolution of local tradition, modified in response to the changing circumstances of the peninsula.

The cross-in-square type, represented in a peculiarly South Italian form at Stilo, Rossano, and Otranto, also has an impact on later building in the province. The church of S. Basilio, now S. Andrea, at Trani, probably built in the second half of the twelfth century, is a Norman version of this scheme.[100] As in the Byzantine

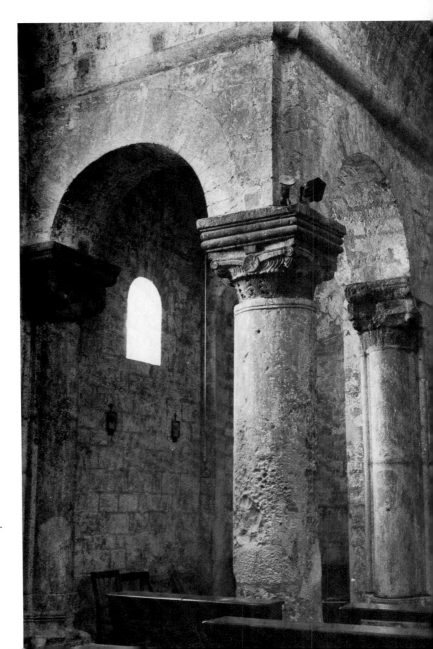

FIG. 5.22. Trani, S. Andrea.
Interior of the northeast
corner bay

churches, S. Andrea has nine bays, with apses attached directly to the east side of the building and no narthex (fig. 5.22). Like S. Pietro, the church has a central dome, longitudinally barrel-vaulted corner bays, columnar piers, and half-round pilaster responds. S. Andrea has a crispness missing in S. Pietro due to its more carefully wrought ashlar masonry, but it remains in concept essentially analogous to the earlier monument. Cross-in-square churches such as S. Giovanni degli Eremiti and the Martorana in Palermo also indicate that there were close architectural links between South Italy and Sicily, which had been politically linked by the Normans. The plans of these cross-in-square churches, without additional sanctuary bays, are similar to those in South Italy. The odd stepped squinches supporting the central dome and the columnar supports of the triumphal arch are also part of a shared formal vocabulary.[101]

The vitality of the Byzantine tradition may also be measured by the assimilation in Norman structures of earlier spatial concepts. Two relatively early Norman churches—S. Maria di Siponto and S. Leonardo near the same city—both appear to be a combination of the multidomed and cross-in-square plan.[102] Neither could be described as anything other than Apulian Romanesque. Perhaps even the prominence of the dome over the crossing in the Norman churches of South Italy may be partially ascribed to the popularity of the cupola in the Byzantine architecture of the province.

Basilicas with nonprotruding transepts and single- or triple-apsed terminations may also have been part of the local architectural tradition: The pre-Norman cathedrals of Bari and Taranto suggest that this arrangement, whatever its origins, was known in Byzantine times. Whether or not S. Nicola at Bari, as the earliest surviving structure of this type in the province, reflects the influence of Monte Cassino, the popularity of this light, open basilican form may well represent the resonance of a familiar building type.[103] Monte Cassino, as rebuilt by Desiderius between 1066 and 1071, was itself much more than the revival of an Early Christian idea remembered with the help of St. Peters in Rome. Finally, Roccelletta provides an example of a building which could be either a Westernized Byzantine or a Byzantinizing Norman structure. Whatever its date, it embodies the synthetic character of South Italian culture. The features that early Norman cathedrals such as Mileto and Gerace share with Roccelletta again emphasize the force of regional tradition.[104]

The architecture and monumental painting of Apulia and Calabria are too complex to be understood adequately in terms of simple stylistic progressions. Neither can their complexities be cogently explained by the *deus-ex-machina* means of "artistic influence," whether these external perpetrators of form are designated as Constantinopolitan, Roman, or French. The rich variety of South Italian art can be more positively comprehended as a reflection of the diverse society which produced it. South Italy, to a greater degree than any of the other provinces considered, was subjected to overlays of political, religious, and social structures, each of which contributed to the strong, if idiosyncratic, artistic personality of the province. Even more fundamentally, it may be argued that South Italian artistic heterogeneity is indicative of the province's relative independence of the metropolitan center.

Conclusion

Monumental painting is the visual embodiment of the urge for ideological unity within the large and ethnically diverse Byzantine Empire. Notions of authority realized in artistic form were refined in Constantinople and disseminated from the capital. The study of painting and architecture in the provinces indicates that the local habitat and audience modified the production even of those artisans and patrons most closely connected with Constantinople. Regional character is determined through such particularities as geology, the traditional popularity of certain cults, the existence of earlier local monuments of high status, and specific social habits or political perspectives. Yet the monuments of the hinterland almost inevitably reveal the artistic dominance of the imperial core in their formal and programmatic features.

Each of the four provinces considered offers its own historical contribution to an understanding of the tension in the Empire between the center, the force of unity, and the periphery, source of diversity. The two eastern provinces, Cappadocia and Cyprus, isolated by religious differences from competing neighboring cultures, most clearly demonstrate the cultural hegemony of Constantinople. The rich artistic preserves of the rock-cut churches in Cappadocia document how deeply Constantinopolitan artistic formulations permeated social strata. Although great wealth was necessary to obtain the skills of the most highly trained artists, at least after the ninth century even simple programs indicate a familiarity with metropolitan concepts. Cappadocia also demonstrates that the creation of cultural, if

not political, barriers between the core and its provinces might put an end to provincial art as it is defined in chapter 1.

The artistic internalization which occurs in Cyprus in the thirteenth century following the Latin occupation cannot be explained in the same way as that which characterizes Cappadocia after the Seljuk conquest. Not only was Cyprus cut off from the imperial capital, but the artistic production of Constantinople was disrupted by the dismemberment of the Empire in 1204. The core lost the centripetal force that it had previously exerted. Any crude equation between artistic production and close political relations with the center are, indeed, called into question by Cypriot monuments ascribed to the late ninth or tenth centuries, a period when the island was a so-called no-man's-land. Territories could be culturally integrated without being militarily secured as part of the Empire.

In Macedonia, too, Byzantine art forms reflect cultural incursions across political borders. But Macedonian monuments also provide evidence that political rivalries might lead to an active imposition of metropolitan art forms. Art with imperial associations might be adopted (or rejected) for explicitly propagandistic purposes. In Macedonia the Byzantines exploited art in their attempts to acculturate the Slavic population. Particularly after the conversion of the Bulgars, both sides attempted to use ecclesiastical monumental art and architecture to establish the legitimacy of political authority where that authority was open to question.

The absence in South Italy of a stylistic development dependent on the capital is indicative of the relative cultural independence of the province within the Empire. South Italy was the most peripheral of the four provinces studied, both because of its remoteness from Constantinople and its proximity to Rome. The heterogeneity of South Italy's artistic and architectural production is not a reflection of its cultural isolation. It is due rather to the variety of alternatives offered it by its own history. South Italy's relative independence of Constantinople throws into even greater relief the authority exerted by the capital in other provinces of the Empire.

If each province provides distinct perspectives on the central issue of the interaction between the center and its periphery, all four contribute evidence for broad generalizations about this relationship. As might be expected, the importation of new forms can often be associated with elite patronage, though patrons of high social status also support local artistic production. Local artisans, either working with itinerant masters or impressed by their achievements, reformulated their own artistic modes of expression. Local patrons or groups of patrons might either hire an itinerant painter once he was in the region or require that a prominent monument provide the model for their own. It appears that artistic ideas generated in the capital are introduced or adopted by donors of all social levels in part as a means of affirming their status.

The assimilation of metropolitan form in the provinces is much more clearly articulated in monumental painting than in architecture. The strength of local building traditions within the Empire is evident from this study as it could not be in monographs on particular structures or even in broad architectural surveys. The analysis here also serves as a reminder of the formative force of available building materials on architectural style.

A comparative analysis of four Byzantine provinces also suggests something about the relationship between monasticism and the arts in the Empire. The flexibility of monastic institutions, the privatization of spiritual life, the relative independence of monasteries from the authority of the secular church, the lack of intermonastic links are features which significantly affected artistic production throughout the Empire. These features also distinguish Eastern monasticism from its Western counterpart. Monastic foundations in Byzantium tended to be small. Church plans were not identifiable with monastic orders but rather expressed local building traditions. The form and quality of a monastic church's decoration depended on the relative positions of the *hegoumenos* and the *ktetor*, as well as the latter's wealth: A secular patron as well as a holy abbot might have determined a church's decoration. There are programs which demonstrate specifically monastic preoccupations, but there is no such thing as a monastic style in painting or architecture.

Most fundamentally, the remarkable homogeneity of the art of the Empire reflects the dominance of the metropolitan core. At least some of the same rhythms of artistic production are identifiable in all four provinces. Art flourishes throughout the Empire during the late ninth and early tenth centuries, in the early to mid-eleventh century, and in the later twelfth century. In Cappadocia and South Italy the efflorescence of the late ninth and early tenth centuries may simply have been a natural response to the favorable political conditions of those regions. However, heightened artistic activity occurs in the same era also where the historical circumstances appear much less favorable: in Macedonia, which was divided between the Bulgars and the Byzantines, and in Cyprus, which was still officially a "no-man's-land." Significant artistic developments do not apparently depend on political security and material prosperity.

Again in the early to mid-eleventh century, surviving monuments suggest a period of heightened artistic activity. In Cyprus and especially in Cappadocia, this activity is evidenced within a rural monastic context. In contrast, the widespread construction of large congregational churches marked the reemergence of urban life in Macedonia and South Italy. The economic ballast of the Empire moved from the east to the west. In South Italy, the development of city life was accompanied by the strengthening of communal political structures. In contrast, elsewhere in the Empire the continued ideological dominance of the center is reflected in a new programmatic uniformity: A dramatically hierarchical arrangement of church decoration was codified and ubiquitously adopted.

Finally, the extensive construction and decoration of monuments in the late twelfth century in provinces still held by the Byzantines contradict any simplistic notion of internal collapse leading to the fall of the capital to the Crusaders in 1204. The very distinct dominant style of painting of this age attests to the vitality of Constantinopolitan artistic practice. The remarkably expressive modification of this style in Macedonia has been interpreted as an independent provincial tradition in painting complementing the long-standing regional practice in architecture. The disappearance of this style with the Latin conquest of Constantinople contradicts such a notion. The treasures accrued through a millennium of continuous artistic production were despoiled by the Crusaders. Just as significantly,

with the collapse of the capital came the destruction of the rich artistic tradition bred of tension between the core and its periphery.

The art that has survived in the periphery of the medieval Byzantine state varies greatly in its level of lavishness and craft, from the magnificent donations of the wealthy to the unpretentious offerings of the peasant. Each of these works, if looked at closely enough, provides a chink in the wall of time through which we may better visualize the artistic dynamics of domination. Byzantine art is an art of great formal and psychological complexity, of great historical and aesthetic value. It is not exclusively the art of Constantinople. It is the art of Empire.

Notes

ABBREVIATIONS

AASS: Acta Sanctorum Bollandiana
BCH: Bulletin de Correspondance Hellénique
Byz.: Byzantion
BZ: Byzantinische Zeitschrift
CA: Cahiers Archéologiques
Corso: Corsi di cultura sull'arte ravennate e bizantina
DCAH: Deltion tēs Christianikēs archaiologikēs hetaireias
DOP: Dumbarton Oaks Papers
JOB: Jahrbuch der Österreichischen Byzantinistik
PG: J. P. Migne, *Patrologia cursus completus,* series graeca
REB: Revue des études byzantines
TM: Travaux et Mémoires

CHAPTER 1

1. S. N. Eisenstadt, "Empires," *International Encyclopedia of the Social Sciences* (New York, 1968), v: 41–49; see also idem, "The Causes of Disintegration and Fall of Empires: Sociological and Historical Analyses," *Diogenes* 34 (1961): 82–107.

2. For the terms "core" and "periphery," see E. Wallerstein, *The Modern World-System* (New York, 1980), esp. chapter 1, "Medieval Prelude," 15–63; and idem, "World-Systems Analysis: Theoretical and Interpretative Issues," in *World-Systems Analysis: Theory and Methodology,* ed. T. K. Hopkins and I. Wallerstein (Beverly Hills, Calif., 1982), 91–103.

3. P. Lemerle, "Esquisse pour une histoire agraire de Byzance," *Revue historique* 219/1 (1958): 32–74, 254–84; 220/2 (1958): 43–94. N. Svoronos, "Remarques sur les structures économiques de l'empire byzantine au XIe siècle," 6 (1976): 49–67.

4. For example, I. Dujčev, ed., *To eparchikon biblion* (London, 1970).

5. For a plan and bibliography, see W. Müller-Wiener, *Bildlexikon zur Topographie Istanbuls* (Tübingen, 1977), 229–37.

6. A. P. Kazhdan and A. Wharton Epstein, *Change in Byzantine Culture in the Eleventh and Twelfth Centuries* (Berkeley, 1985), 111–16.

7. Symeon Magistros, *Chronographia*, PG, 109, 744A; Leo Grammatikos, *Chronographia*, PG, 108, 1081A.

8. See above, note 1.

9. C. Mango, *Byzantium: The Empire of the New Rome* (New York, 1980), 208, connects this epithet with the transfer of the True Cross to Constantinople.

10. F. Dvornik, *The Idea of Apostolicity in Byzantium* (Cambridge, Mass., 1958).

11. Averil Cameron, "The Theotokos in Sixth-Century Constantinople: A City Finds Its Symbol," *Journal of Theological Studies*, n.s., 29 (1978): 79–108.

12. L. Rydén, "The Andreas Salos Apocalypse," *DOP* 28 (1974): 201–2; trans. Mango, *Byzantium*, 208–9.

13. H. Ahrweiler, "La frontière et les frontières de Byzance en Orient," *Actes du XIVe Congrès international d'études byzantines*, 1 (Bucharest, 1974), 209–30; Ja. Ferluga, "Quelques problèmes de politique byzantine de colonisation au XIe siècle dans les Balkans," *Byzantinische Forschungen* 7 (1979): 35–56.

14. J. D. Mansi, *Sacrorum Conciliorum nova et amplissa collectio* (Florence, 1769–), VII, 360, 4. For a summary of monastic legislation, see R. Janin, "Le monachisme byzantine au moyen âge: Commende et typica (Xe–XIVe siècle)," *REB* 22 (1964): 5–44.

15. Mansi, XVI, 536, 1.

16. Examples are taken from Italo-Greek lives because, due to the foibles of survival, they present the richest selection for the period. *AASS*, 11 September III, 864, par. 41.

17. *AASS*, 9 March II, 30, par. 12.

18. "The Lord of the town, named Gregory, celebrated for despotic power and for injustice but nevertheless shrewd and intelligent, descending [from his fortress] and prostrating himself at the feet of the saint (Nilus), said these things: 'Truly, O Servant of the most high God, because of my many sins I am not worthy, nevertheless you have entered under my roof. From whence comes to me this grace that the Holy Man of the Lord has come to me? Since you, in imitation of your Teacher and Lord, have preferred me to the just, behold I place at your disposal my house, my fortress with its territories.' " *PG*, 120, 160, par. 96.

19. For example, E. von Dobschütz, *Christusbilder: Untersuchungen zur Christlichen Legende*, Texte und Untersuchungen zur Geschichte der altchristlichen Literatur, 18 n.f. 3 (Leipzig, 1899); E. Kitzinger, "The Cult of Images in the Age of Iconoclasm," *DOP* 8 (1954): 83–150; H.-G. Beck, *Problematica della Icone*, Centro Tedesco di Studi Veneziani, 3 (Venice, 1977); J. Séguy, "Images et 'religion populaire,' " *Archives de sciences sociales des religions*, 44,1 (1977): 25–43.

20. This centrality of the text obviously affected the presentation of the image. For example, narrative images in Byzantine monuments are commonly read from left to right and from top to bottom. The physical reality of "the word" as truth also helps explain the prominence given to labeling in medieval images. The image was empowered by its title. As Michael Camille has pointed out in respect to Western medieval art, in such circumstances the image was intended to convey the meaning of the word rather than re-create the visual effects of nature. "Seeing and Reading: Some Visual Implications of Medieval Literacy and Illiteracy," *Art History* 8 (1985): 26–49.

21. Homily XVII translated by C. Mango, *The Homilies of Photius, Patriarch of Constantinople* (Cambridge, Mass., 1958), 294.

22. S. Borsari, *Archivio storico per la Calabria e la Lucania* 22 (1953): 137–51, esp. 142–43.

23. W. Ong, *Orality and Literacy: The Technologizing of the Word* (London, 1982), 68–69.

24. L. Gougaud, "Muta praedicatio," *Revue Bénédictine* 42 (1930): 168–71, provides a survey of the Western references.

25. G. G. Litavrin and A. P. Kazhdan, "Ekonomischeskie i politicheski otnosheniya drevnei Rusi e Vizantii," *Proceedings of the XIIIth International Congress of Byzantine Studies* (London, 1967), 69–81.

26. S. H. Cross, trans., *The Russian Primary Chronicle* (Cambridge, Mass., 1953), 111.

27. Quoted from A. A. Vasiliev, *Byzance et les Arabes. II. La dynastie macédonienne*, ed. H. Grégoire and M. Canard (Brussels, 1950), 425–26.

28. Villehardouin, *La conqueste de Constantinople d'après le manuscrit no. 2137 de la B.N.*

(Nancy, 1978), 70, par. 307; trans. M. R. B. Shaw, *Chronicles of the Crusades* (Baltimore, 1963), 76.

29. For example, Photius's Homily X, delivered probably in 869 encomiastically before the rebuilder of the church of the Virgin of the Pharos, Michael III, at the time of its inauguration. For a translation and commentary, see C. Mango, *The Homilies of Photius*, 177–90.

30. For example, Michael Psellus, *Chronographia*, ed. C. Sathas (London, 1899), 33–35, 57–58, 171–73; trans. E. R. A. Sewter, *Fourteen Byzantine Rulers: The Chronicle of Michael Psellos* (Baltimore, 1966), 71–75, 105–6, 251–52.

31. I. Maxeiner, *Byzantine Icons in Steatite*, Byzantina vindobonensia, xv/1 (Vienna, 1985), 73–79.

32. For such analogies by Michael Psellus, a Constantinopolitan intellectual, and by the Neophytus, a provincial ascetic, see Kazhdan and Wharton Epstein, *Change in Byzantine Culture*, 199–200, 211–12. A translation of Psellus's expression of appreciation for a beautifully painted icon of the Virgin is also found there (p. 199). See also Nicetas Choniates' lamentation over the classical sculptures of Constantinople destroyed by the Crusaders. *O City of Byzantium: Annals of Niketas Choniates*, trans. H. J. Magoulias (Detroit, 1984), 357–62.

33. G. B. Ladner, "Origin and Significance of the Byzantine Iconoclastic Controversy," *Medieval Studies* 2 (1940): 127–49.

34. P. Brown, "A Dark Age Crisis: Aspects of the Iconoclastic Controversy," *English Historical Review* 346 (1973): 1–34; L. W. Bernard, "The Emperor Cult and the Origins of the Iconoclastic Controversy," *Byz.* 43 (1973): 13–29.

35. For an introduction to the economy of color, see J. Schneider, "Peacocks and Penguins: The Political Economy of European Cloth and Colors," *American Ethnologist* 5 (1979): 413–47. The recent exhibition of objects from the treasury of San Marco in Venice makes one feel that it is easier to sense the resplendence of Constantinople in the treasury of San Marco, full as it is with the spoils of the city, than from the few remaining Middle Byzantine structures in Istanbul. *The Treasury of San Marco*, exhibition catalogue, Metropolitan Museum of Art (Milan, 1984).

36. Ch. Bouras, "The Byzantine Bronze Doors of the Great Lavra Monastery on Mount Athos," *JOB* 24 (1975): 229–50; W. E. Kleinbauer, "A Byzantine Revival: The Inlaid Bronze Doors of Constantinople," *Archaeology* 29 (1976): 16–29. The Byzantine origins of the so-called Korsunskie vrata (Gates of Cherson) in the church of St. Sophia in Novgorod are debated. A. V. Bank, "Constantinopol'skie obrazcy i mestnye kopii," *Vizantijskij Vremennik* 34 (1973): 193–95.

37. H. Terrasse, *L'art hispano-mauresque des origines au XIIIe siècle* (Paris, 1932), 84, 101–2. The author does not cite his primary sources.

38. Ibn Rusteh, *Les atours précieux*, trans. G. Wiet (Cairo, 1955), 73–74. For a summary of Arab sources on the subject, see A. Papadopoulo, *Islam and Muslim Art*, trans. R. W. Wolf (New York, 1976), 60–61.

39. Leo of Ostia, *Chronica Monasterii Casinensis*, ed. H. Hoffmann, *Monumenta Germaniae Historica*, vol. 34 (Hannover, 1980), 396.14–28; trans. E. G. Holt, *A Documentary History of Art*, 2 vols. (Garden City, New York, 1953), 1: 13.

40. D. Abramovich, *Kievo-Pechersky Paterik* (Kiev, 1930), 172; *La Ducale Basilica, Documenti*, 298 and nos. 85–87, 99, and 823. For a discussion of workshops, see V. Lazarev, *Old Russian Murals and Mosaics* (London, 1966), 11–29.

41. For example, E. Kitzinger, *The Mosaics of Monreale* (Palermo, 1960), 69–89.

42. Theophanes continuatus, *Chronographia* (Bonn), 163.19–164.17.

43. S. A. Zenkovsky, *Medieval Russia's Epics: Chronicles and Tales* (New York, 1963), 112–14.

44. J. Morganstern, *The Byzantine Church at Dereağzı and Its Decoration*, Istanbuler Mitteilungen, Beiheft 29 (Tübingen, 1983), and Ch. Bouras, *Nea Moni on Chios: History and Architecture* (Athens, 1982).

45. E.g., see above, pages 75–76, 105, and 118–19.

46. C. Mango, "Lo stile cosiddetto 'Monastico' della pittura bizantina," in *Habitat, Strutture, Territorio: Atti del III convegno internazionale della cività rupestre medioevale nel mezzogiorno d'Italia*, ed. C. D. Fonseca (Galatina, 1978), 42–62, esp. 58–60.

47. Such arguments have nevertheless been made for Thessaloniki. See chapter 4.

48. See above, pages 44 and 125.

49. C. Mango, "Les monuments de l'architecture du XIe siècle et leur signification historique et sociale," *TM* 6 (1977): 351–65.

50. A. Riegl, *Spätrömische Kunstindustrie* (Vienna, 1927), 18.

51. Kurt Weitzmann's application to art of rules governing the transmission of written texts extrapolated by philologists might be considered a scientific proof of devolution. This method is, however, explicitly limited to iconography. *Illustration in Roll and Codex: A Study of the Origin and Method of Text Illustration*, Studies in Manuscript Illumination, vol. 2, second printing with ad-

denda (Princeton, 1970), esp. chapter 4, "The Relation between Text Criticism and Picture Criticism." Moreover, Weitzmann certainly recognizes consciously introduced change, e.g., *Roll and Codex*, 258–59.

52. A. Dundes, "The Devolutionary Premise in Folklore Theory," *Journal of Folklore History* 6 (1969): 5–19.

53. U. Eco, *The Role of the Reader: Explorations in the Semiotics of Texts* (Bloomington, Indiana, 1979); S. E. Fish, *Is There a Text in This Class? The Authority of Interpretive Communities* (Cambridge, Mass., 1980). For a summary of reader-response theory, see J. P. Tompkins, ed., *Reader-Response Criticism: From Formalism to Post-Structuralism* (Baltimore, 1983).

54. For example, H. Hunger, "Stilstufen in der byzantinischen Geschichtsschreibung des 12. Jahrhunderts: Anna Komnene und Michael Glykas," *Byzantine Studies/Etudes byzantines* 5 (1978): 139–70; I. Ševčenko, "Levels of Style in Byzantine Prose," *Akten XVI Internationaler Byzantinistenkongress*, I,1, *JOB* 31,1 (1981): 289–312.

55. For a depiction of the duties of a provincial bishop, see J. Herrin, "Realities of Byzantine Provincial Government: Hellas and Peloponnesos, 1180–1205," *DOP* 29 (1975): 255–83.

56. E. Herman, "Die kirchlichen Einkünfte des byzantinischen Niederklerus," *Orientalia christiana periodica* 8 (1942): 378–442; H.-G. Beck, *Kirche und theologische Literatur in byzantinischen Reich* (Munich, 1977), 83–86.

57. H. Ahrweiler, "Charisticariat et autres formes d'attribution de fondations pieuses aux Xe–XIe siècles," *Zbornik radova* 10 (1967): 1–27; P. Lemerle, "Un aspect du rôle des monastères à Byzance: Les monastères donnés à des laïcs, Les charisticaires," *Comptes rendus de l'Académie des Inscriptions et Belles-Lettres* (1967), 9–28.

58. K. A. Manaphes, *Monastēriaka typika—Diathēkai* (Athens, 1970); R. Janin, "Le monachisme byzantin au moyen âge: Commende et typica (X–XIV siècle)," *REB* 22 (1964): 5–44. For a discussion of two instances of a founder's concern with the art as well as the life of the monastery, see A. Wharton Epstein, "Formulas for Salvation: A Comparison of Two Byzantine Monasteries and Their Founders," *Church History* 50 (1981): 385–400.

59. *AASS*, 7 November III, par. 246–50, as quoted in Kazhdan and Wharton Epstein, *Byzantine Culture*, 88.

60. N. Hadjinicolaou, *Art History and Class Struggle* (London, 1978), presents a clear formulation.

61. P. Veyne, "The Hellenization of Rome and the Question of Acculturations," *Diogenes* 106 (1979): 1–27.

62. K. M. D. Dunbabin, *The Mosaics of Roman North Africa* (Oxford, 1978).

63. For example, R. Brilliant, "'I Come to You as Your Lord': Late Roman Imperial Art," in *Artistic Strategy and the Rhetoric of Power: Political Uses of Art from Antiquity to the Present*, ed. D. Castriota (Carbondale and Edwardsville, Illinois, 1986), 27–38.

CHAPTER 2

1. The province can be territorially defined by the distribution of its traditional metropolitans (Caesarea, Tyrana, and Mokissos [Koron, Justinianopolis]) and their suffragans. See J. Darrouzès, *Notitiae episcopatuum ecclesiae constantinopolitanae* (Paris, 1981). The region includes in the north the bowl of the Kızıl Irmak (Halys) from the Parnassos up to Aipolio, to the west and south the slopes of the Anti-Taurus and Taurus from Kiskisos through Tyrana to Kybistra and to the Great Salt Lake in the west. For a more exact drawing of the boundaries, see F. Hild and M. Restle, *Kappadokien (Kappadokia, Charsianon, Sebasteia und Lykandos)*, Tabula imperii byzantini, II (Vienna, 1981), 41–42.

2. U. Andolfato and F. Zucchi, "The Physical Setting," in *Arts of Cappadocia*, ed. L. Giovanni (Geneva, 1971), 50–61.

3. The rock-cut city described by Xenophon in the *Anabasis* (ed. and trans. C. L. Brownson [London, 1922], IV, vv. 25–26) seems to be located in Armenia, though this description certainly fits underground cities like Kaymaklı in Cappadocia.

4. In the southernmost nave of the complex is this funerary inscription: "I, Bathystrokos the abbot, greatly toiling in this church and after these (toils) dying, I am laid down here. I died in the month of..." G. de Jerphanion, *Une nouvelle province de l'art byzantine: Les églises rupestres de Cappadoce*, 4 vols. (Paris, 1925, 1932, 1936, 1942), II, 1: 356.

5. Nicetas Choniates, *Historia*, ed. I. A. Van Dieten, Corpus Fontium Historiae Byzantinae, XI, i (Berlin, 1975), 207.2–4; trans. H. M. Magoulias, *O City of Byzantium: Annals of Niketas Choniates* (Detroit, 1984), 118.

6. Jerphanion, *Une nouvelle province*, I,2: 568–80. Symeon's epitaph reads:

> As a fetus I was shaped within the belly of my mother.
> For nine months long (?), not eating of sustenance,
> I was nourished by . . . liquid.
> I [came forth from the womb] of my (own) mother.
> I know the creature, I came to recognize the Creator
> And I was taught the divinely inspired Scriptures,
> I understood those tidings brought to me.
> The sons of Adam, the first-molded, have come
> That he lies dead, and all the prophets, too.
> Living, I prepared my slanting tomb;
> Therefore receive me, grave, as (you did) the [Stylite].
> The servant of God, Symeon the monk,
> Fell asleep in the month of June . . . in the year . . .

For a transcription of the Greek, see Jerphanion, *Une nouvelle province*, I,2: 577–78. I want to thank professors Elizabeth Clark and Francis Newton for their comments on and corrections of my translation.

7. R. J. Lilie, *Die byzantinische Reaktion auf die Ausbreitung der Araber*, Miscellanea Byzantina Monacensia, 22 (Munich, 1976), 93–96.

8. J. F. Haldon and H. Kennedy, "The Arab-Byzantine Frontier in the Eighth and Ninth Centuries: Military Organization and Society in the Borderlands," *Zbornik Radova* 19 (1980): 79–116.

9. F. Hild, *Das byzantinische Strassensystem in Kappadokien* (Vienna, 1977), 34.

10. Ibn Hawqual, *Configuration de la terre*, intro. and trans. J. H. Kramer and G. Wiet (Beirut, 1964), 194–95.

11. Nicetas Choniates, *Historia*, 124.13–15; 150.40–44; 228.46–49; 400.88–89.

12. N. Oikonomidès, "L'épopée de Digénis et la frontière orientale de Byzance aux Xe et XIe siècles," *TM* 7 (1979): esp. 377. *Digenis Akritas*, ed. and trans. J. Mavrogordato (Oxford, 1956).

13. Jerphanion, *Une nouvelle province*, is still the best source for both inscriptions and graffiti; see also G. P. Schiemenz, "Herr, hilf deinem Knecht: Zur Frage nimberter Stifter in den kappadokischen Höhlenkirchen," *Römishe Quartalschrift* 71 (1976): 133–74; N. Thierry, "Remarques sur la peinture populaire et la pratique de la foi dans les églises rupestres de Cappadoce," *Artistes, artisans et production artistique au Moyen-Age*, Université de Haute-Bretagne, Rennes, 2–3 May 1983, Rapports provisoires (Rennes, 1983), 703–30. For the definition of titles, see N. Oikonomidès, *Les listes de préséance byzantines de IXe et Xe siècles* (Paris, 1972).

14. See above, pages 34 and 44. See also M. Kaplan, "Les grands proprietaires de Cappadoce (VIe-XIe siècles)," in *Le aree omogenee della civiltà rupestre nell'ambito dell'Impero Bizantino: La Cappadocia*, ed. C. D. Fonseca (Galatina, 1981), 125–85.

15. *Kleisourarch* is discussed above, page 21; *taxiarch* appears in the church of St. Michael in the Peristrema Valley (N. Thierry, "Un style byzantin schématique de Cappadoce daté du XIe siècle d'après une inscription," *Journal des Savants* [1965]: 45–61); *domestikos*, above, pages 40–41; John Scepides, a *strategos* and *protospatharios* of the Golden Diningroom, who appears as the donor in Geyik Kilise in the Soğanlı Valley (Jerphanion, *Une nouvelle province*, II, 1: 372), is part of the same family which supported Karabaş Kilise, above, page 44.

16. Jerphanion, *Une nouvelle province*, I,2: 471, 477. For Kotiaion, see W. M. Ramsay, *The Historical Geography of Asia Minor* (reprinted, New York, 1972), 199.

17. S. Vryonis, *The Decline of Medieval Hellenism in Asia Minor and the Process of Islamization from the Eleventh through the Fifteenth Century* (Berkeley, 1977), esp. chapters 2 and 3.

18. Baldricus, *Historia Jerusalem*, Recueil des historiens des croisades: Historiens occidentaux, 5 vols. (Paris, 1879), IV: 39.

19. William, Archbishop of Tyre, *A History of Deeds Done Beyond the Sea*, trans. and annotated by E. A. Babcock and A. C. Krey, 2 vols. (New York, 1943), 1: 296.

20. G. P. Schiemenz, "Die Kapelle des Styliten Niketas in den Weinbergen von Ortahisar," *JOB* 18 (1969): 238–58; N. Thierry, "L'église peinte de Nicétas Stylite," *Communications, XIVe Congrès international des études byzantines, Bucharest, 1971* (Bucharest, 1976), 451–55; L. Rodley, *Cave Monasteries of Byzantine Cappadocia* (Cambridge, 1985), 184–89.

21. Theodore the Studite, *Oration II*, in *PG*, 99, col. 697.

22. F. Dvornik, *La vie de saint Grégoire le Décapolite et les Slaves macédoniens au IXe siècle* (Paris, 1926), 50.

23. This translation depends on that offered by C. Mango and I. Ševčenko in N. Thierry, "Le culte de la croix dans l'empire byzantin du VIIe siècle au Xe dans ses rapports avec la guerre contre l'infidèle," *Rivista di studi bizantini e slavi*, Miscellanea Agostino Pertusi, I (Bologna, 1981), 208–10.

24. See also Schiemenz, "Kapelle des Styliten Niketas," 248–49.

25. The popularity of sequences from the life of John the Baptist (the cycles of two of the churches of the Belli Kilise complex in Soğanlı Valley are characteristic) appears to reflect a particular veneration for the Precursor in Cappadocia, as does the prominence of the image of the Baptism (e.g., in the Column Churches) and the widespread use of the Deesis (in which the Baptist plays a major part) as the decorative theme for the sanctuary apse in the eleventh century.

26. N. Oikonomidès, *Listes de préséance*, 48 n. 24 and 348; J. Ferluga, "Le clisure bizantine in Asia Minor," *Zbornik Radova* 16 (1975): 9–23; Hild and Restle, *Kappadokien*, 163–64; D. Potache, "Le thème de la forteresse de Charsianon," *Geographica Byzantina*, ed. H. Ahrweiler (Paris, 1981), 107–17.

27. In N. Thierry, "Mentalité et formulation iconoclastes en Anatolie," *Journal des Savants* (1976): 81–119, her "Le culte de la croix," 205–28, and elsewhere, the author argues that the church of Nicetas and the monuments with which it is associated date to around the year 700. Because neither Cappadocia nor Charsianon was a *kleisoura* at that time, such a date seems unlikely to me.

28. N. Thierry, "Les peintures murales de six églises du haut moyen âge en Cappadoce," *Académie des inscriptions et Belles-Lettres* (July-October 1970): 444–80; A. Wharton Epstein, "The 'Iconoclast' Churches of Cappadocia," in *Iconoclasm*, ed. A. Bryer and J. Herrin (Birmingham, 1976), 103–11.

29. See A. Wharton Epstein, *Tokalı Kilise: Tenth-Century Metropolitan Art in Byzantine Cappadocia* (Washington, D.C., 1986), for a discussion of the chronology of the monument and earlier scholarly bibliography.

30. R. Cormack, "Byzantine Cappadocia: The Archaic Group of Wall-Paintings," *Journal of the British Archaeological Association*, ser. III, 38 (1967): 19–36, esp. 24–26; also see below, page 000.

31. N. Thierry and M. Thierry, "Ayvalı Kilise ou pigeonnier de Gülli Dere," *CA* 15 (1965): 97–154. For the ascription of these frescoes to a single atelier, see Cormack, "Byzantine Cappadocia," 22–23, and N. Thierry, "Un atelier de peinture du debut du Xe s. en Cappadoce: L'atelier de l'ancienne église de Tokalı," *Bulletin de la société nationale des antiquaires de France* (Paris, 1971), 170–78.

32. Thierry and Thierry, "Ayvalı Kilise," 128.

33. Jerphanion, *Une nouvelle province*, I,1: 199–242; M. Restle, *Die byzantinische Wandmalerei in Kleinasien*, 3 vols. (Recklinghausen, 1967; reprinted in English the same year; all references are to the German edition), 1: 130–33; Rodley, *Cave Monasteries*, 39–45.

34. For Marciana gr. 538 (now gr. 540), see K. Weitzmann, *Die byzantinische Buchmalerei des 9.und 10. Jahrhunderts* (Berlin, 1935), 51–53, figs. 337–49; I. Spatharakis, *Corpus of Dated Illuminated Greek Manuscripts to the Year 1453*, 2 vols. (Leiden, 1981), 9–10.

35. Despite objections raised (though not universally accepted) to the Constantinopolitan origins of Vat. gr. 699, the style of the miniatures is intimately linked with Constantinopolitan production. J. Leroy, "Notes codicologiques sur le Vat. gr. 699," *CA* 23 (1974): 73–78. For Gar. 6, see G. Vikan, ed., *Illuminated Greek Manuscripts from American Collections* (Princeton, 1973), 52–55.

36. C. L. Striker, *The Myrelaion (Bodrum Camii) in Istanbul* (Princeton, 1981); Bodrum Camii has groin-vaulted corner bays; however, the Nea Ecclesia of Basil I is commonly assumed to be a cross-in-square church, with domical vaults covering the corner bays. See, for example, R. Krautheimer, *Early Christian and Byzantine Architecture*, 2d ed. (Harmondsworth, 1975), 376–77. Doubts about the Nea's form have been expressed. S. Ćurčić, "Architectural Reconsideration of the Nea Ekklesia," *Abstracts of the Sixth Annual Byzantine Studies Conference* (Oberlin, Ohio, 1980), 11.

37. It runs as follows: Annunciation, south side of the barrel vault of the east arm; Visitation and Trial by Bitter Water, east side of the barrel vault of the south arm; Joseph's Reproach, south tympanum; Nativity and Annunciation to the Shepherds, west side of the barrel vault of the south arm; Adoration of the Magi, west side of the barrel vault of the north arm; Dream of Joseph, north tympanum; Flight to Egypt, east side of the barrel vault of the north arm. The sequence continues to scroll from left to right in two registers on the walls through an abbreviated Ministry cycle and an extended Passion cycle.

38. In the *prothesis* apse: "This sanctuary was decorated [by the hand of?] Nicephorus through the benefactions of the servant of God, Leo [son] of Constantine; and those reading this pray for them to the Lord. Amen." Constantine alone is mentioned in the inscription in the nave.

39. C. Mango, "The Date of the Cod. Vat. Regin. Gr. 1 and the 'Macedonian Renaissance,' " *Institutum Romanum Norvegiae, Acta ad archaeologiam et artium historiam pertinentia*, Institutum Romanum Norvegiae, 4 (1969), 121–26. I have argued this comparison more fully in *Tokalı Kilise*, 40–44.

40. The cycle begins with a large framed scene of the Annunciation in the eastern half of the north transept barrel vault with predellalike scenes, including the apocryphal Trial by Bitter Water below.

The narrative continues across the north tympanum with the Dream of Joseph and the Journey to Bethlehem. Another great icon of the Nativity, complementing the Annunciation opposite, appears on the west half of the north transept vault, again with scenes below—the Magi seeing the star and the Adoration. The narrative continues in a frieze zone that encompasses the nave, running from the Flight to Egypt through a Baptism cycle to the first miracle of the Ministry, the Marriage at Cana, at the end of the north wall. The miracles extend across the spandrels of the sanctuary arcade to the Raising of Lazarus in the middle of the south wall and the beginning of the Passion. The Passion cycle occupies the remainder of the frieze zone; an elaborate Crucifixion fills the sanctuary conch, once more with subsidiary scenes on the wall below. The Blessing of the Apostles and the Ascension are ordered in a splendidly balanced composition across the whole of the central bay of the barrel vault; the Pentecost, again with scenes below, occupies the south bay of the barrel vault.

41. A. J. Wharton, "Tenderness and Hegemony: Exporting the Virgin Eleousa," *Acts of the XXVth International Congress of Art History* (Washington, D.C., 1987). Also see below, note 76.

42. I want to thank Professor Raymond van Dam for this suggestion.

43. G. Bell in M. van Berchem and J. Strzygowski, *Amida, Beiträge zur Kunstgeschichte des Mittelalters von Nordmesopotamien, Hellas und dem Abendland* (Heidelberg, 1910), 236–42.

44. J. Lafontaine-Dosogne, "Sarıca Kilise en Cappadoce," *CA* 12 (1962): 263–84, esp. 282–84; M. Restle, *Byzantinische Wandmalerei*, 2: ii, viii, xv, xxiii.

45. I want to thank Memduh Güzelgöz for showing me this complex. On the ceiling, the frame around the cross was decorated with interlaced roundels of prophets; between the arms of the cross were scenes from the Life of the Virgin, of which only the Presentation in the Temple with the attending angel survives. The Christological sequence began in the upper register of the south wall of the church probably with the Annunciation. At present, after a break in the architecture, the narrative reads: Trial by Bitter Water, Journey to Bethlehem, Nativity, and the Virgin and Child enthroned from the Adoration of the Magi. On the west wall the narrative continues with the Magi themselves. Complementing this divided scene on the south is the divided scene of the Presentation on the north, with Joseph and the Virgin and Child on the west wall and Symeon on the north. The cycle continues on the north wall with the Raising of Lazarus, Entry into Jerusalem, the Baptism [*sic*], and Crucifixion, the rest of the wall having been destroyed. The center of the west wall is occupied by a Last Judgment: Christ enthroned between the Virgin and the Baptist in a Deesis and two enthroned apostles. In the lower register of the west wall is, at the center, a cross flanked by angels and further enthroned apostles(?).

46. Restle, *Byzantinische Wandmalerei*, 3: i.

47. For example, in Göreme Valley, El Nazar (Chapel 1) and chapels 9 and 6; in the Peristrema Valley, Bahatin Samanlığı Kilise, Eski Baca Kilisesi, Karağedik Kilise, and Kale Kilise; in Soğanlı Valley, Belli Kilise.

48. L. Rodley, "The Pigeon House Church, Çavuşin," *JOB* 33 (1983): 301–39.

49. The Holy Apostles at Sinassos has a nave decoration executed by the same artist who worked in Ayvalı Kilise in Güllü Dere and the Old Church of Tokalı. See above, note 31.

50. See, for example, F. van der Meer, *Maiestas Domini, Théophanies de l'Apocalypse dan l'art chrétien* (Rome, Paris, 1938), 274ff. On apsidal programs generally, see C. Ihm, *Die Programme der christlichen Apsismalerei* (Wiesbaden, 1960), esp. 45–49. On the Prophetic Vision in Cappadocia, see J. Lafontaine-Dosogne, "Théophanies-Visions auxquelles participent les prophètes dans l'art Byzantine après la restauration des images," in *Synthronon* (Paris, 1968), 135–43.

51. Isaiah, 6:1–7; Ezekiel, 1:1–28; Daniel, 7:9; Revelation, 4:1–11.

52. F. E. Brightman and C. E. Hammond, *Liturgies Eastern and Western* (Oxford, 1896), 313.4–30.

53. Ibid., 323.14–30.

54. Still the most lucid description of the Middle Byzantine feast program is found in O. Demus, *Byzantine Mosaic Decoration* (London, 1948). Also see J. Lafontaine-Dosogne, "L'évolution du programme décoratif des églises," *XVe Congrès international d'études byzantines* (Athens, 1976), 131–56.

55. The twelve major feasts are generally identified as the Annunciation, Visitation, Nativity, Presentation, Baptism, Transfiguration, Raising of Lazarus, Entry into Jerusalem, Anastasis (Harrowing of Hell), Ascension, Pentecost, and Koimesis (Death of the Virgin). The selection and number of scenes in churches are in fact extremely varied.

56. P. Grierson, *Catalogue of the Byzantine Coins in the Dumbarton Oaks and in the Whittemore Collection*, 3 vols. (Washington, D.C., 1973), III,1: esp. 168–69.

57. *PG*, 102, 572B. Translation from C. Mango, *The Homilies of Photius, Patriarch of Constantinople* (Cambridge, Mass., 1958), 187–88.

58. Ed. Akakios, *Leontos tou sophou panēgyrikoi, logoi* (Athens, 1868), 245–46. Translation from C. Mango, *The Art of the Byzantine Empire, 312–1453: Sources and Documents*, 202–3.

59. Ed. Akakios, 275-76. Translation from Mango, *Art of the Byzantine Empire*, 203-4.

60. Jerphanion, *Une nouvelle province*, II,1: 308-11.

61. For example, the Triconch of Tağar has the Deesis in two apses and the Maiestas Domini in the third. See M. Restle, *Byzantinische Wandmalerei*, 3: xxxv. The artists of Eski Gümüş and the church of Ayvalı köy have added the Virgin and Baptist to a simplified rendition of the Maiestas. See M. Gough, "The Monastery of Eski Gümüş: A Preliminary Report," *Anatolian Studies* 15 (1965): 157-64; N. Thierry, "A propos des peintures d'Ayvalı köy (Cappadoce): Les programmes absidaux à trois registres avec Dejsis, en Cappadoce et en Géorgie," *Zograf* 5 (1974): 5-22.

62. For example, the splendid Lectionary, Dionysiou 587, on Mount Athos, of the mid-eleventh century. See K. Weitzmann, "The Wanderings of the Imperial Lectionary of Mount Athos," *Revue des études sud-est européenes* 7 (1969): 239ff. Also see his assessment of the period in "Byzantine Miniature and Icon Painting in the Eleventh Century," *Proceedings of the XIIIth International Congress of Byzantine Studies, Oxford, 1966* (London, 1967), 207-24.

63. I want to thank Memduh Güzelgöz for showing me this monument. Similar strapwork and diaper patterns occur not only in St. Barbara but also in Chapel 33 in Göreme, which was decorated by the Avcılar master. See Restle, *Byzantinische Wandmalerei*, 2: 279, 288; 3: 435, 443.

64. For a thorough consideration of the Deesis, see C. Walters, "Two Notes on the Deesis," *REB* 26 (1968): 311-36; "Further Notes on the Deesis," *REB* 29 (1970): 161-87; and "Bulletin on the Deesis and Paraclesis," *REB* 38 (1980): 261-69. Also see above, pages 137-39.

65. The Deesis is associated with the Last Judgment also in the Ayvalı Kilise in Güllü Dere.

66. Brightman and Hammond, *Liturgies*, 331.12-332.30.

67. Restle, *Byzantinische Wandmalerei*, 2: xxv.

68. For example, the most prominent saint in the chapel at Avcılar is the mounted St. George, which occupies the whole of the west arch of the south wall. The pendant image has been destroyed.

69. Jerphanion, *Une nouvelle province*, II,1: 330-60; Rodley, *Cave Monasteries*, 193-207.

70. N. Thierry, "Etude stylistique des peintures de Karabaş Kilise in Soğanlı Dere," *CA* 17 (1967): 165-75. M. Restle, "Zum Datum der Karabaş Kilise in Soğanlı Dere," *JOB* 19 (1970): 261-66, argues that the frescoes are late twelfth century on the basis of their style. His discussion of the inscription was not, for me, convincing.

71. Jerphanion, *Une nouvelle province*, II,1: 334.

72. Oikonomidès, *Listes de préséance*, 297.

73. Jerphanion, *Une nouvelle province*, I,2: 393-473. For further support of Jerphanion's eleventh-century ascription, see A. Wharton Epstein, "Rock-cut Chapels in Cappadocia: The Column Churches and the Yılanlı Group," *CA* 15 (1974): 115-35. M. Restle, on the basis of style, attributes the Column Churches to the late twelfth century (*Byzantinische Wandmalerei*, 1: 57-65).

74. Thierry, "L'art byzantin en Asie Mineur," 89; Rodley, *Cave Monasteries*, 53-55.

75. For turbans in Byzantium, see C. Mango, "Discontinuity with the Classical Past in Byzantium," in *Byzantium and the Classical Tradition*, ed. M. Mullet and R. Scott (Birmingham, 1981), 51-52.

76. For example, if Michael Psellus, the eleventh-century scholar and historian, is to be believed, the consorts of the Empress Zoe seem to have experimented with a number of complex centralized structures in an attempt to outdo one another as church builders: Romanus III (1028-34) built St. Mary Peribleptos; Michael IV (1034-41), in the hope of recovering from dropsy, reconstructed the monastery of Sts. Cosmas and Damian; Constantine IX Monomachus (1042-55) raised the church of St. George of Mangana. Michael Psellus, *Chronographia*, ed. C. Sathas (London, 1899), 32.36-35.17; 57.15-58.3; 168.11-169.16. Foundations identified with the church of St. George of Mangana have been excavated. For bibliography, see W. Müller-Wiener, *Bildlexikon zur Topographie Istanbuls* (Tübingen, 1977), 136-38.

77. Jerphanion, *Une nouvelle province*, I,2: 445, 470-73.

78. For example, in the Pantokrator monastery and in the monastery of the Theotokos Kecharitōmenēs, two early twelfth-century monasteries in Constantinople, offices are said in the narthex. In the latter, royal tombs were found in the exonarthex. See P. Gautier, "Le typikon du Sauveur Pantocrator," *REB* 32 (1974): 31.63-33.65; Fr. Miklosich and J. Müller, *Acta et diplomata graeca medii aevi* (Vienna, 1860-90), II: 359.

79. The frescoes of the rock-cut churches of Cappadocia are being cleaned and restored by the International Center for Conservation, Rome, with funding from UNESCO.

80. N. Thierry, "L'art monumental byzantin en Asie Mineure du XIe siècle au XIVe," *DOP* 29 (1975): 87-91. See also A. Wharton Epstein, "The Fresco Decoration of the Column Churches, Göreme Valley, Cappadocia: A Consideration of Their Chronology and Their Models," *CA* 21 (1981): 27-45.

81. The best source on the Mandylion is still E. von Dobschütz, *Christusbilder: Untersuchungen*

zur christlichen Legende (Leipzig, 1899), 102–96. For the Mandylion in art and for its close imperial associations, see K. Weitzmann, "The Mandylion and Constantine Porphyrogennetos," *CA* 11 (1960): 163–84. More recently, N. Thierry, "Deux notes à propos du Mandylion," *Zograf* 11 (1981): 16–19.

82. Cedrenus, 156.3–15.

83. Ibid., 508.9–15.

84. The Way to Golgotha and Simon Carrying the Cross seem to be adaptations of an image more logically combining both scenes, such as that found in Kılıçlar Kilise. The combined Blessing of the Apostles and Ascension is derived from the New Church of Tokalı Kilise. Like the adaption of the same scene in the Great Pigeon House at Çavuşın, the number of apostles is multiplied. The artist at Karanlık Kilise includes fifteen apostles in the Blessing.

85. N. Thierry, "La Vierge de tendresse à l'époque macédonienne," *Zograf* 10 (1979): 59–70. Also, see above, note 41.

86. For the development of the liturgical emphasis on the Anastasis in the tenth century, see A. Kartsonis, *Anastasis: The Making of an Image* (Princeton, 1986), esp. 168–85.

87. For the definition of this group and its architectural dependence on the Column Churches, see Wharton Epstein, "The Yılanlı Group," 115–22. More recently, see G. P. Schiemenz, "Felskapellen im Göreme-Tal, Kappadokien: Die Yılanlı-Group und Saklı Kilise," *Istanbuler Mitteilungen* 30 (1980): 291–319.

88. Jerphanion, *Une nouvelle province*, I,1: 171–76.

89. Even work of the thirteenth century (e.g., the Forty Martyrs of Söviç), though richer in palette and in program, appears to be much more closely related stylistically to the Column Churches and the Yılanlı Group than to contemporary work in the heartlands of the Empire.

CHAPTER 3

1. Such estimates can be deduced from contemporary documents such as Mukaddasi (fl. 985), *Description of Syria*, trans. Guy Le Strange, Palestine Text Society (London, 1886), 82, for the distance to Palestine, and S. Doanidou, "Hē paraitēsis Nikolaou tou Mouzalōnos apo tēs archiepiskopēs Kyprou," *Hellēnika* 7 (1934): 119.260–63, for the sojourn to Constantinople.

2. The historicity of this tradition is questionable as it is recorded only in late sources, e.g., Ph. Georgiou, *Eidēseis istorikai peri tēs ekklēsias tēs Kyprou* (Athens, 1875), 28, cited in J. Hackett, *A History of the Orthodox Church of Cyprus* (London, 1901), 24.

3. Cf. V. Laurent, *Le corpus des sceaux de l'empire byzantine* (Paris, 1965), V,2: 307–16.

4. H. Grégoire, "Saint Démétrianos, évêque de Chytri (île de Chypre), *BZ* 16 (1907): introduction, 209–12; R. Browning, "Byzantium and Islam in Cyprus in the Early Middle Ages," *Epetētris tou Kentrou Epistēmonikōn Ereuvōn*, 9 (1977–79): 101–16.

5. This and other learned opinions were recorded by Baladhuri, *Origins of the Islamic State*, ed. P. K. Hitti, Studies in History, Economics and Public Law, Faculty of Political Science of Columbia University, 68 (New York, 1916), 239–41.

6. Theophanes, *Chronographia*, ed. Bonn, I: 778.10–779.10.

7. For a compelling negative assessment, see C. Mango, "Chypre Carrefour du monde byzantine," *XV Congrès international des études byzantines* (Athens, 1976).

8. Browning, "Byzantium and Islam," 106–7.

9. Grégoire, "S. Démétrianos," 217–37.

10. Cedrenus, *PG*, 122, 281; Anna Comnena, *Alexiades*, ed. A. Reifferscheider (Leipzig, 1884), II: 33.1–35.7; Nicetas Choniates, *Historia*, ed. I. A. van Dieten, Corpus fontium historiae byzantinae, 9 (Berlin, 1975), 290.12–291.40.

11. H. Ahrweiler, *Byzanz et la mer* (Paris, 1966), 186.

12. C. Mango, "Chypre Carrefour du monde byzantine," provides a list of Byzantine officials.

13. I. P. Tsiknopoullos, ed., *Kypriaka typika* (Nicosia, 1969), 2–68.

14. For a general discussion of the absence of nartheces before the twelfth century, see A. Papageorghiou, "The Narthex of the Churches of the Middle Byzantine Period in Cyprus," *Rayonnement Grec*, ed. L. Hadermann-Misguich and G. Raepsaet (Brussels, 1982), 437–48.

15. C. H. Talbot, trans., *The Anglo-Saxon Missionaries in Germany* (New York, 1954), 153–77, esp. 162–63; *AASS*, August III, 489–507, esp. 492–93.

16. F. Micheau, "Les itinéraires maritimes et continentaux des pèlerinages vers Jérusalem," *Occident et Orient au Xe siècle* (Paris, 1979), 79–91.

17. Anonymous pilgrim, *Account of a Journey to Palestine*, trans. A. Stewart, Palestine Pilgrims' Text Society, 6 (London, 1894), 17.

18. William of Tyre, *A History of Deeds Done Beyond the Sea*, trans. E. A. Babcock and A. C. Krey, 2 vols. (New York, 1941), I: 381–82.

19. C. P. Kyrris, "Military Colonies in Cyprus in the Byzantine Period," *Byzantinoslavica* 31 (1970): 157–81.

20. K. Weitzmann, "A Group of Early Twelfth Century Sinai Icons Attributed to Cyprus," in *Studies in Memory of David Talbot Rice*, ed. G. Robertson and G. Henderson (Edinburgh, 1975), 60.

21. G. L. F. Tafel and G. M. Thomas, *Urkunden zur älteren Handels- und Staatsgeschichte der Republik Venedig*, 3 vols. (Vienna, 1856, reprinted Amsterdam, 1964), I: 114–24.

22. C. Enlart, *Les monuments des Croisés dans le Royaume de Jérusalem*, 2 vols. (Paris, 1925, 1928), I: 67–70. For artistic relations between Cyprus and the Crusaders, see also A. Papageorghiou, "L'art byzantin de Chypre et l'art des croisés: Influences réciproques," *Report of the Department of Antiquities Cyprus* (Nicosia, 1982), 217–26.

23. Doanidou, "Hē paraitēsis Nikolaou tou Mouzalōnos," 119.260–63.

24. For example, Abbot Daniel, *Pilgrimage in the Holy Land*, trans. C. W. Wilson, Palestine Pilgrims' Text Society, 4 (London, 1888), 2–3. Abbot Daniel visited Cyprus in 1106 or 1107.

25. For example, *Itinerarium Regis Ricardi*, ed. W. Stubbs, Rolls Series, 38, 2 vols. (London, 1864, 1865), II, chap. 42, 204.

26. Mukaddasi, *Description of Syria*, 82.

27. Anonymous pilgrim, *Account of a Journey to Palestine*, 14.

28. M. B. Ephthimiou, "Greeks and Latins of Thirteenth Century Cyprus," *Greek Orthodox Theological Review* 20 (1975): 35–52.

29. A. H. S. Megaw and E. J. W. Hawkins, *Church of the Panagia Kanakaria at Lythrankomi in Cyprus: Its Mosaics and Frescoes* (Washington, D.C., 1977).

30. A. H. S. Megaw, "Three Vaulted Basilicas in Cyprus," *The Journal of Hellenic Studies* 64 (1946): 48–56.

31. A. H. S. Megaw and E. J. W. Hawkins are preparing a monograph on the church at Kiti. A. H. S. Megaw, "Byzantine Architecture and Decoration in Cyprus: Metropolitan or Provincial?" *DOP* 28 (1974): 59–69.

32. For brief restoration notices, see *Annual Report of the Director of Antiquities, 1978* (Nicosia, 1979), 17; *Annual Report of the Department of Antiquities, 1982* (Nicosia, 1983), 20. I want to thank professors Annemarie Carr and John Younger, who visited the site at my request, for their helpful comments concerning this monument. This church is presently being restored under the direction of A. Papageorghiou, who will publish the monument. The few observations made here are, consequently, of a tentative nature.

33. From the highly abstracted bull that appears in the northeast corner, the protomes may have represented the four evangelists.

34. A. Papageorghiou, "Recently Discovered Wall-Paintings in the 10th–11th Century Churches of Cyprus," *Actes du XIV Congrès international des études byzantines, Bucarest, 1971* (Bucharest, 1976), 411–13; *Annual Report of the Director of the Department of Antiquities, 1969* (Nicosia, 1970), 11.

35. M. Restle, *Die byzantinische Wandmalerei in Kleinasien*, 3 vols. (Recklinghausen, 1967), II: i, 18.

36. *Byzantine Murals and Icons*, exhibition catalogue, National Gallery (Athens, 1976), 57–59; color plate I.

37. See above, pages 78–79.

38. C. Mango, in Megaw and Hawkins, *Panagia Kanakaria*, 72–74.

39. Megaw and Hawkins, *Panagia Kanakaria*, 30–34; see also S. Ćurčić's review of Megaw and Hawkins, *Panagia Kanakaria*, in *Speculum* 55 (1980): 813.

40. Specifically on this series, see C. Enlart, "Les églises à coupoles d'Aquitaine et de Chypre," *Gazette des Beaux-Arts* 1 (1926): 129–52; G. A. Soteriou, "Les églises byzantines de Chypre à cinq coupoles et leur place dans l'histoire de la architecture byzantine," *Atti del V Congresso internazionale di studi bizantini*, 2 vols. (Rome, 1940), II: 401–9.

41. T. S. R. Boase, "Mosaic, Painting and Minor Arts," *Art of the Crusader States* (Madison, 1977), 119–23, plates 31–33. The paintings at Yeroskipos will be published by A. Papageorghiou.

42. For crosses in church vaults in Georgia, see T. Velmans, "L'image de la Déisis dans les églises de Géorgia," *CA* 31 (1983): 129–73.

43. H. Delehaye, "Saints de Chypre," *Analecta Bollandiana* 26 (1907): 253. For the church, see A. Stylianou, "Peristerona (Morphou)," *Kypriakai Spoudai* 27 (1963): 241–47; A. Stylianou and J. Stylianou, *Peristerona (Morphou)* (Nicosia, 1964), and G. A. Soteriou, *Ta Byzantina Mnēmeia tēs Kyprou* (Athens, 1935), fig. 15, plates 20 and 21. Dr. Papageorghiou has recently written to me of his belief that the present structure was built no earlier than the twelfth century on the site of an earlier church of which only the north wall survives. I have not had access to the evidence on which his chronology is based.

44. For plans and views of these churches, see Soteriou, *Byzantina Mnēmeia*, figs. 11 and 13, plates 15-19, and A. H. S. Megaw, "Byzantine Architecture and Decoration in Cyprus: Metropolitan or Provincial?" *DOP* 28 (1974), figs. 77H, 27, 29, 31. For a general survey of Middle Byzantine architecture on the island, including the domed basilicas, see A. Papageorghiou, "L'architecture de la periode byzantine à Chypre," *Corso* 13 (1985): 325-35.

45. Megaw, "Byzantine Architecture in Cyprus," 57-88, esp. 78-79. On St. Barnabas, see G. A. Soteriou, "Ho naos kai taphos tou Apostolou Barnaba para tēn Salamina tēs Kyprou," *Kypriakai Spoudai* 27 (1963): 241-47.

46. O. Demus, *The Church of San Marco in Venice: History, Architecture, Sculpture* (Washington, D.C., 1960); A. Wharton Epstein, "The Date and Significance of the Cathedral of Canosa in Apulia, South Italy," *DOP* 37 (1983): 79-90.

47. P. Grierson, "The Tombs and the Obits of the Byzantine Emperors (337-1047)," *DOP* 16 (1962): 1-64.

48. This masonry shares something of the aesthetic found in southern First Romanesque. E. Armi, *Masons and Sculptors in Romanesque Burgundy* (University Park, Pa., 1983), 48-73, with a critique of earlier scholarship.

49. P. Michelis, *Aisthētikē theōrēse tēs Byzantinēs technēs* (Athens, 1946), 45-46.

50. A. Stylianou and J. Stylianou, "Ho naos tou Hag. Nikolaou tēs Stegēs, agnōston mouseion byzantinēs technēs," *Kypriakai Spoudai* 10 (1946-48): 95-196; M. G. Soteriou, "Hai archaikai toichographiai tou naou tou Hag. Nikolaou tēs Stegēs Kyprou," *Charistērion eis A. K. Orlandon*, 3 vols. (Athens, 1966), 3: 133-41. M. Sacopoulo, "A Saint-Nicholas-du-Toit: Deux effigies inédites de Patriarches Constantinopolitains," *CA* 17 (1967): 193-202. A. Papageorghiou is currently preparing a monograph on the monument.

51. Many of the distinctively provincial features of St. Nicholas are also found in the church of St. Heracleidus, part of the monastery of St. John Lampadistis at Kalopanayiotis: similar fabric and plan, oblong piers, insteped corona and conical dome, longitudinal barrel vaults over the corner bays, abbreviated sanctuary, and later narthex. St. Heracleidus is larger and more carefully set out than St. Nicholas, but unfortunately its earliest painting dates from the thirteenth century. E. Vogel, "St. Jean Lampadiste," *Kypriaka Chronika* 1 (1923): 7-10; A. Stylianou, "An Italo-Byzantine Series of Wall-Paintings in the Church of St. John Lampadistis, Kalopanayiotis, Cyprus," *XI Internationalen Byzantinisten-Kongresses 1958* (Munich, 1960), 595-98.

52. N. Thierry, *Nouvelles églises rupestres de Cappadoce: Région du Hasan Daği* (Paris, 1963), 183-92. M. Restle, *Byzantinische Wandmalerei*, 3: lxii, xxxv.

53. A. Cutler, *The Aristocratic Psalters in Byzantium* (Paris, 1984), 37ff.

54. See above, pages 75-76.

55. J. Hackett, *History of the Orthodox Church of Cyprus*, 331-45. For the iconographic importance of the Virgin of Kykko, see P. Santa Maria Mannino, "La Vergine 'Kykkiotissa' in due icone del Duecento," in *Atti del congresso internazionale di storia dell'arte medievale, Roma, 1980* (Rome, 1983), 487-96.

56. A. H. S. Megaw, "The Arts of Cyprus: Military Architecture," in *The Art and Architecture of the Crusader States*, ed. H. W. Hazard (Madison, 1977), 204-5; idem, "Metropolitan or Provincial," 82-83.

57. For St. George Manganes, see chapter 2, note 76. For the architecture of the Nea Moni, see Ch. Bouras, *Nea Moni on Chios: History and Architecture* (Athens, 1982); on this plan more generally, see the same author's "Twelfth and Thirteenth Century Variations of the Single Domed Octagon Plan," *DCAH* 4 (1977-79): 21-32.

58. Soteriou, *Byzantina Mnēmeia*, plate 238; E. Reusche, *Polychromes Sichtmauerwerk byzantinischer und von Byzanz beeinflusster Bauten Südosteuropas* (Cologne, 1971), 60ff.; H. Schäfer, *Die Gül Camii in Istanbul* (Tübingen, 1973), esp. 77-80; P. L. Vocotopoulos, "The Concealed Course Technique: Further Examples and a Few Remarks," *JOB* 28 (1979): 247-60.

59. Bouras, *Nea Moni*, 126-27.

60. C. Mango and E. J. W. Hawkins, "Report on Field Work in Istanbul and Cyprus, 1962-1963," *DOP* 18 (1964): 333-40; C. Mango, "Summary of Work Carried Out by Dumbarton Oaks Byzantine Center in Cyprus, 1959-1969," *Report of the Department of Antiquities, 1969* (Nicosia, 1969), 101. The same authors are preparing a monograph on the church.

61. See above, pages 109-10.

62. Bouras, *Nea Moni*, 70, 149-50.

63. Mango and Hawkins, "Field Work, 1962-63," 334 n. 58.

64. On Eumathius Philokales, see Anna Comnena, *Alexiadis*, II: 34.32, 125.11, 135.1, 224.13ff., 229.26ff., 234.10

65. A. Papageorghiou, "Hē Monē Apsinthiōtissēs," *Report of the Department of Antiquities, Cyprus* (Nicosia, 1963), 73-83; V. Karageorghis, "Chronique des fouilles—1963," *BCH* 88 (1964): 376.

66. I have not seen these frescoes because of the political situation in Cyprus. I gratefully rely here on comments made by Ernest Hawkins and Susan Boyd, who have had an opportunity to study these frescoes closely, as well as on photographs.

67. I. Andreescu, "Torcello, III. La chronologie relative des mosaïques pariétales," *DOP* 30 (1976): 247–76; V. Lazarev, *Old Russian Murals and Mosaics* (London, 1966), 67–72. For Daphni, see A. Frolow, "La date des mosaïques de Daphni," *Corso* 9 (1962): 265–99; Fr. Gerke, "I mosaici del katholikon di Daphni presso Eleusi," *Corso* 11 (1964): 201–23.

68. D. Mouriki, *The Mosaics of the Nea Moni on Chios* (Athens, 1985); H. Logvin, *Kiev's Hagia Sophia* (Kiev, 1971), 16–28.

69. A. Papageorghïou, *Masterpieces of the Byzantine Art of Cyprus* (Nicosia, 1965), 22–23, plate 22.

70. A. Stylianou and J. Stylianou, "Donors and Dedicatory Inscriptions, Supplicants and Supplications in the Painted Churches of Cyprus," *JOB* 9 (1960): 97–99; M. Sacopoulo, *Asinou en 1106, et sa contribution à l'iconographie* (Brussels, 1966); D. Winfield and E. J. W. Hawkins, "The Church of Our Lady at Asinou, Cyprus: A Report on the Seasons of 1965 and 1966," *DOP* 21 (1967): 260–66; C. Mango, "Asinou," *Annual Report of the Department of Antiquities, Cyprus, 1966* (Nicosia, 1967), 102–21; D. Winfield, "Hagios Chrysostomos, Trikomo, Asinou: Byzantine Painters at Work," *Praktika tou Prōtou Diethnous Kyprologikou Synedriou, Leukosia, 1969* (Nicosia, 1972), 2: 285–91. A. Stylianou, *Panagia Phorbiōtissa, Asinou* (Nicosia, 1973). R. Cormack is preparing a monograph.

71. D. Winfield, *Asinou: A Guide* (Nicosia, 1969), 18.

72. N. Oikonomidès, *Les listes de préséance byzantines des IXe et Xe siècles* (Paris, 1972), 294.

73. For a summary of the discussion concerning the donor of Asinou, see A. Nicolaïdès, "Les ktitors dans la peinture XIIe siècle à Chypre: Une remise au point," in *Artistes, artisans et production artistique au Moyen-Age* (Rennes, 1983), 679–86.

74. For example, at Kurbinovo in Macedonia and at Bari in South Italy. See below, page 000.

75. D. Winfield, *Asinou: A Guide*, 7. See also A. Stylianou, "A Cross Inside a Crescent on the Shield of St. George: A Wall-Painting in the Church of Panagia Phorbiotissa, Asinou, Cyprus," *Kypriakai Spoudai* 2 (1983): 133–34.

76. See above, page 115.

77. The same phenomenon may be seen in such monuments as Sant'Angelo in Formis near Capua in the West and Ateni in Georgia in the East. J. Wettstein, *Sant'Angelo in Formis et la peinture médiévale en Campanie* (Geneva, 1960); R. Mepisashvili and V. Tsintsadze, *The Arts of Ancient Georgia* (New York, 1979). The crude works of Episkopi on Santorini and the Myrtia monastery in southwest Greece also bear some resemblance to the Cypriot frescoes. The Bury Bible or the frescoes of Berze-le-Ville may be the products of a similar evolution of metropolitan art of the mid-eleventh century.

78. Winfield, "Hagios Chrysostomos, Trikomo, Asinou"; S. Boyd, "The Church of the Panagia Amasgou, Monagri, Cyprus and Its Wallpaintings," *DOP* 28 (1974): 276–328; the images of the Forty Martyrs, Virgin, and standing saints at Kelliana have not yet been published.

79. Weitzmann, "Sinai Icons Attributed to Cyprus," 47–63.

80. P. Grierson, *Byzantine Coins* (London, 1982), 234–35.

81. Tsiknopoullos, ed., *Kypriaka Typika*, 16, 17, 23.

82. O. Demus, "Die Entstehung des Paläologenstils in der Malerei," *Berichte zum XI. Internationalen Byzantinisten-Kongres, 1958* (Munich, 1958), 4,2: 1–63; E. Kitzinger, "The Byzantine Contribution to Western Art of the Twelfth and Thirteenth Centuries," *DOP* 20 (1966): 25–47, 265–66; K. Weitzmann, "Eine spätkomnenische Verkündigungsikone des Sinai und die zweite byzantinische Welle des 12. Jahrhunderts," *Festschrift für Herbert von Einem zum 16. Februar 1965*, ed. G. von der Osten and G. Kauffmann (Berlin, 1965), 299–312.

83. P. Magdalino and R. Nelson, "The Emperor in Byzantine Art of the Twelfth Century," *Byzantinische Forschungen* 8 (1982): 123–83.

84. A description of the foundation of the monastery is found in the *typikon* of the monastery written by the monk Nilos. Tsiknopoullos, ed., *Kypriaka Typika*, 2–68.

85. Brief restoration reports have appeared: see, for example, A. Papageorghiou, "Kato Lefkara," *Report of the Department of Antiquities, Cyprus, 1975* (Nicosia, 1976), 18.

86. G. Babić, "Les discussions christologiques et le décor des églises byzantines au XIIe siècle: Les évêques officiant devant l'Hétimasie et devant l'Amnos," *Fruhmittelalterliche Studien* 2 (1968): 368–86. A. L. Townsley, "Eucharistic Doctrine and the Liturgy in Late Byzantine Painting," *Oriens Christianus* 58 (1974): 138–53; C. Walter, "The Christ Child on the Altar in Byzantine Apse Decoration," *Actes du XVe Congrès international des études byzantines, Athens, 1976* (Athens, 1981), 909–13.

87. A. H. S. Megaw and E. J. W. Hawkins, "The Church of the Holy Apostles at Perachorio, Cyprus, and Its Frescoes," *DOP* 16 (1962): 277–348, esp. 346–48.

88. See above, pages 48-49.

89. This inscription has not yet been published.

90. V. Laurent, *Le corpus des sceaux de l'empire byzantin* (Paris, 1981), II: 383.

91. For reports on the cleaning and conservation of the frescoes carried out by Dumbarton Oaks in cooperation with the Department of Antiquities between 1968 and 1973, see D. Winfield, with an appendix by C. Mango, "The Church of the Panagia tou Arakos, Lagoudera: First Preliminary Report, 1968," *DOP* 23-24 (1969-70): 377-80; D. Winfield, "Reports on Work at Monagri, Lagoudera, and Hagios Neophytos, Cyprus, 1969/1970," *DOP* 25 (1971): 262-64; A. H. S. Megaw, "Background Architecture in the Lagoudera Frescoes," *JOB* 21 (1972): 195-201. Also see D. Winfield, *Panagia tou Arakos, Lagoudera: A Guide* (Nicosia, n.d.).

92. Winfield, *Panagia tou Arakos*, 15-16.

93. A. Papageorghiou, "Eikōn tou Christou en tō naō tēs Panagias tou Arakos," *Kypriakai Spoudai* 32 (1968): 45-55; A. Papageorghiou, "Duo byzantines eikones tou 12ou aiōna," *Report of the Department of Antiquities, Cyprus, 1976* (1976), 267-70.

94. See above, note 82.

95. Winfield, *Lagoudera*, 16.

96. See Mango and Hawkins, "The Hermitage of St. Neophytos," 206, for stylistic similarities; see Winfield, "Reports, 1969/1970," 264, for technical similarities.

97. See C. Mango and E. J. W. Hawkins, "The Heritage of St. Neophytos and Its Wall Paintings," *DOP* 20 (1966): 119-206, for a complete publication of the church, as well as a thorough consideration of the primary sources. For minor revisions in the chronology of the paintings, see Winfield, "Reports, 1969/1970," 264; A. Wharton Epstein, "The Chronology of the Construction and Decoration of St. Neophytos on Cyprus," *Byzantine Studies/Etudes Byzantines* 9 (1982): 71-80. For a readable introduction to the church, see R. Cormack, *Writing in Gold: Byzantine Society and Its Icons* (New York, 1985), 215-51.

98. Tsiknopoullos, ed., *Kypriaka typika*, 71-104; K. A. Manaphes, "Paratērēseis eis ta 'Kypriaka Typika,'" *Epistēmonikē epetērida tēs philosophikēs scholēs tou panepistēmiou Athēnōn, 1969-1970* (Athens, 1970), 155-68.

99. Mango and Hawkins, "Hermitage of St. Neophytos," 124. Despite protestations to the contrary, Neophytus seems to have accepted land donations. According to a note in a Cypriot manuscript in the Bibliothèque Nationale, Paris gr. 301, by 1234 the Encleistra had already acquired as a *metochion* the sanctuary of Ag. Epiphanios tōn Kouboukliōn. J. Darrouzès, "Manuscrits originaires de Chypre à la Bibliothèque Nationale de Paris," *REB* 8 (1951): 172-74.

100. See above, page 130.

101. A. Wharton Epstein, "Formulas for Salvation: A Comparison of Two Byzantine Monasteries and Their Founders, *Church History* 50 (1981): 385-400.

102. I am grateful to Professor Annemarie Carr for pointing this out to me. See H. Vincent and F. M. Abel, *Jerusalem nouvelle* (Paris, 1914), 261, who reconstruct the program of the Holy Sepulchre from pilgrims' accounts.

103. In this he was not unique. The ascetic who lived above the El Nazar, Chapel 1 in Göreme Valley in Cappadocia, made certain he was close to God in exactly the same way.

104. For thirteenth-century painting, see D. Mouriki, "The Wall Paintings of the Church of the Panagia at Moutoullas, Cyprus," in *Byzanz und der Westen: Studien zur Kunst des europäischen Mittelalters*, ed. I. Hutter (Vienna, 1984), 171-213.

CHAPTER 4

1. The territorial definition of such important studies as V. Djurić, *Byzantinische Fresken in Jugoslawien* (Munich, 1976), R. Hamann-MacLean and H. Hallensleben, *Die Monumentalmalerei in Serbien und Makedonien vom 11. bis zum frühen 14. Jahrhundert*, 3 vols. (Giessen, 1963, 1976), and G. Millet, *La peinture du moyen âge en Yougoslavie*, 3 vols. (Paris, 1954), were obviously determined by current political boundaries rather than by a historical rationale. National prejudice has also affected consideration of the region. S. Kyriakides, *The Northern Ethnological Boundaries of Hellenism* (Thessaloniki, 1955; reprinted Amsterdam, 1980), provides an extreme example. The debate is somewhat more subtle in the field of art history. A. Xyngopoulos, *Thessalonique et la peinture macédonienne*, Hetaireia Makedonikōn Spoudōn, 7 (Athens, 1955), attempts to prove that Thessaloniki and its artistic workshops dominated the development of Macedonian painting from the eleventh century onward, denying the existence of significant Constantinopolitan or Bulgarian influence. V. Lazarev criticizes Xyngopoulos's thesis, suggesting instead Slavic inspiration for works of the early eleventh century. "Zhivopis XI-XIII vekov v Makedonii," *Actes du XIIe Congrès international d'études byzantines, Ochride, 1961*, 3 vols. (Beograd, 1963-64), I: 105-34.

2. N. G. L. Hammond, *A History of Macedonia: Historical Geography and Prehistory* (Oxford, 1972), I: 3-12.

3. Still basic is P. Lemerle, "Invasions et migrations dans les Balkans depuis la fin de l'époque romaine jusqu'au VIIIe siècle," *Revue Historique* 211 (1954): 265-308. See also R. J. H. Jenkins, "Byzantium and Byzantinism," in *Lectures in Memory of L. T. Semple*, ed. D. W. Bradeen, et al. (Princeton, 1967), 133-78, esp. 160-65.

4. Much has been written on this subject, for instance, V. Besevliev, "Zur Frage der slavische Einsiedlungen in Hinterland von Thessaloniki im 10. Jahrhundert," reprinted in the author's *Bulgarish-Byzantinische Aufsätze* (London, 1978), no. 34.

5. *Pseudo-Luciano, Timarione*, ed. R. Romano, Byzantina et neohellenica neapolitana, 2 (Naples, 1974), 53.114-23; *Timarion*, trans. B. Baldwin (Detroit, 1984), 44.

6. G. C. Soulis, "The Legacy of Cyril and Methodius to the Southern Slavs," *DOP* 19 (1965): 19-43.

7. A. Pertusi, *Costantino Porfirogenito de Thematibus*, Studi e Testi, 160 (Vatican, 1952), 168-70.

8. V. Zlatarski, "Izvestijata za Bulgarite v chronikata na Simeona Metafrasta i Logoteta," *Sbornik za narodni umotvorenija, nauka i knižnina* 24 (1908): 1-161, esp. 70ff.

9. J. M. Speiser, "Les inscriptions de Thessalonique," *TM* 5 (1973): 159; R. Cormack, "The Apse Mosaics of S. Sophia at Thessaloniki," *DCAH* 4,1 (1980/81): 111-35.

10. C. Mango, *Byzantine Architecture* (New York, 1975), 161-65.

11. Cormack, "Apse Mosaics of S. Sophia," 119-23.

12. R. Janin, *Les églises et les monastères des grands centres Byzantins. II. Bithynie, Hellespont, Latros, Galèsios, Trébizonde, Athènes, Thessalonique* (Paris, 1975), 407.

13. The episcopal function of the church is argued by Cormack, "Apse Mosaics of S. Sophia," 119-21.

14. The recently published Ph.D. dissertation on St. Sophia in Thessaloniki by K. Theocharidou is not available to me. For the earlier church on the site, see A. Mentzos, "Symbolē stēn ereuna tou vaou tēs Hag. Sophias Thessalonikēs," *Makedonika* 21 (1981): 198-221.

15. For the Koimesis, see T. Schmit, *Die Koimesiskirche von Nikaia, das Bauwerk und die Mosaiken* (Berlin, 1927); C. Mango, "Date of the Narthex Mosaics of the Church of the Dormition at Nicaea," *DOP* 13 (1959): 245-52; U. Peschlow, "Neue Beobachtungen zur Architektur and Ausstattung der Koimesiskirche in Iznik," *Istanbuler Mitteilungen* 22 (1972): 145-87. For St. Nicholas, see O. Feld, "Die Innenausstattung der Nikolaoskirche in Myra," and his "Die Kirchen von Myra und Umgebung," in *Myra: Ein lykische Metropole*, ed. J. Borchhardt, Istanbuler Forschungen, 30 (Berlin, 1975), 360ff.; 398ff.

16. Mango, *Byzantine Architecture*, 174-78.

17. M. Kalligas, *Die Hagia Sophia von Thessalonike* (Wurzburg, 1935), 23.

18. U. Peschlow, *Die Irenenkirche in Istanbul: Untersuchung zur Architektur* (Tübingen, 1977).

19. R. Cormack, "The Arts during the Age of Iconoclasm," in *Iconoclasm*, ed. A. Bryer and J. Herrin (Birmingham, 1977), 35-44.

20. A. Grabar, *L'empereur dans l'art byzantin* (Paris, 1946), 32-39; 170-71.

21. For the problematic inscription in the dome, see Spieser, "Inscriptions," 160-61, who dates it to 885. New evidence is presented by K. Theocharidou, "Ta psēphidōta tou troullou stēn Hagia Sophia Thessalonikēs: Phaseis kai problēmata chronologēsēs," *Archaiologikon Deltion* 31 (1976): 265-73, though her conclusion that the inscription dates the founding of the church to before 690 has been questioned by Cormack, "Apse Mosaics of S. Sophia," 123-26 and n. 42.

22. A. Xyngopoulos, "Hē toichographia tēs Analēpseōs en tē apsidi tou Hag. Geōrgiou tēs Thessalonikēs," *Archaiologikē ephēmeris* (1938), 32-53.

23. Notably the holy bishops in the tympana and in the mosaic decoration of the rooms above the southwest vestibule. For a discussion of this style, see R. Cormack and E. J. W. Hawkins, "The Mosaics of Saint Sophia at Istanbul: The Rooms above the Southwest Vestibule and Ramp," *DOP* 30 (1976): esp. 235-40. Also see above, chapter 2, note 31, and N. Thierry, "A propos de l'Ascension d'Ayvalı kilise et de celle de Sainte-Sophie de Salonique," *CA* 15 (1965): 145-54.

24. F. Forlati, C. Brandi, and Y. Froideraux, *Saint Sophia in Ohrid* (Paris, 1953); A. Wharton Epstein, "The Political Content of the Paintings of Saint Sophia at Ohrid," *JÖB* 29 (1980): esp. 325-29. For a current survey, with bibliography, see P. Miljković-Pepek, "L'architecture chrétienne chez les slaves macédoniens," *The 17th International Byzantine Congress*, Major Papers (Washington, D.C., 1986), 483-505.

25. For example, Theophanes continuatus, *Chronographia* (Bonn, 1838), 163.19-164.17.

26. *PG*, 126, 1229, par. 23.

27. Scholars debate as to whether such great churches as the basilica at Pliska and the Round Church at Preslav were reused Early Christian foundations or Bulgarian constructions. G. Stričević,

"La rénovation du type basilical dans l'architecture ecclésiastique des pays centrales des Balkans au IXe–XIe siècles," *XIIe Congrès internationale des études byzantines, Ochride, 1961* (Beograd, 1963), 165–211. Also see C. Bouras, "Zourtsa: Une basilique byzantine au Péloponnèse," *CA* 21 (1971): 142, 144, and P. A. Vokotopolos, *Hē ekklēsiastikē architektonikē eis tēn dutikēn sterean Helada kai tēn Epeiron* (Thessaloniki, 1975), 95–105.

28. I have not visited the site of St. Achilleus as the church is located in a militarily sensitive region on the Greek-Albanian border. St. Pelekanides, *Byzantina kai metabyzantina mnēmeia tēs Prespas*, Hetaireia Makedonikon Spoudōn, 16 (Thessaloniki, 1957), 64–78. N. K. Moutsopoulos has also published extensively on St. Achilleus, e.g., "Anaskaphē basilikēs Hag. Achilleiou," *Epistēmonikē epetērida tēs Polutechnikēs Scholēs* 4 (1969); 63ff., his "Anaskaphē basilikēs Hag. Achilleiou," *Epistēmonikē epetērida tēs Polutechnikēs Scholēs* 5 (1971/72): 149ff.

29. Georgius Cedrenus, *Synopsis historiōn* (Bonn, 1839), 436.7–11; 718.23–719.1; C. de Boor, "Weiteres zur Chronik des Skylitzes," *BZ* 14 (1905): 436. The evidence is summarized by J. Ferluga, "Vreme podizanja crkve Sv. Ahileja na Prespi," *Zbornik za likovne umetnosti* 2 (1966): 3–7.

30. A. Grabar, "Deux témoignages archéologiques sur l'autocéphalie d'une église: Prespa et Ochrid," *Zbornik Radova* 8 (1964): 163–68.

31. The still-basic survey of the churches of Kastoria is A. K. Orlandos, "Ta Byzantina mnēmeia tēs Kastorias," *Archeion tōn byzantinōn mnēmeiōn tēs Hellados* 4 (1938): 3–213; for plates, see S. Pelekanides, *Kastoria* (Thessaloniki, 1953); also see N. Moutsopoulos, *Kastoria* (Thessaloniki, 1974); A. Wharton Epstein, "Middle Byzantine Churches of Kastoria: Dates and Implications," *The Art Bulletin* 62 (1980): 190–207; and S. Pelekanides and M. Chatzidakis, *Kastoria* (Athens, 1985).

32. See above, pages 123–24.

33. The proportional ratios of width to height in the naves of St. Stephen and the Taxiarchs are approximately 1:4.6 and 1:4.3, respectively.

34. A. H. S. Megaw, "Byzantine Reticulate Revetments," *Charistērion eis A. K. Orlandon*, 3 vols. (Athens, 1966), III: 10–22; E. Reusche, *Polychromes Sichtmauerwerk byzantinischer und von Byzanz beeinflusster Bauten Südosteuropas* (Cologne, 1971); A. Pasadaios, *Ho keramoplastikos diakosmos tōn byzantinōn ktēriōn tēs Kōnstantinoupoleōs* (Athens, 1973); M. Čanak Medić, "Contribution à l'étude de l'origine de la polychromie sur les façades des édifices byzantins," *Actes du XVe Congrès international d'études byzantines, Athens, 1976* (Athens, 1981), II, A: 107–20.

35. In the Taxiarchs, Christ and Matthew are depicted in the *prothesis* and *diakonikon*, respectively, and a bishop on the north face of the northeast arcade respond. In H. Stephanos, there are fragmentary remains of a bishop in the prothesis apse, a three-quarter-length figure on the east face of the north pier seemingly by the same hand as the Matthew in the Taxiarchs, a holy knight on the north jamb of the door into the south aisle, and a number of other isolated figures and busts.

36. See above, page 60.

37. For a fuller argument about the openness of the *templon* screen during the Middle Byzantine period, see A. Wharton Epstein, "The Middle Byzantine Sanctuary Barrier: Templon or Iconostasis?" *Journal of the British Archaeological Association* 134 (1981): 1–28.

38. A. K. Orlandos, "To katholikon tēs para tēn Thessalonikēn monēs Peristerōn," *Archeion tōn byzantinōn mnēmeiōn tēs Hellados* 7 (1951): 146–67; C. Mauropoulou-Tsiume and A. Kuntura, "Ho vaos tou Hagiou Andrea stēn Peristera," *Klēronomia* 13 (1981, appeared 1983): 487–507. For evidence of an earlier structure on the site, see C. Mauropoulou-Tsiume, in *Trito symposio byzantinēs kai metabyzantinēs archaiologias kai technēs*, Christianikē Archaiologikē Hetaireia (Athens, 1983), 54–56.

39. See below, page 000.

40. L. Petit, "Vie et office de saint Euthyme le Jeune," *Revue de l'orient Chrétien* 8 (1903): 192–94, par. 28–29.

41. L. Petit, "Vie de S. Athanase l'Athonite," *Analecta Bollandiana* 25 (1906): 26, par. 17. P. Lemerle, "La vie ancienne de saint Athanase l'Athonite," in *Le millénaire du Mont Athos, 963–1963*, 2 vols. (Chevetogne, Belgium, 1963), I: 59–100; *Vitae duae antiquae Sancti Athasasii Athonitae*, ed. J. Noret (Turnhout Brepols, 1982). For a discussion of the two versions of the Life, see A. P. Kazhdan, "Hagiographical Notes," *Byz.* 53 (1983): 538–44.

42. Petit, "Vie de S. Athanase," 32–34, par. 23–24.

43. Ibid., 47–48, par. 35; 76–77, par. 66; for the date, see "La vie ancienne," 96–97.

44. The Lavra has not been fully investigated; until a complete survey of the monument has been published, many of the questions concerning it will remain unresolved. The architectural survey of P. Mylonas should remedy this situation. See his "Research on Athos" and "Two Middle Byzantine Churches on Athos," *Actes du XVe Congrès international d'études byzantines, Athens, 1976* (Athens, 1981), II, B: 529–44, 545–74. For the Lavra, see G. Millet, "Recherches au Mont-Athos (Age et structure du catholicon de Lavra)," *BCH* 29 (1905): 72–98 and P. Mylonas, "Le plan initial du catholicon de la Grande-Lavra au Mont Athos et la genèse du type du catholicon athonite," *CA* 32 (1984): 89–112.

45. For the relative chronologies of these structures, see ibid., 101-3.

46. P. Mylonas, "Les étapes successives de construction du Protaton au Mont Athos," *CA* 28 (1979): 143-60.

47. C. Mango, "Les monuments de l'architecture du XIe siècle et leur signification historique et sociale," *TM* 6 (1977); 351-65. Georgian associations with Athos need not have influenced its architecture. Bačkovo, for instance, was built by a Georgian exclusively for Georgians, yet the surviving ossuary and its paintings are unadulteratedly Byzantine. S. Grishin, "Literary Evidence for the Dating of the Bačkovo Ossuary Frescoes," *Byzantine Papers*, Proceedings of the First Australian Byzantine Studies Conference (1981), 90-100.

48. Mylonas, "Le plan initial," 96-103.

49. For example, the galleried Triconch of Tağar in Cappadocia (see chapter 2, note 61) and the Constantinopolitan Panagia Kamariotissa. See T. Mathews, "Observations on the Church of the Panagia Kamariotissa on Heybeliada (Chalke), Istanbul," with "A Note on Panagia Kamariotissa and some Imperial Foundations of the Tenth and Eleventh Centuries at Constantinople," by C. Mango, *DOP* 27 (1973): 117-32. For triconches in the region, see G. Stričević, "Eglises triconques médiévales en Serbie et en Macédoine," *XIIe Congrès internationale des études byzantines, Ochride, 1961*, 3 vols. (Beograd, 1963), I: 224-40.

50. Georgius Cedrenus, *Synopsis historiōn*, 459-60.

51. H. Gelzer, *Der Patriarcat von Achrida* (Leipzig, 1902), 6.

52. D. Koko, "Crkvata sv. Sofija vo Ohrid," *Godisen Zbornik, Skopje* 2 (1949): 343-58.

53. Pasadaios, "Ho keramoplastikos diakosmos," 56-57.

54. See above, page 79. V. Lazarev, "Zhivopis," 105-34, discusses the Slavic connections of these paintings. Because the author was unaware of stylistic analogies elsewhere in the Empire, he concluded that the frescoes of St. Sophia in Ohrid were Slavic in character.

55. The program has been hypothetically reconstructed in R. Hamann-MacLean, *Die Monumentalmalerei*, I; 1-31; II: 224-42; A. Vasilić, "Stilske osobine fresaka XI veka u Svetoj Sofiji ohridskoj," *Zbornik Narodnog muzeja* 9-10 (1979): 233-41.

56. For a reconstruction of St. Sophia's screen, see Wharton Epstein, "Middle Byzantine Sanctuary Barrier," 13-14.

57. A. Grabar, "Les peintures murales dans le choeur de Sainte-Sophie d'Ochrid," *CA* 15 (1965): 257-65. Also, C. Grozdanov, "Slika javljanja premudrosti sv. Jovanu Zlatoustom u sv. Sofiji Ohridskoj," *Zbornik Radova* 19 (1980): 147-55.

58. Wharton Epstein, "Political Content of the Paintings," 315-25. C. Walters, "Portraits of Local Bishops: A Note on Their Significance," *Zbornik Radova* 21 (1982): 7-17, suggests perhaps rather innocently that "strictly the pictures (in St. Sophia at Ohrid) have no 'political' content, for their themes are entirely religious" (n. 63).

59. *PG*, 126, cols. 508B, 308A, 541D, 544B, 396BC.

60. D. Evangelides, *He Panagia tōn Chalkeōn* (Thessaloniki, 1954), 10. For a corrected reading of the inscription, see P. Lemerle's review of Evangelides' book in *BZ* 48 (1955): 173-74.

61. V. von Falkenhausen, *Untersuchungen über die byzantinische Herrschaft in Süditalien vom 9. bis ins 11. Jahrhundert* (Wiesbaden, 1967), 87-88, tentatively identifies Christopher as Christopher Burgaris or Baragis.

62. For the architecture, see Ch. Diehl, M. LeTourneau, and H. Saladin, *Les monuments chrétiens de Salonique* (Paris, 1918), 153-63.

63. See above, page 25.

64. See above, page 74.

65. K. Papadopoulos, *Die Wandmalerei des XI Jahrhunderts in der Kirche Panagia tōn Chalkeōn in Thessaloniki* (Graz, 1966); A. Tsitouridou, *Hē Panagia tōn Chalkeōn* (Thessaloniki, 1975); A. Tsitouridou, "Die Grabkonzeption des ikonographischen Programms der Kirche Panagia Chalkeon in Thessaloniki," *JOB* 32/5 (1982): 435-41.

66. K. Weitzmann, "Das Evangelion in Skevophylakion zu Lawra," *Seminarium Kondakovianum* 8 (1938): 83-98. See also Papadopoulos, *Wandmalerei*, 112-20.

67. Attempts to make the Panagia the key monument in the establishment of a Macedonian school depend less on architectural or stylistic features than on programmatic peculiarities, such as the "archaizing" or, more correctly, "localizing" introduction of the Ascension in the central dome. A. Xyngopoulos, *Thessalonique et la peinture macédonienne*, 15ff.

68. For the postulated eleventh-century construction, see K. Theocharidou (cited above, note 14). For the frescoes, see S. Pelekanidis, "Neai ereuvai eis tēn Hagian Sophian Thessalonikēs kai hē apokatastasis tēs archaias autēs morphēs," *Pepragmena tou 8 diethnous byzantinologikou synedriou, Thessalonikē, 1953* (Athens, 1955), 404-7.

69. A. Xyngopoulos, *Ta mnēmeia tōn Serbiōn*, Hetaireia Makedonikōn Spoudōn, 18 (Athens,

1957), 26–75; the author transcribed an inscription, which is no longer legible, naming the bishop Michael as donor, p. 45. N. K. Moutsopoulos, "Anaskaphē basilikēs," (1971/72), fig. 37.

70. A sixth-century date for the church has also been argued. G. Soteriou, "Byzantinai basilikai Makedonias kai palaias Hellados," *Byzantinische Zeitschrift* 30 (1929/30): 568–69. More recently, E. Tsigaridas, "Hoi toichographies tēs Prothesēs stēn Palia Mētropolē Beroias," *Prōto symposio byzantinēs kai metabyzantinēs archaiologias kai technēs*, Christianikē Archaiologikē Hetaireia (Athens, 1981), 85–86; and his "Hoi toichographies tēs Palias Mētropoleōs Beroias," *Deutero symposio byzantinēs kai metabyzantinēs archaiologias kai technēs*, Christianikē Archaiologikē Hetaireia (Athens, 1982), 98–99.

71. Wharton Epstein, "The Middle Byzantine Churches," 195–98.

72. C. N. Bakirtzis, "Epigraphē stous Hagious Anargyrous Kastorias," *Makedonika* 9 (1971): 324ff.

73. See above, pages 123–24.

74. Stylistic analogies might also be drawn to Cappadocian frescoes of the early eleventh century, notably St. Barbara in Soğanlı Dere in Cappadocia (see above, page 41), or closer to hand, the crypt paintings of Hosios Loukas in Phokis (ascribed to the fourth decade of the eleventh century by D. Mouriki, "Stylistic Trends in Monumental Painting of Greece during the Eleventh and Twelfth Centuries," *DOP* 34/5 [1980/81]: 81–86).

75. Wharton Epstein, "The Middle Byzantine Churches," 202–6.

76. Mouriki, "Monumental Painting," 100–102. The dating of these frescoes is still under discussion. See, for example, L. Hadermann-Misguich, "Arguments iconographiques pour le maintien de la datation des peintures de la Mavriotissa au début du XIIIe siècle," *Abstracts of Short Papers, The 17th International Byzantine Congress, 1986* (Washington, D.C., 1986), 136–37.

77. For Asinou, see above, pages 78–79; for the Myrtia monastery, see A. K. Orlandos, "Hē en Aitōlia monē tēs Myrtiās," *Archeion tōn byzantinōn mnēmeiōn tēs Hellados* 9 (1961): 74–112; for Santorini, see A. K. Orlandos, "Hē Piskopē tēs Santorinēs (Panagia tēs Gōnias), *Archeion tōn byzantinōn mnēmeiōn tēs Hellados* 7 (1951): 178–214.

78. J. Wettstein, *Sant'Angelo in Formis et la peinture médiévale en Campanie* (Geneva, 1960); also see E. Bertaux, *L'art dans l'Italie méridionale: Aggiornamento dell'opera*, ed. A. Prandi, 3 vols. (Rome, 1978), II: 484.

79. See chapter 1, note 39.

80. A. Wharton Epstein, "Frescoes of the Mavriotissa Monastery near Kastoria: Evidence of Millenarianism and Anti-Semitism in the Wake of the First Crusade," *Gesta* 21 (1982): 21–29.

81. J. Starr, *The Jews in the Byzantine Empire (641–1204)*, Texte und Forschungen zur byzantinisch-neugriechischen Philologie, 30 (Athens, 1939), 203–6.

82. P. Miljković-Pepek, "Les données sur la chronologie des fresques de Veljusa entre les ans 1085 et 1094," *Actes du XVe Congrès international d'études byzantines, Athens, 1976* (Athens, 1981), II,B: 499–510; idem, *Veljusa, Manastir Sv. Bogorodica Milostiva vo Seloto Veljusa kraj Strumica* (Skopje, 1981).

83. L. Petit, "Monastère de Notre-Dame de Pitié en Macédoine," *Bulletin de l'institut archéologique Russe à Constantinople* 6 (1900): 6.

84. Ibid., 1–153.

85. See above, note 49.

86. H. Schäfer, *Die Gül Camii in Istanbul: Ein Beitrag zur mittelbyzantinischen Kirchenarchitektur Konstantinopels* (Tübingen, 1973); T. Mathews, *The Byzantine Churches of Istanbul: A Photographic Survey* (University Park, Pa., 1976), 59–70.

87. For the painting of church facades, see L. Hadermann-Misguich, "Une longue tradition byzantine: La décoration extérieure des églises," *Zograf* 7 (1977): 5–10.

88. There is a considerable debate concerning the date of the frescoes of Veljusa. On stylistic and iconographic grounds, Lazarev, "Zivopis," 132, and G. Babić, *Les chapelles annexes des églises byzantines* (Paris, 1969), 94, and her "Hristološke raspre u XII veku i pojava novih scena u apsidalnom dekoru vizantijskih crkava," *Zbornik za likove umetnosti* 2 (1966): 11–31, argue a late twelfth-century date. Hamann-MacLean favors a mid-twelfth-century date in *Monumentalmalerei*, 255–61. I have accepted here the arguments put forward by Miljković-Pepek and V. J. Djurić, "Fresques du monastère de Veljusa," *Akten des XI Internationalen Byzantinistenkongresses, München, 1958* (Munich, 1960), 113–21, for a late eleventh-century ascription.

89. Djurić, "Fresques du monastère de Veljusa," 114–16.

90. The image's identification as Vision of God is, however, more likely. Theophanies in monumental art are more common in the tenth than the eleventh century, but they occur in contemporary manuscript illuminations. Babić, *Chapelles annexes*, 94–95.

91. See chapter 3, note 86.

92. R. Miljković-Pepek, *Nerezi* (Beograd, 1966); Hamann-MacLean and Hallensleben, *Monumentalmalerei*, I: 32–45; II: 261–81.

93. G. Ostrogorsky, "Der Aufsteig des Geschlects der Angeloi," in his *Zur byzantinische Geschichte, Ausgewählte kleine Schriften* (Darmstadt, 1973), 166–82.

94. N. Okuneff, "La découverte des anciennes fresques du monastère de Nérès," *Slavia* 6 (1927/28): 603–9.

95. K. Weitzmann, "The Origin of the Threnos," *De artibus opuscula XL: Essays in Honor of Erwin Panofsky*, ed. M. Meiss (New York, 1961), 476–90.

96. Kazhdan and Wharton Epstein, *Byzantine Culture*, 220–30.

97. For example, the church at Vodoča. Z. Tatić, "Zwei byzantinische Kirchen im Gebiet vom Strumica: Vodoča, Veljusa," *Glasnik Skopje* 3 (1928): 83–96.

98. G. Gsodam, "Die Fresken von Nerezi, ein Beitrag zum Problem ihrer Datierung," *Festschrift W. Sas-Zaloziecky zum 60. Geburtstag* (Graz, 1956), 86–89, dates the frescoes to the thirteenth century. Lazarev, "Zivopis," 122–23, rightly criticizes his arguments.

99. Orlandos, "Mnēmeia tēs Kastorias," 145. For donors' portraits in St. Nicholas and the Anargyroi, see S. Tomeković-Reggiani, "Portraits et structures sociales au XIIe siècle," *Actes du XVe Congrès international d'études byzantines, Athens, 1976* (Athens, 1981), II,B: 823–36.

100. Despite the appearance of this title, Ihor Ševčenko was kind enough to confirm a twelfth-century date for the inscription on the basis of its palaeography. For a late eleventh-/early twelfth-century ascription, see N. Lavermicocca, "Sull'iscrizione di fondazione della chiesa di S. Nicola di 'Kasnitzi' a Kastorià (Macedonia)," *Nicolaus* 4 (1976): 209–23.

101. T. Malmquist, *Byzantine 12th Century Frescoes in Kastoria* (Uppsala, 1979), provides a diagram of the programs for both St. Nicholas and the Anargyroi.

102. N. Okunev, "Altarnaja pregrada XII veka v Nereze," *Seminarium Kondakovianum* 3 (1929): 5–23.

103. N. Ševčenko, *The Life of Saint Nicholas in Byzantine Art* (Turin, 1983), esp. 180–81.

104. J. Muzyczka, *De Aqua in liturgia byzantina* (Vatican City, 1957), 32ff. I want to thank Father Robert Taft of the Pontifical Institute for this and other references on the subject of the ritual of the Blessing of the Waters.

105. L. Hadermann-Misguich, *Kurbinovo: Les fresques de Saint-Georges et la peinture byzantine du XIIe siècle* (Brussels, 1975), 563–84.

106. Ibid., 17.

107. Orlandos, "Mnēmeia tēs Kastorias," 52–55.

108. Ibid., 57.

109. Ibid., 56.

110. The church at Kurbinovo also received figural frescoes on the exterior of the church, as did the Anargyroi in Kastoria. Hadermann-Misguich, "Une longue tradition byzantine," 5–10.

111. See above, pages 000, 000; more generally on stylistic affinities between Greece and Cyprus, emphasizing Macedonian works, see H. Grigoriadou, "Affinités iconographiques de décors peints en Chypre et en Grèce au XIIe siècle," and L. Hadermann-Misguich, "Fresques de Chypre et de Macédoine dans la seconde moitie du XIIe siècle," both in *Praktika tou prōtou diethnous Kyprologikou synedriou, Leukōsia, 1969* (Nicosia, 1972), 37–41 and 43–49.

112. For the late twelfth or early thirteenth-century frescoes of H. David, see Mouriki, "Monumental Painting," 119–24. For the late twelfth-century fresco on the original west facade of St. Sophia in Ohrid, see P. Miljković-Pepek, "Materijali za istorijata na srednovekovnoto slikarstvo vo Makedonija," *Kulturno Nasledstvo*, 1 (1966): 1–28, esp. 25. Neither of these works has the expressive qualities of the Kurbinovo master.

CHAPTER 5

1. For the problem of defining the borders of the province, see Jean-Marie Martin, "Une frontière artificielle: La catepanate italienne," *Actes du XIVe Congrès international des études byzantines, Bucarest, 1971*, 3 vols. (Bucharest, 1975), II: 379–85.

2. G. Rohlfs, *Studi e ricerche su lingua e dialetti d'Italia* (Florence, 1972), esp. part 3, 195–296; Greek and bilingual inscriptions show the impact of imperial control. V. von Falkenhausen, "Taranto in epoca bizantina," *Studi medievali*, 3d ser., 9 (1968), 149–52.

3. F. Dölger, *Regesten der Kaiserurkunden des oströmischen Reiches von 565–1453*, 3 vols. (Hildesheim, 1976), 92, no. 717, indicates that an attempt was made to ban the Latin liturgy in Apulia. Bari-Canosa had been raised to archiepiscopal status by 953, Taranto in 978, Trani in 987, Lucera in 1005, Brindisi in 1010, and Siponto in 1023. Vera von Falkenhausen, *Untersuchungen über die byzantinische Herrschaft in Süditalien vom 9. bis ins 11. Jahrhundert* (Wiesbaden, 1967), 152–53.

4. Two saints, Leo-Luke of Corleone and Elias Spelaeotes (*AASS*, 1 March I, 99, par. 6; *AASS*, 11 September III, 850–51, par. 8), went before their tonsure; others went after.

5. Great Britain Admiralty, *Italy*, Geographic Handbook Series 1 (London, 1944), esp. 289 and 364.

6. A. Guillou, "Un document sur le gouvernment de la province. L'inscription historique en vers de Bari (1011)," reprinted in his *Studies on Byzantine Italy* (London, 1970), VIII.

7. A. Guillou, "Production and Profits in the Byzantine Province of South Italy: An Expanding Society," *DOP* 28 (1974): 108ff.; idem, "La soie du katépanat d'Italie," *TM* 6 (1976): 69–84.

8. O. Baldacci, *Puglia*, Le regioni d'Italia, 14 (Turin, 1972); more generally, G. Luzzato, *An Economic History of Italy from the Fall of the Roman Empire to the Beginning of the Sixteenth Century* (London, 1961).

9. A. Guillou, "L'Italie byzantine du IXe au XIe siècle: Etat des questions," *L'art dans l'Italie méridionale: Aggiornamento dell'opera di Emile Bertaux*, ed. A. Prandi, 6 vols. (Rome, 1978), III: 415–26. L. Gambi, *Calabria*, Le regioni d'Italia, 16 (Turin, 1978).

10. F. Carabellese, *L'Apulia ed il suo comune nell'alto medioevo*, Commissione provinciale di archeologia e storia patria. Documenti e monografie, 7 (Trani, 1905); G. Fascoli and F. Bocchi, *La città medievale italiana* (Florence, 1973).

11. N. Kamp, "Vescovi e diocesi dell'Italia meridionale nel passaggio dalla dominazione bizantina allo Stato normanno," *Forme di potere e struttura sociale in Italia nel Medioevo*, ed. Gabriella Rossetti (Bologna, 1977), 392–93.

12. Guillou, "Etat des questions," 37.

13. An enormous amount has been written on the development of urbanism and intercity competition among the municipalities of northern Italy. Useful contributions in English include A. B. Hibbert, "The Origins of the Medieval Town Patriciate," *Past and Present* 3 (1953): 15–27, and P. L. Jones, "Communes and Despots: The City State in Late-Medieval Italy," *Transactions of the Royal Historical Society* (1964), 71–96.

14. For the primary and secondary sources of saints' lives in South Italy, see G. da Costa-Louillet, "Saints de Sicile et d'Italie méridionale aux VIIIe, IXe et Xe siècles," *Byz.* 29/30 (1959/60): 89–180; V. von Falkenhausen, "Aspetti economici dei monasteri bizantini in Calabria," *Calabria bizantina: Aspetti sociali ed economici. Atti del terzo incontro di studi bizantini, Reggio Calabria* (Reggio, 1978), 29–55; idem, "I monasteri greci dell'Italia meridionale e della Sicilia dopo l'avvento dei Normanni: Continuità e mutamenti," *Il passaggio dal dominio bizantino allo Stato normanno nell'Italia meridionale. Atti del II Convegno internazionale di studio sull Civiltà rupestre medioevale nel mezzogiorno d'Italia, Taranto/Mottola, 1973* (Taranto, 1977), 197–229. Also see volumes in the series *Corpus des actes grecs d'Italie du Sud et de Sicile* (Vatican, 1967–).

15. So far as I know, there is no surviving Italo-Greek life of a female monastic saint. However, women relations are mentioned often in the lives of male holy men. Christopher's (tenth century) wife took religious orders when her husband established a monastery (G. Cozza-Luzi, *Studi e documenti di storia e diritto* 13 [1892]: 375–76, par. 7). Luke of Demena (d. 993?) had a sister Catherine who founded a nunnery dedicated to the Theotokos (*AASS*, 13 October VI, 341D, par. 14). Nilos sent the mother and sister of one of his disciples to the *hegoumena* Theodora that they might enter the monastic life (*AASS*, 26 September VII, 279E, par. 28).

16. See above, page 4.

17. *AASS*, 26 September VII, 208C, par. 31; *AASS*, 11 September III, 864D–865A, par. 42–43. See above, pages 131–32.

18. G. Schirò, *Vita di S. Luca*, Vite dei santi siciliani 1 (Palermo, 1954), 94–95.

19. G. Cozza-Luzzi, *Studi e documenti di storia e diritto* 12 (1891): 33–56, par. 20–22, 46–48.

20. *AASS*, 9 March II, 30B, par. 11.

21. *AASS*, 26 September VII, 302C, par. 72.

22. *AASS*, 13 October VI, 340B–D, par. 8–9; P. G. Giovanelli, *S. Bartolomeo juniore confondatore di Grottaferrata* (Grottaferrata, n.d.), 32–33, par. 7; *AASS*, 1 March I, 102E, par. 27; G. Rossi-Taibbi, *Vita di Sant'Elia* (Palermo, 1962), 119, par. 74.

23. *AASS*, 9 March II, 30B, par. 11; *AASS*, 1 March I, 101F, par. 21.

24. H. Belting, "Byzantine Art in Southern Italy," *DOP* 28 (1974): 24–25; for a rich discussion of the patronage of local notables, see V. von Falkenhausen, "A Provincial Aristocracy: The Byzantine Provinces in Southern Italy," in *The Byzantine Aristocracy IX to XIII Centuries*, ed. M. Angold, BAR International Series 221 (Oxford, 1984), 211–35.

25. Von Falkenhausen, "Taranto," 145.

26. Cozza-Luzzi, *Studi* (1892), 375–400, par. 3–5.

27. F. Dölger, *Regesten der Kaiserurkunden des oströmischen Reiches von 565–1453*, 3 vols. (Hildesheim, 1976), 100–101, no. 783. For the case of a man who converts his property into a monastery, see A. Guillou, "Saint-Elie près de Luzzi en Calabre: Monastères byzantins inconnus du Xe siè-

cle," *Miscellanea Agostino Pertusi (Rivista di studi bizantini e slavi* 2), 2 vols. (Bologna, 1982), 3–11.

28. A number of surveys of the art, architecture, and social setting of these rock-cut chapels has been published. Still basic is A. Medea, *Gli affreschi delle cripte ermitische pugliesi*, 2 vols. (Rome, 1939). Also see A. Prandi, "Il Salento provincia dell'arte bizantina," in *L'Oriente cristiano nella storia della civiltà* (Rome, 1964); La Scaletta, *Le chiese rupestri di Matera* (Rome, 1966); A. Prandi, ed., *Bertaux, Aggiornamento*; C. D. Fonseca, *Civiltà rupestre in Terra Jonica* (Rome, 1960); M. Rotili, *Arte bizantina in Calabria e in Basilicata* (Cava dei Terreni, 1980); P. Belli D'Elia et al., *La Puglia fra Bisanzio e l'Occidente* (Milan, 1980); G. Cavallo et al., *I Bizantini in Italia* (Milan, 1982). Unfortunately, few rock-cut monuments may be dated with great assurance. The dating criteria of building technique are absent; epigraphic evidence is rare; painting, where it does remain, might provide a *terminus ante quem*, although in many cases the frescoes are so fragmentary that a convincing analysis of the style is impossible. Because of these problems, as well as the multiplicity of monuments, this medium is dealt with broadly in an attempt to identify those features which reflect on the province's artistic tradition. Examples are generally restricted to monuments which have been ascribed in the secondary literature to a period no later than the twelfth century and which have Greek inscriptions.

30. Hall churches and double churches: S. Barbara in Matera is dated to the tenth or eleventh century by A. Rizzi, "La chiesa rupestre de S. Barbara a Matera," *Napoli nobilissima* 7 (1976): 41–55; the Cripta del Cappuccin, also in Matera, shares so many details with S. Barbara that it may well date from the same time (A. Venditti, *Architettura bizantina nell'Italia méridionale* [Naples, n.d.], 342–44). Basilicas: S. Nicola at Mottola, which retains fragments of eleventh-century(?) paintings (Venditti, *Architettura bizantina*, 284–86; Medea, *Affreschi*, figs. 136–49); S. Antonio Abate in Massafra (Fonseca, *Civiltà rupestre*, 112).

31. S. Leonardo in Massafra, Medea, *Affreschi*, 208–9. The Deesis in the apse, ascribed to the fourteenth century, has been badly over-painted. The fragmentary Annunciation of the templon has formal features of the late twelfth century. For S. Maria in Poggiardo, which is located under the central square of the town, see B. Molajoli, "La cripta di Poggiardo," *Atti e memorie della Societa Magna Grecia bizantina-medioevale* 1 (1934): 9–23. For Giurdignano and S. Domenica in Ginosa, see *Architettura bizantina*, 232–33, figs. 21–27; 300, figs. 144–46. For S. Gregorio in Mottola, see Fonseca, *Civiltà rupestre*, 156, figs. 137–40.

32. P. Prandi, "Elementi bizantini e non-bizantini nei santuari rupestri della Puglia e della Basilicata," *La chiesa greca in Italia dall'VIII al XVI sec.*, Italia Sacra, 22 (Padua, 1973), 1363–75.

33. Another impressive screen is found in S. Gregorio in Matera. It is 4.5 meters high, with three arches supported on four rock-cut free standing columns. The side arches are narrower than the central opening and closed at their base by low parapet slabs. Venditti, *Architettura bizantina*, fig. 217. The simple screens of the two apses at S. Lorenzo in Fasano represent the more common form of this high screen. S. Lorenzo in Fasano is dated to the mid-eleventh century by E. Bertaux, *L'art dans l'Italie méridionale*, 2 vols. (Paris, 1903), I: 220, who suggests that its frescoes, "after the first Christ at Carpignano, are the oldest basilian paintings conserved in South Italy."

34. Medea, *Affreschi*, 91–101.

35. Idid., 109–18; Belting, "Byzantine Art," 12–14; Guillou, "Notes d'épigraphie byzantine," *Studi medievali*, ser. 3, 11 (1970), 403–8; L. Capone, *La cripta della Santa Marina e Cristina in Carpignano* (Fasano, 1979).

36. A. Jacob, "L'inscription métrique de l'enfeu de Carpignano," *Rivista di studi bizantini e neoellenici* 20/21 (1983/84): 103–22.

37. Benedict's monastery at Monte Cassino received patronage from Constantinople from the ninth to the twelfth century. P. Toubert, "Pour une histoire de l'environnement économique et social du Mont-Cassino (IXe–XIIe siècles)," *Académie des inscriptions et belles-lettres, Comptes rendus* (1976), 689–702; *Regesten*, 66, no. 555, and II, 20, no. 1006. For artistic patronage at MonteCassino and bibliography, see P. Mayo, "Art-Historical Introduction to the Codex Benedictus," in P. Meyvaert, ed., *The Codex Benedictus* (New York, 1982), 33–57. For Nilus's canon, see *AASS*, 26 September VII, 304B, par. 74.

38. Nicholas is depicted in, for example, SS. Marina e Cristina, Carpignano; the Candelora, Massafra; S. Margherita, Mottola; S. Nicola, Mottola; S. Falcione, Matera; S. Maria, Poggiardo; SS. Stefani, Vaste; the Cripta della Celimanna, Supersano; and S. Biagio, S. Vito dei Normanni. For images inspired by the cult of S. Nicholas, see N. Ševčenko, *The Life of Saint Nicholas in Byzantine Art* (Turin, 1983).

39. A number of churches of the first half of the eleventh century are dedicated to Nicholas. See A. Guillou, "Le brébion de la métropole byzantine de Règion (vers 1050)," *Corpus des actes grecs d'Italie du Sud et de Sicile*, Recherches d'histoire et de géographie, 4 (Vatican, 1974), 252. For Nicholas's cult, see L. Heiser, *Nikolaus von Myra Heiliger der ungeteilten Christenheit*, Sophia 18 (Trier, 1978).

40. The Baptist is depicted in, for example, S. Simeon a Famosa, Massafra; S. Nicola, Mottola; S. Maria, Poggiardo; Cripta della Celimanna, Supersano; and S. Giovanni, S. Vito dei Normanni.

41. The translation of Cataldo's relics to the Cathedral of Taranto took place in 1115. For these saints, see G. Kaftel, *Iconography of the Saints in Central and Southern Italian Painting* (Florence, 1952), 254–56, 280–81, 848–49, 1153–56.

42. N. Lavernicocco, "Il programma decorativo del santuario rupestre di S. Nicola di Mottola," in *Atti del II Convegno international di studio sulla Civiltà rupestre medioevale nel Mezzogiorno d'Italia, Taranto/Mottola, 1973* (Taranto, 1977), 291–337; Pace, in D'Elia, *L'Puglia*, 340–48.

43. C. Walter, "The Origins of the Iconostasis," *Eastern Churches Review* 3 (1971): 251–67; A. Wharton Epstein, "The Middle Byzantine Sanctuary Barrier: Templon Screen or Iconostasis?" *Journal of the British Archaeological Association* 134 (1981): 1–28.

44. The frescoes of this church have virtually disappeared since they were studied by Bertaux, *L'art dans l'Italie méridionale*, 123–24.

45. For a discussion of Italo-Cypriot artistic relations in which the wall paintings of South Italy are treated, see V. Pace, "Presenze e influenze cipriote nella pittura duecentesca Italiana," *Corso* 32 (1985): 259–98.

46. For a summary of earlier bibliography, see G. Lavermicocco, *Bertaux, Aggiornamento*, 204–8. See also H. Teodoru, "Les églises à cinq coupoles en Calabre: San Marco de Rossano et la Cattolica de Stilo," *Ephemeris Dacoromana* 4 (1929): 149–80; C. A. Willemsen and D. Odenthal, *Kalabrien: Schicksal einer Landbrücke* (Cologne, 1966), 81–84; G. Dimitrokallis, "Il problema della datazione della Cattolica di Stilo," *Archivio storico per la Calabria e Lucania* (1967), 31–36; Venditti, *Architettura bizantina*, 852–79.

47. S. Borsari, "Vita di S. Giovanni Terista," *Archivio storico per la Calabria e la Lucania* 22 (1953): 137, par. 1.

48. A. Guillou, "Italie méridionale byzantine ou Byzantins en Italie méridionale," *Byz.* 44 (1974): 184.

49. Teodoru, "San Marco et la Cattolica," 149–80; Lavermicocco, *Bertaux, Aggiornamento*, 308–10. Venditti, *Architettura bizantina*, 863–73, does not accept the contemporaneity of Stilo and Rossano.

50. Lavermicocco, *Bertaux, Aggiornamento*, 121–22; G. Gianfreda, *Basilica bizantina di S. Pietro in Otranto* (Galatina, 1976); G. Demetrokalles, "Hoi stauroeideis eggegrammenoi naoi tēs sikelias kai katō Italias," *Epetēris Hetaireias Byzantinōn Spoudōn* 36 (1968): 267–334, esp. 295–300.

51. A. Antonaci, *Otranto: Testi e monumenti* (Galatina, 1955).

52. Two bishops from Otranto attended councils in Constantinople in the eleventh century. Von Falkenhausen, *Untersuchungen*, 149. If this does not show the importance of the see, it does reflect its connections to the imperial capital. Generally for bishops' lists in South Italy, see H.-W. Klewitz, "Zur Geschichte der Bistumsorganisation Campaniens und Apuliens im 10. und 11. Jahrhundert," *Quellen und Forschungen aus italienischen Archiven und Bibliotheken* 24 (1932/33): 1–61.

53. For archaeological evidence supporting a late ninth-/early tenth-century date, see F. D'Andria, "Otranto: Ricerche archeologiche a S. Pietro," in *Le aree omogenee della civiltà rupestre nell'ambito dell'Impero Bizantino: La Cappadocia*, ed. C. D. Fonseca (Galatina, 1981), 223–25. See also Guillou, "Italie meridionale byzantine," 181–84, and idem, "Notes d'épigraphie," 403–8.

54. For a twelfth-century dating, see I. P. Marasco, "Affreschi medievali in S. Pietro d'Otranto," *Annali della Facoltà di Lettere di Lecce* 2 (1964–65): 64–97; for a thirteenth-century date, see V. Pace, in *Byzantini in Italia*, 476.

55. O. Demus, *Mosaics of Norman Sicily* (London, 1950), 91–108.

56. A. Prandi, "Aspetti archeologici dell'eremitismo in Puglia," *Atti della II settimana internazionale di studio sul tema: L'eremitismo in Occidente nei secoli XI e XII, Mendola, 1962* (Milan, 1965), 438–44; idem, "Pittura inedite di Casaranelli," *Rivista dell'istituto nazionale d'archeologia e storia dell'arte*, n.s., 10 (1961), 227–92.

57. Von Falkenhausen, *Untersuchungen*, 18–29.

58. Pina Belli D'Elia, ed., *Alle sorgenti del Romanico Puglia XI secolo* (Bari, 1975), with substantial contributions by Tessa Garton, Michele D'Elia, and others.

59. P. Antonio Beatillo, *Historia di Bari, Principal città della Puglia* (Naples, 1637, reprinted, Historiae urbium et regionum Italiae rariores, III, Bologna, 1965), 5.

60. *Codice diplomatico Barese: Le pergamene del duomo di Bari, 952-1264*, ed. G. B. Nitto de Rossi, 5 vols. (Bari, 1897), V: 221.

61. Von Falkenhausen, "Taranto," 133–66; F. Ughelli, *Italia sacra sive de episcopis Italiae*, 10 vols. (Rome, 1644–1722), IX: 119.

62. D'Elia, *Puglia XI secolo*, 11–17, 27–30; M. D'Onofrio and V. Pace, *La Campania*, Italia Romanica, 4 (Milan, 1981).

63. For sculpture in Bari and Taranto, as well as in other Apulian sites, see *Puglia XI secolo*; for

Bari, see also the excellent article by M. M. Lovecchio, "La sculptura bizantina dell'XI secolo nel Museo di San Nicola di Bari," *Mémoires del l'école française de Rome* 93 (1981): 7–87, which discusses the Byzantine links of South Italian sculpture.

64. A. Grabar, *Sculptures byzantines de Constantinople (IVe–Xe siècle)*, Bibliothèque archéologique et historique de l'Institut français d'archéologie d'Istanbul, 17 (Paris, 1963), 65–66, plate 19, figs. 4 and 5, provides an example for comparison from the Archaeological Museum in Istanbul, no. 3902. This is a large composite capital with an acanthus register below and protomes of griffons alternating with standing angels above.

65. F. W. Deichmann, with J. Kramer and U. Peschlow, *Corpus der Kapitelle der Kirche von San Marco zu Venedig*, Forschungen zur Kunstgeschichte und christlichen Archäologie, 12 (Wiesbaden, 1981), plate 31, 452; O. Demus, *The Church of San Marco in Venice, Architecture and Sculpture* (Washington, D.C., 1960), plates 18 and 19.

66. Gregory requested assistance from the bishop of Siponto to remedy the situation: "Felicem, episcopum Sipontinum, visitatorem constituit vacuae ecclesiae Canusinae, ubi dos presbyteros perochiales ordinet. 'Pervenit ad nos, quod Canosina.' " P. Jaffé, *Regesta pontificum romanorum*, 2 vols. (Leipzig, 1888), I: 148, anno 591.

67. For a biography of Saint Sabinus and bibliography, see A. Lentini, "San Sabino di Canosa," *Biblioteca Sanctorum*, 12 vols. (Rome, 1968), XI, cols. 552–55.

68. Beatillo, *Historia*, 30.

69. C. Baronio, *Annales ecclesiastici*, 12 vols. (Rome, 1601–8), XI, cols. 819–22.

70. Von Falkenhausen, *Untersuchungen*, 152.

71. *Codice diplomatico barese*, I: 21–23; von Falkenhausen, *Untersuchungen*, 152.

72. P. F. Kehr, ed., *Italia pontificia, sive repertorium privilegiorum et litterarum a romanis pontificibus ante annum MCLXXXXVIII* (Berlin, 1961), 9, 291, and 339.

73. A. Wharton Epstein, "The Date and Significance of the Cathedral of Canosa in Apulia, South Italy," *DOP* 37 (1983): 79–90. For a different perspective, see M. Falla Castelfranci, *Contributo alla conoscenza dell'edilizia religiosa nella Longobardia meridionale*, Canosa Longobarda, part 1 (Rome, 1985).

74. Ughelli, *Italia sacra*, VII: 603; Anonyme de Bari, ed. L. A. Muratori, *Rerum italicarum scriptores*, 34 vols. (Milan, 1724), 5: 155–56 (1043).

75. For a series of small Byzantine churches, see F. Martorana and D. Minuto, "Cinque chiese calabresi di tradizione bizantina: Struttura muraria, tipologia architettonica, decorazione," in *Bisanzio e l'Italia: Raccolta di studi in memoria di Agostino Pertusi* (Milan, 1982), 239–59.

76. V. Laurent, "A propos de la métropole de Santa Severina en Calabre (Quelques remarques)," *REB* 22 (1964): 177–78.

77. A. Guillou, *Aspetti della civiltà bizantina in Italia: Società e cultura* (Bari, 1976), 369; see also P. Orsi, *Le chiese basiliane della Calabria* (Florence, 1929), 215–21.

78. Orsi, *Chiese della Calabria*, 206–37; P. Lojacono, "Sul restauro compiuto al battistero di Santa Severina," *Bollettino d'Arte* 28 (1934): 174–85; G. Lavermicocco, *Bertaux, Aggiornamento*, 231–33; E. Zinzi, "Per il battistero di Santa Severina: Studi e problemi," in *Civiltà di Calabria*, ed. A. Placanica (Chiaravalle, 1984), 541–47.

79. An archbishop Theodore is mentioned in a second inscription. Orsi, *Chiese della Calabria*, 208–9, figs. 140–41. Laurent, "Santa Severina," 179, ascribes the baptistery to an unspecified archbishop John of Reggio and to a date sometime between 745 and 835.

80. G. Ficker, *Erlasse des Patriarchen von Konstantinopel, Alexios Studites* (Kiel, 1911), 26.

81. For a summary of the arguments for the various datings of the church, see G. Lavermicocco, *Bertaux, Aggiornamento*, 321–22, and Willemsen and Odenthal, *Kalabrien*, 85–89. The monograph by L. Monardo, *Realtà storica ed essenza artistica in S. Maria della Roccella* (Rome, 1964), is disappointing. See also G. Urban, "Strutture architettonische normanne in Sicilia: Bemerkung zur 'Anfangsarchitektur' der Normannenzeit in Suditalien," *BZ* 59 (1966): 72–93; C. Bozzoni, *Calabria Normanna: Ricerche sull'architettura dei secoli undicesimo e dodicesimo* (Rome, 1974), 65–112.

82. J. Groschel, "S. Maria della Roccelletta," *Zeitschrift für Bauwesen* 53 (1903): 430–48, esp. 445–46; Venditti, *Architettura bizantina*, 899.

83. G. Occhiato, "L'abbatiale détruite de la Sainte-Trinité de Mileto (Calabre)," *Cahiers de civilisation médiévale* 21 (1978): 231–46.

84. For this group, see below, note 104.

85. Ughelli, VIII: 425, 450; J. Gay, "Les diocèses de Calabre à l'époque byzantine," *Revue d'histoire et de littérature religieuses* 5 (1900): 256. Unfortunately there is little literary evidence concerning the monument. Those documents relating to a "monasterio beatae Mariae de rokella" which seem to support a late eleventh-century dating for the church may in fact refer to another monument. Ughelli, IX: 182, 426–29. The description found in the Liber Visitationis (M.-H. Laurent

and A. Guillou, *Le 'Liber Visitationis' d'Athanase Chalkéopoulos (1457-1458): Contribution à l'histoire du monachisme grec en Italie méridionale* [Vatican, 1960], 120-21, 253, 276, and esp. 301) seems to imply that the monastery of S. Maria de Veteri Squillace is distinct from the Episcopatus Squillasensis.

86. M. E. Avagnina, V. Garibaldi, and C. Salterini, "Strutture murarie degli edifici religiosi di Roma nel XII secolo," *Rivista dell'istituto nazionale d'archeologia e storia dell'arte*, n.s., 23/24 (1976-77), 173-255.

87. H. Logvin, *Kiev's Hagia Sophia* (Kiev, 1971), 8-11, fig. 20; H. Schäfer, "Beziehungen zwischen Byzanz und der Kiever Rus im 10. und 11. Jahrhundert," *Istanbuler Mitteilungen* 23/24 (1973/74): 197-224.

88. F. Chalandon, *Histoire de la domination Normande en Italie et en Sicile*, 2 vols. (Paris, 1907; reprinted New York, 1960), I: 42-58; E. Joranson, "The Inception of the Career of the Normans in Italy: Legend and History," *Speculum* 23 (1948): 353-98; V. von Falkenhausen, "I ceti dirigenti prenormanni al tempo della costituzione degli stati normanni nell'Italia meridionale e in Sicilia," *Forme di potere e struttura sociale in Italia nel Medioevo*, ed. G. Rossetti (Bologna, 1977), 321-77.

89. *Regesten*, 17, no. 973; 18, no. 1003; 68, no. 1374.

90. Ioannes Kinnamos, *Epitome*, ed. A. Meineke (Bonn, 1836), 134-75, par. 1-15.

91. R. Janin, "Les Francs au service des Byzantins," *Echos d'Orient* 29 (1930), n. 157; Marquis de la Force, "Les conseillers latins du basileus Alexis Comnène," *Byz.* 11 (1936): 163-65.

92. See above, page 8.

93. On the continuity of administrative forms, see von Falkenhausen, "Taranto," 160-66.

94. R. B. Yewdale, "Bohemund I, Prince of Antioch," Ph.D. dissertation, Princeton University, June 1917, 29-30.

95. A. Engel, *Recherches sur la numismatique et la sigillographie des Normands de Sicile et d'Italie* (Paris, 1882), plate II, i.

96. See above, pages 150-51.

97. Von Falkenhausen, "I ceti dirigenti prenormanni," 321-77.

98. For this argument and for earlier bibliography, see P. Belli D'Elia, *Puglia XI secolo*, 188-89.

99. The bibliography on the domed churches of Apulia is extensive. For a summary of the discussion, see R. A. Morrone and M. S. Calo Mariani, *Bertaux, Aggiornamento*, 599-620. The more significant contributions include: G. Jonescu, "Le chiese pugliese a tre cupole," *Ephemeris Dacromana* 6 (1935): 50-128; M. Berucci, "Il tipo di chiesa coperta a cupole affiancate da volte a mezzabotte," *Atti del IX congresso nazionale di storia dell'architettura, Bari, 1955* (Rome, 1959), 81-116; G. Simoncini, "Chiese pugliese a cupole in asse," *Atti del IX congresso nazionale di storia dell'architettura, Bari, 1955* (Rome, 1959), 67-80. The group has also been reviewed in a series of articles by A. Venditti, the most important of which is "Architettura a cupola in Puglia," *Napoli Nobilissima* 6 (1967): 108-22.

100. Bertaux, *L'art dans d'Italie méridionale*, 379.

101. G. Angello, *Monumenti della Sicilia bizantina* (Palermo, 1952), and G. di Stefano, *Monumenti della Sicilia normanna*, 2d ed. by W. Krönig (Palermo, 1979), 40-44.

102. For S. Maria, see P. Belli D'Elia and M. D'Elia, *Puglia XI secolo*, 47-56; A. Venditti, "La chiesa di S. Maria Maggiore di Siponto," *Napoli Nobilissima* 5 (1966): 105-15. For S. Leonardo, see Bertaux, *L'art dans d'Italie méridionale*, 638-40, and for further bibliography, see A. Thierry, *Bertaux, Aggiornamento*, 594, n. 153.

103. R. Krautheimer, "San Nicola in Bari und die apulische Architektur des 12. Jahrhunderts," *Wiener Jahrbuch für Kunstgeschichte* 9 (1934): 5-42. F. Schettini, *La basilica di San Nicola* (Bari, 1967), argues unconvincingly that San Nicola is the refurbished palace of the catepanate. For the character and influence of MonteCassino, see G. Carbonara, *Iussu Desiderii: MonteCassino e l'architettura Campano-Abruzzese nell'indicesimo secolo* (Rome, 1979).

104. The best summaries of the links among these monuments and their relationship to Greek monasteries of the Norman period are: H. M. Schwarz, "Die Baukunst Kalabriens und Siziliens im Zeitalter der Normannen," *Römisches Jahrbuch für Kunstgeschichte* 6 (1942/44): 1-112; G. Urban, "Strutture architettoniche normanna in Sicilia," 72-93; C. Bozzoni, *Calabria Normanna*; G. Occhiato, "L'abbatiale détruite de la Sainte-Trinité de Mileto," 231-46; idem, "L'abbaziale Normanna di Saint' Eufemia," *Mélanges de l'école Française de Rome* 93 (1981): 565-603.

Index of Names

Iconographic Index